Einfach –
Vollkommen

Simple
and Perfect

Einfach – Vollkommen

Sachsens Weg in die internationale Uhrenwelt

Ferdinand Adolph Lange zum 200. Geburtstag

Simple and Perfect

Saxony's Path into the World of International Watchmaking

In Celebration of Ferdinand Adolph Lange's 200ᵗʰ Birthday

Herausgegeben von / Published by
Staatliche Kunstsammlungen Dresden
Peter Plaßmeyer, Sibylle Gluch

S TAATLICHE
K UNSTSAMMLUNGEN
D RESDEN

DEUTSCHER KUNSTVERLAG

Inhaltsverzeichnis
Contents

Grußwort
Foreword

»Einfach – Vollkommen. Sachsens Weg in die internationale Uhrenwelt« ist eine faszinierende Ausstellung und zugleich ein weiterer Höhepunkt in der seit neun Jahren bestehenden Zusammenarbeit zwischen den Staatlichen Kunstsammlungen Dresden und A. Lange & Söhne. Aus Anlass des 200. Geburtstages von Ferdinand Adolph Lange (1815 – 1875) zeigt der Mathematisch-Physikalische Salon den Gründer der sächsischen Feinuhrmacherei als Experten, Entrepreneur und Europäer mit Weitblick. Wir erfahren Neues über Langes vielfältige Inspirationsquellen und die Merkmale seines vom Streben nach höchster Präzision und mechanischer Einfachheit geprägten Stils. Wir erhalten einen Eindruck von der Bedeutung der Chronometrie für Astronomie und Seefahrt und verstehen, wie das Bildungssystem der Zeit zur Ansiedlung von Werkstätten in Sachsen beitrug. Durch die Gründung der ersten Glashütter Uhrenmanufaktur im Jahr 1845 wirken die Ideen und Ideale Langes bis heute fort.

Für die Jubiläumsausstellung kann es keinen besseren Ort geben als den Mathematisch-Physikalischen Salon, die Wiege der sächsischen Präzisionsuhrmacherei und seit Ende des 18. Jahrhunderts oberste Instanz in allen Zeitfragen des Landes. Hier ließ sich der junge Ferdinand Adolph Lange um 1830 für die Uhrmacherei begeistern. Aus der Begegnung mit den Werken der sächsischen Meister erwuchs seine Vision, in Sachsen die besten Uhren der

Simple and Perfect. Saxony's Path into the World of International Watchmaking is a fascinating exhibition and a new highlight in the nine-year collaboration between the Staatliche Kunstsammlungen Dresden and A. Lange & Söhne. To mark the 200th anniversary of the birth of Ferdinand Adolph Lange (1815 – 1875), the Mathematisch-Physikalischer Salon is presenting the founder of the Saxon precision-watchmaking industry as an expert, entrepreneur, and farsighted European. The exhibition sheds fresh light on Lange's richly varied sources of inspiration and on the characteristics of his style, which was distinguished by the pursuit of utmost exactitude and mechanical simplicity. Visitors gain an insight into the significance of chronometry for astronomy and maritime navigation and into the role of the educational system in the establishment of watchmaking workshops in Saxony in the nineteenth century. Lange's ideas and ideals informed the foundation of the first Glashütte watch manufactory in 1845, and they continue to shape the company to this day.

There can be no better place for the bicentenary exhibition than the Mathematisch-Physikalischer Salon, the cradle of Saxon precision horology and the state's highest authority in all matters havong to do with time. It was here, in around 1830, that young Ferdinand Adolph Lange first became interested in watchmaking. His dream of producing the world's best watches right here in Saxony was kindled by the Salon's

Welt zu bauen. Ohne den Salon, soviel ist sicher, gäbe es weder die Uhrenmarke A. Lange & Söhne noch die Uhrenstadt Glashütte, und der Name Sachsen hätte in der internationalen Uhrenwelt allenfalls eine historische Bedeutung.

Für uns ist die Unterstützung des Museums mehr als nur ein Bekenntnis zu unseren kulturellen Wurzeln. Denn was uns mit seiner aktuellen Arbeit verbindet, ist das gemeinsame Interesse, über die Erklärung wissenschaftshistorischer Zusammenhänge hinaus ein Gefühl für die Bedeutung der Zeitmessung und damit auch den Wert der Zeit zu vermitteln. Wir wünschen der Ausstellung »Einfach – Vollkommen« zahlreiche, begeisterte Besucher.

Wilhelm Schmid
CEO Lange Uhren GmbH

collection of masterpieces by Saxon horologists. Without the Salon, that much is certain, there would be no A. Lange & Söhne, Glashütte would not be the centre of the German watchmaking industry, and Saxony's place in the history of international horology would be a footnote at best.

Supporting the museum thus means more to us than merely a nod to our cultural roots. What connects us to the Salon's work today is the shared desire to convey a sense of the significance of chronometry and, with it, of the value of time itself. We wish the exhibition *Simple and Perfect* every success and a great many enthusiastic visitors.

Wilhelm Schmid
CEO Lange Uhren GmbH

Vorwort

Preface

Der 200. Geburtstag von Ferdinand Adolph Lange (1815 – 1875) ist ein willkommener Anlass, in einer Ausstellung die Geschichte der Präzisionsuhrmacherei in Dresden zu würdigen. Sie nahm ihren Anfang im Mathematisch-Physikalischen Salon und mündete schließlich in die Gründung der Uhrenindustrie in Glashütte. Die Uhren aus Glashütte stehen heute für die ökonomische Leistungsfähigkeit Sachsens in der Welt; dieser Erfolg ist mit der Uhrenmanufaktur A. Lange & Söhne eng verbunden.

Diese Erfolgsgeschichte begann 1780, als im Mathematisch-Physikalischen Salon ein Observatorium eingerichtet wurde. Für die Himmelsbeobachtung benötigte man Präzisionspendeluhren und baute diese gleich vor Ort. Die Inspektoren des Salons avancierten schnell zu Akteuren eines internationalen Netzwerkes von Astronomen, in dessen Zentrum der sächsische Gesandte in London, Graf Hans Moritz von Brühl (1736 – 1809), und der Gothaer Astronom Franz Xaver von Zach (1754 – 1832) standen.

Wie wichtig ein reger internationaler Austausch für substanzielle technische und wirtschaftliche Erfolge ist, das zeigen diese von Sibylle Gluch kuratierte Ausstellung und der sie begleitende Katalog mit neuem Archivmaterial und einer genauen Untersuchung der Zeitmesser. Auch die Taschenuhren und -chronometer von Johann Heinrich Seyffert (1751 – 1817), Inspektor des Mathematisch-Physikalischen Salons, belegen die Auseinandersetzung mit den

The 200th anniversary of the birth of Ferdinand Adolph Lange (1815 – 1875) is a fitting occasion to hold an exhibition paying tribute to the history of precision watchmaking in Dresden. That history began at the Mathematisch-Physikalischer Salon in Dresden and ultimately led to the founding of the watchmaking industry in Glashütte, some thirty kilometres to the south. The watches manufactured in Glashütte continue to serve as a torchlight for Saxony's economic prowess on the international stage, and this success is inextricably linked to the watch manufactory A. Lange & Söhne.

The opening chapters of this Saxon success story unfold in 1780, when an observatory was set up at the Mathematisch-Physikalischer Salon and the precision pendulum clocks needed in making astronomical observations were constructed at the Salon itself. The inspectors of the Salon thus swiftly became part of an international network of astronomers, at whose centre were the Saxon envoy to London, Count Hans Moritz von Brühl (1736 – 1809), and the Gotha-based astronomer Franz Xaver von Zach (1754 – 1832).

Today's exhibition, curated by Sibylle Gluch, and the accompanying catalogue featuring fresh archival material and recent scientific findings show how lively international exchange is a precondition for local technical and economic success. After closer technical examination, the pocket watches and chronometers designed by

internationalen Vorbildern, insbesondere aus England. Seyfferts Ideen wurden vor allem durch den Hofuhrmacher Johann Christian Friedrich Gutkaes (1785 – 1845), der die Uhren des Salons wartete, und seinen Schüler Ferdinand Adolph Lange fortgeführt. Ohne die Kenntnisse neuer Produktionsmethoden in der Schweiz, die Lange auf seiner Wanderschaft kennenlernte, wäre dieser entscheidende Schritt für die sächsische Uhrmacherei jedoch kaum denkbar. Vom Forscherdrang getrieben baute Lange bald ein blühendes mittelständisches Industrieunternehmen auf, das wieder hoch erfolgreich arbeitet.

Hartwig Fischer
Generaldirektor
Staatliche Kunstsammlungen Dresden

Johann Heinrich Seyffert (1751 – 1817), inspector of the Mathematisch-Physikalischer Salon, reveal a profound knowledge of contemporaneous international models, especially of those from England. Seyffert's ideas were further developed by the court clockmaker Johann Christian Friedrich Gutkaes (1785 – 1845), who maintained the Salon's clocks, and, in turn, by his pupil Ferdinand Adolph Lange. The pivotal moment in the history of Saxon precision watchmaking, the founding of a manufactory in Glashütte, would have been inconceivable without the new Swiss production methods that Lange learned during his journeyman years. What began as scientific curiosity led to the emergence of a thriving medium-sized industry. The same industrial criteria continue to prevail today.

Hartwig Fischer
Director General
Staatliche Kunstsammlungen Dresden

Peter Plaßmeyer

Der Mathematisch-Physikalische Salon und der Weg Sachsens in die internationale Uhrenwelt

The Mathematisch-Physikalischer Salon and Saxony's Path into the World of International Watchmaking

Als Ferdinand Adolph Lange (Abb. 1) 1845 im erzgebirgischen Glashütte begann, Uhrmacher auszubilden und eine Uhrenfabrikation aufzubauen, schuf er ein Imperium, dessen Glanz bis heute von Sachsen in die Welt strahlt. Diese berufliche Zukunft ward Lange allerdings nicht in die Wiege gelegt, entstammte er doch keiner Uhrmacherfamilie. Es waren eher die Frühindustrialisierung und das Zusammentreffen verschiedener Personen, die ihm den Weg eröffneten. Im Zentrum der Konstellation stand der Mathematisch-Physikalische Salon im Dresdner Zwinger, eine 1728 aus der Kunstkammer des 16. Jahrhunderts gelöste Sammlung mathematischer und physikalischer Instrumente, die sich in der Mitte des 18. Jahrhunderts zum physikalischen Kabinett und Observatorium wandelte und Dresden den Anschluss an die naturwissenschaftlichen Diskussionen der Aufklärung bescherte (Abb. 2).

Mit der 1777 erfolgten Berufung von Johann Gottfried Köhler (1745 – 1800) als erstem As-

When Ferdinand Adolph Lange (ill. 1) set up a watchmaking manufactory in Glashütte in the Ore Mountains in 1845 and started to train young watchmakers there, he created an empire whose light continues to shine from Saxony far into the world. Born in 1815, Lange was not necessarily predestined to a future as a horologist, for he did not come from a family of watchmakers. It was instead Saxony's burgeoning age of industrialization and the particular constellation of different individuals that opened this path for him. Most pivotal of all was the Mathematisch-Physikalischer Salon, housed in Dresden's Zwinger Palace, a collection of mathematical and scientific instruments that came into being in its own right in 1728, after splintering off from the original princely 'Kunstkammer' ('cabinet of art and marvels') that dated back to the sixteenth century. In the mid-eighteenth century, the Salon was transformed into an observatory and 'cabinet of scientific instruments,' propelling Dresden into

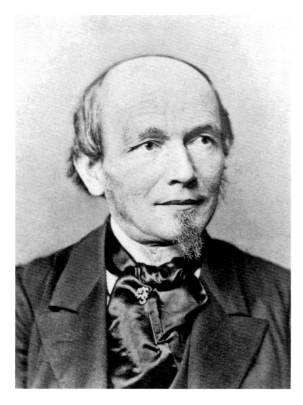

1
Ferdinand Adolph Lange (1815 – 1875)

the scientific discourses of the Age of Enlightenment (ill. 2).

With the appointment, in 1777, of Johann Gottfried Köhler (1745 – 1800) as the first astronomer at the Salon, an observatory was founded in the Zwinger itself. It was a move that would have far-reaching consequences. It was here that the first precision pendulum clocks were built in Dresden and where a time service was established, giving Dresden a reliable source of the time well into the twentieth century. For his celestial observations, Köhler constructed a longcase clock, which he continually improved over the years (ill. 3). It was the first mechanical clock in the Mathematisch-Physikalischer Salon's collection. The collection soon grew, with Köhler adding his own seconds counter and other timekeepers designed by Johann Heinrich Seyffert (1751 – 1817). We do not know where Köhler found inspiration for his precision pendulum clock, nor whether he received any assistance in its construction. What we do know, however, is that Köhler initiated the study and exploration of precision clock and watch design in Dresden.

A few years ago, a pendulum clock designed by Johann Gottfried Zimmer surfaced on the art market. Constructed in 1744 in the workshop of Count Hans von Löser (1704 – 1763) at Schloss Reinharz,[1] the clock is one of the earliest astronomical clocks built in Germany (ill. 4). At his castle near Wittenberg, Löser ran a precision-mechanical workshop for constructing the instruments, including telescopes and reflecting telescopes, for use in his personal cabinet of scientific instruments.[2] To better observe the night sky, he even ordered that the castle tower be heightened. Zimmer's pendulum clock and a reflecting telescope that Zimmer constructed together with Johann Siegmund Mercklein are an indication that clocks were used in making astronomical observations and measurements at Schloss Reinharz. Since after his death, Löser's collection eventually ended up in the Mathematisch-Physikalischer Salon, almost in its entirety, it seems very likely that Köhler came to learn of Zimmer's clock. Only a few instruments for other

tronom an den Salon wurde im Zwinger ein Observatorium eingerichtet: Hier wurden die ersten Präzisionspendeluhren in Dresden hergestellt und hier entstand ein Zeitdienst, der für Dresden bis in das 20. Jahrhundert die Uhrzeit ermittelte. Für seine Himmelsbeobachtungen verwendete Köhler eine eigens erbaute Standuhr, die er stetig perfektionierte (Abb. 3). Es war die erste mechanische Uhr im Bestand des Mathematisch-Physikalischen Salons. Ihr fügte Köhler später einen eigenen Sekundenzähler hinzu und ergänzte den Bestand um weitere Uhren von Johann Heinrich Seyffert (1751 – 1817). Woher Köhler die Anregung für seine Präzisionspendeluhr erhielt und ob ihm jemand bei der Fertigung half, ist ungeklärt. Offensichtlich ist aber, dass durch Köhler in Dresden eine Aus-

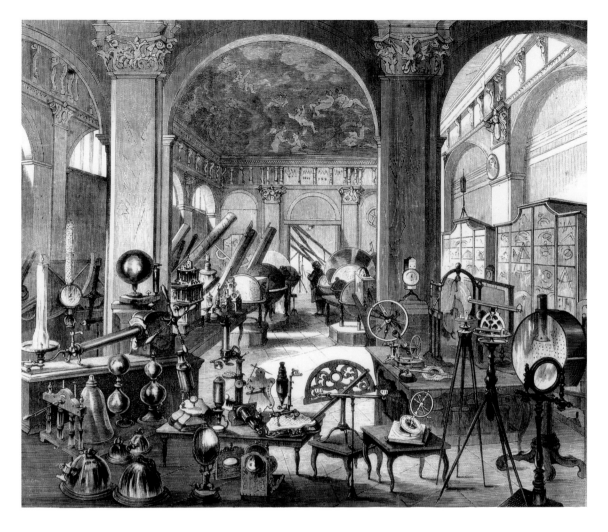

2
Sammlungssaal des Mathematisch-Physikalischen Salons in der 2. Hälfte des 19. Jahrhunderts.
Zeichnung von Reinhardt für die Illustrierte Zeitung von Weber, Jg. 62, 1874
Collection room of the Mathematisch-Physikalischer Salon, second half of the nineteenth century.
Drawing by Reinhardt for Illustrierte Zeitung von Weber, issue 62, 1874

einandersetzung mit der Konstruktion präziser Uhren begann.

Vor einigen Jahren tauchte auf dem Kunstmarkt eine Pendeluhr von Johann Gottfried Zimmer auf, die 1744 in der Werkstatt des Reichsgrafen Hans von Löser (1704 – 1763) auf Schloss Reinharz bei Wittenberg entstanden war.[1] Sie zählt zu den frühesten in Deutschland

owners were produced in Löser's workshop. We know little more about Zimmer's clock, but it is striking that it shares many things in common with the seconds counter built by Köhler in 1790.[3] Zimmer's clock already anticipated the essential characteristics of later precision pendulum clocks, as seen for example in the inverse construction of the movement as well as the un-

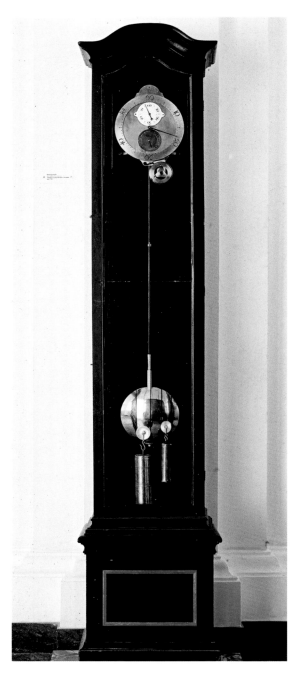

3
Johann Gottfried Köhler, Bodenstanduhr, Dresden, vor 1777,
Mathematisch-Physikalischer Salon, Dresden (seit 1783
im Salon nachweisbar)
Johann Gottfried Köhler, Longcase clock, Dresden,
before 1777, Mathematisch-Physikalischer Salon, Dresden
(detectable in the Salon since 1783)

usual shape of the dial with its digital-display format for the hours and minutes. Only the seconds are indicated by a rotating hand.

Köhler's pendulum clocks were working tools used both in scientific practice at the observatory and for the subsequent time service, which from 1783 onwards accurately determined local time, initially for the observatory and subsequently for Dresden as a whole. Pendulum clocks were the first reliable precision clocks and had a lasting impact on the work conducted in the observatories. Christiaan Huygens (1629–1695) was the first to fit a clock with a pendulum in Leiden in 1657. The next step in the evolution of the precision pendulum clock was taken by George Graham (1673–1751) in the 1720s in England. Essential for its accuracy was the uniformity of its swing, and a low-friction running of the movement. For clocks, mounted on the wall or floor, the seconds pendulum, measuring just under one metre in length, became standard. Each swing of the pendulum in one direction lasted a second, recognizable by the ticking of the clock. On the basis of this 'eye and ear method,' astronomers were able to determine the position of the stars accurately. At the same time, these precisely running clocks measured local time, and, as a result, the precision pendulum clocks at the Mathematisch-Physikalischer Salon were also used for Dresden's time service. All other clocks and watches in Dresden were thus set to the Salon's clocks.

It is striking that, rather than using English pendulum clocks, which had long become the professional standard, Köhler chose to construct his own. He then made countless alterations to this clock to fine-tune it. Köhler informed fellow astronomers of his fine-tuning improvements through his correspondence, and Johann Elert Bode published them in his *Berliner Astronomisches Jahrbuch*. This helped to create the impression, within astronomical circles, that Dresden figured on the map of precision watchmaking. This impression was subsequently consolidated by Johann Heinrich Seyffert, who worked closely with Köhler and built precision pendulum clocks (ill. p. 24).[4]

gebauten astronomischen Uhren (Abb. 4). Löser betrieb auf seinem Schloss eine feinmechanische Werkstatt, in der er sich das Instrumentarium für ein persönliches physikalisches Kabinett fertigen ließ, wozu auch Fernrohre und Spiegelteleskope gehörten.[2] Zur Beobachtung des Sternenhimmels ließ er sogar den Schlossturm erhöhen. Die genannte Pendeluhr sowie ein Spiegelteleskop, das Zimmer gemeinsam mit Johann Siegmund Mercklein ausführte, legen nahe, dass astronomische Beobachtungen und Vermessungen auf Schloss Reinharz mithilfe von Uhren praktiziert wurden. Da Lösers Sammlung nach seinem Tod fast vollzählig in den Mathematisch-Physikalischen Salon gelangte, ist durchaus zu vermuten, dass Köhler von Zimmers Pendeluhr Kenntnis besaß. Denn nur wenige Instrumente in Lösers Werkstatt wurden für andere Besitzer gearbeitet. Obwohl der weitere Weg von Zimmers Uhr bislang nicht geklärt werden konnte, weist sie augenfällige Gemeinsamkeiten mit dem etwa 1790 von Köhler entwickelten Sekundenzähler auf.[3] Zimmers Uhr nimmt bereits wesentliche Merkmale späterer Präzisionspendeluhren vorweg: Die gestürzte Bauweise des Uhrwerks ebenso wie die ungewöhnliche Form des Zifferblattes mit seinen digitalen Anzeigen für Stunde und Minute. Nur die Sekunden wurden von einem rotierenden Zeiger angegeben.

Köhlers Pendeluhren waren Gebrauchsgegenstände des Observatoriums, die ersten verlässlichen Präzisionsuhren, und veränderten die dortige Arbeit nachhaltig. Erstmals ließ Christiaan Huygens (1629 – 1695) 1657 in Leiden ein Pendel in eine Uhr einbauen. Den Schritt zur Präzisionspendeluhr vollzog George Graham (1673 – 1751) in den 1720er Jahren in England. Bestimmend für die Ganggenauigkeit waren die gleichmäßige Pendelbewegung und ein reibungsarmer Lauf des Uhrwerks. Als Wand- oder Bodenstanduhr ausgeführt, setzte sich das Sekundenpendel durch, das etwa einen Meter lang war. Jede Halbschwingung des Pendels dauerte eine Sekunde, zählbar am »Ticken« der Uhr. Mit der sogenannten Auge-Ohr-Methode ließ sich

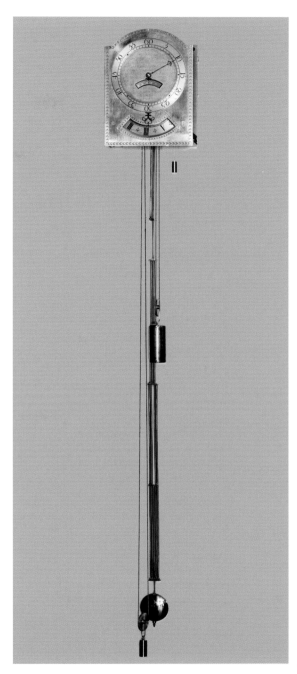

4
Johann Gottfried Zimmer, Astronomische Pendeluhr, Werkstatt des Reichsgrafen Hans von Löser, Schloss Reinharz, 1744, Privatsammlung
Johann Gottfried Zimmer, Astronomical pendulum clock, workshop of Count Hans von Löser, Schloss Reinharz, 1744, Private collection

die Position von Sternen genau ermitteln. Gleichzeitig hielten diese sehr genau gehenden Uhren die Ortszeit fest, was dazu führte, dass die Präzisionspendeluhren des Mathematisch-Physikalischen Salons ab etwa 1783 auch den Zeitdienst für Dresden übernahmen. Von hieraus erhielten alle anderen Dresdner Uhren die Ortszeit.

Auffällig ist, dass Köhler keine englischen Pendeluhren verwendete, die lange das Maß aller Dinge waren, sondern eine eigene baute. Diese Uhr modifizierte er wiederholt, um die Funktionsweise zu verbessern. Die Überarbeitungen teilte Köhler befreundeten Astronomen in Briefen mit und Johann Elert Bode veröffentlichte sie in seinem »Berliner Astronomischen Jahrbuch«. Dadurch konnte in den einschlägigen Kreisen der Eindruck entstehen, Dresden sei ein Ort des Präzisionsuhrenbaus. Neben Köhler war es zunächst Johann Heinrich Seyffert, der, eng mit Köhler zusammenarbeitend, Präzisionspendeluhren schuf (Abb. S. 24).[4]

Seyffert folgte Köhler nach dessen Tod im Jahr 1800 als Inspektor des Salons. Kurz vorher hatte der Autodidakt eine Präzisionsreisependeluhr mit einem Halbsekundenpendel gebaut (Abb. 5).[5] Diese Uhr verweist auf das größte Problem bei Pendeluhren: Sie waren nur stationär zu betreiben, aber für Beobachtungen auf Reisen und »im Feld« nicht geeignet. Mit der Reisependeluhr versuchte Seyffert, diesen Mangel zu beheben, um auch an anderen Orten Längengradbestimmungen vornehmen zu können. Sein Hauptaugenmerk konzentrierte sich jedoch auf die Konstruktion von Taschenuhren und -chronometern. Der Bau von Taschenchronometern wurde in Dresden von Seyffert eingeleitet. Er stellte etwa 90 Taschenuhren und 8 heute bekannte Taschenchronometer her. Seine Leistungen im internationalen Kontext zu erforschen, ist ein Ziel dieser Publikation. Kein Geringerer als Alexander von Humboldt (1769 – 1859) erwarb ein Taschenchronometer von Seyffert, das er auf seiner Südamerikareise neben einem Taschenchronometer von Louis Berthoud (1754 – 1813) für seine Beobachtungen einsetzte.

When Köhler died in 1800, Seyffert succeeded him as 'inspector' of the Salon. Shortly prior to this, Seyffert, the autodidact horologist, had fashioned a precision travelling pendulum clock whose period was one second rather than the conventional two (ill. 5).[5] This clock highlighted the biggest drawback of the pendulum clock: it could only keep time accurately when stationary. As such it was unsuitable for making 'field' observations while travelling. Seyffert's travelling pendulum clock was his attempt to remedy this shortcoming, allowing longitude to also be measured anywhere on land. His true focus of his attention, however, was the construction of pocket watches and pocket chronometers. Seyffert gave priority to the construction of pocket chronometers in Dresden. He fashioned around 90 watches and at least 8 pocket chronometers known to us today. One of the aims of this publication is to analyse his achievements within the broader international context. Among Seyffert's notable clients was Alexander von Humboldt (1769 – 1859), who used one of Seyffert's pocket chronometers along with one designed by Louis Berthoud (1754 – 1813) in making his observations on his expedition across Latin America.

Before being able to study Seyffert's pocket chronometers at the Mathematisch-Physikalischer Salon, it was necessary to develop a non-destructive method by which to examine the timepieces, which were severely damaged in World War II. Due to the effects of the extreme heat of the firestorm caused by the bombing of Dresden on 13 February 1945 and the subsequent corrosion, the movements can no longer be removed from the case without damaging them further (ill. 6). In recent years, the Salon's conservators, principally Johannes Eulitz, have joined with researchers from the Fraunhofer Institute for Ceramic Technologies and Systems (IKTS–MD) to scan these pocket watches using micro computed tomography, making it possible to view and measure all individual components of the movements inside (ill. 7). Only now has it been possible to trace and show the changes

5
Johann Heinrich Seyffert, Reisependeluhr Nr. 2, Dresden, um 1801, Privatbesitz
Johann Heinrich Seyffert, Travelling pendulum clock No. 2, Dresden, around 1801,
Private collection

Eine Voraussetzung für die Untersuchung von Seyfferts Taschenchronometern im Mathematisch-Physikalischen Salon war es, eine Methode zu entwickeln, mit der die im Zweiten Weltkrieg stark beschädigten Uhren begutachtet werden können. Wegen starker Hitzeeinwirkung während des

that Seyffert undertook from watch to watch, to show how he arrived at his ideal pocket chronometer, and to see which models he drew inspiration from. The scans only serve to confirm that his watches were all unique pieces; serial production was never his goal.

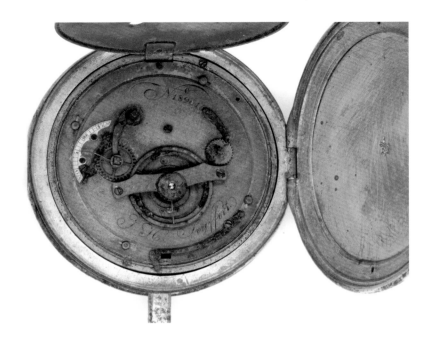

6
**Johann Heinrich Seyffert, Brandgeschädigte Taschenuhr mit Äquations-Indikation, Nr. 96,
Dresden, 1815, Mathematisch-Physikalischer Salon, Dresden**
Johann Heinrich Seyffert, Pocket watch damaged by fire, with equation of time, No. 96,
Dresden, 1815, Mathematisch-Physikalischer Salon, Dresden

Bombardements Dresdens am 13. Februar 1945 und späterer Korrosion können die Uhrwerke nicht mehr ohne weitere Beschädigungen aus dem Gehäuse gelöst werden (Abb. 6). In den letzten Jahren haben die Restauratoren des Salons und namentlich Johannes Eulitz von diesen Taschenuhren mithilfe des Fraunhofer Instituts für Keramische Technologien und Systeme (IKTS-MD) mittels Mikro-Computertomographie Röntgendurchstrahlungsbilder erstellt, um die Uhrwerke in all ihren Einzelheiten betrachten und vermessen zu können (Abb. 7). Erst jetzt war es möglich, die Veränderungen, die Seyffert von Uhr zu Uhr vornahm, zu belegen sowie aufzuzeigen, wie er zu seinem idealen Taschenchronometer fand und mit welchen Vorbildern er sich auseinandersetzte. Seine Uhren blieben allesamt Einzelstücke, eine serielle Fertigung war sein Ziel nicht.

Der Beginn einer fabrikmäßigen Fertigung von Taschenuhren ist eng verbunden mit der

The factory-like production of pocket watches has its roots in the burgeoning industrialization of the first half of the nineteenth century and is the second area of inquiry in this publication. And here, too, the Mathematisch-Physikalischer Salon served as a crucial catalyst for the evolution of precision watchmaking in Saxony.

In 1827, Wilhelm Gotthelf Lohrmann (1796–1840) was appointed the new inspector of the Salon. Lohrmann was already general surveyor at the Royal Saxon Institute of Surveying and treated the post of Salon inspector as secondary. Lohrmann's greatest achievement was the founding, in 1828, of the Technische Bildungsanstalt (or 'Technical School'), the precursor to Dresden's Technische Universität. It was tasked with the specialised training of young men, primarily in the fields of mechanics and mechanical engineering, to assist the emerging industry, and Lohrmann was its founding director. In training

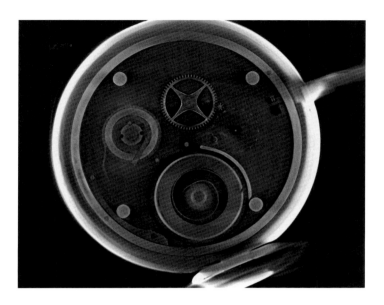

7
Computertomographie der Taschenuhr Nr. 96 von Johann Heinrich Seyffert,
Dresden, 1815
CT scan of pocket watch No. 96, designed by Johann Heinrich Seyffert,
Dresden, 1815

aufkeimenden Industrialisierung und bildet den zweiten Schwerpunkt des vorliegenden Bandes. Für Sachsen ist auch in diesem Punkt der Mathematisch-Physikalische Salon eine entscheidende Schnittstelle.

1827 wurde Wilhelm Gotthelf Lohrmann (1796 – 1840) Inspektor des Salons. Der hauptamtliche Landvermesser in der Königlich-Sächsischen Kameralvermessungsanstalt bekleidete diese Position im Nebenamt. Lohrmanns größtes Verdienst war die Gründung der Technischen Bildungsanstalt, die 1828 als Vorgängereinrichtung der heutigen Technischen Universität entstand. Ihre Aufgabe bestand darin, junge Männer zu Fachkräften vor allem in den Bereichen Mechanik und Maschinenbau für die aufstrebende Industrie auszubilden. Lohrmann wurde Gründungsdirektor dieser Institution. Für Schulungszwecke nutze er auch die Instrumente des Mathematisch-Physikalischen Salons. Zu den ersten Schülern dieser Einrichtung gehörte Ferdinand Adolph Lange, der ab 1830 in der Tech-

students, he used instruments from the Mathematisch-Physikalischer Salon. Among the first students was Ferdinand Adolph Lange, who enrolled at the Technical School in 1830. It was at the Mathematisch-Physikalischer Salon that Lange met the later court watchmaker Johann Christian Friedrich Gutkaes (1785 – 1845), under whom he would complete his apprenticeship as a watchmaker. Gutkaes oversaw the timepieces at the Salon and also constructed clocks for the time service. Lange thus had immediate contact with premium precision clocks and watches, including, not least, a marine chronometer from the London manufactory of Thomas Mudge Jun. (1760 – 1843), which was one of the earliest examples of its kind. This 'Copie No. 18' was a replica of the marine chronometer that his father Thomas Mudge (1715 – 1794) had designed. Marine chronometers were the first precision timekeepers that functioned in motion on voyages (ill. 8). Thomas Mudge Sen. was the first watchmaker to fit a lever escapement into a pocket

nischen Bildungsanstalt unterrichtet wurde. Im Mathematisch-Physikalischen Salon traf er auf den späteren Hofuhrmacher Johann Christian Friedrich Gutkaes (1785 – 1845), bei dem er eine Uhrmacherlehre absolvierte. Gutkaes betreute nicht nur die Uhren des Salons, sondern baute auch Uhren für den Zeitdienst. Lange kam durch diesen Umstand rasch in Kontakt mit erstklassigen Präzisionsuhren, wie dem Seechronometer aus der Londoner Manufaktur von Thomas Mudge jun. (1760 – 1843), das zu den frühen Exemplaren seiner Art zählt. Diese »Copie No. 18« fertigte er nach dem Vorbild der Seechronometer seines Vaters Thomas Mudge (1715 – 1794). Seechronometer waren die ersten reisefähigen Präzisionsuhren (Abb. 8) und Thomas Mudge der erste Uhrmacher, der eine Ankerhemmung in eine kleine Zahl von Taschenuhren einbaute.[6] Die berühmteste Taschenuhr entstand etwa 1769 für Königin Charlotte und befindet sich im Besitz der Königlichen Sammlungen auf Schloss Windsor (Abb. 6, S. 43). Eine weitere, um 1768 entstandene Reiseuhr mit Ankerhemmung (Abb. 2, S. 35) befand sich ab 1774 im Besitz von Graf Hans Moritz von Brühl (1736 – 1809), dessen Familie sie später dem British Museum verkaufte. Brühl war sächsischer Gesandter in London und ein wichtiger Förderer von Mudge sowie anderen englischen Instrumentenbauern. Gemeinsam mit dem Gothaer Astronomen Franz Xaver von Zach (1754 – 1832) errichtete er ein europäisches Netzwerk von Astronomen[7] und vermittelte erstklassige englische Instrumente an den Mathematisch-Physikalischen Salon.

Die von Mudge erstmals in eine Taschenuhr eingebaute Ankerhemmung führt uns wieder zu Ferdinand Adolph Lange, der diese Hemmung zur Basis für sein Glashütter Uhrwerk erkor. Nach seiner Lehre begab sich Lange auf Wanderschaft nach Paris und in die Westschweiz. Über die genaue Route und den Verlauf seiner Reise ist wenig bekannt, abgesehen von seiner Tätigkeit in der Pariser Werkstatt des Breguet-Schülers Thaddäus Winnerl (1799 – 1886). Nach Dresden zurückgekehrt, trat er in den Dienst seines Lehr-

watch.[6] The most famous of the few pocket watches Mudge fitted with a lever escapement was fashioned sometime around 1769 for Queen Charlotte and is still held in the Royal Collection at Windsor Castle (ill. 6, p. 43). Another travel clock equipped with a lever escapement (ill. 2, p. 35), and built around 1768, came into the possession, in 1774, of Hans Maurice Count von Brühl (1736 – 1809), whose family later purchased it to the British Museum. Brühl was a Saxon envoy in London and an important patron of Mudge and other English scientific instrument makers. Together with the astronomer of the Gotha Observatory, Franz Xaver von Zach (1754 – 1832), he fostered ties with an array of European astronomers,[7] and supplied the Mathematisch-Physikalischer Salon with first-class English instruments.

The first of Mudge's lever escapements to be built into a pocket watch thus brings us back to Ferdinand Adoph Lange, who took this escapement as the basis for his Glashütte movement. As part of his training, Lange's journeyman years took him to Paris and western Switzerland. Little is known about his activities during these years, but records show that he spent some time working in the Paris studio of Breguet's pupil, Thaddäus Winnerl (1799 – 1886). Upon his return to Dresden, Lange entered the workshop of his teacher Gutkaes, and later married his daughter. Lange resolved to establish a watchmaking firm in Saxony that would manufacture simple but technically perfect watches in serial production. In the small locality of Glashütte in the Ore Mountains he came one giant step closer to achieving this goal when he started training young watchmakers there in 1845. It was not the first attempt to establish a watch factory in Saxony, but it was most certainly the first to prove successful. For the serial and thus mass production of pocket watches, Lange needed to do more than just design a suitable movement, train enough watchmakers, and build a production line. He also urgently needed to find a market for his wares. Local demand was far too small. But in this, Lange went into business at

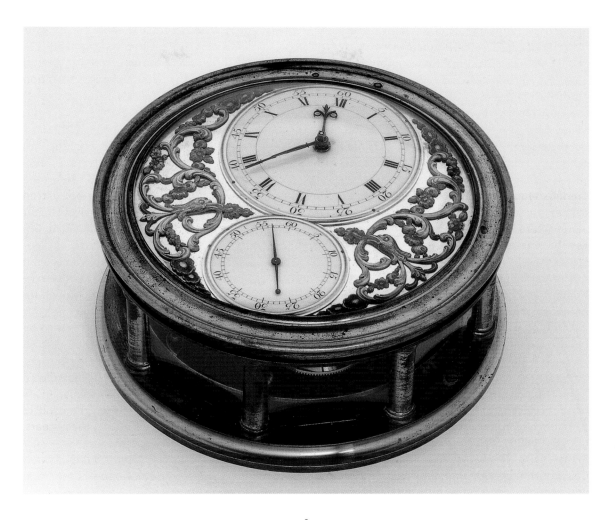

8
Thomas Mudge jun., Robert Pennington, Richard Pendleton u. a., Seechronometer »Copie No. 18«, London, 1796,
Mathematisch-Physikalischer Salon, Dresden (1803 als Geschenk von Graf Hans Moritz von Brühl)
Thomas Mudge Jun., Robert Pennington, Richard Pendleton and others, Marine chronometer 'Copie No. 18', London, 1796,
Mathematisch-Physikalischer Salon, Dresden (donated by Hans Maurice Count von Brühl in 1803)

meisters Gutkaes und heiratete dessen Tochter. Sein erklärtes berufliches Ziel war es nun, eine Fabrik aufzubauen und einfache, aber vollkommene Uhren in Serie herzustellen. Bekanntlich gelang ihm dies in Glashütte im Erzgebirge, wo er 1845 selbst begann, Uhrmacher auszubilden. Es war nicht der erste Versuch, in Sachsen eine Uhrenfabrik zu gründen, aber es war der erste erfolgreiche. Denn für eine Serien- und damit

just the right time, for the railways needed pocket watches for their conductors, and Lange managed to break into the emerging American market, as well as other international markets. Ferdinand Adolph Lange set up production practices for pocket watches in Saxony from scratch, and he constructed a movement that was suitable for mass production and could hold its ground in the face of Swiss competition.

Peter Plaßmeyer

Massenfertigung von Taschenuhren genügte es nicht, ein entsprechendes Uhrwerk zu entwickeln, genügend Uhrmacher auszubilden und eine Produktionslinie aufzubauen. Es war auch notwendig, Märkte für diese Uhren zu eröffnen, denn die regionale Nachfrage war viel zu gering. Langes Vorhaben kam aber zur richtigen Zeit, denn die Eisenbahnen benötigten Taschenuhren für ihre Schaffner, und Lange gelang es, auf dem immer wichtiger werdenden amerikanischen Markt Fuß zu fassen und weitere internationale Märkte zu bedienen. Ferdinand Adolph Lange baute die Produktionsmethoden für Taschenuhren in Sachsen völlig neu auf und konstruierte ein Uhrwerk, das serientauglich war und der Schweizer Konkurrenz standhalten konnte. Die Früchte dieser Saat durften schließlich seine Söhne ernten, die mit ihrem Eintritt in die Firma das Qualitätslabel »A. Lange & Söhne« gründeten.

Dank

Diese Publikation begleitet eine Ausstellung, die vom 18. Februar bis zum 14. Juni 2015 im Mathematisch-Physikalischen Salon der Staatlichen Kunstsammlungen Dresden gezeigt wird. Wir danken dem Deutschen Schiffahrtsmuseum Bremerhaven, der Stiftung Deutsches Uhrenmuseum Glashütte – Nicolas G. Hayek und der Lange Uhren GmbH in Glashütte, dem British Museum und dem National Maritime Museum in London, dem Landesmuseum Württemberg in Stuttgart, dem Deutschen Museum in München, dem Uhrenmuseum Beyer in Zürich sowie jenen Privatpersonen, die diese Ausstellung durch ihre Leihgaben erst ermöglicht haben. Wir danken ebenfalls den Autoren dieses Begleitbuches dafür, dass die Anfänge der Präzisionsuhrmacherei in Dresden und die Gründung der Uhrenindustrie in Glashütte durch Ferdinand Adolph Lange nun in ihrem geschichtlichen und internationalen Zusammenhang erfahrbar werden. Größter Dank gebührt der Kuratorin Sibylle Gluch: Sie hat sich intensiv mit der Geschichte

These entrepreneurial seeds were finally harvested by his sons, whose incorporation into the company gave it the seal of quality known to all by its name: 'A. Lange & Söhne' ('A. Lange & Sons').

Acknowledgements

This publication coincides with an exhibition, on show at the Staatliche Kunstsammlungen Dresden's Mathematisch-Physikalischer Salon from 18 February to 14 June 2015. We wish to thank the Deutsches Schiffahrtsmuseum in Bremerhaven, the Stiftung Deutsches Uhrenmuseum Glashütte – Nicolas G. Hayek and Lange Uhren GmbH in Glashütte, the British Museum and the National Maritime Museum in London, the Landesmuseum Württemberg in Stuttgart, the Deutsches Museum in Munich and the Zurich Beyer Clock and Watch Museum, as well as the relevant private collectors, for providing the loaned works that have made this exhibition possible.

We also wish to thank the authors for outlining, against the broader international context, the history of the beginnings of precision watchmaking in Dresden and the creation of the watchmaking industry in Glashütte by Ferdinand Adolph Lange. A special word of thanks goes to the exhibition's curator, Sibylle Gluch; without her commitment the exhibition and this accompanying publication would have been impossible. In the technical analysis of the timepieces, she was assisted by Johannes Eulitz, who supported the endeavour with his technical knowledge and conservation know-how.

Andreas Holfert was the coordinator of the exhibition, which was designed by Christian Frommelt and Daniel Sommer (whitebox GbR, Dresden). Important notes and suggestions were kindly given to the curator from Paul Buck/London (British Museum), Kirsten Hultzsch/Glashütte, Dieter Landrock/Seifhennersdorf, Karl J. Langer/Gräfelfing, Monika Leonhardt/Zurich, Ludwig Oechslin/La Chaux-de-Fonds, Christian Pfeifer-Belli/Munich, Reinhard Reichel/Glashütte,

22

der Präzisionsuhrmacherei beschäftigt, Literatur und Archivalien kritisch gesichtet und mit der Ausstellung ihrem Wissen eine spannende Form verliehen. Unterstützt wurde sie von Johannes Eulitz mit all seiner technischen und restauratorischen Erfahrung. Andreas Holfert koordinierte die von Christian Frommelt und Daniel Sommer (whitebox GbR, Dresden) gestaltete Ausstellung. Wichtige Hinweise und Anregungen erreichten uns darüber hinaus von Paul Buck/ London (British Museum), Kirsten Hultzsch/ Glashütte, Dieter Landrock/Seifhennersdorf, Karl J. Langer/ Gräfelfing, Monika Leonhardt/Zürich, Ludwig Oechslin/La Chaux-de-Fonds, Christian Pfeifer-Belli/München, Reinhard Reichel/Glashütte, Thomas Rebény/München, David Rooney/ London (Science Museum). Nicht zuletzt gilt unser Dank der Lange Uhren GmbH, ohne deren großzügige Unterstützung weder die Ausstellung noch dieses Begleitbuch denkbar gewesen wären.

Thomas Rebény/Munich, David Rooney/London (Science Museum). Last, but by no means least, our thanks goes to Lange Uhren GmbH in Glashütte, without whose generous support neither the exhibition nor this companion book would have been thinkable.

1 *Das Bewahren der Zeit*
Keeping Time

Die ersten Uhren, die in einem relativen Gleichklang mit der täglichen Rotation der Erde blieben, waren Pendeluhren. Galileo Galilei (1564 – 1642) hatte erkannt, dass die gleichmäßige Schwingung eines Pendels für die zeitliche Erfassung astronomischer Beobachtungen genutzt werden kann. Galilei hatte auch die Idee, das Pendel mit einem Uhrwerksmechanismus zu verbinden, um ihm so stetige Energie zuzuführen. Indes wurde die erste Pendeluhr 1657 von dem niederländischen Gelehrten Christaan Huygens (1629 – 1695) in Zusammenarbeit mit dem Uhrmacher Salomon Coster (ca. 1622 – 1659) gebaut. Das Aufkommen verlässlicher Zeitmesser veränderte die Arbeit in den Observatorien. Deren Aufgabe war die exakte Vermessung der Himmelskörper, um akkurate Himmelskarten anfertigen zu können. Diese Informationen wurden unter anderem zur Ermittlung des Längengrades benötigt. Die Technik der Pendeluhren wurde daher kontinuierlich verbessert, um eine immer größere Genauigkeit in der Zeitmessung zu erzielen. Wesentlich für einen gleichmäßigen Gang der Uhr waren die Optimierung der Hemmung und die Entwicklung des Kompensationspendels. Auf dem Gebiet der Präzisionspendeluhren waren englische Uhrmacher führend. Die erste Präzisionspendeluhr des Mathematisch-Physikalischen Salons konstruierte jedoch Johann Gottfried Köhler (1745 – 1800). Er begründete damit eine Tradition, die noch von Ferdinand Adolph Lange (1815 – 1875) fortgeführt wurde.

The first clocks that stayed relatively consistent with the Earth's daily rotation were pendulum clocks. Galileo Galilei (1564 – 1642) had recognized that the regular swing of a pendulum could be used to measure time in astronomical observations. Galileo also had the idea of connecting the pendulum to a clockwork mechanism as a means of providing the latter with a steady energy source. However, the first pendulum clock was built in 1657, by the Dutch scholar Christiaan Huygens (1629 – 1695), in cooperation with the clockmaker Salomon Coster (c. 1622 – 1659). The advent of reliable timekeepers changed the work conducted at observatories. Their task was to precisely measure the position of celestial bodies in order to make accurate star charts. This information was required, among other things, to determine longitude. The technology of pendulum clocks was therefore continuously improved in order to achieve ever greater accuracy in timekeeping. Essential for the regularity of the clock's performance were an improved escapement and the development of the compensation pendulum. The pioneers of precision pendulum clockmaking were English horologists. The first precision pendulum clock kept at the Mathematisch-Physikalischer Salon, however, was made by the Salon's curator, Johann Gottfried Köhler (1745 – 1800). Köhler thereby established a tradition that was later continued by Ferdinand Adolph Lange (1815 – 1875).

◄

Johann Heinrich Seyffert, Bodenstanduhr, Dresden, 1794,
Mathematisch-Physikalischer Salon, Dresden
Johann Heinrich Seyffert, Longcase clock, Dresden, 1794,
Mathematisch-Physikalischer Salon, Dresden

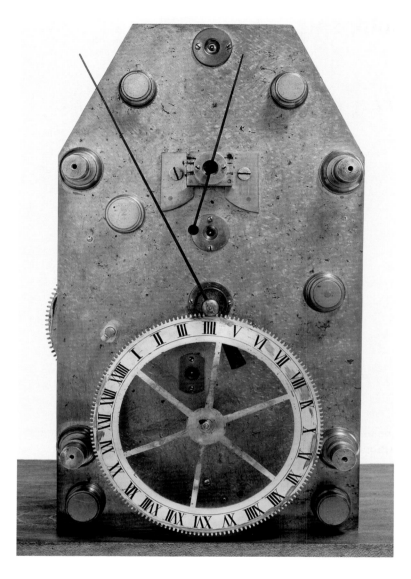

Johann Andreas Klindworth, Pendeluhr, Göttingen,
vor 1787, Deutsches Museum, München

Johann Andreas Klindworth, Pendulum clock, Göttingen,
before 1787, Deutsches Museum, Munich

Wie auch Johann Heinrich Seyffert (1751 – 1817), baute der
Göttinger Uhrmacher Johann Andreas Klindworth (1742 –
1813) Uhren für den Gothaer Hofastronomen Franz Xaver von
Zach (1754 – 1832). Bei seinen Pendeluhren orientierte er
sich an Uhrwerken von John Arnold aus London. Klindworth
verwendete Lagersteine und dickere Platinen als Seyffert und
erreichte dadurch eine bessere Qualität.

Like Johann Heinrich Seyffert (1751 – 1817), the Göttingen-
based clockmaker Johann Andreas Klindworth (1742 – 1813)
built clocks for the Gotha court astronomer Franz Xaver von
Zach (1754 – 1832). For his pendulum clocks, Klindworth
drew inspiration from movements designed by John Arnold in
London. Klindworth used jewel bearings and stronger plates
than Seyffert, achieving higher quality as a result.

David Thompson

Englische Uhrmacherkunst im 18. Jahrhundert

Watchmaking in England in the Eighteenth Century

England und insbesondere London hatte sich Mitte des 18. Jahrhunderts zum weltweit wohl bedeutendsten Zentrum der Uhrmacherei entwickelt. Was das handwerkliche Können und den Stil betraf, mussten die Londoner Uhrmacher schon im 17. Jahrhundert keinen Vergleich mit den Kollegen ihrer Zunft aus Frankreich, der Schweiz, den Niederlanden oder mit den Uhrenzentren in den deutschen Staaten im Heiligen Römischen Reich scheuen. Doch mit der Einführung der Unruhspirale 1675 konnte sich London in Hinblick auf Produktion und Perfektion langsam eine Vormachtstellung erarbeiten. In den Werkstätten von Uhrmachern wie Thomas Tompion (1639 – 1713) wurde eine beträchtliche Menge Uhren für Tausende von wohlhabenden Kunden in Europa und weit darüber hinaus produziert. 1725 wurde die bis dahin verwendete Spindelhemmung von der Zylinderhemmung abgelöst, die George Graham (1673 – 1751) auf der Grundlage von früheren Entwürfen seines

By the middle of the eighteenth century, England, and London in particular, had become established as perhaps the most important centre of watchmaking in the world. As early as the previous century, watchmakers in London had developed a style and expertise which rivalled all other centres in France, Switzerland, the Netherlands, and the Germanic states of the Holy Roman Empire. Following the introduction of the balance spring to watches in 1675, London began to outstrip all other centres of watchmaking in terms of production and perfection. Makers such as Thomas Tompion (1639 – 1713) had workshops with a prolific output, there alone producing thousands of watches for wealthy customers throughout Europe and further afield. Until 1725, the only escapement available to watchmakers was the verge, but in 1725 George Graham (1673 – 1751) introduced his newly invented cylinder escapement, based on an earlier design of 1695 by his mentor Thomas Tompion.[1]

Lehrers Thomas Tompion aus dem Jahr 1695 entwickelt hatte.[1] Graham und viele andere Londoner Uhrmacher konnten fortan Uhren herstellen, die aufgrund dieser Zylinderhemmung eine bessere Ganggenauigkeit aufwiesen. In den meisten Uhren für den Alltagsgebrauch wurde die gewöhnliche Spindelhemmung allerdings weiterhin verwendet.

Edelsteine als Lagersteine

Eine bedeutende Weiterentwicklung war der Einsatz von Edelsteinen als Lagersteine, der seit 1704 belegt ist. Der früheste Nachweis dafür findet sich in einem Antrag auf Patenterneuerung von Nicholas Facio de Duillier und den Brüdern Peter und Jacob Debaufre in London. Dem Gesuch wurde zwar nicht stattgegeben, doch setzten sich Edelsteine von da an allmählich in Uhrwerken durch. Obwohl diese wichtige Neuerung in der Uhrentechnik zunächst nur für die Gleitlager der Unruh Verwendung fand, sollte dies später zu einer optimierten Leistung des gesamten Uhrwerks führen. Doch erst 1753 fertigte der Uhrmacher John Jefferys (1701 – 1754) eine Uhr ausschließlich auf der Grundlage von Steinlagern, und zwar nach einer Vorlage von John Harrison (1693 – 1776), dem berühmten Hersteller von Schiffschronometern.[2] Diese Uhr revolutionierte nicht nur das Uhrmacherhandwerk, sondern führte Harrison auch zu einem völlig neuen Verständnis von Präzisionstechnik. Mit diesem neuen Wissen baute er sein viertes Marinechronometer, das nach langen Versuchen endlich den Beweis erbrachte, dass sich die geographische Länge auf Seereisen mit einem Zeitmesser bestimmen lässt. Erst danach gingen auch andere Uhrmacher dazu über, in den Uhrwerken – allerdings nur in Präzisionswerken – eine größere Anzahl von Edelsteinen zu benutzen. In Uhren mit Spindelhemmung finden sich daher nur in seltenen Fällen andere Edelsteine als der Unruhdeckstein. Interessanterweise wurde die Verwendung von Edelsteinen in Uhrwerken in England noch in den 1760er Jahren wie

From that year onwards Graham and many other leading London makers employed the escapement to achieve greater accuracy in their watches. At the same time, the standard verge watch was still commonly used for countless numbers of everyday watches.

Jewelling

A significant event in 1704 was the first known use of jewelling in watches. The earliest record of this refers to a request for a renewal of a patent by Nicholas Facio de Duillier and brothers Peter and Jacob Debaufre in London. Their application was refused, but from this early beginning, the use of jewelling in watch bearings began in earnest. Whilst the initial use of this important improvement in watch technology was limited to the bearings of the balance, it was to lead to a significant improvement in the long-term performance of the watch. Jewelling was increasingly employed in English precision watches from this time, and in the early 1750s a revolutionary watch was designed by the famous maker of marine timekeepers, John Harrison (1693 – 1776), and made for him by the watchmaker, John Jefferys (1701 – 1754).[2] This watch was revolutionary in terms of watchmaking and led Harrison to change his understanding of portable precision timekeepers and to go on to make his fourth marine timekeeper, which finally determined that longitude could be established at sea using such a device. Makers continued to jewel their watch movements, some even more extensively but usually only in their precision work. A verge watch with any jewels apart from those for the balance was a rare product. It is interesting to note that even in the 1760s watch train jewelling was something of a closely guarded secret in England. When the celebrated maker, Ferdinand Berthoud (1754 – 1813) returned to Paris after being in London to examine Harrison's H4 timekeeper, he said, 'If some parts of the watch would be difficult to make, there are others which could

ein Geheimnis gehütet. Der namhafte Uhrmacher Ferdinand Berthoud (1754 – 1813), der in London Harrisons Zeitmesser inspiziert hatte, sagte bei seiner Rückkehr nach Paris: »Einige Teile dieser Uhr wären, wenn auch nur unter Schwierigkeiten, nachzubauen, wieder andere aber könnten in Frankreich gar nicht hergestellt werden. Ich spreche von den durchbohrten Rubinen, die die Zapfen tragen.«[3]

Das Uhrengewerbe

Der Fortgang der Entwicklungen in der Uhrmacherei in London während der zweiten Hälfte des 18. und Anfang des 19. Jahrhunderts lässt sich in drei Stränge unterteilen. Zum einen entwickelte sich ein Luxussegment für Uhren von höchster Qualität in fein verzierten Repoussé-Gehäusen und Übergehäusen aus Gold, auf denen kunstvolle Reliefdarstellungen mit Szenen aus der klassischen Antike oder aus der Bibel abgebildet waren. Für die Verzierung der Gehäuse mit solchen Ziselierarbeiten galten George Michael Moser, Henry Manly oder Ishmael Parbury als gefragte Künstler, die von einer ganzen Reihe führender Londoner Uhrmacher herangezogen wurden. Einige Uhrmacher taten sich nicht nur auf dem Gebiet der Gold- und Silberarbeiten, sondern auch in der Emaillemalerei hervor. Diese Kunst war zwar vor allem in Genf hoch entwickelt, aber auch in London gab es Künstler wie George Michael Moser und William Craft, die imstande waren, prächtige Gehäuse für die führenden Uhrmacher zu fertigen.

Daneben bestand ein größerer Markt für preiswertere Handelsware mit Spindelhemmung und einem Uhrgehäuse aus Silber oder vergoldetem Metall, die in großer Zahl hergestellt wurde, wobei der Erwerb von Uhren generell den wohlhabenderen Gesellschaftsschichten vorbehalten blieb. Einige Uhrmacher hatten sich auf die Herstellung von Uhren spezialisiert, die für den Markt im Nahen oder Fernen Osten bestimmt waren. Firmen wie Markwick Markham konzentrierten ihr Geschäft in der zweiten

not be done at all in France. I mean the pierced rubies carrying the pivotal staffs.'[3]

The General Trade

When looking at the progress of watchmaking in London in the second half of the eighteenth century and into the nineteenth century, there are clearly three strands which can be identified. Firstly, the luxury market for which the leading makers provided the highest quality watches in fine gold pair-cases richly decorated in repoussé work depicting classical or biblical scenes. In this respect, the work of George Michael Moser, Henry Manly, and Ishmael Parbury was highly sought after, and a number of the leading London makers used them to embellish the cases. In addition to gold and silver cases, some makers also excelled in the use of pictorial enamel. Whilst this skill was highly developed in Geneva, there were those such as George Michael Moser and William Craft who produced magnificent cases for the top London watchmakers.

At another level, there was the larger market for cheaper standard watches in either silver or gilded base-metal cases, usually with a verge escapement. These watches were made in huge numbers, but even so, it should be realised that such watches were still only affordable to the reasonably wealthy in society. In addition to this, there were makers who specialised in making watches for export to the Middle and Far East. In the second half of the eighteenth century, companies such as Henry Borrell, Francis Perigal, and others added the inscription 'Markwick Markham' to associate themselves with an earlier famous name in the export business. Whilst these companies had thriving businesses in London, they also specialised in making watches for export to the Ottoman Empire. Further east there was a thriving market for watches in China and here, perhaps, the name William Ilbery is best known, especially in the early years of the nineteenth century. Increasingly, in that period a significant proportion of the so-called London wat-

Hälfte des 18. Jahrhunderts vor allem auf den Handel mit dem Osmanischen Reich. Für den ebenfalls regen Geschäftsverkehr mit dem Fernen Osten und China dürfte der bekannte Name William Ilbery stehen, wenngleich die sogenannten Londoner Uhren, die Anfang des 19. Jahrhunderts nach Fernost exportiert wurden, wohl zum überwiegenden Teil aus Schweizer Fabrikation, insbesondere von Herstellern wie Bovet in Fleurier stammten. Die mit dem Signet »Ilbery London« versehenen Uhren weisen jedenfalls alle charakteristischen Merkmale von Uhren aus Fleurier auf.[4]

Dass gewöhnliche Uhren, deren Auflage in die Abertausende ging, im Laufe des 18. Jahrhunderts immerhin erschwinglicher wurden, verdankte sich ihrer zunehmend effizienten Produktion. Die Vorstellung, ein Uhrmacher säße allein in seiner Werkstatt und stelle aus vielen Einzelteilen ein filigranes Uhrwerk zusammen, war schon damals weit von der Realität entfernt. Bereits im 17. Jahrhundert war die Fertigstellung einer Uhr das Ergebnis der Arbeit zahlreicher Handwerker – von Uhrmachern, Gehäusemachern, Vergoldern, Graveuren und Uhrfedermachern. Im Laufe des 18. Jahrhunderts nahm die Zahl der Berufe, die an der Herstellung einer Uhr beteiligt waren, sogar noch zu, so dass Expertise immer wichtiger wurde. Die Produktion ging in kleinen Werkstätten vonstatten, meist im Besitz des Uhrmachers, der Angestellte und reisende Handwerker mit der Ausführung der Arbeit auf ihrem jeweiligen Spezialgebiet beauftragte und von ihnen die erforderlichen Einzelteile herstellen ließ. Zu Beginn des 19. Jahrhunderts bedurfte es zur Herstellung einer Uhr über 100 verschiedener Arbeitsgänge.[5] Der Uhrmacher, dessen Namen auf dem Zifferblatt oder dem Uhrwerk erschien, war nicht selten lediglich für den Verkauf und die anschließende Wartung des Produkts für den Kunden zuständig. Im Laufe dieser Entwicklung entstanden verschiedene Zentren, in denen sich Einzelhändler mit vorgefertigten Rohwerken versorgen konnten. Ein Beispiel dafür ist das Unternehmen Ellicotts in der Sweetings Alley,

ches for this trade were being made in Switzerland, particularly by companies such as Bovet in Fleurier. These watches were signed 'Ilbery London' but have all the particular characteristics of watches made in Fleurier.[4]

The ordinary watch was made in countless thousands and in the course of the eighteenth century became more affordable, facilitated by more efficient means of production. In this respect, the image of a watchmaker working alone producing a fine watch from basic materials is far from the reality. As early as the seventeenth century a finished watch would be the result of the labours of a number of skilled craftsmen – the watchmakers, watchcase makers, gilders, engravers, mainspring makers. During the eighteenth century, the diversity of the trades involved in making a watch continued to expand, with more and more specialists involved. It was also the case that the work was carried out in relatively small workshops owned and run by a single watchmaker, who employed apprentices and journeyman watchmakers to carry out the work in their specialised areas to make the necessary components. By the beginning of the nineteenth century, a watch could be the result of over 100 separate skills.[5] The watchmaker whose name appeared on the dial and movement might only have been involved in selling the product and then looking after it for the owner in subsequent years. In this process, different centres developed where watch movements were made to be supplied to retailers. There were principally two centres of manufacture, where rough movements were made, in Lancashire, north of Liverpool and secondly in London where mostly finishing was done. An example of this can be found in the practice of the Ellicotts in Sweetings Alley, Royal Exchange, London, where they ordered quantities of watches from Richard Wright of Cronton, Liverpool, to be delivered to the Bell Inn, Bread Street in the city of London.[6] As well as the Liverpool trade, an important centre of watchmaking grew up in Clerkenwell, London, where many of the leading watch houses had their watches either made, completed, or at least,

Royal Exchange, London, das eine große Zahl solcher »Ebauches« (Rohwerke) bei Richard Wright in Cronton bei Liverpool anfertigen und zum Bell Inn in der Bread Street in der City of London liefern ließ.[6] Neben dieser Liverpooler Adresse bildete sich der Londoner Stadtteil Clerkenwell als weiteres Zentrum heraus, wo viele führende Uhrenhäuser ihre Uhren entweder herstellen, zusammensetzen oder wenigstens – sofern die Uhrwerke selbst aus Liverpool stammten – fertigstellen und regulieren ließen. Die Praxis, Rohwerke zu benutzen, setzte sich im Laufe des 18. Jahrhunderts bei immer mehr Uhrenherstellern durch, wobei neben Grundkomponenten aus England zum Teil auch solche aus der Schweiz verwendet wurden.

Für den dritten und – in Hinblick auf die Geschichte der Uhrmacherkunst – wohl wichtigsten Strang stehen Namen von Uhrmachern wie John Arnold (1736 – 1799), Thomas Earnshaw (1749 – 1829) und Thomas Mudge (1715 – 1794), die unermüdlich an der Entwicklung von Uhren von immer höherer Präzision arbeiteten. Außerdem gab es Produzenten, die alle Arten von Uhren herstellten, von eher schlichten Modellen über exquisite Luxusuhren bis hin zu Uhren, die mit den neuesten Erfindungen und Verbesserungen ausgestattet waren.

Uhren mit Zentralsekunde

Mitte des 18. Jahrhunderts produzierten alle führenden Uhrmacher Uhren mit Zentralsekunde. Bei diesen handelte es sich um einfache Uhren, für gewöhnlich mit Zylinderhemmung. Solche Uhren waren stets mit einer Stoppvorrichtung versehen, die in ihrer einfachsten Form aus einer Arretierung an zwei Stellen bestand, die das Gangrad und mit ihm die ganze Uhr zum Stehen brachte. Zu den ersten, die sich dieses Mechanismus bedienten, gehörten unter anderem George Graham, John Ellicott jun. und Thomas Mudge (1706 – 1772). Thomas Hatton notierte 1773, »Abb. 112 zeigt den Entwurf für horizontale Sekunden durch das zentrale Rad,

when Liverpool movements were involved, finished and adjusted there. The practice of using unfinished watch movements, known as 'rough movements' expanded during the eighteenth century and included makers who used those made in Switzerland as well as those manufactured in England.

At a third level, and the most important in terms of horological history, there were makers such as John Arnold (1736 – 1799), Thomas Earnshaw (1749 – 1829), and Thomas Mudge (1715 – 1794), who continued the struggle to design and make the ultimate precision watch. There were those, of course, who produced all kinds of watches, from the most exquisite luxury goods to the more mundane, as well as to watches that incorporated their latest innovations and improvements.

The Centre-Seconds Watch

By the middle of the eighteenth century, the centre-seconds watch had come into existence and was being made by the leading makers. It was generally associated with a timepiece only, and usually had a cylinder escapement. Such watches were invariably provided with a stop mechanism, which in its simplest form consisted of a simple two-position detent, which intercepted the escape wheel and thus stopped the whole watch. Early users of the mechanism were George Graham, John Ellicott Jun., and Thomas Mudge, but many other makers also employed it. Thomas Hatton in 1773 said, 'Fig. 112 is a plan for horizontal seconds, through the centre-wheel, a plan that was never attempted before with any success, that I know of, but by two gentlemen, viz. Mr. Ellicott and Mr. Exelby, the former of which is much the better.'[7]

Case Makers and Dial Makers

From very early on in the story of watchmaking, the business of watchcase making was a sepa-

was meines Wissens noch von niemandem mit Erfolg angegangen wurde mit der Ausnahme zweier Herren, nämlich Mr. Ellicott und Mr. Exelby, deren Ersterer der weitaus bessere ist.«[7]

Gehäuse- und Zifferblattmacher

Bereits seit den frühen Tagen in der Geschichte der Uhrmacherei war die Herstellung des Uhrgehäuses ein eigenes Gewerbe. In der zweiten Hälfte des 18. Jahrhunderts fertigten Gehäusemacher in London Produkte von höchster Qualität, die der Feinmechanik der Uhrmacher als Hülle dienten. Weil Gehäusemacher in der Regel nicht nur für einen einzigen Auftraggeber arbeiteten, finden sich ihre Gehäuse bei verschiedenen Herstellern. Viele in der Zunft waren hugenottischer Herkunft, stammten also von französischen Calvinisten ab, die bei der Widerrufung des Edikts von Nantes 1685 aus dem katholischen Frankreich geflohen waren. Einer der berühmtesten war Peter Mounier, der bei den führenden Londoner Herstellern im Dienst stand. Bei Uhrengehäusen herrschte zwar einerseits Stilvielfalt, doch bestanden zumindest die Gehäuse von Präzisionszeitmessern, wie etwa Taschenchronometern, meist aus reinem Gold oder Silber.

Schon bald nach seiner Einführung in den 1720er Jahren gehörte das Zifferblatt aus weißer Emaille, anfänglich vor allem von George Graham und John Ellicott eingesetzt, zur Standardausrüstung von Uhren. In der Regel wurde es bis Ende des 18. Jahrhunderts mit römischen Ziffern mit oder ohne Sekundenzeiger ausgestattet, erst danach wurden gelegentlich arabische Ziffern eingeführt. Die meisten Zifferblattmacher blieben namenlos, da sie ihre Arbeit nicht signierten. Ein Hersteller hat sich dennoch ins Gedächtnis eingeschrieben, weil er alle anderen übertraf: William Weston, später Weston and Willis,[8] dessen aus Emaille gefertigte Zifferblätter in London schlicht einzigartig waren.

rate trade. In the second half of the eighteenth century, the London case makers were producing a high-quality product in which the watchmakers could house their mechanisms. Case makers rarely worked exclusively for one watchmaker and so their cases can be found on different makers' watches. Some of the case makers were of Huguenot origin, whose forbears had fled France during the religious conflict that culminated in the Revocation of the Edict of Nantes in 1685. One of the most celebrated of these was Peter Mounier, who produced cases for some of the leading London makers. Watchcases varied in style but generally, the cases that housed high quality precision timekeepers, such as pocket chronometers, were plain either in gold or silver.

Following the introduction of the white enamel dial in the 1720s, favoured by George Graham and John Ellicott in particular in the early days, it became an almost standard aspect of the watch. The normal arrangement of Roman numerals was also a standard, with or without a subsidiary seconds dial and reigned supreme until the end of the eighteenth century when the Arabic numeral was sometimes preferred. For the most part, dial makers remain obscure with their work being unsigned. However, one company that perhaps excelled above all others was that of William Weston, later Weston and Willis,[7] whose enamel dials were unsurpassed in London.

Thomas Mudge

One exceptional maker was Thomas Mudge,[9] who had been apprenticed to the renowned maker George Graham. Following an incident in which a fine equation of time watch was dropped and damaged in the presence of King Ferdinand, it became known that John Ellicott, whose name appeared on the watch, had not made it and that the only person fit to carry out the repairs was the man who had made it, Thomas Mudge. Soon after this unfortunate event, in 1752, King Ferdinand's agent, clockmaker Miguel Smith visited Mudge in London

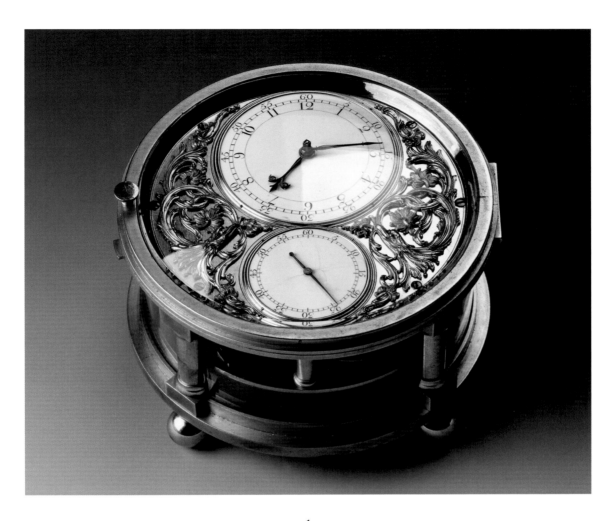

1

Thomas Mudge, Das »Blaue Seechronometer« (eine der drei von Mudge gebauten Seeuhren), Plymouth, 1776 – 1779,
Mathematisch-Physikalischer Salon, Dresden
Thomas Mudge, The 'Blue Marine Chronometer' (one of the three marine timekeepers constructed by Mudge),
Plymouth, 1776 – 1779, Mathematisch-Physikalischer Salon, Dresden

Thomas Mudge

Eine Ausnahmeerscheinung unter den Uhrma-
chern war Thomas Mudge,[9] der das Handwerk bei
seinem berühmten Kollegen George Graham er-
lernt hatte. Sein Name drang sogar bis zum
spanischen Hof unter König Ferdinand VI. vor.
Nachdem nämlich in Madrid eine Uhr zu Bruch
gegangen war, sah sich John Ellicott, der den
Schaden beheben sollte, zu dem Eingeständnis

and on 3 July of that year he wrote to Mudge
saying that he had been asked by the king,
prime minister, and noble gentlemen to recom-
mend a watchmaker and that Mudge had been
their favoured maker. Mudge went on to make a
series of spectacular watches for the king,
amongst them a minute-repeating watch and a
watch made to fit in the pommel of a walking
cane, which had both hour striking and minute
repeat.

gezwungen, nicht er selbst habe die Uhr gebaut, sondern ein gewisser Thomas Mudge, obwohl die Uhr Ellicotts Namen trug. Mudge sei daher auch der Einzige, der sie reparieren könne. Nach diesem Zwischenfall stattete der Uhrmacher Miguel Smith auf Geheiß König Ferdinands 1752 Mudge einen Besuch in London ab. Am 3. Juli desselben Jahres wurde Mudge von seinem Besucher schriftlich darüber in Kenntnis gesetzt, dass er, Miguel Smith, ihn, Thomas Mudge, seinem König, dem Premierminister und anderen hohen Herren als Uhrmacher ans Herz gelegt habe, da er um eine Empfehlung gebeten worden sei. Mudge stünde nun in deren Gunst weit oben. Tatsächlich fertigte Mudge in der Folge einige ausgefallene Uhren für den König von Spanien an, darunter eine Minuten-Repetieruhr sowie eine in den Stockknauf des Königs eingebaute Äquations-Uhr mit Stundenschlag und Minutenrepetition.

Berühmt geworden ist Thomas Mudge aber nicht nur für seine bemerkenswerten Taschenuhren, sondern auch für die Konstruktion einer 1774 fertiggestellten Längenuhr, die heute unter der Bezeichnung Seechronometer Nr. 1 bekannt ist. In seinem Werk »The Marine Chronometer«[10] bescheinigte Rupert Gould dieser Uhr gegenüber sämtlichen im 18. Jahrhundert auf Schiffen eingesetzten Zeitmessern Überlegenheit in ihrer Ganggenauigkeit – sie übertraf selbst Harrisons berühmte H4 (Abb. 1). Bereits zuvor hatte Mudge die Arbeit an einer anderen Uhr aufgenommen, die die Zeitmessung revolutionieren sollte. Erste Überlegungen dazu gehen auf das Jahr 1748 zurück; fertiggestellt wurde sie um 1754. Diese elegante, mit Ebenholz furnierte Tischuhr war eine Einzelanfertigung, zu der auch eine Mondindikation gehörte, die bei einem Mondumlauf von 29,5 Tagen nur eine Fünftelsekunde Abweichung aufwies – eine außerordentliche Präzision, die mehr als ein halbes Jahrhundert lang unübertroffen blieb. Doch dies ist noch nicht der bedeutsamste Aspekt der Uhr. Weit wichtiger ist die völlig neue Art der Hemmung, die hier erstmals Verwendung fand. In dieser schlichten, federgetriebenen Tischuhr verwendete Mudge zum ersten Mal den von ihm

As well as making remarkable watches, Thomas Mudge is also renowned for a superb marine timekeeper, now known as his first marine timekeeper, completed in 1774 and which, according to Rupert Gould in *The Marine Chronometer*[10] was the most accurate sea-going timekeeper to be made in the eighteenth century, out-performing even Harrison's renowned H4 (ill. 1). Earlier, Mudge had embarked on what was to be a revolutionary new timekeeper. He began work on it in about 1748 and completed it in about 1754. This elegant ebony veneered table clock was a unique production, incorporating a lunar indication with an error of only one fifth of a second in a lunation of 29.5 days – a remarkable achievement which was not improved upon for more than half a century. However, this aspect of the clock is far less significant than the escapement that Mudge designed and made for the clock. It is in this unassuming spring-driven table clock that Mudge incorporated his new detached lever escapement (ills. 2a – c). Both the verge escapement and the cylinder were what is known as frictional rest escapements in which the balance was constantly in contact with the escapement and consequently suffered from timekeeping errors caused by the influences of changes in friction. In this new escapement, Mudge placed a lever between the escape wheel and the balance, which on the one hand imparted an impulse to it to keep it oscillating and on the other transferred motion from the balance to the escape wheel to provide the locking and unlocking functions to determine the rate at which the machine ran. In his new design, Mudge had adapted George Graham's highly regarded deadbeat escapement for use in portable timekeepers. Whilst in itself it was not in effect the first detached lever escapement, it did establish the principle of inserting a lever between the balance and the escape wheel to carry out the locking, unlocking, and impulse functions.[11] It was to be the next generation of makers who would develop the concept of the detached lever escapement.

As well as this innovatory escapement, the clock also had bi-metallic temperature compen-

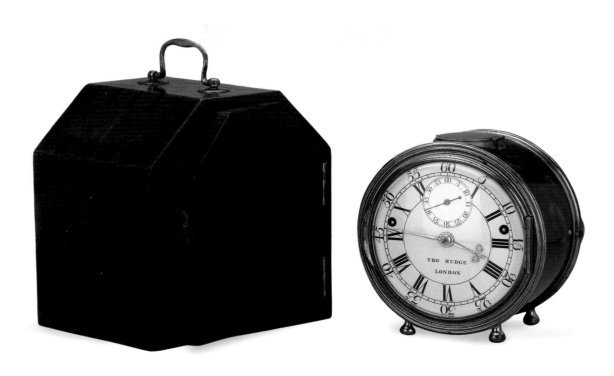

2a – c
Thomas Mudge, Reiseuhr mit Ankerhemmung, London, um 1768, British Museum, London
Thomas Mudge, Travelling clock with lever escapement, London, around 1768, British Museum, London

entwickelten freien Ankergang (Abb. 2a – c). So-
wohl die bis dahin gebräuchliche Spindel- als
auch die Zylinderhemmung gehören nicht zu
den freien Hemmungen, bei denen die Unruh in
ständigem Kontakt mit dem Hemmungsrad
steht, so dass es aufgrund wechselnder Rei-
bungsverhältnisse zu Abweichungen bei der
Zeitmessung kommt. Das Neue an Mudges Hem-
mung war nun, dass er einen Anker zwischen
Hemmrad und Unruh einbaute, der einerseits die
Unruh durch Impulsvermittlung in Schwingung
versetzte und diese Bewegung andererseits auf
das Hemmrad übertrug. Der Anker legte durch
Anhalten und Freigeben des Gangrades den
Rhythmus des Uhrwerks fest. Mit seiner neuen
Konstruktion hatte Mudge die hoch angesehene
ruhende Hemmung George Grahams für trans-
portable Uhren nutzbar gemacht. Obwohl es
nicht die erste freie Ankerhemmung war, hatte
Mudge mit seiner Konstruktion doch das Prinzip

sation, a system introduced by John Harrison in
his marine timekeepers. In the first quarter of
the eighteenth century, it was already recognised
that temperature change had a profound effect
on the rate of both static clocks and portable
timekeepers and leading London makers made
efforts to devise a method by which this problem
could be overcome. Beginning in about 1715,
George Graham was the first to devise a method
using mercury in the pendulum bob. Later John
Harrison in about 1725 introduced the gridiron
for a pendulum that utilised the differential ex-
pansion of brass and steel to maintain a constant
position for the pendulum bob in changing tem-
peratures. Harrison later developed a system of
bimetallic strips of brass and steel which would
move to adjust their position in relation to the
balance spring in order to compensate for
changes in elasticity of the balance spring in
changing temperatures.[12]

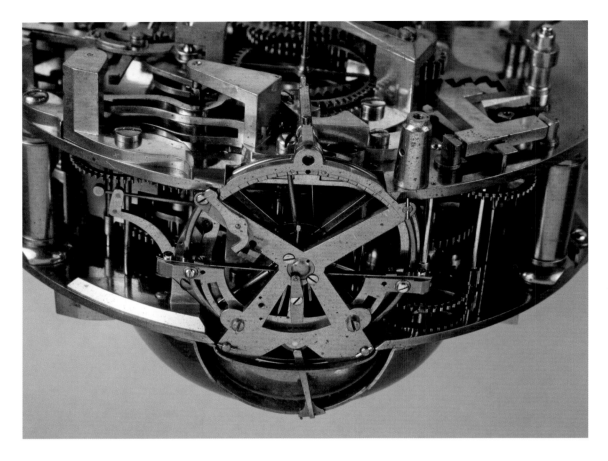

2b

des zwischen Unruh und Gangrad eingeschobenen Ankers etabliert. Der Anker stoppte das Gangrad, gab es wieder frei und übermittelte Energie.[11] Es blieb der nächsten Generation von Uhrmachern überlassen, das Konzept der freien Ankerhemmung weiterzuentwickeln.

Neben dieser bahnbrechenden Neuerung verwendete Mudge für seine Uhr auch ein von John Harrison in seinen Schiffschronometern eingeführtes System, das Bimetall zum Ausgleich von Temperaturunterschieden verwendete. Dass Temperaturunterschiede sich drastisch auf den Gang von Standuhren und tragbaren Uhren auswirken, war bereits im ersten Viertel des 18. Jahrhunderts erkannt worden, und führende Londoner Uhrmacher hatten mit unterschied-

The Pocket Chronometer

Following the impact of Harrison's H4 marine timekeeper on the horological world, it fell to other makers to refine and improve the accuracy of portable precision timekeepers. In this field in London, it was both John Arnold[13] (ill. 3) and Thomas Earnshaw[14] (ill. 4) who pioneered a new type of marine chronometer. Although Harrison had proved with his H4 timekeeper that it was possible to devise a machine that would be capable of maintaining impressive accuracy in hostile conditions over long periods of time, H4 was very expensive and difficult to maintain, and only very few had the skills to deal with it. In 1771 John Arnold began working on a marine

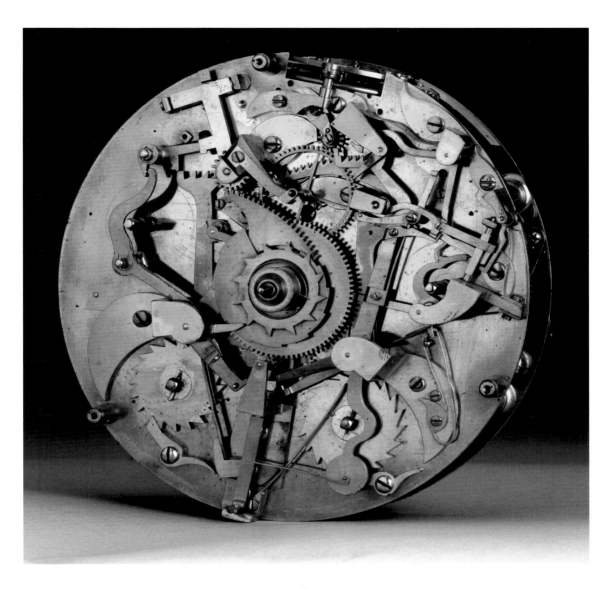

2c

lichen Methoden versucht, dieses Problem zu beheben. Den Anfang machte George Graham 1715 mit einem Quecksilber-Kompensationspendel, welches als Pendellinse ein mit Quecksilber gefülltes Gefäß trug. 1725 führte John Harrison das Rostpendel ein, bei dem die unterschiedlichen Ausdehnungskoeffizienten von Messing und Stahl so genutzt wurden, dass die Position der Pendellinse bei Temperaturände-

chronometer with a pivoted detent escapement, which went to sea with Captain James Cook (1728 – 1779) in 1772. Just ten years later, he applied for a patent for his new spring-detent escapement, a new device that importantly needed no oil on the acting faces of the escapement, a situation that John Harrison had recognised years earlier. In 1783, Thomas Earnshaw also applied for a patent for his new spring-detent es-

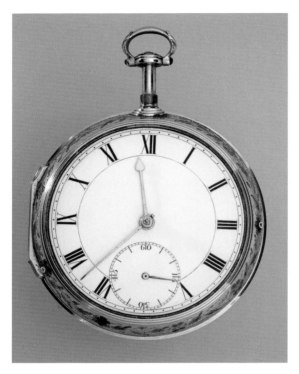

3
John Arnold, Taschenchronometer Nr. 37, London, 1778, British Museum, London
John Arnold, Pocket chronometer No. 37, London, 1778, British Museum, London

rungen weitgehend konstant blieb. Später entwickelte Harrison ein System mit bimetallischen Bändern aus Messing und Stahl, die durch Veränderung ihrer Position auf die Unruhspirale einwirkten und damit die zu- oder abnehmende Elastizität der Spirale bei Temperaturschwankungen kompensieren konnten.[12]

Die Taschenuhr

Nachdem Harrisons Marinechronometer H4 das Uhrmacherhandwerk auf neue Grundlagen gestellt hatte, fiel anderen Uhrmachern die Aufgabe zu, die tragbaren Präzisionszeitmesser mit einer höheren Ganggenauigkeit auszustatten. Die Pionierarbeit, eine transportable Schiffsuhr neuen Typs zu bauen, wurde in London von zwei Männern geleistet: John Arnold[13] (Abb. 3)

capement, applied for through Thomas Wright who registered the application on Earnshaw's behalf. These two applications began a dispute over the right of precedence for the invention of the spring-detent escapement, a dispute that lasted for many years and even took them into the public eye in print. Both Arnold and Earnshaw continued their improvements in the field of marine chronometry, particularly in devising new methods of temperature compensation, in which field they both developed methods which, unlike the earlier methods of Harrison and Mudge, took the compensation mechanism into the oscillating balance itself, a method pioneered by John Harrison in H1 (1730) and further developed by Pierre Le Roy (1717 – 1785) in Paris (1766). The work of these two celebrated London makers brought the marine timekeeper to a level of perfection that had not been previously

4
Thomas Earnshaw, Taschenuhrwerk Nr. 570, London, um 1800, Mathematisch-Physikalischer Salon, Dresden
Thomas Earnshaw, Pocket chronometer movement No. 570, London, around 1800, Mathematisch-Physikalischer Salon, Dresden

und Thomas Earnshaw[14] (Abb. 4). Mit seiner H4 hatte Harrison zwar die Möglichkeit einer Mechanik aufgezeigt, die noch unter widrigsten Umständen und über lange Zeiträume hinweg mit beeindruckender Präzision arbeitete, doch war dieser Apparat nicht nur extrem kostspielig in der Anschaffung, sondern auch schwierig in der Wartung. Nur wenige waren dazu fähig. 1771 nahm John Arnold die Arbeit an einer Schiffsuhr auf, die mit einer Chronometerhemmung mit

achieved and at the same time developed machines which were relatively cheap to produce and could be made relatively quickly by any number of suitably trained specialists – makers who were also essential for the maintenance of them when they were put into service (ill. 5). The success of the marine chronometer had an offshoot in the form of a pocket version which could be worn in everyday use, although it has to be said that the pocket chronometer

Wippe ausgestattet war und 1772 mit Kapitän James Cook (1728 – 1779) auf Reise ging. Kaum zehn Jahre später beantragte Arnold das Patent auf die Federchronometerhemmung, einen neuen Hemmungstyp, der nicht mehr geölt werden musste – eine Entwicklung, die John Harrison bereits Jahre zuvor erkannt hatte. Das gleiche Patent beantragte 1783 jedoch auch Thomas Wright im Namen und Auftrag von Thomas Earnshaw. Damit begann ein jahrelang währender, auch in den öffentlichen Printmedien der damaligen Zeit ausgetragener Streit über die Frage, auf welchen der Antragsteller die Erfindung nun tatsächlich zurückging. Ungeachtet dessen setzten sowohl Arnold als auch Earnshaw ihre Arbeit an weiteren Verbesserungen auf dem Gebiet der Marinechronometer fort. So ersannen sie neue Methoden des Temperaturausgleichs, die im Unterschied zu früheren Ansätzen von Harrison und Mudge an der Unruh selbst ansetzten, womit bereits Pierre Le Roy (1717 – 1785) in Paris erste Versuche unternommen hatte. Den beiden berühmten Londoner Uhrmachern ist es zu verdanken, dass die Marinechronometer nicht nur genauer gingen als je eine Uhr zuvor, sondern auch zu einem vergleichsweise geringen Preis produziert, schnell von entsprechend ausgebildeten Fachleuten nachgebaut und – einmal in Gebrauch – von diesen auch repariert werden konnten (Abb. 5). Der Erfolg der Marinechronometer führte zu einer Taschenvariante, die für den alltäglichen Gebrauch geeignet war. Allerdings litt die Genauigkeit der Taschenchronometer beim Reiten: Auf dem Rücken eines Pferdes konnte das Gangrad versehentlich freigegeben werden und so die Ganggenauigkeit der Uhr in Mitleidenschaft ziehen.[15]

Die Duplexhemmung

Eine Form der Hemmung, die besonders in London Ende des 18. und Anfang des 19. Jahrhunderts hoch im Kurs stand, war die Duplexhemmung. Im Januar 1782 hatte Thomas Tyrer das Patent Nr. 1331 für seine neue Hem-

did not lend itself to good performance when used on horseback where the escapement could accidently unlock, affecting its timekeeping qualities.[15]

The Duplex Escapement

An escapement which was perhaps favoured more in London than anywhere else in the late eighteenth century and into the nineteenth century was the duplex. Thomas Tyrer was granted a patent for this new escapement – Patent No. 1331 in January 1782. His initial form was for an escape wheel with two wheels mounted on a common arbour, which acted with a hollow jewelled cylinder mounted on the balance staff. One wheel was to provide impulse to the balance and the other for locking. However, examples of his double-wheel version are rare whereas those with a single wheel with one set of teeth radial to the centre and one set rising vertically from the wheel rim are relatively common. This form of escapement was undoubtedly favoured by the London makers for their good quality precision watches.

Josiah Emery and the Lever Escapement

After Thomas Mudge had successfully completed his new experimental clock incorporating his new detached lever escapement he went on to make a watch for Queen Charlotte, wife of King George III in 1769 (ill. 6). It could be said that this watch was the forerunner of the modern mechanical watch, but it was not for Thomas Mudge to continue its development. Mudge's original concept had been a difficult one to make, and it was not until the late 1770s – early 1780s that the escapement was developed by, among others, Josiah Emery (c. 1725 – 1797).[16] In adult life, his reputation as a watchmaker quickly grew and thus it is perhaps not surprising that he should gain the attention of Mudge's patron and supporter Hans Maurice Count von Brühl (1736 – 1809), who would spur Emery on

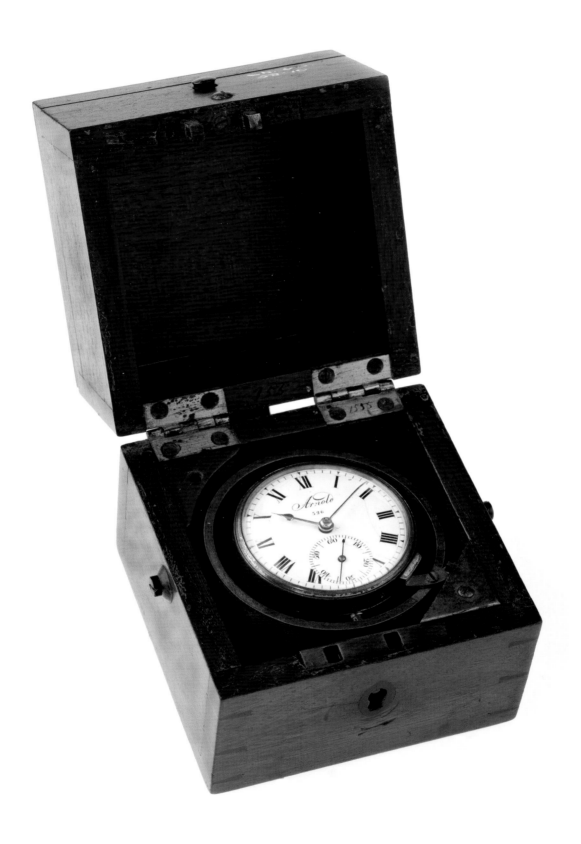

5
John Arnold & Son, Marinechronometer Nr. 326, London, zwischen 1788 und 1810,
National Maritime Museum, Greenwich, London
John Arnold & Son, Marine chronometer No. 326, London, between 1788 and 1810,
National Maritime Museum, Greenwich, London

mung erhalten. In ihrer ursprünglichen Form bestand das Gangrad aus zwei Rädern, die auf einer gemeinsamen Welle montiert waren. Eines der Räder wirkte auf eine Steinrolle, die ihrerseits auf der Unruhwelle befestigt war. Das zweite Rad fungierte als Impulsgeber für die Unruhe, während das erste die Ruhe bewirkte. Es gab allerdings nur wenige Exemplare, die mit dem ursprünglichen Doppelhemmrad ausgestattet waren. Üblicher waren Versionen mit einem einzelnen Rad, bei denen ein Zahnkranz radial zum Zentrum verlief, während der andere vertikal auf dem Radkranz stand. Die Duplexhemmung setzten die Londoner Uhrmacher bevorzugt für Uhren von guter Qualität und hoher Ganggenauigkeit ein.

Josiah Emery und der freie Ankergang

Nachdem Thomas Mudge sein neuestes Uhrenmodell mit der freien Ankerhemmung vollendet hatte, begann er ab 1769 eine Taschenuhr für Königin Charlotte, die Gemahlin Königs George III., zu entwerfen (Abb. 6). Diese Uhr war die Vorläuferin moderner mechanischer Taschenuhren, allerdings führte Mudge selbst die Entwicklung ihrer Technik nicht fort. Sein Originalentwurf war so kompliziert, dass er sich nur schwer replizieren ließ. Erst Ende der 1770er, Anfang der 1780er Jahre gelang es Uhrmachern, unter anderem Josiah Emery (ca. 1725 – 1797), die freie Ankerhemmung weiterzuentwickeln.[16] Emery hatte sich schnell als Uhrmacher einen Namen gemacht, und so war es nicht verwunderlich, dass auch Mudges Mäzen und Förderer, Graf Hans Moritz von Brühl (1736 – 1809), auf ihn aufmerksam wurde und ihn drängte, die von Mudge entwickelte Hemmung weiterzuführen. Dazu bemerkte Emery:

»Vor etwa siebzehn oder achtzehn Jahren bat mich der Graf von Brühl wiederholte Male inständigst, ich möge ihm eine Uhr auf der Grundlage einer Hemmung fertigen, die Mr. Mudge erfunden hatte. Lange Zeit gab ich ihm darauf immer wieder zur Antwort, dass Mr. Mudge die

to develop Mudge's escapement. On the matter, Emery said:

'About seventeen or eighteen years ago Count von Brühl repeatedly urged me to make him a watch upon an escapement Mr. Mudge had invented. I for a long time successively answered that Mr Mudge was the properist person for such an undertaking; for to own the truth, I doubted whether it would be possible to ever make a common sized pocket watch with an escapement on so large a scale. But the Count, not contented with my repeated refusal, at last prevailed upon me. It was then he brought me a large frame, like a clock escapement, but at the same time he gave me no rules concerning it, nor any of the smallest hint of the construction of Mr Mudge's watch; nor did I ever see the said watch till many years after (for the Queen had it) and his Majesty himself did me the honor to shew it to me.'[17]

Between 1782 and 1786 Emery produced a series of lever escapement watches, numbering at least thirty-eight (ill. 4, p. 75). In order to achieve this, Emery employed a highly skilled escapement maker, Richard Pendleton, to make the escapements for the watches, a fact referred to by Thomas Mudge Jun. in his account of his father's work, *A Description with Plates*, published in 1799, where he states, 'It is a fact now very well known, that this watch as well as all others of the same kind, made in Mr Emery's name, was executed for him by Mr. Pendleton.'[18] Others too, in London, were involved in the early story of the lever escapement, particularly, John Grant (died 1810), of whose work at least eight examples are known to survive. Others were John Leroux, Francis Perigal, George Margetts, Thomas Cummins, and Louis Recordon but with these makers only very small numbers of watches are known.

The Liverpool Lever Escapement

As the eighteenth century progressed, Liverpool increased as an important centre of the watchmaking industry[19] and it was here that the de-

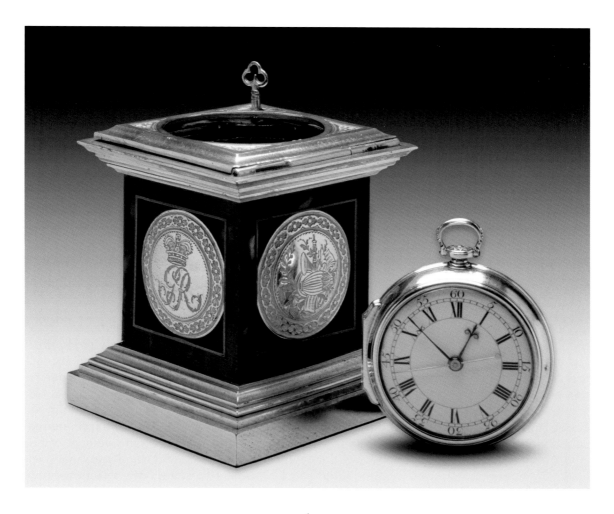

6
Thomas Mudge, Queen Charlotte Watch, London, 1769, Windsor Castle, Royal Collection

wohl für eine solche Unternehmung geeignetste Person sei; denn, um die Wahrheit zu bekennen, ich zweifelte daran, dass es möglich wäre, eine Taschenuhr üblicher Größe mit einer so großen Hemmungspartie zu machen. Doch der Graf – nicht willens, sich mit meiner wiederkehrenden Ablehnung abzufinden – obsiegte schließlich. Er lieferte mir ein großes Modell, ähnlich einer Hemmung für eine Pendeluhr, aber ohne Bestimmung, wie damit umzugehen sei, und ohne auch nur den kleinsten Fingerzeig betreffs der Bauweise von Mr. Mudges Taschenuhr; auch hatte

velopment of the lever escapement was to take place (ill. 7). Peter Litherland (1756 – 1805)[20] was granted his first patent for a rack lever watch with a 15-tooth escape wheel in 1791, and in 1792 he was granted a further patent for a watch with a thirty-tooth escape wheel and the insertion of an extra wheel between the rack and the balance to produce a seconds beating balance. His original rack lever escapement had a pinion on the balance staff that engaged with and rotated a toothed rack mounted on the lever operating between the escape wheel and the bal-

ich die fragliche Uhr nie gesehen. Erst viele Jahre später sollte dies geschehen (denn die Königin besaß sie), und Seine Majestät selbst erwies mir die Ehre, sie mir zu zeigen.«[17]

Von 1782 bis 1786 produzierte Emery eine Reihe von Uhren mit Ankergang, mindestens 38 an der Zahl (Abb. 4, S. 75). Dies war nur möglich, weil er den handwerklich begnadeten Richard Pendleton zur Fertigung der Hemmungen eingestellt hatte, wie wir von Thomas Mudge jun. wissen, der davon in seinem 1799 verfassten Bericht über das Lebenswerk seines Vaters »A Description with Plates« Zeugnis ablegt: »Es ist heute allgemein bekannt, dass diese Uhr, ebenso wie alle anderen derselben Machart, die auf Mr. Emerys Namen lauten, von Mr. Pendleton hergestellt wurde.«[18] Neben Josiah Emery hatten weitere Londoner Uhrmacher Anteil an der frühen Entwicklung der freien Ankerhemmung, darunter vor allem John Grant (gestorben 1810), von dessen Uhren mit Ankerhemmung mindestens acht Exemplare erhalten geblieben sind. Nur sehr vereinzelt existieren dagegen noch Stücke von Uhrmachern wie John Leroux, Francis Perigal, George Margetts, Thomas Cummins und Louis Recordon.

Der Liverpooler Ankergang

Im Lauf des 18. Jahrhunderts stieg Liverpool zu einem bedeutenden Zentrum der Uhrmacherei auf,[19] das auch für die Weiterentwicklung der Ankerhemmung richtungsweisend war (Abb. 7). 1791 erhielt Peter Litherland (1756 – 1805)[20] das erste Patent für eine Uhr mit Rechenankerhemmung mit einem 15-zähnigen Ankerrad; 1792 erteilte man ihm ein weiteres Patent für eine Uhr mit einem 30-zähnigen Ankerrad und die Hinzufügung eines zusätzlichen Rades zwischen Rechen und Unruhe, um eine Unruhe mit Sekundenschlägen zu erhalten. Sein ursprünglicher Entwurf für die Rechenankerhemmung sah ein Trieb auf der Unruhwelle vor, das in einen gezahnten Rechen eingreift und diesen in eine Drehbewegung bringen sollte. Der Rechen war

ance. The oscillating motion of the balance moved a lever placed between the balance and the escape wheel so that the pallets on the lever allowed the teeth of the escape wheel to be released and locked alternately to allow the escape wheel to turn at a rate determined by the rate at which the balance oscillated.

Compared with the elevated skills needed to make Emery's lever escapement, the Litherland version was far easier to manufacture, using special tools, and was relatively cheap and affordable to a much wider market. It is, however, interesting to note that in London the leading makers were reluctant to get involved and continued their use of the cylinder and the more recently invented duplex escapement, as well as making pocket chronometers with variants of the spring detent escapement.

Following the success of the rack lever it was to be another maker, Edward Massey (1768 – 1852), who would take the lever watch to a new level of efficiency.[21] Massey is renowned in the horological world for his introduction of a new form of lever escapement, now referred to as the 'Massey lever,' which in many ways established the pattern for the modern detached lever escapement still in use today. Massey was granted a patent in 1812 for his new escapement and subsequently in 1814 a further patent covered his refinement of the design. In essence, the escapement took the form of a ratchet toothed escape wheel, a lever with pallets acting on the escape wheel teeth and at the other end a slot into which a single tooth imparted impulse to the balance on the one hand, and on the other, the tooth moved the lever back and forth to lock and unlock the escape wheel. Massey developed the design from a single tooth to a single roller in a cage and thence to a single jewelled pin. It was from this that the modern lever escapement came into being.

seinerseits auf dem Anker montiert, der zwischen Gangrad und Unruh saß. Durch die Schwingung der Unruh wurde der zwischen Unruh und Ankerrad befestigte Anker in Bewegung gebracht, so dass seine Palletten in die Zähne des Gangrads eingriffen und sie abwechselnd freigaben oder sperrten. Der Rhythmus, in dem die Unruh schwang, gab also den Takt für die Drehung des Ankerrads vor.

Im Vergleich zu Emerys Ankerhemmung, deren Konstruktion großes handwerkliches Können erforderte, ließ sich Litherlands Version wesentlich einfacher und billiger produzieren und eröffnete so einen entsprechend breiten Markt. Erstaunlicherweise setzte sich dieses System bei Londons führenden Uhrenherstellern aber nur langsam durch. Sie blieben vorerst bei der Verwendung der Zylinderhemmung und der unlängst erfundenen Duplexhemmung und griffen für die Produktion von Taschenchronometern auf verschiedene Arten der Federchronometerhemmung zurück.

Ein weiterer Fortschritt in der Entwicklung von Uhren mit Ankergang ist auf Edward Massey (1768 – 1852) zurückzuführen.[21] Berühmt wurde er in der Welt der Uhrmacherkunst für einen neuen, nach ihm benannten Hemmmechanismus, den »Massey-Ankergang«, der in mehrfacher Hinsicht den modernen, noch heute gebräuchlichen freien Ankergang vorwegnahm. Massey erhielt 1812 Patentschutz für seine Entwicklung und 1814 ein weiteres Patent für eine Verfeinerung des Entwurfs. Die Hemmungspartie bestand im Wesentlichen aus einem spitzzahnigen Gangrad und einem Anker, dessen Palletten auf die Zähne des Gangrads wirkten. Am Ende des Ankers befand sich ein Schlitz, in den ein einzelner Zahn eingriff und so einerseits der Unruhe einen Impuls übermittelte und andererseits den Anker vor und zurück bewegte, um das Gangrad zu stoppen und wieder frei zu geben. Massey entwickelte seine Konstruktion von einem einzelnen Zahn zu einer Hebelscheibe im Käfig und schließlich zu einem einzelnen Edelsteinstift. Dieses System ist der direkte Vorläufer des modernen Ankergangs.

7
Michael Isaac Tobias & Co., Taschenuhr mit Rechenanker-hemmung, Liverpool, um 1820,
Mathematisch-Physikalischer Salon, Dresden
Michael Isaac Tobias & Co., Pocket watch with rack lever escapement, Liverpool, around 1820,
Mathematisch-Physikalischer Salon, Dresden

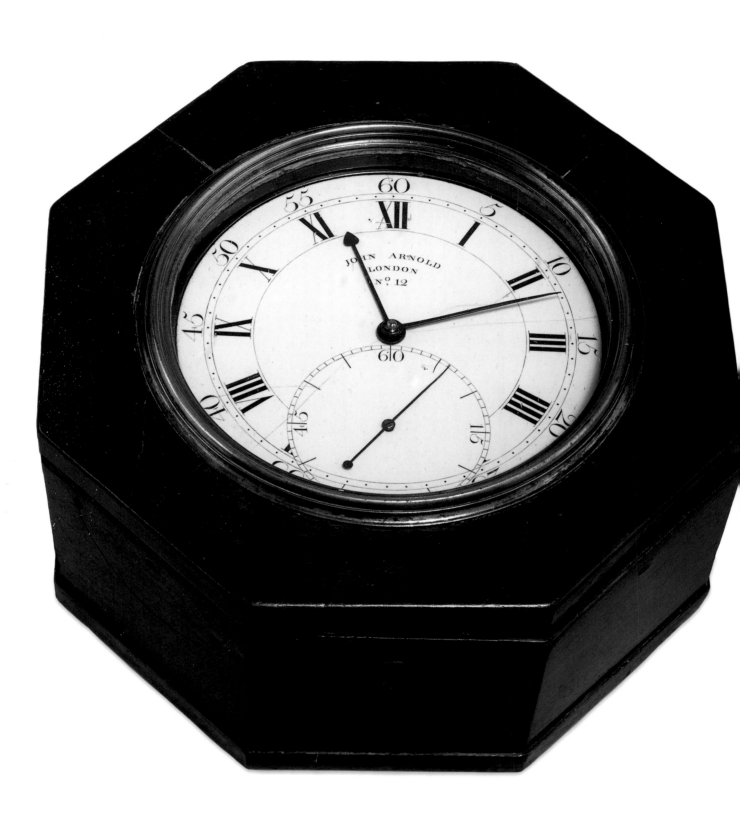

2 Die Zeit auf See
Time at Sea

Über Jahrhunderte konnten Seefahrer auf dem offenen Meer nur vermuten, auf welcher Position sich ihr Schiff befand. Die geographische Breite ließ sich mittels der Sonne oder der Sterne relativ sicher bestimmen, die geographische Länge jedoch nicht. Dabei hatte der Gelehrte Gemma Frisius (1508 – 1555) schon 1530 eine Lösung des Problems vorgeschlagen: die Mitnahme einer Uhr mit der Zeit des Ausgangshafens. An Bord sollte die lokale Zeit ermittelt und mit der mitgebrachten Zeit verglichen werden. Aus der Differenz ließe sich dann die geographische Länge errechnen. Der Vorschlag war klug, scheiterte jedoch an der Unzulänglichkeit der Uhrentechnik. Eine Uhr auf See hatte vielerlei Widrigkeiten zu trotzen: schwankenden Temperaturen, Feuchtigkeit und starken Bewegungen. Wollte man nach einer sechswöchigen Reise die Länge bis auf einen halben Grad genau ermitteln, durfte die Uhr pro Tag kaum drei Sekunden und insgesamt nicht mehr als zwei Minuten falsch gehen. Diese Gangabweichung brachte am Äquator immer noch eine Ungenauigkeit von ca. 56 Kilometern. Erst 1759 gelang es dem Engländer John Harrison (1693 – 1776), eine Uhr zu bauen, die diesen Anforderungen entsprach. Es war Aufgabe der nachfolgenden Generationen, dieses komplizierte Unikat in eine einfachere, effizient arbeitende und bezahlbare Uhr zu verwandeln. Letztlich war Frisius' Lösungsvorschlag erst um 1780 anwendbar.

For centuries, seafarers on the open sea could only guess the position of their ship. Latitude could be determined with relative certainty using the Sun or the stars, but not longitude. A solution was suggested as early as 1530 by the scholar Gemma Frisius (1508 – 1555): a clock should be taken on the voyage, set to the local time of the port of departure. At sea, the ship's local time could be determined, compared with the time on the clock, and longitude calculated from the difference between the two. It was a clever solution, but came to nothing because the technology of clocks and watches was not sufficiently developed. A timepiece at sea had many challenges to contend with: fluctuating temperatures, dampness and violent movement. If a ship were to be able to determine its longitude up to half a degree after a voyage of six weeks, then the timepiece would have to be in error by less than three seconds per day, and no more than two minutes over the whole six weeks. Even with a deviation as small as this, a ship at the equator would still only know its position to within some 50 kilometres. It was not until 1759 that the Englishman John Harrison (1693 – 1776) succeeded in building a timepiece which met these specifications. It fell to following generations to turn this complicated one-off instrument into a simpler chronometer which was both efficient and affordable. In the end, it was not until around 1780 that Frisius' solution could be applied in practice.

John Arnold, Seechronometer Nr. 12, London, 1778/79,
British Museum, London
◄ John Arnold, Marine chronometer No. 12, London, 1778/79,
British Museum, London

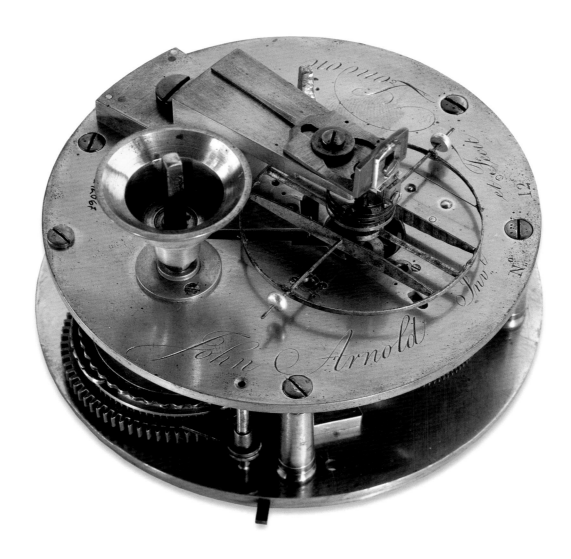

**John Arnold, Seechronometer Nr. 12, London, 1778/79,
British Museum, London**

John Arnold, Marine chronometer No. 12, London, 1778/79,
British Museum, London

Dem englischen Uhrmacher John Arnold (1736 – 1799) ge-
bührt neben dem Franzosen Pierre Le Roy (1717 – 1785) das
Verdienst, eine praktikable Form des Seechronometers ent-
wickelt zu haben. Die Pioniere des Chronometerbaus, etwa
John Harrison und Thomas Mudge (1715 – 1794), stellten in
vorwiegend eigenhändiger Arbeit Unikate her; die Bauzeit
einer Uhr nahm dementsprechend mehrere Jahre in Anspruch.
Arnold vereinfachte die Bauweise des Seechronometers und
griff zugleich auf eine arbeitsteilige Fertigung zurück. Auf
diese Weise vollendete Arnold vier bis fünf Seechronometer
pro Jahr. Diese kosteten zwischen 60 und 80 Guineen – ein
Bruchteil des Preises der Chronometer von Harrison und
Mudge, doch immer noch ein Fünftel oder gar ein Viertel des
Jahresgehalts eines Kapitäns.

The credit for having developed a practical version of the
marine chronometer is shared by the English watchmaker
John Arnold (1736 – 1799) and the Frenchman Pierre Le Roy
(1717 – 1785). The pioneers of marine chronometers, men like
John Harrison and Thomas Mudge (1715 – 1794), worked
mostly alone, producing one-off instruments, each taking
several years to make. By simplifying the construction and
subcontracting specialised tasks, Arnold succeeded in com-
pleting four or five marine chronometers per year. These cost
between 60 and 80 guineas – a fraction of the price of a
chronometer by Harrison or Mudge, but still a fifth or even a
quarter of the annual wages of a sea captain.

Johann Georg Thiell, Chronometer Nr. 1, Bremen, 1768, Landesmuseum Württemberg, Stuttgart

Johann Georg Thiell, Chronometer No. 1, Bremen, 1768, Landesmuseum Württemberg, Stuttgart

Das Chronometer Nr. 1 des Bremer Uhrmachers Johann Georg Thiell (1714 – 1784) ist das älteste bekannte deutsche Seechronometer. Thiell stattete es mit einer aufwändigen Technik aus: Die Uhr verfügt über zwei Schwingsysteme. Die nicht kompensierte Unruh 2 dient als Gangregler für ein selbstständiges Räderwerk mit Kette und Schnecke und die Unruh 1 mit Kompensation reguliert den Ablauf eines einfachen verzahnten Federhauses. Beide Werke sind miteinander verbunden, so dass Werk 2 als Sekundärantrieb für Werk 1 dient und dessen gleichbleibenden Antrieb garantiert. Mit den zwei Werken korrespondieren die zwei Zifferblätter: Das Zifferblatt 1 dient der Zeitanzeige, Zifferblatt 2 der Kontrolle des Gleichlaufs beider Werke.

Chronometer No. 1 by the Bremen watchmaker Johann Georg Thiell (1714 – 1784) is the oldest known German marine chronometer. Thiell equipped it with a highly elaborate mechanism, including two complete balances. Balance 2, which is uncompensated, regulates an independent train with chain and fusee. Balance 1, which is compensated, regulates a train with a simple going barrel. The two movements are interlinked, so that Movement 2 provides a back-up impulse for Movement 1, to guarantee that its drive remains steady. The two faces correspond to the two movements. The first shows the time, while the second is for controlling the synchronous going of the two movements.

Jonathan Betts

Die Geburt der Präzisionsuhr
The Birth of the Precision Watch

John Harrison und das Chronometer

In den frühen 1750er Jahren versuchte der Pionier in der Bestimmung des Längengrades, John Harrison (1693 – 1776), ein Vierteljahrhundert lang und mit aller Kraft, einen Zeitmesser zu erfinden, der auch auf See zuverlässig die Zeit messen konnte. Bis zu diesem Zeitpunkt hatte er sich mit großen »tragbaren« Uhrenkonzepten beschäftigt. Im Jahr 1752 entschied er sich jedoch, einen neuen Weg einzuschlagen, der ihn zu einem historisch bedeutsamen Durchbruch führen sollte, der der Präzisionsuhr den Weg ebnete.

Harrison erkannte, dass entgegen der landläufigen Meinung nicht ein großer Zeitmesser das Längengrad-Problem würde lösen können, sondern etwas viel Kleineres. Die erfolgreiche Konstruktion, auf deren Basis er seinen vierten Zeitmesser entwickelte – heute als H4 bekannt – ähnelte einfach einer großen Taschenuhr (Abb. 2).

John Harrison and the Chronometer

By the early 1750s, the great longitude pioneer John Harrison (1693 – 1776) had been struggling for about a quarter of a century in his attempt to create a timekeeper capable of stable timekeeping at sea. Up until that point he had been working on large 'portable clock' designs, but in 1752 decided to take a new path, and made the historically important breakthrough that saw the beginnings of the precision watch.

Harrison discovered that it was not, as everyone had supposed, a large timekeeper that would solve the longitude problem but something on a much smaller scale. The successful design, developed into his fourth timekeeper and known today as H4, appeared to be simply a large watch (ill. 2). The view generally held internationally during the first half of the eighteenth century was that watches were simply not capable of sufficiently good timekeeping.

Johann Georg Thiell, Chronometer Nr. 1, Bremen, 1768,
Landesmuseum Württemberg, Stuttgart
Johann Georg Thiell, Chronometer No. 1, Bremen, 1768,
Landesmuseum Württemberg, Stuttgart

In der ersten Hälfte des 18. Jahrhunderts wurde international jedoch die Ansicht vertreten, dass Taschenuhren grundsätzlich nicht zu einer ausreichend zuverlässigen Zeitmessung fähig seien. Damals verfügten die besten Taschenuhren über eine Zylinderhemmung, mit der sie die Zeit bei einer Abweichung von plus/minus einer Minute pro Tag messen konnten. Zur Bestimmung des Längengrades waren sie damit aber bei Weitem nicht präzise genug. Mehrere Uhrmacher führten daher verschiedene Experimente an Taschenuhren durch, mit denen deren Leistung verbessert werden sollte, die allerdings nur die alte Ansicht zu bestätigen schienen, dass Taschenuhren nicht zu einer ausreichenden Genauigkeit imstande seien. Wie also erreichte Harrison seinen Erfolg und was war das Besondere an seiner Konstruktion einer kleinen tragbaren Präzisionsuhr, mit der er eine zuverlässigere Zeitmessung möglich machte?

Große Zeitmesser: Pendel- bzw. Standuhren

Das allgemeine Prinzip, einen großen, schweren Oszillator von niedriger Frequenz und geringer Amplitude zu verwenden, war fehlerhaft, wenn es in einem tragbaren Zeitmesser umgesetzt werden sollte. Dennoch schien dieses Konzept ein naheliegender und gangbarer Weg zu sein. Als gutes Beispiel diente die Leistungsfähigkeit ortsfester Uhren, in denen der Oszillator (das Pendel) durch kleine Bogen schwang und in niedriger Frequenz schlug, üblicherweise einmal pro Sekunde. Mit einer Temperaturkompensation konnten diese Zeitmesser eine Präzision von bis zu einer Sekunde pro Woche leisten und waren damit um ein Vielfaches besser als damalige Taschenuhren. Daher lag der Versuch nahe, sie für die Verwendung in einem sich bewegenden Umfeld anzupassen.

Aufbauend auf der Arbeit von Christiaan Huygens (1629 – 1695) galt es schließlich als erwiesen, dass ein Pendel als Oszillator auf einem sich bewegenden Schiff niemals stabil genug sein würde. Dennoch hielt man an dem Konzept

The best watches during this period employed a cylinder escapement and were capable of stable timekeeping of about plus/minus one minute a day, but this was nowhere near good enough for longitude determination. There were one or two experiments on watches by various makers, in attempts to improve their performance, but these also seem to have confirmed the old view that they were not likely to perform to sufficient accuracy. So what was the route by which Harrison succeeded, and what was it about his design for a precision watch that induced more stable timekeeping?

Large Timekeepers: Clocks

The general principle of employing any large, heavy, low-frequency, low-amplitude oscillator was flawed when applied to a portable timekeeper. However, the concept had always seemed the logical course to follow. The example was admirably set in the performance of fixed clocks, in which the oscillator (the pendulum) swung through small arcs and beat at a low frequency, commonly one second in period. With temperature compensation, these timekeepers could perform to about one second in a week — incomparably better than contemporary pocket watches — and it simply made sense to try and adapt them for use in a moving environment.

Following the work of Christiaan Huygens (1629 – 1695), it was finally recognized that a pendulum would never be sufficiently stable as an oscillator on a moving ship. However, the concept of a heavy, low-frequency, low-amplitude oscillator was still firmly held onto as the most promising for development by all in the next generation of horological designers. The appearance of seconds-beating balances, as seen in the work of Henry Sully and Harrison (and later by Thomas Mudge in London, and Pierre Le Roy and Ferdinand Berthoud in France) was thus an absolutely logical progression, based on that thinking (ill. 1).

eines schweren Niedrigfrequenz-Oszillators fest, das unter der nachfolgenden Uhrmachergeneration als die vielversprechendste Grundlage für eine Weiterentwicklung galt. Das Auftreten von Sekundenpendeln, wie in der Arbeit von Henry Sully und Harrison (sowie später von Thomas Mudge in London und Pierre Le Roy und Ferdinand Berthoud in Frankreich), war vor dem Hintergrund dieser Denkweise der logische nächste Schritt (Abb. 1).

Das Problem der niedrigen Frequenz und geringen Amplitude

Das Problem an dieser simplen Theorie war, dass die hauptsächlichen Störungen, denen transportable Zeitmesser ausgesetzt sind, indirekt sind. Sie betreffen den Träger des Oszillators. Tatsächlich beeinträchtigen ausgerechnet diese Störungen, denen der Zeitmesser bei Bewegung ausgesetzt ist, einen Niederfrequenz-Oszillator mit geringer Amplitude am stärksten.

Vorstellbar war jedoch auch ein Zeitmesser mit einem andersartigen Oszillator, in dem eine Unruh fünfmal pro Sekunde schlägt und einen Schwingungsbogen von insgesamt ca. 240 Grad aufweist. Es ist offensichtlich, dass die gleichen langsamen und kleinen Störungen auf einen solchen Oszillator viel geringere Auswirkungen haben. Kurz gesagt ist also eine Unruh von hoher Frequenz und großer Amplitude viel besser für einen zuverlässigen Zeitmesser in einem sich bewegenden Umfeld geeignet. Dies bestätigten auch die damals gängigen Taschenuhren, deren Genauigkeit deutlich weniger von Bewegungen gestört wurde. Dieser Umstand wurde bereits 1722 zum ersten Mal beobachtet, als der Abbé de Hautefeuille (1647 – 1724) in seiner Arbeit über tragbare Zeitmesser feststellte, dass Uhren mit einer großen und schweren Unruh hervorragend funktionierten, wenn sie auf dem Tisch lagen, ihre Leistung auf der Jagd aber zu wünschen übrig ließ. Eine Uhr mit einer relativ kleinen und leichten Unruh funktionierte hingegen schlechter als die andere Uhr, wenn beide

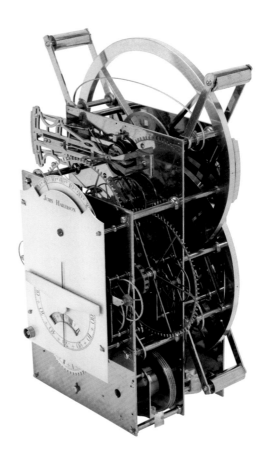

1

John Harrisons dritte Seeuhr, H3. Die Uhr ist 59 cm hoch und wiegt 27 kg. Die Unruh führt eine Halbschwingung pro Sekunde aus. Der Schwingungsbogen beträgt ca. 10 Grad. National Maritime Museum, Greenwich, London
John Harrison's third timekeeper, H3. It stands 59 cm high and weighs 27 kg. The balances beat seconds and swing through an arc of about 10 degrees. National Maritime Museum, Greenwich, London

The Problem with Low Frequency and Low Amplitude

The problem with that simple theory is that the main disturbance faced by portable timekeepers is indirect, in that it affects the support for the oscillator and the typical disturbances to which a low-frequency, low-amplitude oscillator would be subject when moving, were precisely those which upset it most.

unbewegt auf einem Tisch lagen, auf der Jagd lieferte sie im Vergleich aber deutlich bessere Ergebnisse.

Kleine Zeitmesser: Taschenuhren

Die zu dieser Zeit gängigen Taschenuhren mit einem gewöhnlichen Spindelgang verfügten über eine Unruh von relativ hoher Frequenz (normalerweise etwa 17.280 Schläge in der Stunde bzw. etwas weniger als fünf Schläge in der Sekunde) und einen Schwingungsbogen von 90 bis 100 Grad. Allerdings waren diese Uhren, wie bereits angemerkt, verhältnismäßig schlechte Zeitmesser. Auch die besten unter ihnen konnten eine Abweichung von etwa einer Minute pro Tag nicht vermeiden. Wo genau lag also das Hindernis für eine zuverlässige Zeitmessung durch Taschenuhren? Offenbar war es nicht das oben beschriebene Problem, da die hohe Frequenz des Oszillators jenen Störungen entgegenwirkte, die durch Bewegung hervorgerufen wurden.

Das Problem der Taschenuhren

Tatsächlich war das Problem eine andere, tiefgreifende Störung, der alle mechanischen Oszillatoren unterliegen. Es handelt sich dabei um eine Störung von innen heraus, die von der Hemmung verursacht wird und das Ergebnis sich ändernder und direkt auf den Oszillator wirkender Kräfte ist. Schon der Akt des Impulsgebens auf den Oszillator, um dessen Schwingung aufrechtzuerhalten, wirkt sich auf die Zeitmessung aus. Dieser Effekt, der von einigen Theoretikern als »Gangfehler« bezeichnet wurde, ist streng genommen gar kein Fehler, sondern ein Faktor, der die Schwingungszahl des Oszillators verändern kann.

So brachte beispielsweise die Spindelhemmung, die alle gängigen Uhren des 18. Jahrhunderts aufwiesen, einen Gangfehler mit einer deutlichen positiven Zeitabweichung mit sich.

By contrast, one can now imagine a timekeeper with a different specification of oscillator in which a balance beats five times in a second and has a total arc of swing of, say, 240 degrees. It will be obvious, if one applies the same slow, small disturbances to it, that such an oscillator will be much less affected by the disturbance. In short, a balance swinging through large amplitudes and at high frequency will be a much more stable timekeeper when subject to external motions, something proved in the case in pocket watches, which are certainly less easily disturbed when moved about. This was, incidentally, observed as far back as 1722, when the Abbé de Hautefeuille (1647 – 1724), in a work on portable timekeepers, noted that a watch with a large heavy balance went well lying on the table but badly when hunting (i. e. on horseback), whereas a watch with a relatively small, light balance went worse than the other when both were tried stationary on a table, but better than the other when both were tried hunting.

Small Timekeepers: Watches

The common pocket watch of the period, with an ordinary verge escapement, had a balance of relatively high frequency (commonly 17,280 beats in an hour, or a little under five beats a second) and an arc of swing of about 90 to 100 degrees: but, as already noted, these watches were relatively poor timekeepers, even the best being incapable of variations less than about one minute in a day. What, then, was the problem that seemed to render them incapable of stable timekeeping? Evidently it was not primarily one of disturbance caused by external motions, as the relatively high-amplitude and high-frequency specification of the oscillator defended against this.

The Problem with Watches

The answer is that there was another very significant disturbance to which all mechanical os-

Dabei führte allein der Effekt des Impulses zum schnelleren Gang einer solchen Uhr. Solange die Abweichung konstant bleibt, handelt es sich dabei nicht um ein Problem, da die Tendenz der Hemmung zu einem schnelleren Gang einfach und wirkungsvoll durch Anpassung des Regulators der Uhr, der für die Zeitmessung verantwortlich ist, korrigiert werden kann. Wird der Impuls allerdings stärker, geht die Uhr wieder schneller, wird der Impuls schwächer als gewöhnlich, geht die Uhr langsamer. Jeder, der schon einmal mit einer alten Uhr mit Spindelhemmung herumgespielt, das Kronrad ganz leicht berührt und es ein wenig gedrückt hat, weiß, wie empfindlich eine Uhr mit Spindelhemmung auf unterschiedliche Impulse reagiert. Ein leichtes Drücken des Kronrades ist eine einfache Möglichkeit, die Unruh wild tanzen zu lassen und die Zeitmessung außer Kontrolle zu bringen.

Eine Lösung

Es gibt allerdings Wege, diesen Effekt zu minimieren. Ihnen liegt die Idee zugrunde, einen Oszillator zu verwenden, der über ein relativ hohes Maß an gespeicherter Energie verfügt. Wenn der Oszillator eine Menge an Energie speichert, die im Vergleich zu der durch den Impuls gelieferten Energie verhältnismäßig groß ist, werden die Auswirkungen der Hemmung und der unterschiedlich starken Impulse proportional reduziert. Bei seinen Pendeluhren beschrieb John Harrison diesen Faktor als »Dominanz« des Pendels über die Räder. Diese Dominanz trug maßgeblich zur guten Leistungsfähigkeit von Pendeluhren bei.

Derselbe Schutzmechanismus kann auch bei der Unruh einer Taschenuhr angewandt werden. Tatsächlich besteht bei Taschenuhren aufgrund des Federantriebs ein größerer Bedarf für einen solchen Schutzmechanismus; auch mit Schnecke schwanken die Kräfte, die auf die Unruh wirken, stärker als bei einer Pendeluhr. Wie kann also die in einer Unruh gespeicherte Energie gestei-

cillators are subject. This is one introduced from within, by the escapement itself, and concerns the effects of changing forces directly on the oscillator. The very act of giving impulse to the oscillator, to maintain its swings, has an effect on the timekeeping. Referred to by some theoreticians as 'escapement error,' this effect is not strictly speaking an error but simply a factor that tends to modify the rate at which the oscillator swings.

For example, the verge escapement fitted to all common watches in the eighteenth century had a considerable gaining escapement error, the effect of the impulse itself causing such a watch to have a relative gain. As long as this is constant there is no problem, as the gaining tendency of the escapement is simply corrected, once and for all, by adjusting the regulator of the watch, which will then keep time. However, if the strength of the impulse then increases, the watch will start to gain and, if it falls below the norm, it will lose. Anyone who has ever played with an old verge watch and has gently touched the contrate wheel, and given it a little push, will know just how sensitive an ordinary verge watch is to changing impulse. By giving the wheel a gentle push in that way it is very easy to set the balance dancing a merry jig and see the timekeeping gallop away.

A Solution

There are, however, ways of minimizing these effects. Principal among these is the concept of using an oscillator that has relatively high stored energy within it. If the oscillator has a great deal of energy stored, in proportion to the energy delivered at each impulse, then the effects of the escapement, and any variations in the impulses delivered by it, are proportionately reduced. In his pendulum clocks, Harrison described this factor as the 'dominion' of the pendulum over the wheels, and this quality was a major contributor to the good performance of pendulum clocks.

gert werden? Eine Ideallösung wurde bisher nicht gefunden, es gibt jedoch vier Möglichkeiten, die alle ihre Grenzen haben:

1. **Masse der Unruh:** Zunächst kann die Masse der Unruh erhöht werden, indem man sie beispielsweise aus einem schwereren Metall herstellt. Auf diese Weise wird auch ihr Massenträgheitsmoment erhöht. Die Grenzen dieser Methode liegen darin, dass die Verwendung einer schweren Unruh, insbesondere für Taschenuhren, auch die Verwendung starker (und damit dicker) Zapfen an der Unruhwelle notwendig macht. Jedoch bedingt ein größerer Zapfendurchmesser auch einen höheren Reibungsverlust.

2. **Durchmesser der Unruh:** Als zweite Möglichkeit kann der Durchmesser der Unruh vergrößert werden, was ebenfalls ein höheres Massenträgheitsmoment nach sich zieht. Der Vorteil dieser Methode gegenüber der Steigerung der Masse liegt darin, dass die Unruhzapfen nicht dicker sein müssen. Dies bedeutet, dass die Reibungseffekte der Unruhzapfen nahezu gleich sind, wenn sich die Uhr in einer liegenden oder hängenden Position befindet, was zum Isochronismus der Unruh beiträgt. Allerdings hat auch die Vergrößerung des Durchmessers Grenzen, denn ab einem bestimmten Punkt führen Luftverwirbelungen am Unruhreif zu Ungleichmäßigkeiten.

3. **Schwingungsamplitude:** Als Drittes führt eine größere Amplitude in der Unruh zur Speicherung von mehr Energie im Oszillator und reduziert, wie bereits erwähnt, die Empfindlichkeit des Oszillators gegenüber Bewegungen von außen. Die Geometrie der Hemmungspartie und die Kapazitäten der Materialien, aus denen diese Teile gefertigt sind, begrenzen die Größe der Amplitude, unter der eine bestimmte Unruh zuverlässig läuft.

4. **Schwingungsfrequenz:** Als vierte Möglichkeit führt die Erhöhung der Schwingungsfrequenz der Unruh durch eine Steigerung der Rückstellkraft (beispielsweise durch Einbau einer stärkeren Unruhspirale) zu einer Speicherung von mehr Energie durch den Oszillator, wobei seine Empfindlichkeit gegenüber Bewe-

The same protection can be applied to the balance of a watch. Indeed, there is a greater need for such protection in a watch as it is spring-driven and, even with a fusee, the force delivered to the balance will vary more than in weight-driven clocks. So, how does one increase the stored energy in a balance? There are four ways, but all four have their limitations and an optimum level has to be found.

1. Mass of balance: first, the mass of the balance can be increased; for example, by making it of a heavier metal. In this way, its moment of inertia is also increased. The limitations are that with a very heavy balance, especially in a pocket watch, strong (and hence thick) pivots have to be used on the balance staff, and the larger pivot diameter increases the frictional losses.

2. Diameter of balance: second, the diameter of the balance can be increased, which also increases its moment of inertia. The advantage this has over increasing the mass is that the staff pivots do not have to be made much thicker, which means that — with the watch in the hanging and lying positions — the frictional effect of the balance pivots is more nearly equal, aiding isochronism. However, the limitation with increasing the diameter is that, beyond a certain point, air turbulence at the rim introduces instability.

3. Amplitude of oscillation: third, a greater amplitude in the balance will also store more energy in the oscillator and, as mentioned above, renders it less affected by external motion. The geometry of the escapement and the sheer capabilities of the materials of which the parts are made will limit the amplitude at which a given balance will run successfully.

4. Frequency of oscillation: fourth, increasing the frequency of the oscillations of the balance, by increasing the restoring force (i.e. fitting a stronger balance spring) will also store more energy in the oscillator and, as also mentioned above, will render it less affected by external motion. As with amplitude, the sheer capabilities of the materials of which the balance and spring are made will also limit the frequency at which a given balance will run successfully.

gungen von außen gleichzeitig reduziert wird. Wie auch bei der Steigerung der Amplitude begrenzen die Kapazitäten der Materialien, aus denen diese Teile gefertigt sind, die Höhe der Frequenz, unter der eine bestimmte Unruh zuverlässig läuft.

Es wird deutlich, dass die Leistung der Uhr unmittelbar verbessert wird, wenn man die in der Unruh einer Uhr gespeicherte Energie erhöht. Die gespeicherte Energie der schwingenden Unruh ist im Vergleich zum Energieeinsatz so viel größer, dass Impulsabweichungen einen proportional kleineren Effekt auf die Phase der schwingenden Unruh haben.

Die Uhrmacher des 18. Jahrhunderts konstruierten ihre Uhren allerdings nicht auf diese Weise, denn bei den damals verfügbaren Hemmungen hatte diese Verbesserung ihren Preis. Aufgrund des größeren Massenträgheitsmoments der Unruh konnten die gängigen Zylinder- oder Spindelhemmungen die Unruh nicht mehr allein aus dem Stillstand in Schwingung versetzen. Wenn eine Uhr mit einer derartigen Unruh stehen bliebe, würde sie einen Anstoß benötigen, um wieder ticken zu können.

Uhren müssen sich selbst in Gang bringen

Seit der Einführung der Unruhspirale Mitte der 1670er Jahre galt in der Uhrmacherbranche eine goldene Regel bei der Konstruktion von Unruh und Spirale. Diese verlangte, dass der Oszillator immer so konstruiert werden sollte, dass sich die Uhr selbst in Gang bringen konnte: Wenn sie stehen blieb (z. B. weil man die Uhr auslaufen ließ), musste sie automatisch wieder zu laufen beginnen, sobald der Antrieb des Räderwerkes wiederhergestellt wurde. In Anbetracht der Unruhen, die in der ersten Hälfte des 18. Jahrhunderts verfügbar waren, gab es allerdings nur eine Möglichkeit, um sicherzustellen, dass sich eine Uhr selbst in Gang brachte. Diese bestand darin, die Unruh relativ klein und leicht zu halten, so dass sie nur über ein geringes Massenträgheitsmoment verfügte. Der Stellenwert

As can be seen, increasing the stored energy in a watch balance in these ways will immediately improve its performance, because the energy contained in the oscillating balance is so much larger in proportion to the energy input that any variations in impulse will have a proportionately smaller effect on the phase of the swinging balance.

But eighteenth century watchmakers did not design their watches this way. This is because, with the escapements available at the time, there was a price to be paid for this improvement. With a significantly greater moment of inertia in the balance, the typical verge or cylinder escapement of the day would not itself be able to start the balance swinging from rest, and a watch with a balance of that kind, when stopped, would have to be given a twist to start it ticking.

Watches Had to Be Self-Starting

Ever since the introduction of the balance spring in the mid-1670s, there had existed within the watchmaking profession a cardinal rule in the design of the balance and spring. This required that the oscillator should always be designed so that the watch was self-starting: if it stopped (for example because it was allowed to run down), it had to automatically start itself once the drive was restored to the wheelwork. Unfortunately, with the escapements available in the first half of the eighteenth century, there was only one way to guarantee a watch would be self-starting and that was to ensure the balance was relatively small and light, and thus of low moment of inertia. So important was this requirement that a specific exercise was introduced into the process of watch manufacturing, known as 'half-timing.' In this practice, before the balance spring was fitted to the completed watch, the balance was put in place and the watch was wound and set going, with the escapement alone providing the restoring force. The moment of inertia of the balance would be considered correct if, during this test, the watch

dieser Anforderung war so hoch, dass ein zusätzlicher Prüfschritt in den Prozess der Uhrenherstellung eingebunden wurde, das sogenannte »Half-Timing«. Dabei wurde die Unruh vor dem Einsetzen der Unruhspirale in die fertige Uhr eingebaut, die Uhr aufgezogen und in Gang gesetzt, so dass lediglich die Hemmung die erforderliche Rückstellkraft aufbringen musste. Das Massenträgheitsmoment der Unruh galt dann als korrekt, wenn die Uhr bei diesem Test in halber Geschwindigkeit lief, wenn also zwei Stunden benötigt wurden, um das Zifferblatt einmal zu umrunden. Die Unruh wurde vorsichtig so lange immer leichter gemacht, bis sie die richtigen Eigenschaften aufwies, und erst dann wurde die Unruhspirale eingesetzt und die Zeit eingestellt. Durch das Half-Timing neuer Uhren wurde sichergestellt, dass sich die Uhren selbst in Gang setzen konnten. Allerdings führte eine Unruh mit einer derartig geringen gespeicherten Energie dazu, dass sich auch kleinste Impulsveränderungen direkt als fehlerhafte Zeitmessung niederschlugen. Daher ist es wenig verwunderlich, dass diese Uhren nur schlechte Ergebnisse in der Zeitmessung lieferten.

Die Jefferys-Uhr

John Harrison schaffte den Durchbruch, als er ca. 1751/52 eine experimentelle Uhr konzipierte und sie von dem Uhrmacher John Jefferys (1701 – 1754) herstellen ließ. Harrison stattete die Uhr mit einer neuartigen Unruh aus, die im Betrieb mehr Energie speicherte und über eine Art Temperaturkompensation verfügte. Damit wurde er zum ersten Hersteller, dem eine signifikante Steigerung der Leistungsfähigkeit einer Taschenuhr gelungen war. Die Zuverlässigkeit der Jefferys-Uhr überraschte sogar John Harrison selbst. Er berichtete, dass es diese Uhr gewesen war, die ihm den entscheidenden Hinweis für die Konzeption eines neuen Zeitmessers zur Bestimmung des Längengrades gegeben hatte. Vier Eigenschaften sind für die verbesserte Präzision der Jefferys-Uhr primär verantwortlich: Erstens

ran at half speed, taking two hours to show one hour's passing on the dial. The balance would be carefully lightened until this test showed that it was of the correct specification, and only then would the balance spring be fitted and the watch brought to time. By half-timing new watches in this way, they were guaranteed to be self-starting. However, with a balance of such low stored energy, any slight variations in impulse would directly translate into poor timekeeping, and it is no surprise that watches of this kind failed to perform well.

The Jefferys Watch

Harrison's breakthrough came when, in about 1751 or 1752, he designed an experimental watch and had it made for him by the trade watchmaker John Jefferys (1701 – 1754). Harrison provided the watch with a new kind of balance, having more stored energy while running and coupled with a form of temperature compensation. In doing so, he was the first maker to succeed in significantly improving the performance of a pocket watch. The good going of the Jefferys watch surprised Harrison himself, and he tells us that it was this timepiece which gave him the clue he needed on how to proceed with designing a new longitude timekeeper. Four features are mostly responsible for the improved performance of the Jefferys watch. First, the escapement that Harrison instructed Jefferys to fit was of the verge type but was an adapted form, allowing the balance to have a considerably larger amplitude, and by altering the form of the pallets somewhat, the design was intended to induce isochronism in the system. Second, the system was designed so the balance frequency was higher than usual and beat five times a second. Third, the balance was somewhat larger in diameter than the average verge watch. Fourth, the balance was made of gold. As already explained, by making the balance larger and heavier, it had a greater moment of inertia and carried more energy in proportion to the impulse.

handelte es sich bei der Hemmung, die Jefferys auf Weisung von Harrison einsetzte, zwar um eine Spindelhemmung, allerdings in veränderter Form. Dadurch erreichte er eine deutlich größere Amplitude der Unruh. Außerdem veränderte er die Form der Paletten ein wenig, um einen Isochronismus herbeizuführen. Zweitens war das System so konzipiert, dass die Unruhfrequenz mit fünf Schlägen pro Sekunde höher als üblich war. Drittens war der Durchmesser der Unruh etwas größer, als dies normalerweise bei Uhren mit Spindelhemmung der Fall war. Viertens bestand die Unruh aus Gold. Wie bereits zuvor erklärt, führt eine größere und schwerere Unruh zu einem höheren Massenträgheitsmoment und zu einer im Verhältnis zum Impuls höheren gespeicherten Energie. Allerdings konnte sich die Uhr aufgrund ihrer höheren energetischen Eigenschaften nicht selbst in Gang bringen. Für viele Uhrmacher musste dies wie ein Rückschritt aussehen, auch wenn es in der Praxis kein großes Problem darstellte.

John Harrisons vierter Zeitmesser H4

In Anbetracht der verbesserten Leistung der Jefferys-Uhr war sich Harrison sicher, dass der Weg zum Erfolg über die Weiterentwicklung dieser kleinen Uhren und nicht über große Uhren führte. Als er im Juni 1755 erneut vor dem Board of Longitude der britischen Regierung wegen einer finanziellen Unterstützung vorsprach, erklärte er den Kommissaren, dass er Geld benötige, um »zwei Uhren herzustellen, eine in der Größe einer Taschenuhr und eine größere [...] da ich aufgrund der Leistungsfähigkeit einer bereits nach diesem Plan umgesetzten (allerdings noch nicht perfektionierten) Uhr guten Grund zur Annahme habe, dass diese kleinen Maschinen künftig so hergestellt werden können, dass sie sich zur Bestimmung der Längengrade auf See als überaus nützlich erweisen [...]« (Abb. 2).

Die H4 wurde im Jahr 1759 fertiggestellt und durchlief daraufhin Mitte 1761 und Ende 1763 zwei offizielle und sehr erfolgreiche Probeläufe

However, because of the higher energy specification of the balance, the watch was not self-starting, something which must have seemed to many watchmakers a backward step in design, even though not actually a problem in practice.

Harrison's Fourth Timekeeper H4

Based on the improved performance of the Jefferys watch, Harrison was sure the successful path lay in developing these smaller watch designs, rather than continue with large clocks. In June 1755, when he was before the British Government's Board of Longitude again asking for financial support, he told the Commissioners that he needed money 'to make two watches, one of such a size as may be worn in the pocket & the other bigger [...] having good reason to think from the performance of one already executed according to his direction (tho not brought to perfection) that such small machines may be render'd capable of being of great service with respect to the Longitude at Sea [...]' (ill. 2).

H4 was completed in 1759 and underwent two official, and highly successful, trials to the West Indies in 1761/62 and 1763/64, though an ill-prepared subsequent trial of H4 at the Royal Observatory did not produce such a good performance from the timekeeper. However, further proof of the efficacy of the design came when the government commissioned a copy of H4 from London watchmaker Larcum Kendall (1719 – 1790), and the watch, known today as 'K1,' served with Captain Cook (1728 – 1779) on his second and third voyages of discovery to the South Seas (1772 – 1775 and 1776 – 1780) and performed magnificently. Harrison himself made a fifth timekeeper, 'H5,' based on the design of H4, and this also performed exceedingly well when tried by King George III in his private observatory at Kew in 1772.

The most significant key to the success of this design was in having a balance of 2.2 in. (56 mm) diameter, beating five times a second (i.e., having an 18,000 train) and running at an arc of about 220 degrees. As in the Jefferys

zu den Westindischen Inseln, wohingegen ein schlecht vorbereiteter anschließender Probelauf der H4 im Royal Observatory die guten Ergebnisse des Zeitmessers nicht ganz bestätigen konnte. Die Effizienz der Konzeption wurde erneut attestiert, als die britische Regierung eine Kopie der H4 beim Londoner Uhrmacher Larcum Kendall (1719 – 1790) in Auftrag gab. Diese Uhr, bekannt als K1, führte Captain Cook (1728 – 1779) auf seiner zweiten und dritten Erkundungsreise (1772 – 1775 und 1776 – 1780) in der Südsee mit sich, wo sie ihm hervorragende Dienste leistete. Harrison stellte unterdessen seinen fünften Zeitmesser, die H5, auf Basis der H4 her, der ebenfalls hervorragende Ergebnisse lieferte, als er 1772 von König Georg III. in seinem Privatobservatorium in Kew getestet wurde.

Der Schlüssel zum Erfolg von Harrisons Konzeption lag in der Unruh mit einem Durchmesser von 56 mm, die fünfmal pro Sekunde (18.000-mal pro Stunde) schlägt und einen Schwingungsbogen von ca. 220 Grad aufweist. Wie auch die Jefferys-Uhr beinhaltete diese Konstruktion eine Temperaturkompensation und ein automatisches »Gegengesperr«. Das Gesperr stellte sicher, dass der Zeitmesser während des Aufziehvorgangs nicht stehen blieb, und wurde von allen nachfolgenden Herstellern von Marinechronometern übernommen (Abb. 3).

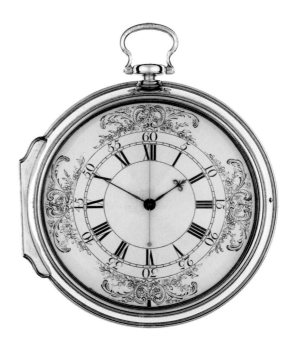

2
Die vierte Seeuhr, H4. Diese Präzisionsuhr lieferte nicht nur die Lösung zum Längengradproblem, sondern war darüber hinaus die erste Präzisionstaschenuhr. National Maritime Museum, Greenwich, London
The fourth marine timekeeper, H4. This timekeeper not only provided the first solution to the longitude problem, it was the first of all precision watches. National Maritime Museum, Greenwich, London

»The Principles of Mr. Harrison's Timekeeper«

Im Jahr 1767 veröffentlichte die Regierung eine Beschreibung der H4 mit dem Titel »The Principles of Mr Harrison's Timekeeper«. Auch wenn es sich dabei kaum um eine präzise Anleitung zur Herstellung exakter Kopien handelte, bot sie der an Marinechronometern interessierten Leserschaft doch aufschlussreiche und wichtige Einblicke.

Einige kritisierten Harrison und die Veröffentlichung als dunkel, geheimniskrämerisch. Andere vermuteten sogar, dass er die Geheimnisse im Innern seiner Präzisionsuhr absichtlich für sich behalten wollte. Es ist richtig, dass die Beschrei-

watch, the design incorporated temperature compensation and automatic 'maintaining power.' This device ensured the timekeeper kept running while being wound up, and was used by almost all subsequent makers of marine chronometers (ill. 3).

The Principles of Mr. Harrison's Timekeeper

The government's published description of H4, entitled *The Principles of Mr. Harrison's Timekeeper*, appeared in 1767 and though it was hardly a working specification for making exact copies, it did have a very significant impact on those interested in marine timekeepers.

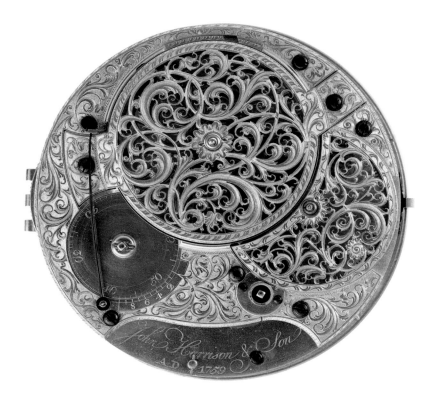

3
**Das Werk der H4. Mit seiner relativ großen Unruh von 55,8 mm Durchmesser mit
5 Schlägen pro Sekunde und einem Schwingungsbogen von 220 Grad wurde es durch
innere und äußere Störungen weit weniger beeinträchtigt. National Maritime Museum,
Greenwich, London**
The movement of H4. With its relatively large watch balance of 55.8 mm diameter,
beating 5 times a second and swinging through an arc of 220 degrees, it was much less
affected by internal and external disturbances. National Maritime Museum,
Greenwich, London

**bung stellenweise nur schwer verständlich ist
und die technischen Zeichnungen – für Laien –
schwer zu interpretieren sind (Abb. 4). Allerdings
ging daraus eindeutig die Verwendung einer
deutlich größeren Unruh mit 18.000 Halb-
schwingungen hervor, genauso wie Harrisons
Beobachtung, dass eine kleine Unruh in Taschen-
uhren besser funktionieren würde, wenn sie noch
schneller schlüge. Für Taschenuhren empfahl
Harrison Räderwerke mit 21.600 Halbschwin-
gungen, diese wurden jedoch erst Mitte des
20. Jahrhunderts in Armbanduhren eingesetzt
und als völlig neue Entwicklung dargestellt.**

Some criticized Harrison and the publication
for being obscure: others even suggested that
he had intended to withhold the secrets within
the timekeeper. It is true the description is diffi-
cult to follow in places and the technical draw-
ings are, for the uninitiated, hard to interpret
(ill. 4). However, the use of an 18,000 train and
a considerably larger balance arc than usual,
were clearly stated, as was his observation that
a small balance, in a pocket watch, would be
better beating even faster, with Harrison recom-
mending a 21,600 train for pocket watches —
something re-introduced in the mid-twentieth

Einige verstanden die Botschaft von »The Principles of Mr. Harrison's Timekeeper« besser. Da die H4 die Größe einer Taschenuhr hatte, war sie besonders für die Hersteller kleinerer Uhren und weniger für Hersteller der großen Modelle interessant. Nur wenige Wochen nach dem Erscheinen wurde die französische Fassung veröffentlicht und mit großem Interesse von den französischen Uhrmachern aufgenommen. Ferdinand Berthoud (1754–1813) äußerte sich wie folgt zu Harrisons Veröffentlichung: »[...] jeder Dorfuhrmacher hat nun Pläne zur Herstellung eines Marinechronometers, die Ergebnisse dieser eifrigen Geschäftigkeit bleiben abzuwarten [...]«. Es gab tatsächlich eine eifrige Geschäftigkeit, vieles davon blieb aber ohne Erfolg. Der eine oder andere der nachfolgenden Uhrmachergeneration beachtete jedoch die Grundelemente von Harrisons Arbeit.

Harrisons Vermächtnis

Was seinen Beitrag zur Konstruktionsweise von Marinechronometern angeht, bewies John Harrison nicht nur, dass eine solche Konstruktion möglich war, er lieferte den Uhrmachern der Welt auch das zentrale Element – nicht nur für ein zuverlässiges Marinechronometer, sondern grundsätzlich für sämtliche Präzisionsuhren. Ohne die korrekte Spezifizierung der Unruh durch Harrison wäre die Umsetzung der Präzisionstaschenuhr niemals möglich gewesen. Die Bedeutung seiner Entdeckung wird besonders deutlich, wenn man bedenkt, dass es vor den 1760er Jahren kein Konzept für einen zuverlässigen tragbaren Zeitmesser in der Größenordnung der H4 gegeben hatte. Im Gegensatz dazu ist für die Jahre nach der Veröffentlichung von Harrisons Prinzipien eine steigende Zahl an Entwürfen für Marinechronometer zu beobachten, die sich nahezu alle in der Größenordnung der H4 bewegen.

Obwohl Harrisons Ausführungen über die ideale Form des Oszillators für Chronometer sicherlich die bedeutendste Weiterentwicklung

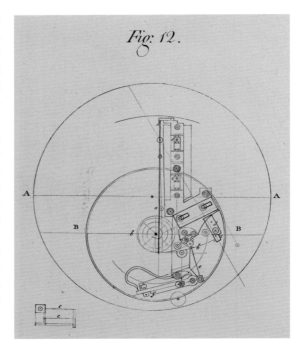

4
Eine der Illustrationen aus »The Principles of Mr. Harrison's Timekeeper« (1767). Die Abbildung zeigt die Größe der Unruh auf dem Werk und die Form der Unruhspirale der H4.
One of the figures from *The Principles of Mr. Harrison's Timekeeper* (1767), showing the size of the balance on the movement, and the form of the balance spring in H4.

century, into wrist watches, as an entirely new improvement.

The message in *The Principles of Mr. Harrison's Timekeeper* was better recognized by some. With H4 on the scale of a watch, watchmakers, as opposed to clockmakers, were now taking an interest. Within just a few weeks of publication, a French edition was released and distributed widely among watchmakers in France. Ferdinand Berthoud (1754–1813) himself remarked, of Harrison's publication: '[...] every village watchmaker now has plans for a marine timekeeper and we shall have to see what this fervent activity produces [...]' There was indeed fervent activity, some of it to no avail, but one or two followers took note of the essential elements in Harrison's work.

der Konstruktion tragbarer Zeitmesser dar-
stellte, gab es noch weitere Neuerungen, die
ihren Beitrag zum »modernen Chronometer«
und zum Erfolg des Instruments leisteten.

Die freie Hemmung

**Dass eine Unruh mit verhältnismäßig großer ge-
speicherter Energie weniger anfällig für Impuls-
abweichungen ist, wurde bereits dargelegt.
Allerdings kann dieser Effekt durch eine Ver-
ringerung der Einwirkung der Hemmung noch
weiter verstärkt werden. Wie Harrison in den
»Principles« erklärte: »Und es muss Folgendes
anerkannt werden: Je weniger Räder mit der
Unruh zu tun haben, desto besser.« In der Praxis
bringt ein Oszillator, der so wenig Kontakt wie
möglich zur Unruh hat, eindeutige Vorteile. Die-
ses Prinzip wurde als »freie Hemmung« bekannt.
Es ist wahrscheinlich, dass dieses Konzept nicht
von Harrison erdacht wurde, sondern aus Paris
kam, wo es der Uhrmacher Pierre Le Roy (1717
– 1785) als einer der Ersten verstand und um-
setzte. Das Maß der Dinge für dieses Konzept,
das auch in den darauffolgenden Jahren in
einem Großteil der Marinechronometer Anwen-
dung fand, war die Erfindung des Londoner Uhr-
machers Thomas Earnshaw (1749 – 1829): eine
Chronometerhemmung mit Feder.**

Eine isochrone Unruhspirale

**Eine zweite bahnbrechende Beobachtung von Le
Roy betraf die beiden Unruhspiralen in seiner
»Montre Marine«, die er im Jahr 1766 dem König
vorstellte. Le Roy erkannte als Erster, dass durch
eine Veränderung der Unruhspirale (bzw. der
beiden Unruhspiralen in seiner Konstruktion)
ein isochrones Oszillieren der Unruh ermöglicht
wurde, d. h. sämtliche Schwingungen der Unruh,
egal ob groß oder klein, gingen in derselben Zeit
vonstatten. Auch wenn Le Roy letztlich nicht die
richtigen Schlüsse aus seiner Beobachtung zog,
so war das Prinzip des Isochronismus durch eine**

Harrison's Legacy

In terms of his contribution to marine time-
keeper design, Harrison not only showed that
such a device was practicable, he also introduced
to the horological world the most important ele-
ment, which led not just to the successful marine
chronometer but to the very concept of the pre-
cision watch itself. Without the correct speci-
fication of balance, introduced by Harrison, the
precision watch could never have succeeded. The
importance of what he demonstrated is shown
clearly when one considers that there is no
design for any successful portable timekeeper
before the 1760s on the scale of H4, or any other.
By contrast, in the years following the publica-
tion of the Principles, one sees a growing num-
ber of designs for marine timekeepers and there
are scarcely any that are not being produced on
the scale of H4, or close to it.

Although Harrison's specification for the op-
timum form of oscillator for the chronometer
was certainly the most significant improvement
in portable timekeeper design, there were of
course further features introduced into what
became the 'modern chronometer' that contri-
buted to the success of the later instrument.

The Detached Escapement

As already stated, having a balance with rela-
tively high stored energy renders it less affected
by variations in impulse, but this can be further
enhanced by ensuring the impact of the escape-
ment is reduced. As Harrison said in the *Prin-
ciples*: 'And it must be allowed, the less the
wheels have to do with the balance the better.'
In practice, there are distinct advantages in hav-
ing an oscillator that avoids contact with the
escapement as completely as possible and this
new concept became known as detachment. It
seems likely that this concept did not originate
with Harrison but came from Paris; the watch-
and clockmaker Pierre Le Roy (1717 – 1785) was
certainly one of the earliest to understand it

Veränderung der Unruhspirale dennoch korrekt und eine bedeutende Entdeckung. Die Schraubenfeder (landläufig oftmals auch als zylindrische Feder oder Sprungfeder bezeichnet) wurde im Jahr 1775 von dem berühmten Uhrmacher John Arnold (1736 – 1799) patentiert und erwies sich als die Form, die von künftigen Uhrmachern übernommen werden sollte und mit der sich ein Isochronismus am einfachsten herstellen lässt. Im Gegensatz zur Spiralflachfeder brachte die Schraubenfeder, die für Torsionsanwendungen (Rotieren um die eigene Längsachse) entwickelt wurde, bereits einen verbesserten Isochronismus der Unruh mit sich. Mit einer weiteren bedeutenden Erfindung von John Arnold konnte dieser dann theoretisch bis zur Perfektion angepasst werden. Arnold konstruierte die beiden Enden seiner Schraubenfeder so, dass sie inwärts zur zentralen Achse der Unruh gebogen waren, was uns heute als »Endkurve« bekannt ist. In seinem Patent von 1782 schreibt Arnold darüber richtigerweise: »Man erwartet von ihr, dass sie sämtliche Vibrationen gleichmacht.« Der große Pariser Uhrmacher Abraham Louis Breguet (1747 – 1823) führte diese Idee weiter, indem er das äußere Ende der flachen Spiralfeder der Unruh über das Niveau der Spirale anhob und zum Zentrum hin bog. Damit erzielte er mit einer flachen Spiralfeder ähnliche Ergebnisse wie Arnold mit der Schraubenfeder.

Die Kompensationsunruh

Harrisons Konzept für eine Temperaturkompensation in seinem H4-Zeitmesser beinhaltete einen Bimetallstreifen, der auf die Unruhspirale wirkte. Dabei handelte es sich jedoch nicht um die Idealkonstellation: Harrison war stets der Meinung, dass sich die Temperaturkompensation in der Unruh selbst befinden musste. Dies war ein wichtiges Element des späteren Chronometers. Er konnte dieses Konzept zwar nie praktisch umsetzen, es ist jedoch unbestritten, dass Harrison der Erste war, der Unruhen mit einer in-

and to name it. The ultimate form of this concept, employed in the majority of marine chronometers made in subsequent years, was the creation of the London watchmaker Thomas Earnshaw (1749 – 1829) in the form of his spring detent escapement.

An Isochronous Balance Spring

A second ground-breaking observation of Le Roy's concerned the two balance springs he used in his 'montre marine,' the timekeeper design he presented to the king in 1766. It was Le Roy who was the first to note that by manipulating the balance spring (two in his design) it was possible to render the oscillations of the balance isochronous (i.e. all swings of the balance, whether large or small, take the same time). In fact, Le Roy misinterpreted what he saw, but the principle of inducing isochronism by manipulating the balance spring was correct and an important discovery. The helical spring (sometimes popularly called a cylindrical or coil spring), patented in 1775 by the great London watchmaker John Arnold (1736 – 1799), then proved to be the form adopted by the vast majority of subsequent chronometer makers and was the form in which the all-important isochronism was easiest to derive. As opposed to the flat spiral spring, the helical spring, designed to work in torsion, (rotation around its longitudinal axis) already caused greater isochronism in the swings of the balance, but a further highly important invention of John Arnold's enabled theoretically perfect adjustments for this feature. Arnold designed the two terminals of his helical spring to curve inwards towards the central axis of the balance, creating what are known today as 'terminal curves.' These, Arnold correctly stated in his further patent of 1782, are '[...] attended with the property of rendering all the vibrations equal.' A logical extension of this idea was conceived by the great Parisian watchmaker Abraham Louis Breguet (1747 – 1823), who raised the outer terminal of the flat spiral balance spring up above the level

tegrierten Temperaturkompensation erdachte. Die H1 hatte ursprünglich solche Kompensationsunruhen, als sie in den späten 1720er Jahren zum ersten Mal gebaut wurde. Da Harrison diese Idee in der Praxis nicht erfolgreich umsetzen konnte, wurde die H1 vor ihrer endgültigen Fertigstellung leider modifiziert und mit einer Kompensation ausgestattet, die auf die Unruhspirale wirkte. Die Grundlage für tatsächlich funktionierende Umsetzungen bildete Le Roys Entwurf einer Kompensationsunruh in seiner »Montre Marine« mit jeweils einem Alkohol- und einem Quecksilberthermometer zur Veränderung des Masseradius der Unruh. Ob er diese Idee aus Grundprinzipien ableitete oder ob er sich auf Kenntnisse rund um Harrisons Konzept stützte, ist allerdings nicht bekannt.

All diese Elemente – die freie Hemmung, die isochrone Unruhspirale und die Kompensationsunruh – ermöglichten es, die Konstruktion des modernen Marinechronometers so zu komprimieren, dass es zu einer lukrativen Handelsware wurde. Doch ohne diesen wichtigen ersten Schritt, die Entdeckung der Idealform des Oszillators, wäre der Erfolg des Chronometers nur mit den verbleibenden Elementen nicht möglich gewesen. Dies war John Harrisons wichtigster und bahnbrechendster Beitrag, mit dem er der Geburt der Präzisionsuhr den Weg bereitete.

of the spiral and curved it in towards the centre, giving a flat spiral spring a quality similar to Arnold's helical spring.

The Compensation Balance

Harrison's design for the temperature compensation in H4 employed a bimetallic curb acting on the balance spring, which was not the ideal arrangement. Harrison always understood the need for the temperature-compensating device to be within the balance itself – an extremely important element of the developed chronometer. He had not managed to make such a design work, but there is no doubt that Harrison was the first person to design balances with the compensation incorporated within them and H1 originally had such balances when first built in the late 1720s. Sadly, having failed to make the concept work in practice, H1 was altered before final completion to have compensation acting on the springs. It was Le Roy's design of compensation balance in his 'montre marine,' using alcohol and mercury thermometer tubes to change the acting radius of the mass in the balance, which proved the first basis of a workable design, though whether the idea came to Le Roy by reasoning from first principles or through knowledge of Harrison's design is unknown.

All these elements, the detached escapement, the isochronous balance spring and the compensation balance, enabled the modern marine chronometer design to be condensed into an economically viable article of commerce. But without that vital first step, the discovery of the optimum specification for the oscillator, the other elements alone could not have created the successful chronometer. This was Harrison's most important and seminal contribution and was what enabled the birth of the precision watch.

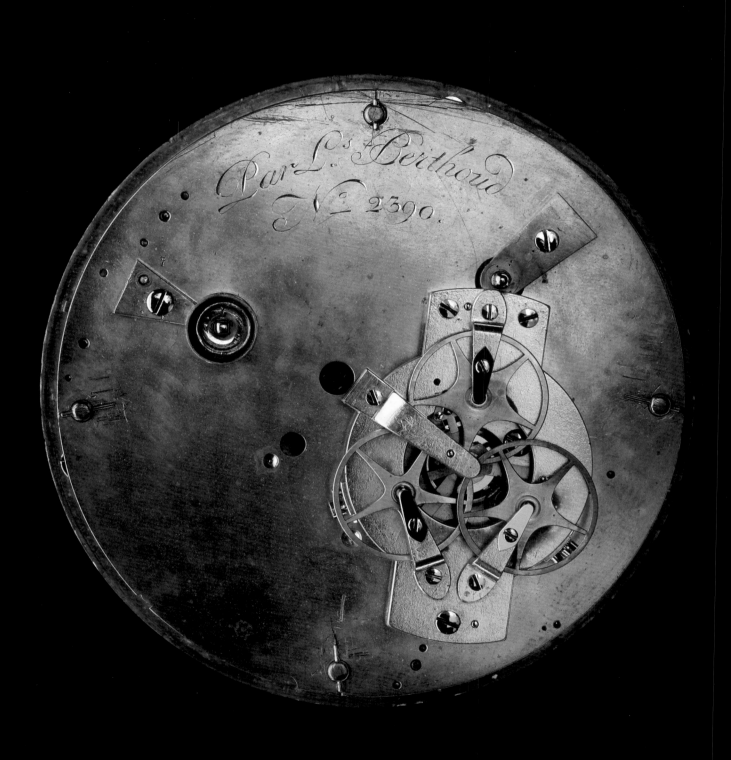

3 Vom Transportieren der präzisen Zeit
Transporting the Precise Time

Die präzise Zeit ließ sich mithilfe eines Chronometers transportieren. Seechronometer eigneten sich jedoch nicht für die Nutzung an Land. An Bord eines Schiffes erhielten sie einen festen Platz, zumeist in der Kajüte des Kapitäns. Ihr Werk war auf eine horizontale Lagerung eingerichtet. Plötzliche Lagenänderungen oder harte Erschütterungen störten den gleichmäßigen Ablauf ihres Mechanismus. Zum Transportieren der Zeit, beispielsweise bei Reisen über Land, wurden daher Taschenchronometer benutzt. Diese Uhren mussten hohen Anforderungen genügen, »unter allen Umständen, in allen Lagen und Temperaturen, hängend und liegend, beim Reiten und Fahren«[1] tadellos funktionieren. Dabei war die technische Entwicklung von Taschen- und Seechronometern direkt miteinander verbunden. So hatte John Arnold (1736 – 1799) seine Seechronometer zwischen 1770 und 1780 entscheidend verbessert, unter anderem durch den Einsatz der Federchronometerhemmung, der zylindrischen Spirale und neuartiger Kompensationsunruhen. Mit eben diesen technischen Komponenten stattete er 1778 seine Taschenuhr Nr. 36 aus. Das Testergebnis des Royal Observatory in Greenwich sorgte 1779 für eine Sensation: Nach 13 Monaten permanenten Tragens in der Tasche ging die Uhr nur um 2 Minuten und 33,2 Sekunden falsch. Arnold bezeichnete die Taschenuhr Nr. 36 fortan als »Chronometer« und führte damit einen neuen Begriff in die Geschichte der Präzisionszeitmesser ein.

The precise time could be transported with the help of a chronometer. Marine chronometers, however, were ill suited for the use on land. On board ship, they were given a fixed position, usually in the captain's cabin. Their movements were adapted to horizontal mountings, and could easily be disturbed by sudden changes of position or severe knocks, upsetting their regularity. For this reason, pocket chronometers were developed to transport the time, for example, on journeys over land. The demands made of these chronometers were considerable. They had to function flawlessly 'under all circumstances, in all positions and temperatures, whether resting horizontally or vertically suspended, when travelling on horseback or by coach,' as a contemporary author noted. But the technical development of pocket and marine chronometers was directly linked. Between 1770 and 1780, for example, John Arnold (1736 – 1799) had made crucial improvements to his marine chronometers, including the use of a spring detent escapement, the helical balance spring and a new type of compensation balance. In 1778, he used the very same innovations in his pocket watch No. 36. The test results of the Royal Observatory in Greenwich caused a sensation in 1779. After being carried in the pocket every day for 13 months, the watch was out by only 2 minutes and 33.2 seconds. Arnold from then on called his pocket watch No. 36 a 'chronometer,' thereby introducing a new concept into the history of precision timekeeping.

◄ **Louis Berthoud, Taschenchronometer Nr. 2390 / Marinetaschenuhr Nr. 16, Paris, 1792, Uhrenmuseum Beyer, Zürich**
Louis Berthoud, Pocket chronometer No. 2390 / Marine pocket watch No. 16, Paris, 1792, Beyer Clock and Watch Museum, Zurich

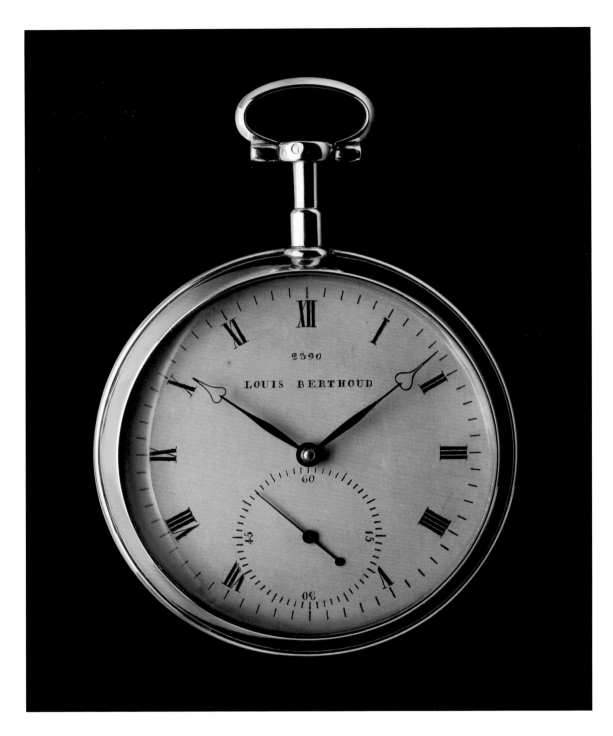

Louis Berthoud, Taschenchronometer Nr. 2390 / Marine-Taschenuhr Nr. 16, Paris, 1792,
Uhrenmuseum Beyer, Zürich
Louis Berthoud, Pocket chronometer No. 2390 / Marine pocket watch No. 16, Paris, 1792,
Beyer Clock and Watch Museum, Zurich

**E. G. Pfaff, Spiegelsextant, um 1790,
Mathematisch-Physikalischer Salon, Dresden**

E. G. Pfaff, Sextant, around 1790,
Mathematisch-Physikalischer Salon, Dresden

Forschungsreisen, wie die Alexander von Humboldts 1799 – 1804 nach Südamerika, dienten immer auch der Vermessung und Kartierung unbekannter Gegenden. Dafür wurde eine Reihe von Instrumenten benötigt; unerlässlich waren Chronometer, Sextant, künstlicher Horizont und Tafelwerk. Humboldts Expedition war aufwändig ausgestattet. Für Vermessungsaufgaben führte er unter anderem einen Reflexionskreis, einen Theodoliten, einen Quadranten, zwei Sextanten sowie zwei Chronometer mit sich. Bei den Chronometern handelte es sich um das Chronometer Nr. 1 von Johann Heinrich Seyffert (1751 – 1817) aus Dresden und das Chronometer Nr. 27 von Louis Berthoud (1754 – 1813). Besonders mit letzterem war Humboldt äußerst zufrieden. Nach viermonatiger Reise mit dem Schiff und über Land bestimmte er die tägliche Gangabweichung des Berthoud-Chronometers mit 1,5 Sekunden. Die Seyffert-Uhr variierte dagegen um 4 bis 5 Sekunden pro Tag.

Part of the purpose of voyages of exploration, like the one undertaken by Alexander von Humboldt to South America from 1799 to 1804, was always to survey and map unknown regions. For this, a whole series of instruments was needed. A chronometer, a sextant, an artificial horizon, and mathematical tables were essential. Humboldt's expedition was elaborately equipped. The surveying tools he took with him included, amongst others, a reflecting circle, a theodolite, a quadrant, two sextants, and two chronometers. The chronometers in question were Chronometer No. 1 by Johann Heinrich Seyffert (1751 – 1817) of Dresden and Chronometer No. 27 by Louis Berthoud (1754 – 1813). Humboldt was particularly pleased with the latter. After a journey of four months, by land and sea, he noted that the Berthoud chronometer was in error by only 1.5 seconds per day. The Seyffert chronometer, on the other hand, deviated by 4 to 5 seconds per day.

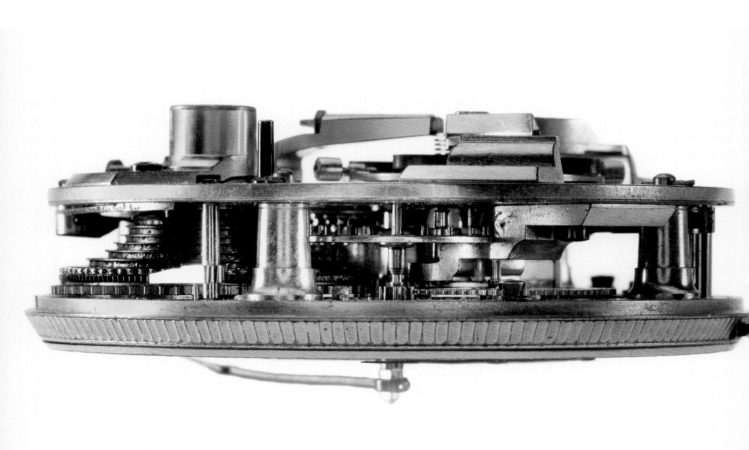

Johann Heinrich Seyffert, Chronometer Nr. 2, Dresden, 1797, Privatsammlung
Johann Heinrich Seyffert, Chronometer No. 2, Dresden, 1797, Private collection

Sibylle Gluch

Die Anfänge und Schwierigkeiten der Dresdner Präzisionsuhrmacherei

The Beginnings and Challenges of Precision Clock- and Watchmaking in Dresden

1793 beschwerte sich die Innung der Dresdner Kleinuhrmacher beim sächsischen Kurfürsten Friedrich August III., dass der im Geheimen Finanzkollegium angestellte Sekretär Johann Heinrich Seyffert

1. auf Messen reise, dort Uhren aufkaufe und anschließend damit handele,

2. Uhren unter seinem und der Stadt Dresden Namen verkaufe,

3. alte Uhren repariere,

4. die Arbeit der Innungsmitglieder tadele und durch all diese Vergehen die bürgerliche Nahrung der Dresdner Kleinuhrmacher beeinträchtige.[1]

Eine ähnliche Beschwerde hatte die Innung bereits 1788 erhoben. Seyffert (1751 – 1817), ein Amateur auf dem Gebiet der Uhrmacherei, hatte die Vorwürfe abgestritten, die Beschäftigung mit der Mechanik der Uhren und Zeitmesser jedoch eingeräumt. Der Kurfürst hatte 1788 eine Geldstrafe über Seyffert verhängt und

In 1793, the Dresden Watchmakers' Guild complained to Friedrich August III, Elector of Saxony, that Johann Heinrich Seyffert, secretary of the Privy Finance Council

1. travelled to fairs and purchased watches in order to trade them

2. sold timepieces under his own name and with the Dresden trademark,

3. repaired old timepieces,

4. publicly denigrated the work of Guild members and by all these various activities, prejudiced the guaranteed civic right of Dresden watchmakers to earn a living by plying their trade.[1]

The Guild had already raised a similar complaint in 1788. Seyffert (1751 – 1817), an amateur in the field of watch- and clockmaking, had denied the charges but admitted working on the mechanisms of clocks and timepieces. On that occasion, the Elector had fined Seyffert and ordered further financial penalties should he give

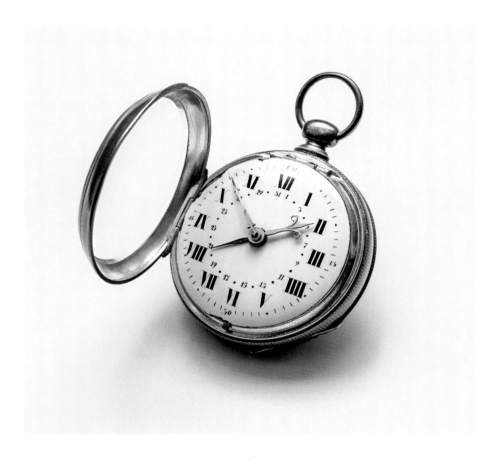

1
Johann Heinrich Seyffert, Taschenuhr Nr. 65, Dresden, 1799, Lange Uhren GmbH, Glashütte
Johann Heinrich Seyffert, Pocket watch No. 65, Dresden, 1799, Lange Uhren GmbH, Glashütte

weitere Geldstrafen angeordnet, sollte Seyffert erneut Anlass zur Klage geben. Der beschriebene Vorgang ist typisch für die Geschichte des Zunft- und Innungswesens. Während die Ältesten der betreffenden Berufsgruppe ihre verbrieften Rechte gegenüber Außenseitern zu verteidigen suchten, rechtfertigte der Störenfried seine Grenzverletzung.

Seyfferts ausführliche Verteidigung verfolgte im Wesentlichen zwei Strategien. Zum einen behauptete er, die Anschuldigungen seien schlechterdings nicht wahr. Er habe nur sehr wenige Uhren und diese nur zu eigenem Gebrauch gebaut, die eine oder andere sei ihm allerdings durch Diebstahl abhanden gekommen. Zum

any further cause for complaint. The process is typical of the history of the guild system: while the elders of a particular professional body sought to defend its chartered rights against outsiders, the troublemaker justified his infringement of them.

In his detailed defence, Seyffert essentially adopted two strategies. On the one hand, he maintained that the accusations were completely untrue. He had only made very few timepieces and these solely for his own use, although one or two had been stolen from him. In addition, he only made timepieces of a particular kind; for him, clock- and watchmaking was a scientific pursuit and his experiments in the field could

zweiten fertige er nur besondere Uhren. Er behandle die Uhrmacherei als Wissenschaft und seine Versuche auf diesem Gebiet seien nicht in die Klasse gewöhnlicher Handwerkskunst einzuordnen. Die Innungsgenossen verstünden seine Arbeit nicht, sondern verharrten in der Mittelmäßigkeit.[2] Seyfferts pauschale Unschuldsbehauptung wirft angesichts der relativ hohen Anzahl bekannter, von ihm gefertigter Uhren einige Zweifel auf (Abb. 1).[3] Seine Beurteilung der Dresdner Uhrmacherei ist hingegen bemerkenswert, zeugt sie doch von einem starken Bewusstsein für die Besonderheit der eigenen Arbeit und nicht zuletzt von einem starken Selbstbewusstsein.

Tatsächlich beschäftigte sich Seyffert zu diesem Zeitpunkt bereits seit einigen Jahren mit dem Bau von Präzisionsuhren, vermutlich angeregt durch die Bekanntschaft mit Astronomen bzw. Astronomieinteressierten. Seyfferts grundsätzliches Interesse für die Uhrmacherei scheint schon früh geweckt worden zu sein, die äußeren Umstände und der genaue Zeitpunkt sind jedoch unbekannt. In jedem Fall studierte er ab Januar 1771 an der Universität Leipzig und legte nach einem Abstecher nach Wittenberg 1773 im November 1775 in Leipzig das Notariatsexamen (*pro candidatura praxi et notariatu*) ab. In Leipzig hatte Seyffert möglicherweise Johann Gottfried Köhler (1745 – 1800) kennengelernt, der 1777 Inspektor des Mathematisch-Physikalischen Salons und der Kunstkammer in Dresden wurde. Nach Seyfferts Aussage wurde Köhler sein Lehrer in der Astronomie und in der Präzisionsuhrmacherei.[4] Ortsfeste Pendeluhren mit einem gefirnissten Holzpendel in Köhler'scher Manier beispielsweise hatte Seyffert noch 1800 im Programm.[5] Darüber hinaus führte ihn Köhler in ein astronomisches Netzwerk ein, das für die Entwicklung von Seyfferts uhrmacherischer Tätigkeit von entscheidender Bedeutung war.

Den Mittelpunkt dieses weitverzweigten astronomischen Kommunikationsnetzes bildete Franz Xaver von Zach (Abb. 2), seit 1786 Astronom des Herzogs Ernst II. von Sachsen-Gotha-Altenburg und damit Herr über eine der mo-

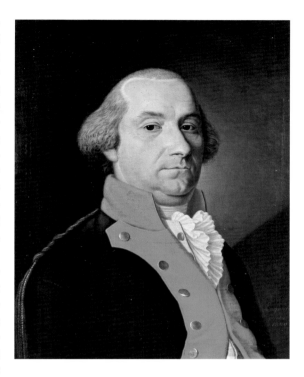

2
Franz Xaver von Zach (1754 – 1832). Pierre-Nicolas Legrand, Öl auf Leinwand, Stiftung Schloss Friedenstein, Gotha
Franz Xaver von Zach (1754 – 1832). Pierre-Nicolas Legrand, oil on canvas, Stiftung Schloss Friedenstein, Gotha

not be classed as an ordinary artisan activity. His work was beyond the understanding of the guild members, who could not see further than their own mediocre efforts.[2] Given the relatively large number of timepieces known to have been made by Seyffert, his sweeping assertion of innocence must give rise to some doubt (ill. 1).[3] His appraisal of Dresden watchmaking, on the other hand, is remarkable for its strong sense of the importance of his own work, and, not least, for its enormous self-assurance.

In fact, Seyffert had been engaged in making precision timepieces for some years by this time, probably motivated by his acquaintance with astronomers and others with an interest in that field. Although it appears to have been awake-

3
**Hans Moritz Graf von Brühl (1736 – 1809).
James Northcote, Öl auf Leinwand, 1796,
Petworth House**
Hans Maurice Count von Brühl (1736 – 1809).
James Northcote, oil on canvas, 1796,
Petworth House

ned early, we do not know exactly when or why this deep interest in clock- and watchmaking first began. In any case, in January 1771 he enrolled at the University of Leipzig and, after a brief excursion to Wittenberg in 1773, he passed the examinations qualifying him as a notary (*pro candidatura praxi et notariatu*) in Leipzig in November 1775. It may have been in Leipzig that Seyffert first got to know Johann Gottfried Köhler (1745 – 1800). In 1777, Köhler was appointed to the post of curator of the Mathematisch-Physikalischer Salon and the Kunstkammer in Dresden (the royal collections of scientific instruments and of works of art, respectively). According to Seyffert, Köhler became his teacher of astronomy and precision clockmaking.[4] Indeed, in 1800 Seyffert still sold stationary pendulum clocks with varnished wooden pendulums à la Köhler.[5] Moreover, Köhler introduced Seyffert to a network of people engaged in astronomy, a fact that was to be of crucial significance for his clock- and watchmaking activity.

At the hub of this wide-reaching astronomical communication network was Franz Xaver von Zach (ill. 2), appointed astronomer to Duke Ernst II of Saxe-Gotha-Altenburg in 1786, and thus master of one of the most modern observatories of the age. Together with Hans Maurice Count von Brühl (ill. 3), Saxony's ambassador at the English court, Zach was engaged in promoting the use of precision timekeepers for determining longitude on land and actively furthering the production and distribution of precision timepieces suitable for this purpose. Seyffert himself referred to Brühl as an enthusiastic patron of precision horology, who had supported him in his own efforts.[6] But it was Zach who encouraged Seyffert to undertake the manufacture of particular timepieces. At the astronomical congress held in Gotha in 1798, Seyffert received a commission, at Zach's instigation, 'to develop portable pendulum clocks suitable for taking on a journey.'[7] A few years earlier, Zach had already induced Seyffert to construct his first chronometer by stipulating an award: 'which involved making a movement which could correctly carry

dernsten Sternwarten seiner Zeit. **Gemeinsam mit Hans Moritz Graf von Brühl (Abb. 3), dem sächsischen Gesandten am englischen Hof, propagierte Zach den Einsatz von Präzisionsuhren zur Längengradvermessung an Land und förderte aktiv die Herstellung und Verbreitung entsprechender Präzisionszeitmesser. Seyffert selbst bezieht sich auf Brühl als einen engagierten Liebhaber der Präzisionsuhrmacherei, der ihn in seinen Bemühungen bestärkt habe.[6] Doch war Zach derjenige, der Seyffert zum Bau konkreter Uhren animierte. Auf dem 1798 in Gotha abgehaltenen, von Zach initiierten Astronomenkongress erhielt Seyffert die Aufgabe, »portative Pendeluhren auszumitteln, welche bequem auf Reisen mitgeführt werden könten«.[7] Einige Jahre**

4
Josiah Emery, Taschenuhr Nr. 1350 mit Ankerhemmung, London, 1792/93,
National Maritime Museum, Greenwich, London
Josiah Emery, Pocket watch No. 1350 with lever escapement, London, 1792/93,
National Maritime Museum, Greenwich, London

zuvor hatte Zach bereits den Bau des ersten Seyffert'schen Chronometers veranlasst, indem er einen Preis aussetzte, »der darinn bestand, daß wenn ich ein Werk fertigen könnte, welches die Zeit richtig von der Sternwarte, bis zur Herzoglichen Residenz auf den Friedenstein, und von da wieder zurük bringen würde, ich [Seyffert] einen Emeryschen Chronometer zur Einsicht gelehnt erhalten sollte.«[8] Über dieses heute verschollene Chronometer Nr. 1 von Seyffert äußerte sich Zach recht abfällig.[9] Indes erfüllte es wohl die Bedingungen, denn Seyffert bekam tatsächlich ein Emery-Chronometer von Zach geliehen. Das Studium dieser Uhr stellte einen Wendepunkt in seinem Schaffen dar.

Anhand des Emery-Chronometers lernte Seyffert, »worauf es bei dem Bau eines solchen Werks ankommt« (Abb. 4 und 5).[10] Grundlegend war selbstverständlich die Gangpartie. Leider

the time from the observatory as far as the Ducal residence at Friedenstein and back again. If I [Seyffert] could succeed in doing so, I would be allowed to borrow and examine an Emery chronometer.'[8] Seyffert's now vanished chronometer No. 1 received fairly derogatory comments from Zach.[9] Nevertheless, it must have fulfilled the requirements, for Seyffert did indeed receive an Emery chronometer on loan from Zach. Studying this watch proved to be a turning point in his creative work. From the Emery chronometer, Seyffert learned 'the essential details and components of such a movement' (ills. 4 and 5).[10] Of course, a fundamental feature was the escapement. Unfortunately, it is difficult to assess how much Seyffert knew before he examined the Emery chronometer. Almost no information has survived about his lost chronometer No. 1. In any event, Seyffert made a model of the lever es-

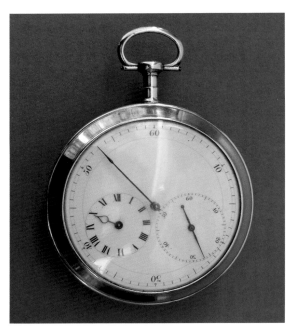
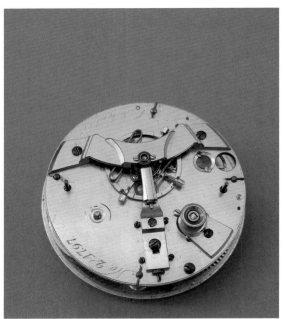

5
Johann Heinrich Seyffert, Chronometer Nr. 2, Dresden, 1797, Privatsammlung
Johann Heinrich Seyffert, Chronometer No. 2, Dresden, 1797, Private collection

lässt sich Seyfferts Wissensstand vor seiner Untersuchung des Emery-Chronometers nicht gut einschätzen. Zu seinem heute verschollenen Chronometer Nr. 1 sind so gut wie keine Informationen überliefert. In jedem Fall fertigte Seyffert ein Modell der Ankerhemmung nach Josiah Emery (ca. 1725 – 1797), auch wusste er, dass der eigentliche Erfinder dieser Hemmung Thomas Mudge (1715 – 1794) war.[11] Seyffert nutzte die typische Emery'sche Konstruktion – vierarmige Unruhe mit Doppel-S-förmigen Kompensationsschleifen, gelagert in einer Unruhbrücke, und Befestigung einschließlich Justierung der Unruhspirale über eine Klemme mit Stellschraube – für etliche seiner Chronometer (Abb. 6). Im Gegensatz zu Emery verwendete Seyffert jedoch für alle Uhren mit Ankerhemmung ein Stiftenrad, vermutlich, weil es für ihn leichter zu fertigen war, dabei aber keine nachteiligen Auswirkungen auf den Gang hatte. Ebenso wie die freien Ankerhemmungen von

capement by Josiah Emery (c. 1725 – 1797), and he was also aware that the actual inventor of this type of escapement was Thomas Mudge (1715 – 1794).[11] Seyffert used the typical Emery build for several of his chronometers (ill. 6) – a four-armed double S compensation balance, mounted in a bridge, with the balance spring fixed and regulated by means of a clamp with an adjusting screw. Unlike Emery, however, Seyffert used a pinwheel for all his lever escapement mechanisms, presumably because it was easier for him to make while having no detrimental effects on the train. Like the free lever escapements of Mudge and Emery, Seyffert's escapements had no draw on the anchor pallets, i.e., the pallets described a circular arc around the fulcrum of the lever.[12] A further significant improvement which followed from the study of the Emery chronometer concerned the use of jewelling. Up until the end of the eighteenth century, the lavish use of jewelling had been predominantly a feature

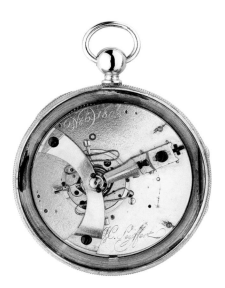 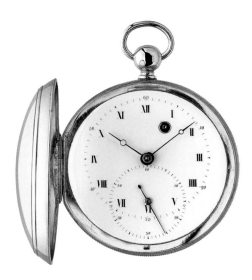

6

Johann Heinrich Seyffert, Chronometer Nr. 5, Dresden, 1803, Uhrenmuseum Beyer, Zürich
Johann Heinrich Seyffert, Chronometer No. 5, Dresden, 1803, Beyer Clock and Watch Museum, Zurich

Mudge und Emery verfügen Seyfferts nicht über einen Zugwinkel an den Ankerpaletten, d. h. letztere beschreiben einen Kreisbogen um den Ankerdrehpunkt.[12] Eine weitere, wesentliche Verbesserung, die das Studium des Emery-Chronometers nach sich zog, betraf die Verwendung von Lagersteinen. Bis Ende des 18. Jahrhunderts war die üppige Ausstattung mit Lagersteinen vorzugsweise ein Merkmal der englischen Präzisionsuhrmacherei. Immerhin hatte Seyffert für sein Chronometer Nr. 1 bereits diamantene Decksteine benutzt.[13] Der Versuch, Emerys Bauweise zu kopieren, kostete ihn jedoch erhebliche Anstrengung, weil »die Behandlung und Fassung der Edelsteine, wovon alle Reibungspunkte gefertigt werden müssen, eine Arbeit von ganz besonderer Art nöthig machte, so daß ich unter andern auch dabei das Metier eines Brillant-Schleifers mir eigen machen musste« (Abb. 7a – b).[14] Die Schwierigkeiten und Kosten der Beschaffung von Lagersteinen führten schließlich

of English precision watchmaking. However, Seyffert had already used diamond endstones in his chronometer No. 1.[13] His attempt to copy Emery's design, however, cost him considerable efforts, 'since the preparation and fitting of the jewels from which all friction points must be made demanded work of a very particular sort, so that I [Seyffert] was obliged, amongst other things, to master the trade of a diamond polisher' (ills. 7a – b).[14] The difficulty and cost of obtaining bearing jewels finally led to Seyffert building his own gem-drilling machine and thus becoming one of the first people in continental Europe to drill into gemstones.[15] There is no doubt that Seyffert's examination of the Emery chronometer had a lasting effect on him. In fact, to his very last chronometer – No. 8 of 1811 – he appears to have remained true to the principles he discovered at this time.[16] The one exception is chronometer No. 4, which points to another of Seyffert's role models: Thomas Mudge.

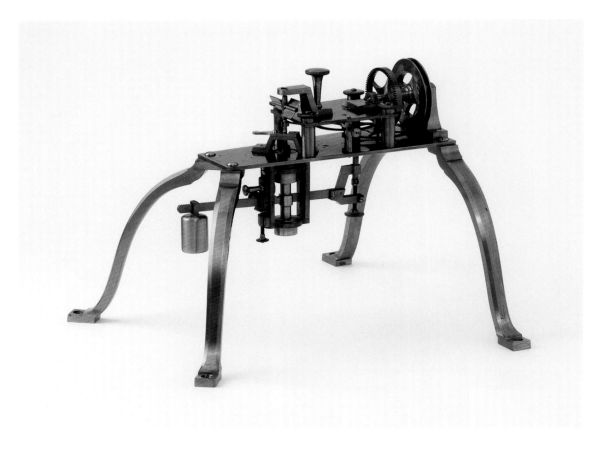

7a – b
Johann Heinrich Seyffert, Steinbohrmaschine, Dresden, 1796, Mathematisch-Physikalischer Salon, Dresden
Johann Heinrich Seyffert, Jewel drilling machine, Dresden, 1796, Mathematisch-Physikalischer Salon, Dresden

dazu, dass Seyffert um 1796/97 selbst eine Steinbohrmaschine baute und damit als einer der ersten auf dem Kontinent Edelsteine bohrte.[15] Zweifellos prägte die Untersuchung des Emery-Chronometers Seyffert nachhaltig. Tatsächlich scheint er bis zu seinem letzten bekannten Chronometer, der Nr. 8 von 1811, bei den einmal gefundenen Prinzipien geblieben zu sein.[16] Eine Ausnahme von dieser Regel bildet das Chronometer Nr. 4, das auf ein weiteres Vorbild Seyfferts verweist: Thomas Mudge.

Das Chronometer Nr. 4 (Abb. 8) ähnelt in Größe und Aufbau einem Marinechronometer. Seyffert rüstete es nach dem Beispiel der Seechronometer Mudges mit einer Unruhe und zwei

In size and construction, chronometer No. 4 (ill. 8) resembles a marine chronometer. Following the example of Mudge's sea chronometers, Seyffert equipped it with a balance with two balance springs, one mounted above and the other below the balance. The compensation provided by two bimetallic arms worked on the lower spring, while the machine was adjusted by means of a regulator with a micrometre screw on the upper spring. Seyffert appears to have used this type of construction and compensation already, in his now-missing chronometers No. 1 and No. 3.[17] His choice of model can probably be explained by the influence of Zach and Brühl, both outspoken admirers of Thomas Mudge. It

7b

Spiralfedern aus, von denen eine oberhalb, eine unterhalb der Unruhe montiert ist. Die Kompensation mittels zweier Bimetallarme wirkt auf die untere der Federn. An der oberen wird die Uhr durch den mit einer Mikrometerschraube ver-

is not known whether Seyffert ever got to see Mudge's first marine chronometer, the so-called 'red chronometer' of 1774, which had been used by Brühl and, for a time, also by Zach.[18] However, he could just as well have taken the construction

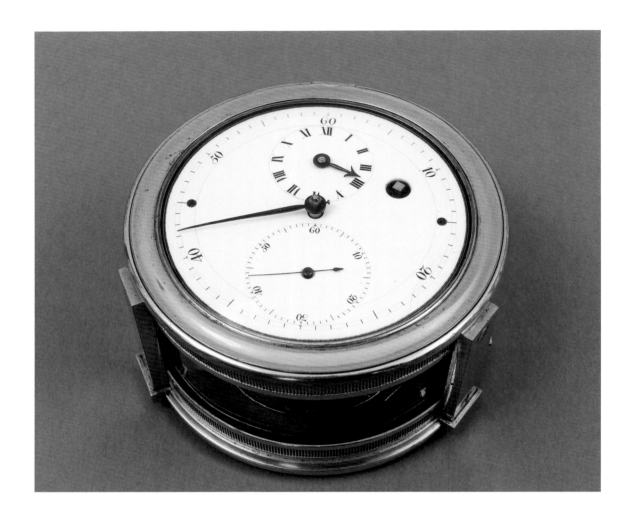

8
Johann Heinrich Seyffert, Chronometer Nr. 4, Dresden, 1803, Privatsammlung
Johann Heinrich Seyffert, Chronometer No. 4, Dresden, 1803, Private collection

sehenen Rücker reguliert. Seyffert scheint diese Art von Aufbau und Kompensation schon bei seinen heute verschollenen Chronometern Nr. 1 und Nr. 3 verwendet zu haben.[17] Die Wahl des Vorbilds lässt sich wohl am ehesten mit der Rolle Zachs und Brühls erklären, beide ausgewiesene Bewunderer Thomas Mudges. Es ist allerdings nicht bekannt, ob Seyffert das sogenannte »rote Seechronometer«, Mudges Nr. 1 von 1774, das von Brühl und zeitweise auch von Zach genutzt wurde, je zu Gesicht bekommen hat.[18] Doch hätte er die Konstruktion der Kom-

of the compensation device from the publication by Thomas Mudge Jun.[19] It was only in 1803 that 'Copy No. 18' (ill. 8, p. 21), a replica of his father's marine chronometers made by order of Thomas Mudge Jun., was gifted to the Mathematisch-Physikalischer Salon by Count von Brühl – too late for Seyffert to study directly when making his No. 3 and No. 4. Yet Seyffert was impressed by the machine and noted: 'This movement is one of the most complex and most skilfully contrived devices which the human mind is capable of inventing.'[20] He was subsequently involved in

pensationseinrichtung ebenso gut der Publikation Thomas Mudge des Jüngeren entnehmen können.[19] Erst im August 1803 gelangte die im Auftrag von Thomas Mudge jun. nach den Seechronometern seines Vaters gefertigte »Copie No. 18« (Abb. 8, S. 21) als Geschenk des Grafen Brühl in den Mathematisch-Physikalischen Salon – zu spät, um direktes Studienobjekt für Seyfferts Nr. 3 und Nr. 4 zu sein. Dennoch war Seyffert von der Uhr beeindruckt und notierte: »Dieses Werk ist eines der compliciertesten und künstlichsten, die der menschliche Geist ausdenken kann«.[20] In der Folge beschäftigte er sich wiederholt mit dem reparaturbedürftigen Werk und vermeldete im Sommer 1805, sich »in den Geist dieses complicirten Echappements ganz hineingedacht« zu haben.[21] Dennoch übernahm er für keines seiner Chronometer die komplizierte Hemmungspartie von Mudge, sondern blieb ab der Nr. 2 bei der bewährten Ankerhemmung mit Stiftenrad. Grundsätzlich war Seyfferts Experimentierfreude bei allem Pioniergeist gering.

Die ihm im Laufe der Zeit zur Reparatur anvertrauten Chronometer von Grant, Brockbanks, Haley und Arnold haben jedenfalls keine Spuren in seinem Werk hinterlassen.[22] Einzig Brockbanks' Überschwungsicherung beeindruckte ihn, doch scheint er sie letztlich nicht eingesetzt zu haben.[23] Anregungen konnte Seyffert natürlich auch der zeitgenössischen Uhrenliteratur entnehmen. Er besaß eine gut ausgestattete Bibliothek, in der die wichtigsten Werke enthalten waren, so Berthouds »Traité des horloges marines« und die »Histoire de la mesure du temps«, auch Lepautes »Traité d'horlogerie« sowie etliche deutsche Titel, darunter Poppes »Ausführliche Geschichte der theoretisch-praktischen Uhrmacherkunst« und Leutemanns »Vollständige Nachricht von den Uhren«.[24] Wie Zach im dritten Band seiner »Monatlichen Correspondenz« schreibt, entlehnte Seyffert die Wippen-Chronometerhemmung seiner Reisependeluhren Berthouds »Supplément au Traité des horloges marines«.[25] Abweichend von der Vorlage verwendete Seyffert auch bei diesen Uhren als

many repairs to the fragile mechanism and in the summer of 1805 reported that he had 'gained complete insight into the spirit of this complicated escapement.'[21] Despite this, he did not adopt Mudge's complex escapement mechanism for any of his own chronometers and from No. 2 onwards stuck to his tried-and-tested lever escapement with pinwheel. For all his pioneering spirit, Seyffert's appetite for experiment was small.

Chronometers by Grant, Brockbanks, Haley, and Arnold, which were also entrusted to him for repair over the years, likewise left no trace in his work.[22] Only Brockbank's amplitude-limiting device impressed him, yet in the end he seems not to have used it.[23] Of course, Seyffert could also have taken inspiration from contemporary horological literature. He owned a well-stocked library containing the most important works, such as Berthoud's *Traité des horloges marines* and *Histoire de la mesure du temps*, as well as Lepaute's *Traité d'horlogerie*, and various German titles, including Poppe's *Ausführliche Geschichte der theoretisch-praktischen Uhrmacherkunst* and Leutemann's *Vollständige Nachricht von den Uhren*.[24] As Zach noted in the third volume of his *Monthly Correspondence*, Seyffert borrowed the pivoted detent escapement of his travelling pendulum clocks from Berthoud's *Supplément au Traité des horloges marines*.[25] But even in these clocks, Seyffert deviated from his model in using a pinwheel for his escapement wheel. In general, Seyffert's watch- and clock-making probably stopped developing around 1801. Having been newly appointed curator of the Kunstkammer and the Mathematisch-Physikalischer Salon at this date, Seyffert may have had less time than before. More significant were probably the death of Duke Ernst II in Gotha in 1804, bringing to an end the era of Zach's dominance, and Brühl's illness in 1800 which led to his retirement from astronomy. Without Zach and Brühl, Seyffert lost his most important sources of ideas and, ultimately, his connection with developments in the world of international precision horology. Only with the work of Johann

Gangrad ein Stiftenrad. Generell war die Ent-
wicklung der Seyffert'schen Uhrmacherkunst um
1801 wohl abgeschlossen. Möglicherweise blieb
Seyffert als zu diesem Zeitpunkt neu ernannter
Inspektor der Kunstkammer und des Mathema-
tisch-Physikalischen Salons weniger Zeit als
zuvor. Wichtiger waren vermutlich der Tod Her-
zog Ernsts II. 1804 in Gotha, der das Ende der
Ära Zach bedeutete, und die um 1800 erfolgte
Erkrankung Brühls, die zu seinem Rückzug aus
der Astronomie führte. Seyffert verlor damit
seine bedeutendsten Ideengeber und letztlich
den Anschluss an die Entwicklungen in der in-
ternationalen Präzisionsuhrmacherei. Den
schaffte erst Johann Christian Friedrich Gutkaes
(1785 – 1845), der im Unterschied zu Seyffert
vom Verkauf seiner Arbeiten leben musste. Seyf-
fert bleibt das Verdienst, als Erster in Sachsen
und als einer der Ersten in den deutschen Län-
dern transportable Uhren mit neuartigen Prä-
zisionsstandards gefertigt zu haben, fernab der
großen Uhrenzentren, ohne Zulieferindustrie
und weitgehend auf sich allein gestellt.

Leider lässt sich Seyfferts Arbeitsweise nach
dem derzeitigen Wissensstand nur grob umrei-
ßen. In seinem Haus in der Pirnaischen Vorstadt,
Neue Gasse 178 hatte er eine Werkstatt, in der
er einen, zeitweise auch zwei Mitarbeiter be-
schäftige. Von ca. 1798 bis 1801 und noch ein-
mal von ca. 1802 bis 1804 arbeitete Joseph
Benno Kirchel bei ihm, der dann auf Seyfferts
Empfehlung als Mechanikus an der Kunstkam-
mer angestellt wurde.[26] Kirchel scheint der ein-
zige gelernte Uhrmacher gewesen zu sein, mit
dem Seyffert in Dresden und Umgebung zusam-
menarbeitete. Die meisten seiner Maschinen
stellte Seyffert offenbar selbst her. In seiner Be-
werbung um die Inspektorenstelle des Mathe-
matisch-Physikalischen Salons verzeichnete er
beispielsweise eine Wälzmaschine, eine Feilen-
haumaschine, eine Maschine zum Schneiden der
Schrauben und Schnecken, einen Teilapparat
und eine Steinbohrmaschine.[27] Ebenso baute er
seine Präzisionsuhren wohl weitestgehend
allein. Bemerkungen in den von 1801 bis 1817
im Mathematisch-Physikalischen Salon geführ-

Christian Friedrich Gutkaes (1785 – 1845) these
international connections were re-established.
Unlike Seyffert, Gutkaes had to earn his living
from sales. Seyffert retained the credit of being
the first in Saxony and one of the first in the
German lands to have made portable timekeep-
ers to modern standards of precision, despite
living far from the great centres of watchmaking
and, with no one to supply him with parts, being
compelled to be largely self-reliant.

Unfortunately, Seyffert's working methods can
only be sketchily described from what we cur-
rently know. In his house at 178 Neue Gasse, in
the district of Dresden known as the Pirnaische
Vorstadt, he had a workshop where he employed
one, and sometimes two assistants. From around
1798 to 1801 and again from around 1802 to
1804, Joseph Benno Kirchel was employed there,
later taking up the post, on Seyffert's recommen-
dation, of 'mechanicus' at the Kunstkammer.[26]
Kirchel appears to have been the only trained
watchmaker from Dresden and the local area
with whom Seyffert collaborated. It would seem
that Seyffert manufactured most of his machines
himself. These included, for example, a watch-
maker's rolling tool, a file-cutting machine, a
machine for cutting screws and screw nuts, a di-
viding engine, and a gemstone drill, as stated in
his application for the position of curator of the
Mathematisch-Physikalischer Salon.[27] In the
same way, he probably built his precision time-
pieces for the most part single-handedly. Re-
marks in the work diaries kept at the Mathema-
tisch-Physikalischer Salon between 1801 and
1817 mention the making of escapement mech-
anisms ('Echappements'), pinions, hands, balance
springs, and mainsprings for watches, although
Seyffert also purchased the latter at the Leipzig
Messe (trade fair) or ordered them, along with
clock and watch faces, directly from Switzerland.
In a few cases, Seyffert even attempted to manu-
facture watchcases, including gilding them, al-
though he did not succeed in this as well as the
Swiss craftsmen.[28] For simpler timepieces, it is
likely that Seyffert used rough movement. The
numbering of his pocket watch movements had

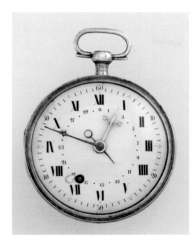 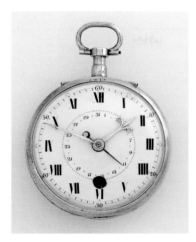 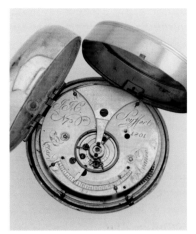

9
Johann Heinrich Seyffert, Taschenuhr Nr. 64 mit zwei Federhäusern, Dresden, 1799, Privatsammlung
Johann Heinrich Seyffert, Taschenuhr Nr. 73 mit zwei Federhäusern, Zifferblatt und Werkseite, Dresden, 1801, Privatsammlung
Johann Heinrich Seyffert, Pocket watch No. 64 with two barrels, Dresden, 1799, Private collection
Johann Heinrich Seyffert, Pocket watch No. 73 with two barrels, front and movement, Dresden, 1801, Private collection

ten Arbeitsjournalen berichten von der Anfertigung der Hemmungspartien (»Echappements«), Triebe, Zeiger, Spiralfedern und Uhrfedern, wobei Seyffert letztere auch auf der Leipziger Messe kaufte bzw. ebenso wie Zifferblätter direkt aus der Schweiz bezog. In einigen Fällen versuchte sich Seyffert gar an der Herstellung von Gehäusen sowie deren Vergoldung, die ihm indes nicht so gut gelang wie den Handwerkern in der Schweiz.[28] Für die einfacheren Uhren liegt die Vermutung nahe, dass Seyffert auf Rohwerke zurückgriff. Die Nummerierung der Taschenuhrwerke, die 1799 die 64, 1801 bereits die 73 erreicht und etliche Uhren mit zwei Federhäusern einschließt, mutet für einen nur in seinen Freistunden arbeitenden Amateur recht hoch an (Abb. 9). Auch berichtet Seyffert im November 1800 von Plänen, Rohwerke für Pendeluhren in La Chaux-de-Fonds herstellen zu lassen und selbst nur das Pendel und die »Dinge, worauß hauptsächlich die Richtigkeit des Gangs beruht« zu fertigen.[29] Indes lässt sich derzeit nicht sagen, ob diese Pläne in die Tat umgesetzt wurden. In jedem Fall verfügte Seyffert über gute Verbindungen zu Uhrmachern bzw. Uhrhändlern

reached 64 by 1799 and was as high as 73 by 1801, including several watches with two barrels. These numbers appear rather high for an amateur working only in his spare time (ill. 9). Seyffert also reported in November 1800 that he planned to have rough movements for pendulum clocks manufactured in La Chaux-de-Fonds and only to make the pendulums and the 'things on which the accurate running of the clock chiefly depends' himself.[29] At present, however, it is impossible to say whether these plans came to fruition. At any rate, Seyffert had good connections with watchmakers and merchants in Switzerland, especially in Geneva, La Chaux-de-Fonds and Le Locle.[30] And contacts appear not to have been restricted to the mere purchase of components. According to the work diary, a request reached Seyffert from La Chaux-de-Fonds to write a treatise 'on certain escapements.'[31] The request can only have strengthened his already high self-esteem as a maker of timekeepers.

Indeed, Seyffert had great confidence in his watch- and clockmaking abilities and considered his work to be quite the equal, in particular, of that of the English horologists. He always re-

in der Schweiz, besonders in Genf, La Chaux-de-Fonds und Le Locle.[30] Die Kontakte scheinen sich dabei nicht auf den bloßen Einkauf von Uhrteilen beschränkt zu haben. Laut Arbeitsjournal ereilte Seyffert aus La Chaux-de-Fonds die Bitte, eine Abhandlung »über gewisse Echappements« zu verfassen.[31] Dieses Ansuchen dürfte sein ohnehin hohes Selbstwertgefühl als Uhrmacher noch gestärkt haben.

Tatsächlich hatte Seyffert großes Vertrauen in seine uhrmacherischen Fähigkeiten und schätzte seine Arbeit besonders auch im Vergleich mit den Engländern als durchaus ebenbürtig ein. Über die Gangresultate seiner Präzisionsuhren äußerte er sich stets außerordentlich positiv. Allerdings sind diese Angaben mit Vorsicht zu interpretieren. Seyfferts Ankerhemmungen verfügten ebenso wie die von Mudge und Emery nicht über den erwähnten Zugwinkel an den Ankerpaletten, so dass ihr Gang beim Gebrauch ständigen Störungen unterworfen gewesen sein dürfte.[32] Auch die Pendeluhren gaben gelegentlich Anlass zur Kritik. Anton von Gersdorf beispielsweise hatte im August 1802 ein Gangregister für eine astronomische Pendeluhr einfacherer Bauart von Seyffert angelegt, das den Erwartungen des letzteren nicht entsprach.[33] Immerhin waren Seyfferts Uhren so gut, dass sie unter anderem von Herzog Ernst II. von Gotha und den Astronomen Johann Elert Bode (Berlin), Anton Jungnitz (Breslau) und Johann Pasquich (Wien) gekauft wurden. In Dresden erfreute sich Seyffert der Wertschätzung des Kurfürsten und späteren Königs Friedrich August, der sich bereits von dem Finanzsekretär Seyffert von diesem gefertigte Uhren vorführen und möglicherweise auch anfertigen ließ (Abb. 10). Das grundsätzliche Interesse des Hofes an außergewöhnlichen Uhren wird darüber hinaus eine Rolle bei der Neubesetzung der Inspektorenstelle für den Mathematisch-Physikalischen Salon und die Kunstkammer gespielt haben. Immerhin setzte sich Seyffert gegen neun andere, teils hochqualifizierte Bewerber durch, darunter der Mathematiker Heinrich August Rothe, der Geograph

ported extremely positively on the trial results of his precision timepieces. However, these results must be interpreted with caution. As mentioned earlier, Seyffert's lever escapements, like those of Mudge and Emery, lacked draw on the lever palettes, meaning that when in use, their movements must have been subject to continual disturbance.[32] Even the pendulum clocks gave occasional cause for complaint. In 1802, for example, Anton von Gersdorf drew up a register of the going of a simple astronomical pendulum clock made by Seyffert, which did not meet von Seyffert's expectations.[33] On the other hand, Seyffert's timepieces were of sufficient quality to be bought by, amongst others, Duke Ernst II of Gotha and the astronomers Johann Elert Bode (Berlin), Anton Jungnitz (Breslau) and Johann Pasquich (Vienna). In Dresden, Seyffert enjoyed the esteem of Elector, and later King, Friedrich August, who requested demonstrations of timepieces made by his Financial Secretary, and possibly even commissioned some (ill. 10). The general interest of the court in unusual timepieces must also have played a role when it came to appointing a new curator for the Mathematisch-Physikalischer Salon and the Kunstkammer, although Seyffert had to compete for the position against nine other, in some cases highly-qualified, applicants including the mathematician Heinrich August Rothe, the geographer Friedrich Christian August Hasse, the mechanicians Johann Gottfried May and Johann Siegmund Mercklein, and the horologist Christian Ehregott Weise.[34] Indeed, Seyffert's work diaries from 1801 to 1817 report countless requests for repairs from the electoral, later royal, couple and orders for new timepieces, including a pocket watch with equation of time and the chronometer No. 8 (ill. 11), both of which, though badly damaged, are still preserved in the Mathematisch-Physikalischer Salon.[35] Seyffert also owed his special status not least to his insistence on the scientific principles underlying his work, an attitude of which there is no comparable trace in any of the master watchmakers of the Dresden guild active in Seyffert's lifetime.

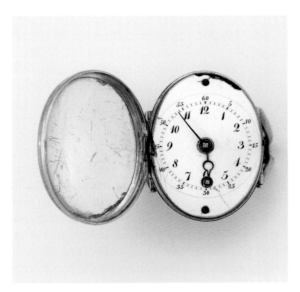 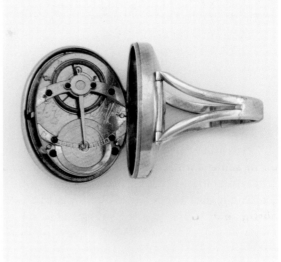

10
Johann Heinrich Seyffert, Ringuhr, Dresden, 1780, aus dem Nachlass König Antons, Grünes Gewölbe, Dresden
Johann Heinrich Seyffert, Ring watch, Dresden, 1780, from the personal effects left by King Anton of Saxony,
Grünes Gewölbe, Dresden

Friedrich Christian August Hasse, die Mechaniker Johann Gottfried May und Johann Siegmund Mercklein und der Uhrmacher Christian Ehregott Weise.[34] Tatsächlich berichten die von 1801 bis 1817 geführten Arbeitsjournale Seyfferts von unzähligen Reparaturaufträgen durch das Kurfürsten- bzw. Königspaar und von Bestellungen neuer Uhren, darunter eine Taschenuhr mit Äquation und das Chronometer Nr. 8 (Abb. 11), die beide, wenn auch stark beschädigt, im Mathematisch-Physikalischen Salon erhalten sind.[35] Die besondere Stellung Seyfferts verdankte sich wohl nicht zuletzt seinem Beharren auf dem wissenschaftlichen Fundament seiner Arbeit, das von keinem der zu Seyfferts Lebzeiten tätigen Meister der Dresdner Uhrmacherinnung in vergleichbarer Weise überliefert ist.

Die Dresdner Kleinuhrmacher waren seit 1668 in einer Innung organisiert. Der Fokus der Innung richtete sich auf Beständigkeit und Werterhalt; einmal gesetzte Regeln galten über Jahrzehnte und wurden nur langsam an die sich verändernden Marktbedingungen angepasst.

The Dresden watchmakers had been organised as a guild since 1668. The guild's focus was on maintaining standards and consistency; once established, regulations continued in force for decades and were only slowly brought into line with the changing demands of the market. Thus, since 1797, the masterpiece examination set by the statutes of the Dresden watchmaker's guild required the making of a repeating pocket watch, striking the hours and the quarters, with either cylinder escapement or verge escapement. Alternatively, a self-striking pocket watch with verge escapement could be made (ill. 12).[36] With this specification, the elders were complying with a demand from the elector, made as early as 1780, that masterpieces should be fashionable timepieces that would sell well. The guild reacted only after considerable delay and by the time they eventually approved the change were limping far behind what had already long been the usual practice of its members. In general, the guild's specifications were aimed at the usual and the useful, since this was chiefly

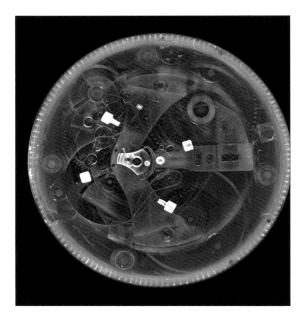

11
**Computertomographische Aufnahme: Johann Heinrich
Seyffert, Chronometer Nr. 8, Dresden, 1811, Mathematisch-
Physikalischer Salon, Dresden (Industrielle Mikro-
Computertomographie, Z-Projektion)**
CT scan: Johann Heinrich Seyffert, Chronometer No. 8,
Dresden, 1811, Mathematisch-Physikalischer Salon, Dresden
(Industrial micro computed tomography, z-projection)

**So verlangten die Statuten der Dresdner Klein-
uhrmacherinnung als Meisterstück seit 1797 die
Anfertigung einer Taschenuhr mit Viertel- und
Stundenrepetition, entweder mit Zylinder- oder
mit Spindelhemmung. Alternativ war die An-
fertigung einer die Viertel und Stunden selbst
schlagenden Taschenuhr mit Spindelhemmung
möglich (Abb. 12).[36] Mit dieser Festlegung
waren die Ältesten einem bereits 1780 ergan-
genen Befehl des Kurfürsten nachgekommen,
der die Anfertigung gut verkäuflicher, der Mode
entsprechender Meisterstücke verlangt hatte.
Die Innung reagierte mit beträchtlicher zeit-
licher Verzögerung und hinkte bei der offiziellen
Festschreibung der Änderung selbst der unter
Innungsmitgliedern längst üblichen Praxis hin-
terher. Grundsätzlich orientierten sich die Vor-
gaben der Innung am Üblichen, Gebräuchlichen**

where its members earned their living. It is no
wonder, therefore, that the guild, as an institu-
tion, had no interest in clocks and watches that
claimed to offer extraordinary precision. This
was a niche market whose small circle of cus-
tomers could only be served by an individual
watchmaker working on his own initiative.

The first master of the Dresden guild who
dared to take this step was Johann Christian
Friedrich Gutkaes. Gutkaes, the son of a violinist,
undertook his watchmaking apprenticeship in
Berlin, probably because his father was em-
ployed at the Prussian court as a chamber mu-
sician.[37] In April 1813, he applied for recognition
as master watchmaker in Dresden, the town of
his birth, and in the autumn of 1815 was finally
accorded this rank.[38] In the same year he married
the daughter of the court watchmaker, Johann
Friedrich Schumann, whose workshop, to judge
from entries in the official register of addresses
for Dresden, he took over. The details of Gutkaes'
professional training, the master with whom he
served his apprenticeship, even the places where
he worked during his years as a journeyman, are
unknown. It is likely that before his return to
Dresden he spent some time in France, possibly
in the workshop of Abraham Louis Breguet
(1747 – 1823).[39] At any rate, in Dresden he made
the acquaintance of Seyffert; something which
the latter, astonishingly, never mentioned. Ac-
cording to his own testimony, Gutkaes, was able
to spend time in the Mathematisch-Physikali-
scher Salon during Seyffert's tenure there, thus
broadening his knowledge of the higher arts of
horology.[40] Seyffert's successor, Major August
Schmidt (died 1827), frequently entrusted him
with the cleaning and repair of the Salon's time-
pieces, although it was not until around 1828[41]
that he was officially appointed as mechanician.
Long before this, Gutkaes had started to make
use of the Salon to test his own clocks. As early
as October 1818, he brought in an astronomical
pendulum clock, whose time-keeping Schmidt
tested until May of the following year.[42] Gutkaes'
regard for the Mathematisch-Physikalischer Sa-
lon as the authority in everything to do with the

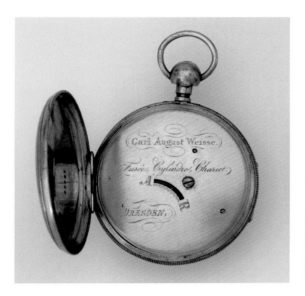 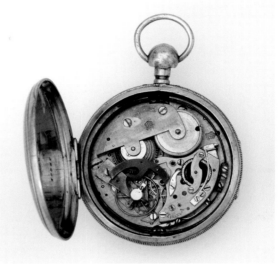

12
Carl August Weisse, Taschenuhr mit Zylinderhemmung und Viertelrepetition, Dresden, um 1814,
Mathematisch-Physikalischer Salon, Dresden
Carl August Weisse, Pocket watch with cylinder escapement and quarter repetition, Dresden, around 1814,
Mathematisch-Physikalischer Salon, Dresden

als dem hauptsächlichen Broterwerb ihrer Mitglieder. Es ist daher nicht verwunderlich, dass die Uhrmacherinnung als Institution kein Interesse an Uhren mit außergewöhnlich hohem Präzisionsanspruch hatte. In diese Nische mit ihrer entsprechend kleinen Käuferschar konnte sich nur der einzelne Uhrmacher und nur aus eigenem Antrieb begeben.

Der erste Dresdner Innungsmeister, der diesen Schritt wagte, war Johann Christian Friedrich Gutkaes. Gutkaes, Sohn eines Violinisten, absolvierte die Uhrmacherlehre in Berlin, vermutlich, weil sein Vater am preußischen Hof die Stelle eines Kammermusikus innehatte.[37] Zur Meisterprüfung meldete er sich im April 1813 in seiner Geburtsstadt Dresden, im Herbst 1815 wurde ihm schließlich das Meisterrecht zuerkannt.[38] Im gleichen Jahr heiratete er die Tochter des Hofuhrmachers Johann Friedrich Schumann, dessen Werkstatt er den Einträgen in den Dresdner Adresskalendern nach zu urteilen übernahm. Die Einzelheiten von Gutkaes' Werdegang, sein Lehr-

precise measurement of time was due to the activities of Johan Gottfried Köhler. During his time as inspector (1776 – 1800), Köhler had turned the museum of mathematical and physical instruments into a place for active astronomical observation and, as part of this development, had established the 'time service.'[43] To determine true local time, from which to calculate and disseminate local mean time, the Salon was from then on reliant on clocks and watches that could keep time precisely. It must therefore have been through his close contacts with the Mathematisch-Physikalischer Salon that Gutkaes hit upon the idea of opening a factory for making precision timepieces.

In July 1823, Gutkaes approached the King of Saxony with a request for financial support to found an 'official factory and centre of instruction' (ill. 13) for the exclusive manufacture of 'astronomical pendulum clocks, second-counters, pocket watches with second hands, and pocket and longitude marine chronometers,' as well as

meister oder auch die Stationen der Wander-
jahre, sind unbekannt. Es ist zu vermuten, dass er
sich vor seiner Rückkehr nach Dresden einige
Zeit in Frankreich, möglicherweise bei Abraham
Louis Breguet (1747 – 1823) aufhielt.[39] In Dres-
den machte er jedenfalls die Bekanntschaft
Seyfferts; ein Umstand, den letzterer erstaun-
licherweise nie erwähnte. Nach eigenem Bekun-
den konnte Gutkaes noch zu Seyfferts Lebzeiten
im Mathematisch-Physikalischen Salon seine
Kenntnisse in der höheren Uhrmacherkunst er-
weitern.[40] Von Seyfferts Nachfolger, dem Oberin-
spektor Major August Schmidt (gestorben 1827),
wurde er seit 1818 häufig mit der Reparatur und
Reinigung von Uhren des Salons betraut. Die of-
fizielle Anstellung als Mechaniker erfolgte aller-
dings erst um 1828.[41] Gutkaes nutzte den Salon
schon sehr früh als Prüfstelle für seine Uhren.
Bereits Anfang Oktober 1818 brachte er eine
astronomische Pendeluhr, deren Gang Schmidt
bis Mai des nächsten Jahres kontrollierte.[42] Dass
Gutkaes den Mathematisch-Physikalischen Salon
als Instanz in Sachen Präzisionszeitmessung be-
trachtete, verdankte sich dem Wirken Johann
Gottfried Köhlers. Als Inspektor (1776 – 1800)
hatte Köhler das Museum der mathematischen
und physikalischen Instrumente zu einem Ort
aktiver astronomischer Beobachtung gemacht
und zugleich den Zeitdienst etabliert.[43] Für die
Bestimmung der wahren Ortszeit, ihre Umrech-
nung in die mittlere Ortszeit und deren Weiter-
gabe war der Salon fortan auf präzise gehende
Uhren angewiesen. Gutkaes dürfte daher durch
seine engen Kontakte zum Mathematisch-Phy-
sikalischen Salon auf die Idee gekommen sein,
eine Fabrik zur Herstellung von Präzisionsuhren
zu gründen.

Im Juli 1823 wandte sich Gutkaes an den
sächsischen König mit der Bitte, ihm finanzielle
Unterstützung zur Gründung eines »förmlichen
Fabrik-Instituts« zu gewähren (Abb. 13), in dem
er »ausschließlich astronomische PendulUhren,
Secunden-Zähler, Taschen-Secunden-Uhren und
Taschen- auch See- Längen-Chronometer« sowie
als Luxusartikel gute Stutz- und Gemäldeuhren
fertigen wollte.[44] Allgemein anerkannte Meister

13
Friedrich Gutkaes an Friedrich August I. von Sachsen,
Dresden, 23. 07. 1823, Sächsisches Staatsarchiv,
Hauptstaatsarchiv Dresden
Friedrich Gutkaes to King Friedrich August I of Saxony,
Dresden, 23 July 1823, Sächsisches Staatsarchiv,
Hauptstaatsarchiv Dresden

good bracket and picture clocks as luxury
items.[44] The generally recognised masters of pre-
cision horology were the English, but Gutkaes
argued that English products were too expensive
for many customers. He, on the other hand,
would be able to satisfy the demand for cheaper
precision timepieces, but he would require
enough capital to acquire the machines and pay
the initial wages of the employees. The en-
deavour would benefit the commonweal at large,
for large sums of money would no longer flow

der Präzisionsuhrmacherei waren die Engländer, doch Gutkaes argumentierte, dass die englischen Erzeugnisse für viele Käufer zu teuer wären. Er hingegen könne den hohen Bedarf an preiswerteren Präzisionsuhren befriedigen, doch benötige er zur Anschaffung der Maschinen und anfänglichen Bezahlung der Arbeiter ein entsprechend hohes Kapital. Das Vorhaben sei gemeinnützig, denn beträchtliche Gelder flössen nicht mehr in das Ausland und die zu gründende Fabrik sei außerdem ein Ort, an dem sich »ausgezeichnete junge Künstler« bilden könnten.[45] Gutkaes nimmt hier in vielen Punkten die Argumentation Ferdinand Adolph Langes (1815 – 1875) vorweg, der sich zwanzig Jahre später mit einem ähnlichen Anliegen an die Regierung wandte. Der Bitte wurde in Langes und auch in Gutkaes' Fall entsprochen. Letzterem gewährte der König mit Reskript vom 12. August 1823 auf sechs Jahre die Zinsen auf ein Kapital von 6000 Talern, das Gutkaes bei dem Kammerherrn Moritz von Zehmen aufnahm. Diese prompte Unterstützung war keinesfalls üblich, wie z. B. der vom November 1825 datierende Antrag des Uhrmachermeisters Carl August Weisse zeigt. Weisse beschäftigte mehr als neun Leute, darunter zwei Arbeiter aus der französischen Schweiz, um anstelle der sonst in Dresden üblichen Reparaturarbeiten neue Uhren auf Bestellung »nach der französischen Methode« zu fertigen.[46] Seine Bitte um Zinsbeihilfe wurde ohne Angabe von Gründen abgelehnt.[47] Im Unterschied zu Weisse konnte Gutkaes jedoch positive Stellungnahmen der Inspektoren des Mathematisch-Physikalischen Salons beibringen und zudem auf öffentliche Empfehlungen im »Astronomischen Jahrbuch« Johann Elert Bodes und den von Ludwig Wilhelm Gilbert herausgegebenen »Annalen der Physik« verweisen.[48] Diese Referenzen erhielt er sicherlich auch, weil er gemeinsam mit dem Oberinspektor des Mathematisch-Physikalischen Salons, August Schmidt, gelegentlich astronomische Beobachtungen durchführte und die Ergebnisse an die entsprechenden Journale sandte. Es würde deutlich zu weit führen, Gutkaes deshalb einen Astronomen zu nennen. Viel-

abroad and the planned factory would also serve as a place of learning for 'outstanding young artists.'[45] Gutkaes here anticipated many points put forward by Ferdinand Adolph Lange (1815 – 1875), who appealed to the government with a similar concern some twenty years later. Both Lange's and Gutkaes' requests were approved. In a rescript dated 12 August 1823, the king granted Gutkaes the interest on a capital of 6000 thalers for a period of six years, which Gutkaes accepted from the chamberlain Moritz von Zehmen. This prompt support was by no means common, as the application from the master watchmaker Carl August Weisse, dated November 1825, shows. Weisse had more than nine people in his employ, including two workers from French-speaking Switzerland, to manufacture new watches to order 'after the French method' instead of repairing those made elsewhere and imported, as was otherwise customary in Dresden.[46] His request for an interest subsidy was flatly rejected without explanation.[47] However, in contrast to Weisse, Gutkaes was able to win favour among the curators of the Mathematisch-Physikalischer Salon and lay claim to public recommendations in Johann Elert Bode's *Astronomisches Jahrbuch* and the *Annalen der Physik,* edited by Ludwig Wilhelm Gilbert.[48] These noteworthy references were no doubt due in part to the fact that Gutkaes occasionally conducted astronomical observations with the curator of the Salon, August Schmidt, and submitted the results to the appropriate journals. But it would clearly be going too far therefore to call Gutkaes an astronomer. The Mathematisch-Physikalischer Salon instead has Johann Gottfried Köhler to thank for establishing its lasting place in the field of astronomy. Köhler's activities also positively impacted on protagonists not central to the astronomical discourse.

Unfortunately, very little material relating to Gutkaes' factory has survived. For example, we do not know how many people he employed. Guild records reveal that after obtaining the right to call himself a master, Gutkaes trained some twelve apprentices, some of whom had

mehr war der Mathematisch-Physikalische Salon durch Johann Gottfried Köhlers Wirken nachhaltig im zeitgenössischen astronomischen Netzwerk etabliert.

Dessen Wirksamkeit kam auch Protagonisten am Rande zu Gute. Leider ist nur sehr wenig Material zu Gutkaes' Fabrik überliefert. Es ist beispielsweise nicht bekannt, wie viele Mitarbeiter er beschäftigte. Aus den Innungsakten geht hervor, dass Gutkaes nach Erlangung des Meisterrechts ca. 12 Lehrlinge ausbildete, von denen einige ihre Lehrzeit ursprünglich bei anderen Meistern begonnen hatten.[49] Von den Gesellen sind namentlich nur Christian Friedrich Tiede aus Berlin, Ernst Georg Schmidt aus Leipzig sowie Friedrich Breuel aus Schwerin bekannt.[50] Damit ist nicht ersichtlich, dass Gutkaes mit seiner Fabrik außerhalb der Innungsregeln stand. Von Seiten der Innung scheint es jedenfalls keine Einwände gegen das Vorhaben ihres Zunftmitglieds gegeben zu haben. Gutkaes' Gründung dürfte daher weniger als Fabrik im heutigen Wortsinne, denn als traditionelle Werkstatt anzusehen sein, die sich hauptsächlich durch ihre Produktpalette von anderen Dresdner Uhrmacherwerkstätten unterschied. Tatsächlich vermerkte der 1831 anlässlich der sächsischen Gewerbeausstellung erschienene Katalog ausdrücklich das Fehlen einer fabrikmäßigen Uhrenerzeugung in Dresden.[51] Schließlich unterstützen auch die Produktionszahlen die Annahme einer traditionellen Werkstattorganisation: Von 1820 bis 1829 stellte Gutkaes 33 Chronometer unterschiedlicher Art (davon 4 noch unvollendet), 3 Seeuhren bzw. Seechronometer, 16 Pendeluhren unterschiedlicher Art und 4 Sekundenschläger her (Abb. 14 – 16).[52] Im Vergleich zu beispielsweise John Arnold (1736 – 1799) erscheint diese Menge relativ gering, doch konnte Gutkaes auch nicht auf eine hochspezialisierte Zulieferindustrie zurückgreifen, wie sie in England und der Schweiz üblich war. Dabei war der Verkauf selbst dieser Stückzahlen problematisch.

1829, nach Ablauf der vom König gewährten sechsjährigen Unterstützung, bat Gutkaes erneut originally started their apprenticeship under other masters.[49] Of the journeymen working with him, only three are known by name: Christian Friedrich Tiede of Berlin, Ernst Georg Schmidt of Leipzig, and Friedrich Breuel of Schwerin.[50] It remains unclear from this whether Gutkaes and his factory operated outside guild rules. For its part, the guild at least seems not to have raised any objections to the proposed endeavour of one of its rank and file. It is likely therefore that Gutkaes' establishment did not so much resemble a factory in the modern sense of the word, but rather a traditional workshop whose product range notably set itself apart from other Dresden watchmaking workshops. In fact, the catalogue published to coincide with the Saxon Industrial Exhibition of 1831 expressly noted the lack of a factory-like production site of clocks and watches in Dresden.[51] Ultimately, the production figures support the assumption that Gutkaes' factory was more akin to a traditional workshop organization. From 1820 to 1829, Gutkaes produced 33 chronometers of various types (4 of which remained incomplete), 3 marine chronometers, 16 different types of pendulum clocks, and 4 second-counters (ills. 14 – 16).[52] In comparison to John Arnold (1736 – 1799), for example, this output appears relatively low, although it should be pointed out that, unlike Arnold, Gutkaes could not rely on a network of highly specialized suppliers, as was customary in England and Switzerland. In Gutkaes' case, even the sale of such relatively few items presented a challenge. In 1829 the six-year-period of support from the king expired and Gutkaes asked for financial assistance again. He explained that he had managed to sell not even half the precision watches manufactured thus far, stating that his most valuable pieces were still locked away in storage. Of the 6000 thalers he had borrowed, he was only able to repay 2000. He therefore asked for assistance in the interest repayments on the remaining 4000 thalers. In return he was willing to train selected pupils from the Technische Bildungsanstalt (Technical School) in his workshop free of charge.[53] After careful con-

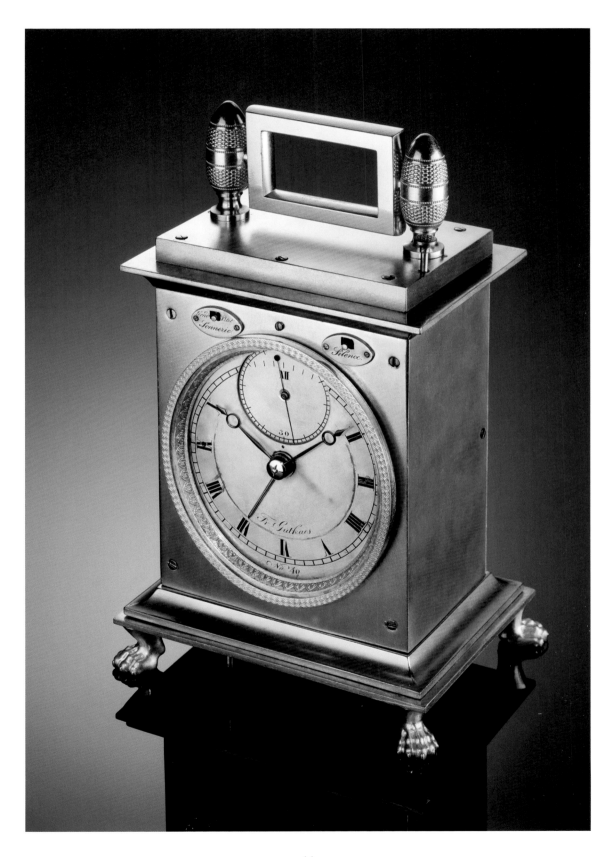

Friedrich Gutkaes, Chronometer Nr. 40, Dresden, um 1825, Lange Uhren GmbH, Glashütte
Friedrich Gutkaes, Chronometer No. 40, Dresden, around 1825, Lange Uhren GmbH, Glashütte

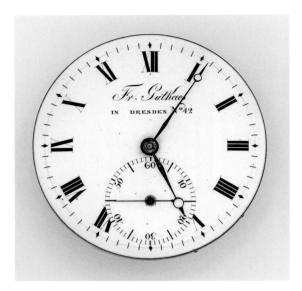

15
Friedrich Gutkaes, Chronometer Nr. 42, Dresden, um 1828, Sammlung Rolf Riekher, Berlin
Friedrich Gutkaes, Chronometer No. 42, Dresden, around 1828, Collection Rolf Riekher, Berlin

um Hilfe. Er habe in den vergangenen Jahren nicht einmal die Hälfte der gefertigten Präzisionsuhren verkaufen können; die wertvollsten Stücke befänden sich noch auf Lager. Von den geliehenen 6000 Talern könne er nur 2000 zurückzahlen und bitte daher um eine Beihilfe in Höhe der Zinsen für die verbleibenden 4000 Taler. Dafür wolle er geeignete Zöglinge der Technischen Bildungsanstalt unentgeltlich in seiner Werkstatt ausbilden.[53] Nach eingehender Prüfung wurde auch diesem Gesuch stattgegeben. Gutkaes erhielt auf weitere drei Jahre die jährliche Summe von 120 Talern ausgezahlt.[54] Tatsächlich dürfte der Bedarf an Präzisionsuhren in Dresden und Umgebung gering gewesen sein. Zudem fiel es Gutkaes schwer, einen überregionalen Ruf als Präzisionsuhrmacher zu erlangen.

Dabei hatte er durchaus interessante Geschäftsideen. 1823 publizierte er beispielsweise in den »Annalen der Physik« eine Subskriptionsanzeige, die darauf verwies, dass jede Gutkaes-Uhr mit einem von Oberinspektor Schmidt des

sideration this second petition was granted. For a further three years, Gutkaes received the annual sum of 120 thalers.[54] The demand for precision watches in and around Dresden may indeed well have been small. Furthermore, Gutkaes faced the additional challenge of making a name for himself as a precision watchmaker beyond the confines of Saxony.

One thing he certainly did not lack was interesting business ideas. In 1823, for example, he published an advertisement in the *Annalen der Physik*, pointing out that each Gutkaes timekeeper came with a newly compiled register of its going, issued by August Schmidt, curator of the Mathematical Salon.[55] This was in effect Dresden's attempt to provide some form of official certification for the quality of the watches and clocks, similar to the tests run at the Royal Observatory in Greenwich. In this regard, however, the qualifications of the examiner were not comparable with his British counterpart, because Major Schmidt was neither a trained astronomer nor a diligent observer. In addition to this mar-

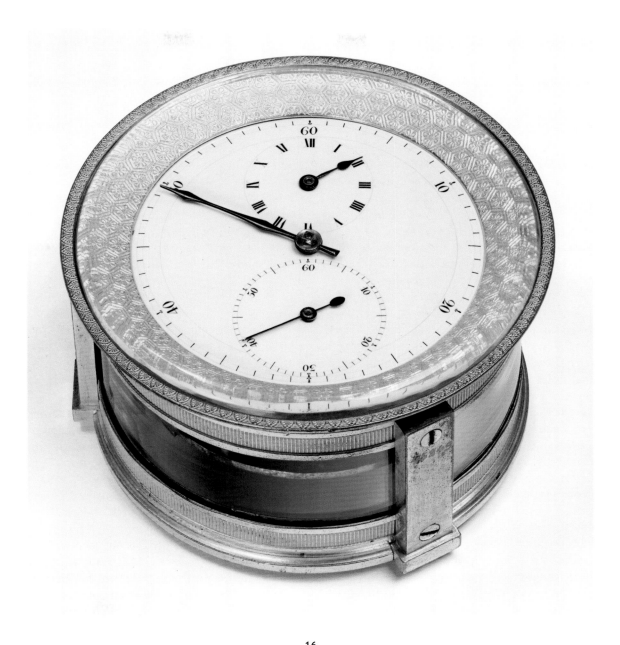

16
Friedrich Gutkaes, Chronometer Nr. 48, Dresden, um 1830, Deutsches Museum, München
Friedrich Gutkaes, Chronometer No. 48, Dresden, around 1830, Deutsches Museum, Munich

mathematischen Salons erstellten Gangjournal versehen werde.[55] Dies war der Dresdner Versuch, die Qualität der Uhren offiziell zu zertifizieren, ähnlich den Gangprüfungen im Observatorium zu Greenwich. Indes dürfte die Qualifikation der Prüfenden nicht vergleichbar gewesen sein, denn Major Schmidt war weder ausgebildeter Astronom noch eifriger Beobachter. Darüber hinaus suchte Gutkaes potenzielle Käufer auch direkt zu erreichen und bot beispielsweise Carl Friedrich Gauss seine Dienste an.[56] Er nutzte das Netzwerk des Salons und verkaufte Uhren z.B. an Karl Gottlieb Behrnauer (Regierungsrat in Berlin), Anton Jungnitz (Sternwarte Breslau) und Franz Hallaschka (Prof. der Physik, Universität Prag). Behrnauer und Jungnitz hatten bereits bei Seyffert gekauft. Hallaschka könnte über seinen Kollegen Alois Martin David, ebenfalls ein guter Bekannter Seyfferts, von den Dresdner Präzisionsuhren erfahren haben. Im Laufe der Zeit etablierte sich Gutkaes als begabter Uhrmacher. Seine Uhren wurden von hochrangigen Privatpersonen wie dem Grafen von Colloredo und von den Sternwarten in Leipzig und Königsberg gekauft.[57] Sein Name war selbst dem norwegischen Astronomen Christopher Hansteen (1784–1873), Leiter der Sternwarte zu Christiania, bekannt, der indes 1853 resümierte, dass Gutkaes' »Verdienste als astronomischer Uhrmacher nicht bedeutend waren«.[58] Gutkaes war ohne Zweifel ein handwerklich ausgezeichnet arbeitender Uhrmacher, der Präzisionsuhren hoher Qualität fertigte. Warum also ging sein Name nicht in die großen Annalen der Präzisionsuhrmacherei ein?

Auf diese Frage ließen sich sicherlich viele Antworten finden. Ein wesentlicher Aspekt scheint mir, dass Sachsen auf der Landkarte der Präzisionszeitmessung des frühen 19. Jahrhunderts schlicht nicht verzeichnet war. Die Zentren der hohen Uhrmacherkunst lagen nach wie vor in England und Frankreich. Zudem besaß Gutkaes keinen einflussreichen Förderer, wie ihn der erfolgreiche und reiselustige Heinrich Johann Kessels (1781–1849) in Altona mit dem namhaften und einflussreichen Astronomen

keting ploy, Gutkaes also sought to reach potential buyers directly and offered his services, for example, to the eminent mathematician Carl Friedrich Gauss.[56] Gutkaes used the Salon's network of contacts and sold timekeepers to such individuals as Karl Gottlieb Behrnauer (councillor in Berlin), Anton Jungnitz (of the Breslau observatory), and Franz Hallaschka (professor of physics at the University of Prague). Behrnauer and Jungnitz had already been clients of Seyffert. Hallaschka may have learned of the Dresden precision clocks and watches through his colleague Martin Alois David, who also was closely acquainted with Seyffert. Over time, Gutkaes established himself as a recognised watchmaker of talent. His timepieces were purchased by influential individuals like the Count von Colloredo and the observatories in Leipzig and Königsberg.[57] His name was even known to the Norwegian astronomer Christopher Hansteen, director of the observatory at Christiania, although in Hansteen's estimation Gutkaes' 'merits as an astronomical cloxk- and watchmaker were of no great significance.'[58] From a technical perspective, Gutkaes was undoubtedly an excellent practicing watchmaker, who fashioned precision clocks and watches of great quality. So why then did his name not make it into the annals of precision horology?

One can certainly find many answers to this question. It seems to me, however, that one crucial factor for this was the fact that in the early nineteenth century Saxony simply did not figure on the map of precision timekeeping. The recognized centres of fine watchmaking remained in England and France. In addition, Gutkaes had no influential supporter of the kind that the successful and widely travelled Heinrich Johann Kessels (1781–1849) of Altona enjoyed in the form of the renowned and influential astronomer Heinrich Christian Schumacher (1780–1850).[59] The Mathematisch-Physikalischer Salon was not an astronomical research facility. Even Wilhelm Gotthelf Lohrmann's (1796–1840) lunar observations failed to garner him wider astronomical recognition. Thus, the Salon remained a marginal

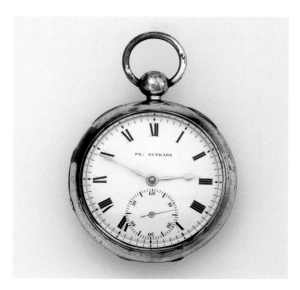
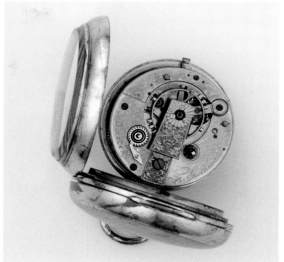

17
Friedrich Gutkaes, Chronometer Nr. 90, Dresden, um 1835, Mathematisch-Physikalischer Salon, Dresden
Friedrich Gutkaes, Chronometer No. 90, Dresden, around 1835, Mathematisch-Physikalischer Salon, Dresden

Heinrich Christian Schumacher (1780 – 1850) an seiner Seite hatte.[59] Der Mathematisch-Physikalische Salon war keine astronomische Forschungsstätte. Auch die Mondbeobachtungen Wilhelm Gotthelf Lohrmanns (1796 – 1840) führten ihn nicht aus seinem astronomischen Randdasein hinaus. Ähnlich ruhig war es um die Sternwarte in Leipzig bestellt. So konnten Kontakte zum Mathematisch-Physikalischen Salon zwar das Initial zur Herstellung astronomischer Uhren sein, zu überregionalen Empfehlungen und Bestellungen führten sie jedoch nicht. In Dresden verhalfen die Präzisionsuhren Gutkaes zu hoher Anerkennung, wie der Auftrag zum Bau der Uhr für das Opernhaus um 1839 und die Bestallung als Hofuhrmacher 1842 bezeugen. Mit seiner Entscheidung für die Präzisionsuhrmacherei hatte er sich als würdiger Nachfolger Seyfferts erwiesen und zugleich die »hohe Uhrmacherkunst« aus der Welt des Amateurs in den Wirkungsbereich der Innung geholt.

Dieser Schritt hatte auch Auswirkungen auf die Qualität der Uhren, die bei Gutkaes ein deut-

figure in astronomy. The observatory in Leipzig similarly failed to make an impact further afield. Consequently, contacts to the Mathematisch-Physikalischer Salon may well have provided the initial impetus for the production of astronomical clocks and watches, however, they did not lead to international recommendations and orders. In Dresden, Gutkaes' precision watches helped raise his profile, as evidenced in the commission to construct the clock for the opera house sometime around 1839 and Gutkaes' appointment as court watchmaker in 1842. By deciding to pursue precision watchmaking, Gutkaes' proved himself a worthy successor of Seyffert and simultaneously took the 'great art of horology' from the domain of the isolated amateur and placed it under the recognized influence of the guild.

This development also had an impact on the quality of the clocks and watches, which reached a significantly higher level under Gutkaes (ill. 17). In contrast to Seyffert, Gutkaes incorporated developments in timekeeping technology,

lich höheres Niveau erreichte (Abb. 17). Im Unterschied zu Seyffert nahm Gutkaes Entwicklungen der Uhrentechnik auf, baute verschiedene Kompensationsunruhen und experimentierte mit Chronometerhemmungen von Johan Arnold und Thomas Earnshaw (1749 – 1829).[60] Überdies profitierte er von den Innungsstrukturen: Wanderjahre, Lehrlinge und Gesellen konnten neue Impulse bringen und erleichterten den Wissensaustausch. Die Gründung des »fabrikmäßigen Instituts« hatte zudem einen weiteren Effekt: Durch sie wurde eine Leitidee der Dresdner Uhrmacherinnung, nämlich die Fokussierung auf die Herstellung des Gebräuchlichen, in Frage gestellt. Gutkaes versuchte von der Erzeugung des Besonderen zu leben und ging damit über seine Innungskollegen, aber auch über Seyffert hinaus, dessen Uhrmachertätigkeit nur Zubrot zu dem soliden Einkommen aus seiner Anstellung bei Hof und den Einkünften seiner vermögenden Ehefrau war. Der Amateur Seyffert hatte sein erstes, nach englischem Vorbild hergestelltes Taschenchronometer noch stolz mit dem Antonio Allegri, genannt Correggio, zugeschriebenen Ausspruch »Anch'io sono pittore« signiert und sich damit in die Tradition der Künstler der Renaissance gestellt, die ihr Metier und ihre Fähigkeiten über den Rang des bloßen Handwerks zu erheben suchten (Abb. 18).[61] Gutkaes hingegen verband das zünftige Handwerk mit der Welt der Wissenschaft und leitete so in der Dresdner Uhrmacherei einen Diversifizierungsschub ein, wie er typisch für viele Handwerke des 18. und frühen 19. Jahrhunderts war. In Zusammenhang mit der beginnenden Industrialisierung wurden die Zünfte schließlich obsolet.[62] Der erhoffte große Erfolg war indes erst Gutkaes' Lehrling Ferdinand Adolph Lange beschieden, der sich anders als sein Lehrmeister auf einen universeller einsetzbaren Uhrentypus spezialisierte und zugleich die Produktionsweise modernisierte.

built various kinds of compensation balances, and experimented with chronometer escapements by Arnold and Thomas Earnshaw (1749 – 1829).[60] Gutkaes also benefited from the guild structures: journeymen and apprentices brought with them fresh possibilities for the spreading and sharing of new ideas and knowledge. The creation of the 'factory-like institution' also had another effect: it questioned a core theme of the Dresden watchmakers' guild, namely the focus on producing the conventional. Gutkaes tried to earn his living by creating special objects of note, which pushed him to achievements that not only outdid his guild colleagues, but also Seyffert, whose activities as a watchmaker only represented an extra source of income on top of his solid income from his position at court and the earnings of his wealthy wife. Seyffert the amateur engraved his first pocket chronometer, produced in the English style, with the proud words 'Anch'io sono pittore,' which are ascribed to Antonio Allegri, called Correggio. By doing so he posited himself in the tradition of Renaissance artists who sought to raise their metier and their skills above that of mere craftsmen (ill. 18).[61] Gutkaes, by contrast, fused organized craftsmanship with the world of science and propelled Dresden horology towards diversification, as was typical of many crafts of the eighteenth and early nineteenth century. With the advent of industrialization, the guilds were eventually to become obsolete.[62] The success Gutkaes strove for, however, would only be achieved some years later by his apprentice Ferdinand Adolph Lange. Unlike his teacher, Lange specialized in a more versatile type of watch, while simultaneously modernizing the mode of production.

18
Johann Heinrich Seyffert, Chronometer Nr. 2, Dresden, 1797, Privatsammlung
Johann Heinrich Seyffert, Chronometer No. 2, Dresden, 1797, Private collection

Gutkaes & Lange, Taschenuhr Nr. 356, Glashütte, um 1849, Privatbesitz
Gutkaes & Lange, Pocket watch No. 356, Glashütte, around 1849, Private collection

4 Qualität in Serie
Quality in Series

1843 wandte sich Ferdinand Adolph Lange (1815 – 1875) an den Geheimen Regierungsrat Carl von Weißenbach mit dem Vorschlag, in einer der hilfsbedürftigen Regionen des Erzgebirges eine Uhrenfabrik zu errichten. Ziel war die Herstellung hochwertiger Taschenuhren mit Ankerhemmung, die in der Qualität englischen Ankeruhren gleichen, dabei aber eleganter und vor allem preiswerter sein sollten. Nach dem Vorbild der Schweiz strebte Lange ein arbeitsteiliges System an. Den Anfang wollte er mit 15 Lehrlingen machen, die sich schon während der Ausbildung auf die Fertigung bestimmter Uhrenteile spezialisieren und nach Beendigung der Lehrzeit eigenständige Zulieferbetriebe für Langes Fabrik gründen sollten. Auf diese Weise sollte schließlich Wohlstand in das strukturschwache Erzgebirge ziehen. Tatsächlich benötigte die Uhrenfabrik nur wenige Rohmaterialien und war damit weder auf natürliche Ressourcen noch in größerem Maße auf ausgebaute Verkehrswege angewiesen. Allerdings war der anfängliche Kapitalbedarf hoch, da Lange zahlreiche Maschinen und Werkzeuge anschaffen musste. Zugleich bedeutete die Ausbildung unerfahrener Strohflechter, dass die Fabrik auf Jahre kaum Uhren ausreichender Qualität produzieren würde. Nach zweijährigen Verhandlungen bewilligte die sächsische Staatsregierung einen zinslosen Kredit von 5580 Talern sowie Unterstützung beim Ankauf der Werkzeuge. Am 7. Dezember 1845 wurde das Unternehmen in Glashütte schließlich feierlich eingeweiht.

In 1843, Ferdinand Adolph Lange (1815 – 1875) approached Privy Councillor Carl von Weißenbach with a proposal for opening a watch manufactury in an impoverished region in the Ore Mountains. The aim was to produce high-quality pocket watches with lever escapements of equivalent quality to English watches, but more elegant and, above all, cheaper. Following the Swiss example, Lange introduced a system of division of labour. He started with 15 apprentices, who specialised in the production of particular watch components during their training. After completion they were to start their own independent businesses, supplying components for Lange's firm. By this means prosperity should come to the economically underdeveloped Ore Mountains. The watch manufactury did need few raw materials, hence, would not be reliant on natural resources or a well-established transport system. However, it required a high initial capital investment as Lange needed to purchase many tools and machines. In addition, having to train inexperienced straw-weavers and servants meant that the factory would not produce watches of sufficient quality for some years. After two years of negotiations, the government of Saxony approved an interest-free loan of 5580 thalers, in addition to support in purchasing equipment. The manufactury in the small town of Glashütte in the Ore Mountains was finally officially opened on 7 December 1845.

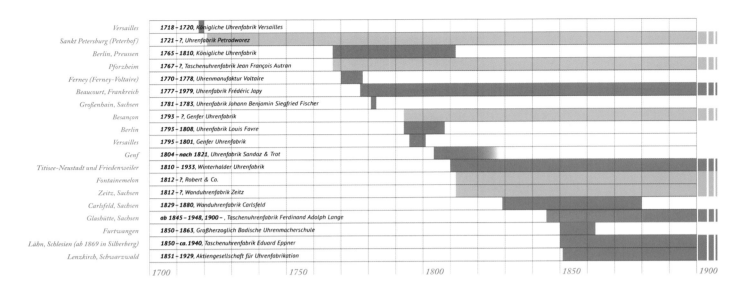

Versailles	1718 – 1720, Königliche Uhrenfabrik Versailles			
Sankt Petersburg (Peterhof)	1721 – ?, Uhrenfabrik Petrodworez			
Berlin, Preussen	1765 – 1810, Königliche Uhrenfabrik			
Pforzheim	1767 – ?, Taschenuhrenfabrik Jean François Autran			
Ferney (Ferney-Voltaire)	1770 – 1778, Uhrenmanufaktur Voltaire			
Beaucourt, Frankreich	1777 – 1979, Uhrenfabrik Frédéric Japy			
Großenhain, Sachsen	1781 – 1783, Uhrenfabrik Johann Benjamin Siegfried Fischer			
Besançon	1793 – ?, Genfer Uhrenfabrik			
Berlin	1793 – 1808, Uhrenfabrik Louis Favre			
Versailles	1795 – 1801, Genfer Uhrenfabrik			
Genf	1804 – nach 1821, Uhrenfabrik Sandoz & Trot			
Titisee-Neustadt und Friedenweiler	1810 – 1933, Winterhalder Uhrenfabrik			
Fontainemelon	1812 – ?, Robert & Co.			
Zeitz, Sachsen	1812 – ?, Wanduhrenfabrik Zeitz			
Carlsfeld, Sachsen	1829 – 1880, Wanduhrenfabrik Carlsfeld			
Glashütte, Sachsen	ab 1845 – 1948, 1900 – , Taschenuhrenfabrik Ferdinand Adolph Lange			
Furtwangen	1850 – 1863, Großherzoglich Badische Uhrmacherschule			
Lähn, Schlesien (ab 1869 in Silberberg)	1850 – ca. 1940, Taschenuhrenfabrik Eduard Eppner			
Lenzkirch, Schwarzwald	1851 – 1929, Aktiengesellschaft für Uhrenfabrikation			

1700 *1750* *1800* *1850* *1900*

Beispiele für die Gründung von Uhrenfabriken bis 1851 (Hellere Balken verweisen auf mangelnde Informationen zur weiteren Existenz bzw. Geschichte der betreffenden Uhrenfabrik.)

Seit der Mitte des 18. Jahrhunderts hatte es in Frankreich und den deutschen Ländern wiederholt Versuche gegeben, größere Uhrenwerkstätten ins Leben zu rufen. Für diese Gründungen wurde zumeist der zu dieser Zeit aufkommende Begriff »Fabrik« verwendet, der indes wenig über die Anzahl der Arbeiter und die Produktionsweisen sagt. Die jeweilige Obrigkeit beurteilte Pläne zur Uhrenfabrikation häufig positiv. Die Landesherren hofften, den Abfluss von Geldern ins Ausland zu verhindern und neue Einkommensmöglichkeiten zu erschließen. Die vermutlich erste sächsische Uhrenfabrik gründete 1781 der Hofuhrmacher Johann Benjamin Siegfried Fischer in Großenhain. Auch er erhielt Unterstützung durch den Kurfürsten. Jedoch wurde bereits zwei Jahre später das spektakuläre Scheitern des Unternehmens bekannt und Fischer von Gläubigern gejagt.

Some watch factory foundations pre-1851 (Light-colored bars indicate that information about the history of the watch manufactory in question is incomplete.)

Since the mid-eighteenth century there had been numerous attempts in France and the German lands to establish watch and clock production on a larger scale. The newly emerging term 'factory' was usually applied to these establishments, but it does not tell us much about the number of workers or the production methods. When plans for watch and clock manufacture were proposed, the reaction of the relevant authorities was often favourable. Local rulers hoped to stem the flow of capital abroad and develop new sources of income. The court watchmaker, Johann Benjamin Siegfried Fischer, was probably the first person to found a watch factory in Saxony, in Grossenhain in 1781. He received support from the Elector, but only two years later news emerged of the spectacular collapse of the enterprise, and Fischer was pursued by creditors.

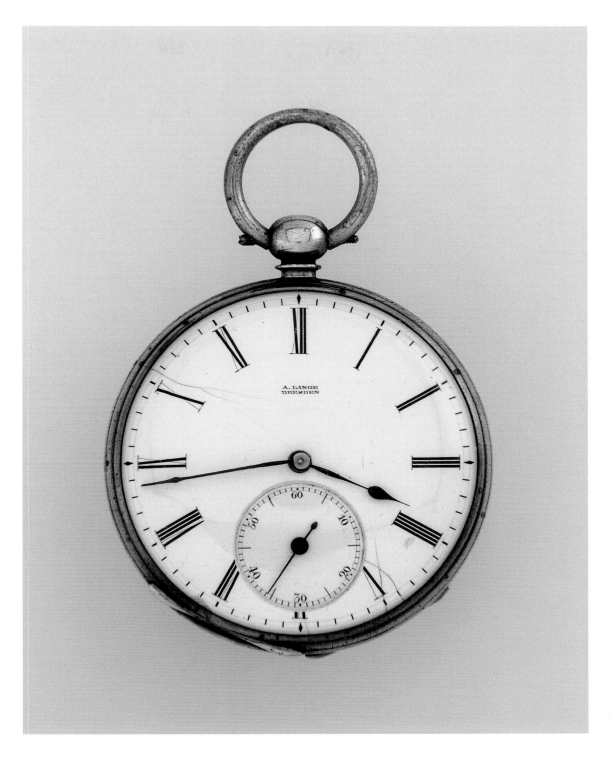

Gutkaes & Lange, Taschenuhr Nr. 683, Dresden, um 1867, Privatbesitz
Gutkaes & Lange, Pocket watch No. 683, Dresden, around 1867, Private collection

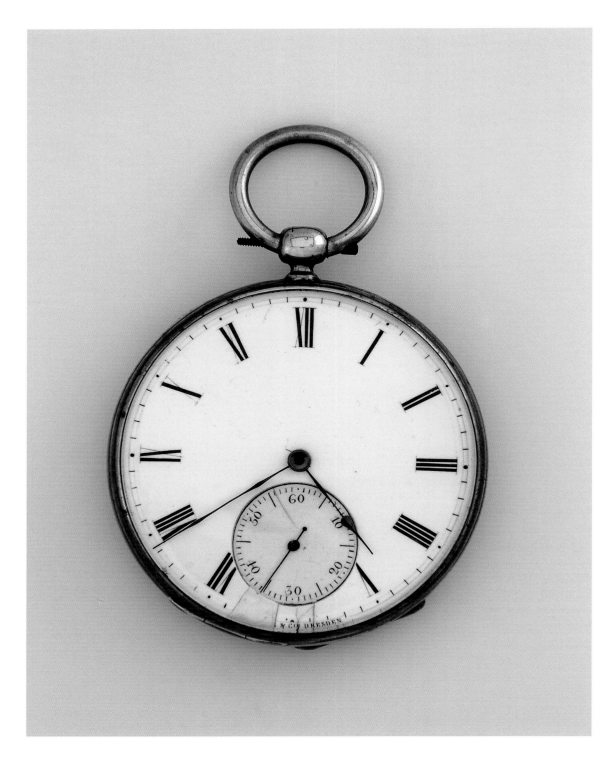

Lange & Cie., Taschenuhr Nr. 1212, Dresden, um 1855, Privatbesitz
Lange & Cie., Pocket watch No. 1212, Dresden, around 1855, Private collection

Mathias Ullmann

Der Weg von Dresden nach Glashütte
The Journey from Dresden to Glashütte

Im Jahr 2015 begeht die Uhrenwelt nicht nur den 200. Geburtstag von Ferdinand Adolph Lange (1815 – 1875), sondern auch den 170. Jahrestag des Beginns der Uhrmacherei in dem sächsischen Ort Glashütte. In den folgenden Ausführungen soll aufgezeigt werden, wie es zur Wahl von Glashütte als Standort der sächsischen Uhrenfertigung kam und welche grundlegenden Änderungen der ursprünglichen Pläne Langes die Wahl dieses Ortes mit sich brachte.

Am 25. Juni 1843 wandte sich der junge Dresdner Uhrmacher Ferdinand Adolph Lange schriftlich an den Regierungsrat im Sächsischen Ministerium des Inneren, Carl Adolph Hermann Freiherr von Weißenbach, mit der Bitte um Unterstützung. Ausgebildet in Dresden bei dem damaligen Hofuhrmachermeister Johann Christian Friedrich Gutkaes (1785 – 1845), hatte Lange seine Kenntnisse auf einer mehrjährigen Wanderschaft in die Schweiz und nach Frankreich, unter anderem bei Thaddäus Winnerl (1799 –

In 2015, the world of horology will not only be celebrating the 200th birthday of Ferdinand Adolph Lange (1815 – 1875), but also the 170th anniversary of watchmaking in the Saxon town of Glashütte. This chapter will demonstrate how Glashütte came to be chosen as the centre for watchmaking in Saxony and how fundamental changes were made to Lange's original plans on account of this choice of location.

On 25 June 1843, the young Dresden watchmaker Ferdinand Adolph Lange wrote to the councillor of the Saxon Ministry of the Interior, Carl Adolph Hermann Freiherr von Weißenbach, with a request for support. After training in Dresden with the then master watchmaker of the Saxon court, Johann Christian Friedrich Gutkaes (1785 – 1845), Lange spent several years furthering his skills abroad in Switzerland and France, for instance with Thaddäus Winnerl (1799 – 1886) in Paris. On his return, he had the idea to establish a domestic watchmaking in-

1886) in Paris, vertieft. Nach seiner Rückkehr schwebte ihm nunmehr die Etablierung einer einheimischen Uhrenherstellung vor und zwar nach einem grundlegend neuen System, welches er in der Schweiz kennengelernt hatte: dem sogenannten Verlagssystem, bei welchem nicht mehr der Uhrmacher selbst die Teile seiner Uhr anfertigt, sondern diese von einem Netz ausgebildeter und speziaisierter Zulieferer erhält. Lange schrieb an von Weißenbach:

»Ich dachte daß der hohen Staatsregierung ein solcher Plan willkommen seyn müße, der, wie aller Grund zu glauben da ist, wen er gelingt, in der Folge Tausenden Nahrung und Wohlstand verspricht. Leben doch, den neuesten Berichten zu Folge, im Canton Neufchatel allein mehr als 8000 Personen von der Uhrmacherei! Und in der That, wo ist auch ein Intustriezweig so unabhängig von Material und folglich der Gegend wo er betrieben wird? ein Geschäft so sehr für alle Intelligencen existent, das für gewisse Arbeiten Weiber und Kinder ausreichen? wo ist ein Industriezweig, der in moralischer Hinsicht so wie dieser den großen Vortheil gewährt, das Arbeiten in der Familie zu begünstigen und so die große Klippe der Begünstigung Einzelner auf Kosten der Menge zu vermeiden? Auf der anderen Seite ist auch wohl schwerlich eine Gegend zur Uhrenfabrikation der Schweiz gegenüber mehr geeignet als gerade unser Erzgebirge, weil die Arbeitslöhne hier ungleich billiger als dorten und der Werth der Uhr nicht durch das Material, sondern lediglich durch die Arbeitslöhne herbeigeführt wird. Das Metall des Werkes ist fast nichts, die Arbeit alles!«[1]

Dass das Anliegen von Lange auf Interesse stieß, lag an den grundlegenden Veränderungen, welche Sachsen in der ersten Hälfte des 19. Jahrhunderts durchlebte. In den Napoleonischen Kriegen an der Seite Frankreichs zählte Sachsen zu den Verliererstaaten und bekam so auf dem Wiener Kongress von 1815 die Rechnung für seine Frankreichtreue präsentiert: Sachsen verlor rund 50 Prozent seines Territoriums und 40 Prozent seiner Bevölkerung, zum größten Teil an Preußen. In den darauffolgenden

dustry, which would be based on an entirely new system that he had become familiar with in Switzerland: the so-called 'établissage' system, in which watchmakers no longer fabricated the components of their watches themselves but acquired them instead from a network of qualified and specialized suppliers. In his letter to von Weißenbach, Lange writes:

'I thought that the higher state authorities must welcome such a plan, which, should it succeed, as there is every reason to believe, would promise sustenance and a livelihood to thousands. According to the latest reports, more than 8000 people in the Canton of Neuchâtel alone are making a living from watchmaking! And indeed, what other branch of industry is there that is so independent of its materials and hence, so too, the region in which it is practised? A business that encompasses all levels of intelligence to such an extent that even women and children can carry out certain jobs? Where is there another branch of industry that, from the moral perspective, offers, as this does, the great advantage of fostering work within families, hence avoiding the pitfalls that arise when individuals profit at the cost of the masses? Moreover, it would be hard to find a region that, in comparison with Switzerland, is more suitable for watchmaking than our Ore Mountains, as wages here are incomparably lower, and the value of a watch is not achieved through its materials but rather through wages. The metal used for the piece is worth almost nothing, the work everything!'[1]

That Lange's concept met with interest was mainly due to the considerable upheaval that Saxony was undergoing in the first half of the nineteenth century. The state of Saxony was considered one of the losers of the Napoleonic wars for siding with France. It paid dearly for its loyalty to the French at the Congress of Vienna in 1815, ceding about 50 per cent of its territory and 40 per cent of its population, mostly to Prussia. Over the following years Saxony attempted to regain its former strength through an extensive modernization programme. A significant aspect of this was the decision to modernize, one could even

Jahren versuchte Sachsen durch ein umfangreiches Modernisierungsprogramm wieder zu einstiger Stärke zurückzugelangen. Eine wesentliche Rolle spielte dabei die Modernisierung, man kann sogar von Revolutionierung sprechen, der bestehenden Infrastruktur mittels des Eisenbahnbaues, welcher seit Mitte der 1830 Jahre in Angriff genommen wurde. Im Zuge dieses Projektes entstand plötzlich ein enormer Bedarf an preiswerten, zuverlässigen und tragbaren Zeitmessern. Diesen Bedarf aus eigener Herstellung und nicht mittels Importen zu decken, lag auch im Interesse des sächsischen Hofes. Da Langes Projekt zudem die Möglichkeit bot, einer notleidenden Region Sachsens zu Beschäftigung zu verhelfen, glückte es ihm, für seinen Plan die finanzielle Unterstützung des Hofes zu erlangen.

Der ursprüngliche Plan Langes beinhaltete einige wesentliche Positionen, die hier kurz zusammengefasst werden sollen: Die von ihm zur Ausbildung anzunehmenden Schüler sollten zwischen 16 und 20 Jahren alt sein, ihre Ausbildung sollte in Dresden erfolgen und nach einer vierjährigen Lehre bei Lange sollten sie in ihren Heimatort zurückkehren und sich dort als selbstständige Zulieferer für ihn niederlassen.

Es erschien Lange wünschenswert, dass alle seine Auszubildenden aus ein und demselben Ort kamen, damit sich dort nach der Ausbildung eine regional begrenzte Zulieferindustrie etablieren konnte, die Kooperation und Kommunikation ermöglichte.

Was den Herkunftsort der Schüler betraf, so hatte Lange zu Beginn keine bevorzugte Wahl. Er schrieb in der oben zitierten Quelle lediglich davon, den »armen Bewohnern des Erzgebirges« die Möglichkeit eines ausgiebigen Broterwerbs verschaffen zu wollen. Die Wahl von Dresden als Ausbildungsort ergab sich hingegen neben der Tatsache, dass Lange selbst hier ansässig war, aus der Möglichkeit für die Schüler, neben der Lehre bei Lange das Polytechnikum für eine allgemeine naturwissenschaftliche und technische Ausbildung zu besuchen.

Das geforderte, relativ hohe Eintrittsalter der Schüler begründete Lange damit, dass diese

say revolutionize, the existing infrastructure through the construction of a railway which began in the mid-1830s. In the course of this project the demand for affordable, reliable and portable timepieces increased dramatically. Covering this need through local production rather than through imports was in the interests of the Saxon court, too. As Lange's project additionally provided the chance to create employment in a deprived region of Saxony, he successfully managed to secure the funding required to implement his plan from the royal court.

Lange's original plan comprised several important points that can be summarized as follows: to be eligible for an apprenticeship, potential students had to be between 16 and 20 years old, their apprenticeship would take place in Dresden, and after a four-year apprenticeship with Lange, they would return to their hometowns and establish themselves there as independent traders who would supply him with the parts that he required.

It was evidently preferable to Lange that all of his apprentices come from one and the same place so that once trained, they could form an industry of suppliers within a specific region, which would facilitate cooperation and communication.

Which region the students came from was at first irrelevant to Lange. He merely mentioned in the source quoted above that he aimed to provide 'the poor inhabitants of the Ore Mountains' with the opportunity to earn a decent living. Conversely, the choice of Dresden as the location for the apprentices' training came about partly because Lange himself was based there but also because the students could then receive a general education in natural sciences and technology at the Dresden Polytechnic College in addition to their apprenticeship with Lange.

The relatively high age required for admittance was justified by Lange with the reasoning that on completion of their training, the students would have acquired enough moral maturity to be able to manage their own enterprise.

nach Beendigung ihrer Ausbildung bereits die nötige moralische Reife zur Führung eines eigenen Unternehmens besitzen sollten.

Die genannten Punkte des Lange'schen Planes erlebten in den kommenden Jahren einige wichtige Änderungen, die die Basis dafür lieferten, dass Glashütte auch heute noch ein weltweit anerkanntes Zentrum feiner Uhrmacherkunst darstellt. Deshalb soll hier neben Lange eine weitere Persönlichkeit gewürdigt werden, welche in den bisherigen Beschreibungen stets etwas stiefmütterlich behandelt wurde: Gustav Adolph Lehmann, der damalige Justizamtmann von Dippoldiswalde.

Das Innenministerium stand Langes Plan aufgeschlossen gegenüber, hatte es doch selbst ein Programm ins Leben gerufen, das Unternehmern, die sich in verarmten Regionen ansiedeln wollten, mittels zinsloser Kredite eine Anschubfinanzierung verschaffen sollte. Als erster Schritt wurde nun nach einem geeigneten Ort gesucht. Am 28. Mai 1844 erging deshalb ein gleichlautendes Schreiben an die Kreisdirektionen Zwickau, Dresden und Bautzen – die Oberlausitz war zur damaligen Zeit von ebenso großer Not gezeichnet wie das Erzgebirge:

»Wenn nun das Ministerium des Innern dieses Project in nähere Erwägung zu ziehen wohl für werth erachtet, so kommt es vor weiterer Beschlußfassung hauptsächlich darauf an, zuvor zu ermitteln, welcher Ort sich vorzüglich zur Einführung dieses neuen Fabrikzweiges eignen dürfte, und ob sich daselbst auch eine solche Bereitwilligkeit vorfinden werde, um mindestens 15 geeignete Lehrlinge auf die 4jährige Lehrzeit dafür darzubieten? Als Qualifikation der letzteren wird ein Mehreres nicht erfordert, als daß dieselben eine gute Ortsschulbildung und einige Gewöhnung an genaues und sorgfältiges Arbeiten in irgend einer auf Handfertigkeiten beruhenden Gewerbsbeschäftigung besitzen, mindestens 16 bis 20 Jahre alt sind und eine gute sittliche Aufführung und Liebe zu dem zu erlernenden Berufe haben. Obwohl der von dem Unternehmer beanspruchte Staatsvorschuß wesentlich mit die Bestimmung hat, den Zöglingen außer dem freien

These points from Lange's original plan were significantly revised over the following years, ultimately creating the conditions that established Glashütte as an internationally acclaimed centre of fine watchmaking right up to the present day. In this context, a second individual deserves to be mentioned alongside Lange, someone who has been somewhat neglected in previous historical discourse: Gustav Adolph Lehmann, then district magistrate of Dippoldiswalde.

The Ministry of the Interior was open to Lange's plan; indeed, it had even instigated its own programme to provide financial aid in the form of interest-free credit to entrepreneurs who wanted to set up businesses in deprived areas. The first step was now to find a suitable location. On 28 May 1844, an identically-worded letter was thus sent to the local authorities of Zwickau, Dresden, and Bautzen, respectively – the situation in the region of Oberlausitz was, at that time, as dire as in the Ore Mountains:

'If the Ministry of the Interior deems this project worthy of closer consideration, the chief concern, before any further resolutions are met, is to first determine which location would be best suited for the implementation of this new branch of manufacture and whether there would be sufficient willingness in said place to commit at least 15 suitable apprentices for the four-year training period? To qualify for the latter, no more will be required from candidates than a good local-school education and a familiarity with precise and meticulous work in any trade that requires manual dexterity, that they are at least 16 to 20 years of age and possess upstanding morals and a love of the trade in which they will train. Although the state funding received by the entrepreneur is intended to not only fund the apprentices' training but also to help pay for the costs of their upkeep in Dresden, where the lessons are to take place, as desired by the watchmaker Lange on account of his other business relations, the execution of the plan in its entirety would gain greater expediency, if the apprentices, or depending on the circumstances, their hometowns on their behalf, are capable of

Unterricht auch ihre Subsistenz selbst hier in Dresden, wo die Unterrichtsertheilung von dem Uhrmacher Lange seiner übrigen Geschäftsverhältniße wegen gewünscht wird, zu erleichtern und zu unterstützen, so würde doch die Ausführung des ganzen Planes um so mehr an Thunlichkeit gewinnen, je mehr die Zöglinge selbst, oder nach Befinden ihre Heimathsorte für sie, einen Theil der Kosten ihres hiesigen Lehraufenthaltes zu übernehmen im Stande und bereitwillig sind. Es wird daher die Kreisdirektion zu [...] hierdurch beauftragt, in genaue Erörterung zu ziehen, welcher Ort ihres Bezirks sich zur Ausführung dieses Projektes theils hinsichtlich des vorzugsweisen Bedürfnisses zu Erlangung eines neuen Gewerbszweiges, theils hinsichtlich der Bereitwilligkeit und etwaigen Beitragsfähigkeit der Lehrlinge, am mehrsten eignen und vielleicht selbst erbieten dürfte? und hierüber Anzeige anher zu erstellen, damit sodann die weiteren Ermittlungen deshalb angestellt werden können.«[2]

Aus einer handschriftlichen Notiz des Regierungsrates von Weißenbach über ein Gespräch mit Lange am 17. Januar 1844 geht hervor, dass das Innenministerium zunächst andere Orte gegenüber Glashütte favorisierte:

»Gegenden, die für die Auswahl für das neue Uhrenfertigungswerk in Frage kommen könnten, sind: Johanngeorgenstadt, wo die Gewerbe gering sind, der Grenzhandel aufgehört hat, das Bergamt wo nicht der Bergbau selbst vielleicht bald eingehen wird, und irgend ein neuer Erwerb höchst drängend ist, Die vogtländischen Waldorte Neukirchen, Klingenthal, Zwota, wo die Instrumentenfabrikation neuerlich sehr zurückgegangen ist, Geyer, Ehrenfriedersdorf, und dasige Gegend, wo die Posamentier- und Nagelschmiede-gewerbe höchst niedergedrückt und der Bergbau gesunken sind.«[3]

Die angeschriebenen Kreisdirektionen antworteten zügig. Langes Plan wurde begrüßt und die Ansiedlung eines solchen Unternehmens im eigenen Verantwortungsbereich befürwortet, bei der konkreten Umsetzung jedoch baten die Kreisdirektionen um Zugeständnisse. Insbesondere ging es dabei um das vorgesehene Alter der

and prepared to take on part of the costs of their time spent here during the course of the apprenticeship. Therefore, we hereby commission the district authorities of [...] to determine which location in their jurisdiction would be most suitable for the implementation of this project, both on account of their urgent need to establish a new trade, and the readiness and potential capability of apprentices to make a financial contribution to their own training, and to issue hither a report on the matter so that further investigations can be undertaken.'[2]

From a handwritten note from councillor von Weißenbach regarding a conversation with Lange on 17 January 1844, it can be seen that the Ministry of the Interior initially favoured other locations over Glashütte:

'Regions that come into question for the site of the new watch manufactory are: Johanngeorgenstadt, where there are few trades, cross-border trade has ceased, the mining office where even mining may soon come to an end and a new trade is urgently required, the wooded regions of the Vogtland: Neukirchen, Klingenthal, Zwota, where the production of instruments has recently declined sharply; Geyer, Ehrenfriedersdorf, and adjacent regions where the trades of loop making and nail smithery are in decline and mining has dwindled.'[3]

The response from the regional authorities that had been contacted was prompt: Lange's plan was generally welcomed and the location of such an enterprise in their jurisdictions approved, although in terms of its implementation, the authorities requested certain concessions. One particular concern was the proposed minimum age for apprentices. The problem of finding enough suitable candidates within this age group is described by the Dresden district administration in its response from 26 October 1844:

'[...] that the prescribed age of 16 years for prospective apprentices may not be too stringently applied and that attention has been brought to a concern that young people between the age of 16 and 20 would justifiably no longer

Auszubildenden. Die Probleme, in dieser Altersgruppe genügend geeignete Bewerber zu finden, beschreibt die Kreisdirektion Dresden in ihrer Antwort vom 26. Oktober 1844 folgendermaßen:

»[...] daß auf dem geforderten Alter von 16 Jahren für die betreffenden Lehrlinge nicht streng bestanden werden möge, und dabei auf das Bedenken aufmerksam gemacht worden, daß junge Leute in dem Alter von 16 – 20 Jahren zu Erlernung des fraglichen Gewerbes nicht füglich mehr geschickt sein würden, weil sie in der Regel nach vollendeter Schulzeit zu einer bestimmten Beschäftigung sich schon wenden müßten, und bei dieser durch die damit verbundenen meistens gröberen Arbeiten die Geschicklichkeit der Hände zu feineren Arbeiten verlören, den Aeltern aber meistens nicht möglich sein würde, ihre Kinder vom 14ten bis 16ten Lebensjahre ohne bestimmte Beschäftigung zu Hause zu behalten, und wenn sie sich einmal einem anderen Erwerbszweige zugewendet haben, es immer für sie mißlich sein, denselben wieder aufzugeben.«[4]

In der erwähnten Stellungnahme der Kreisdirektion Dresden, welche auch für das Osterzgebirge zuständig war, wurde dabei zunächst Altenberg der Vorzug gegeben; Glashütte wurde eher am Rande erwähnt:

»Indem sich daher die unterzeichnete Kreis-Direction, damit nicht noch längerer, und am Ende vielleicht vergeblicher Verzug in die Sache gebracht, vielmehr, als worauf doch etwas Wesentliches anzukommen scheint, dem Uhrmacher Lange die Gewißheit gegeben werden könne, daß sein gemeinnütziger Plan an einem bestimmten Orte bereitwillig aufgefaßt worden sei, vor der Hand für Altenberg vorzugsweise sich zu verwenden erlaubt.«[5]

In dieser Situation trat nun der Dippoldiswalder Justizamtmann Gustav Adolph Lehmann in Aktion, dessen Bedeutung für das Entstehen des Standortes Glashütte und für die Umsetzung von Langes Plan bis heute nicht ausreichend gewürdigt worden ist. Lehmann verschrieb sich sofort dem Ziel, das gesamte Unternehmen nach Glashütte zu holen, woraufhin er sich mehrfach in den Ort begab und mit dem dortigen Stadtrat

be sufficiently adept to learn the trade in question as they would generally have had to take up some other occupation after finishing school, and the often coarser work that this occupation might entail may have diminished the dexterity of their hands for finer work; their parents, however, would not be able to keep them at home between the ages of 14 and 16 without any proper work, and once they had taken up a different line of work it would always be difficult for them to then give it up.'[4]

In the aforementioned response from the district administration of Dresden, which was also responsible for the eastern Ore Mountain region, preference was initially given to Altenberg; Glashütte was only mentioned in passing:

'To avoid lengthy and in the end perhaps futile delays rather than arriving at what seems to be the crux of the matter, the undersigned district administration may provide the watchmaker Lange with the certainty that his charitable plan has been readily construed for one area, and thus permit itself to state its current preference for Altenberg.'[5]

It is at this point that the Dippoldiswalde magistrate Gustav Adolph Lehmann intervened. His significance for the selection of Glashütte as a location for the implementation of Lange's plan has not been adequately acknowledged to this very day. Lehmann made it his goal from the outset to win the entire enterprise for Glashütte, to which end he regularly visited the town and negotiated with the local town council. A short time later he was able to present the Ministry of the Interior with a comprehensive list of young people that appeared to be suitable candidates for the apprenticeship.[6] Furthermore, he managed to extract a statement from the town council that later turned out to be the deciding factor in the battle for the choice of location:

'Moreover, the members of the town council and the representatives of the municipality have declared unanimously that: the community would be prepared to provide a contribution of 53 thalers and 10 neugroschen for the upkeep of each apprentice that comes from the town

verhandelte. Kurz darauf konnte er dem Innenministerium eine umfangreiche Liste mit Jugendlichen präsentieren, die für eine Ausbildung geeignet erschienen.[6] Darüber hinaus bewegte er den Stadtrat zu einer Aussage, welche sich später als entscheidender Trumpf im Kampf um die Standortwahl erweisen sollte:

»Ferner erklärten die Mitglieder des Stadtrathes, sowie die Communrepraesentanten übereinstimmend: Es wolle die Gemeinde zur Sustentation eines jeden Lehrlings, welcher hier heimathsangehörig sey, auf die bedungenen vier Lehrjahre einen Beytrag von 53 Thalern 10 Neugroschen in der Maase bewilligen daß sie für jeden Lehrling zu dessen Bedürfnissen an Alienaten, Bekleidung und Quartiergeld soweit dieselben den Aufwand nicht aus eigenen Mitteln oder durch Unterstützung ihrer Angehörigen oder anderer Personen zu bestreiten vermöchten, jährlich 13 Thaler 10 Neugroschen beyzusteuern verpflichtet sey. Diese Beysteuer betrage in der Voraussetzung, daß aus Glashütte 15 junge Leute die fragliche Taschenuhrenfabrikation innerhalb vier Lehrjahren erlernen und keiner derselben, wie fast mit Bestimmtheit vorauszusehen aus eigenen Mitteln oder durch Unterstützung seiner Angehörigen unterhalten werden könne, überhaupt 800 Thaler mithin eine Summe, die die Gemeinde weder ganz noch theilweise auf andere Weise aufzubringen, als durch von Jahr zu Jahr nach dem Betrage der Bewilligung sich wiederholende Anleihen im Stande sey. Ob nun schon die Gemeinde hiermit von neuen mit Schulden sich belaste, so bringe sie dennoch unbedenklich dieses Opfer, weil allgemein eingesehen werde, daß nur durch die Ergreifung der sich darbietenden Gelegenheit, die Ankeruhren-Fabrikation in hiesigen Ort zu verpflanzen, der Nahrungslosigkeit derselben abgeholfen werden könne.«[7]

In diesem Punkt unterschied sich Glashütte von allen anderen angesprochenen Orten: Die Stadt war bereit, ungeachtet ihrer eigenen angespannten Finanzlage, das Unternehmen von Lange, insbesondere die Ausbildung der Schüler, finanziell zu unterstützen.

for the stipulated period of four years of the apprenticeship, that they obligate themselves to pay an annual contribution of 13 thalers and 10 neugroschen for each apprentice to cover victuals, clothing and quarters, unless said apprentice is able to cover the costs from his own means or through the support of his family or other persons. This contribution is based on the condition that 15 young people from Glashütte will learn the trade of pocket watch manufacturing within a four-year training period and that none of these, as is no doubt foreseeable, can be maintained through his own means or the support of family, not to mind that 800 thalers is indeed a sum that the municipality cannot raise in whole or in part except through loans repeated each year depending on the amount that has been authorized. If to this end the community has to take on new debts, it is, without hesitation, prepared to make this sacrifice because it is generally accepted that only by grasping this opportunity to base the fabrication of lever escapement watches in this region, can the poverty suffered by the very same be remedied.'[7]

In this point Glashütte differed from other regions that were being considered: the town was prepared, irrespective of their difficult financial situation, to help fund Lange's endeavour, in particular the cost of training the students.

Lehmann then sought advice from a watchmaker with whom he was acquainted from La Chaux-de-Fonds in Switzerland, who described in greater detail the 'établissage' system that was common there so that Lehmann was able to present the ministry with concrete figures on the potential benefits of his venture:

'In regions of Switzerland where pocket watches are fabricated, especially Cheaux [sic] de Fonds, the people employed in this area are either pieceworkers or are fully qualified watchmakers (manufacturers). Every pieceworker in Switzerland sets up his own independent workshop after completing his apprenticeship, he delivers his works, excluding polishing and gilding, to a particular manufacturer and, so as to

Lehmann holte darüber hinaus den Rat eines ihm bekannten Uhrmachers aus La Chaux-de-Fonds in der Schweiz ein, welcher das dortige Verlagswesen ausführlich beschrieb, so dass Lehmann dem Ministerium konkrete Zahlen über den möglichen Nutzen des Unterfangens vorlegen konnte:

»In den Orten der Schweitz, wo die Fabrikation der Taschenuhren betrieben wird, insbesondere Cheaux [sic] de Fonds sind die damit beschäftigten Personen entweder Stückarbeiter oder vollendete Uhrmacher (Fabrikanten). Jeder Stückarbeiter ist in der Schweiz nach vollendeter Lehrzeit selbstständig, er liefert seine Arbeiten bis aufs Poliren und Vergolden an einen beliebigen Fabrikanten ab und arbeitet, um nie in den Fall zu kommen, zu feyern oder in der Arbeit aufgehalten zu werden, für mehrere Fabrikanten, deren es dort über 200 giebt. [...] Der niedrigste Verdienst eines Arbeiters in der Schweitz beträgt täglich ungefähr 1 ½ franc, der höchste 15 ff, der der Mehrzahl 5 ff. Auch Frauenzimmer erlernen von kleinen Partien der Uhrbestandtheile Eine und bringen es damit, obschon diese gering bezahlt werden, zu einem guten Arbeitsverdienste, indem sie zu einer bedeutenden Fertigkeit gelangen. [...] Ich habe alle diese Einzelheiten, welche ich hiermit zu referiren mir erlaubt, der, wie ich nicht zweifle, zuverläßigen Auskunft eines mir bekannten Landsmannes, des Uhrfabrikant Krause in Chaux-de-Fonds, an den ich mich brieflich gewendet, zu verdanken, und nur noch hinzuzufügen, daß manchen in Betreff des fraglichen Fabricats dort Statt findenden sehr zweckmäßigen Einrichtungen großer Abbruch durch die herkömmliche Zahlung der Arbeiten, die nicht wöchentlich, sondern in der Regel nach Ablauf eines halben Arbeitsjahres in einer Summe erfolgt, geschieht.«[8]

Auch aufgrund der Lehmann'schen Aktivitäten entschied sich das Ministerium Ende 1844 endgültig für den Standort Glashütte:

»Nach den von den 3 Kreisdirektionen eingegangenen Berichten dürfte sich zu der vom Uhrmacher Lange beabsichtigten Etablirung der Fabrikation von Ankeruhrentheilen Glashütte am

never have time for idleness or to be distracted from working, supplies several different manufacturers, of whom there are more than 200 in the locality. [...] The lowest daily income earned by a worker in Switzerland is about 1½ francs, the highest 15 ff with the majority earning about 5 ff. Women are also taught how to handle small parts of the watch components, and although not well paid, can manage to earn a good income if they achieve a significant level of skill in this craft. [...] All these details, which I have taken the liberty of presenting here, I have thanks to the reliable information, of that I have no doubt, sent to me by a landsman known to me, the watch manufacturer Krause in Chaux de fonds, with whom I have corresponded, and can only add that some practices there, which relate to the factory in question and which are extremely utilitarian, have led to considerable outages due to the customary method of paying for supplies not on a weekly basis but generally in one sum after half a working year.'[8]

Lehmann's activities were another reason why the ministry finally opted for Glashütte at the end of 1844:

'After receiving the reports from the three regional administrations, it would seem that Glashütte would seem to be the most suitable location for the establishment of a manufactory of parts for lever escapement watches as intended by the watchmaker Lange. For (1) apart from Altenberg, no other location that has been considered and since consulted voiced such a heartfelt commitment and understanding of the charitable aspect as Glashütte. Here we can see that the active interest of the town's representatives is expressed through action and not just empty words, indeed is even supported by the offer of funding – considerable for such a small town – to the tune of 800 thalers. It is thus not only that this is the largest material contribution to the undertaking that has been proposed, but rather that this willingness serves as the strongest guarantee that the town's representatives, not only involved in name but through pecuniary interests, will oversee and actively promote the

besten eignen. Denn 1. außer in Altenberg hat sich an keinem der berücksichtigt und resp. befragt gewesenen Orten eine ähnliche warme Theilnahme und Auffassung der wohlthätigen Ader ausgesprochen wie in Glashütte. Hier ist dieses lebhafte Interesse durch die Kommunvertreter selbst ausdrücklich und nicht blos wörtlich, sondern sogar durch das Anerbieten einer – für ein solches Örtchen schon namhaften – Unterstützung von 800 Talern, ausgedrückt worden. Es ist also nicht blos der größte materielle Beitrag für das Unternehmen hier geboten, sondern in dieser Bereitwilligkeit auch die stärkste Garantie gegeben, daß die nemlichen und nun selbst pekuniär dabei interessirten Kommunvertreter den gedeihlichen Fortgang der neuzubegründenden Industrie gewiß überwachen und thunlichst fördern, jedenfalls aber aus eigenem Antriebe den gewöhnlichen Vorurtheilen gegen das Neue entgegentreten werden. 2. Diese Garantie wird zur Zeit noch durch die lebhafte Fürsprache und Theilnahme des Amtmannes Lehmann, des ersten Beamten des Orts und Obrigkeit, verstärkt.«[9]

Unmittelbar nach dieser Entscheidung nahm Lehmann Kontakt zu Lange auf[10] und bewegte diesen dazu, weitere Änderungen an seinem ursprünglichen Plan vorzunehmen. Der wesentliche Punkt dabei war es, nunmehr das gesamte Unternehmen in Glashütte statt in Dresden anzusiedeln, was auch einen Umzug Langes nach Glashütte erforderte:

»Nach Kenntnißnahme der besonderen Umstände erscheinen einige Modificationen meines früheren Planes wünschenswert und nützlich, und ich erlaube mir dieselben hier dem Hohen Ministerium des Innern mitzutheilen und um Unterstützung des Unternehmens in seiner jetzigen Form, unterthänig zu bitten. 1. Um die Schwierigkeiten zu beseitigen, die nöthige Anzahl junger Leute zu finden und um die Kosten ihres Unterhaltes zu mindern, habe ich mich entschloßen, selbst nach Glashütte zu gehen, statt diese jungen Leute während ihrer Lehrzeit hierher zu nehmen, überhaupt aber diese Zeit nach meinen jetzigen Erfahrungen statt auf 4 auf 3

progress of the new industry; simultaneously, through their participation, the usual prejudice against anything new can be circumvented. (2) This guarantee is at present reinforced by the strong support and engagement of district magistrate Lehmann, senior civil servant of the municipality.'[9]

Following this decision, Lehmann immediately made contact with Lange[10] and convinced him to make further changes to his original plan. Essentially, he wanted to relocate the entire operation from Dresden to Glashütte, which would also require Lange to move to Glashütte:

'After learning of the particular circumstances, several modifications to my earlier plan would now seem desirable and beneficial, I would thus like to inform the eminent Ministry of the Interior thereof and, as your humble servant, to request support for the undertaking in its current form. (1) To avoid the difficulty of finding the required number of young people and to minimize the cost of their upkeep, I have decided that I myself will move to Glashütte, rather than bringing these young people here for the duration of their apprenticeship; moreover, in light of the knowledge that I have since gained, to reduce the length of the training to 3 instead of 4 years, and (2) in order to ensure the young people an adequate education in the sciences, for which I initially counted on the technical college in Dresden, whilst there is no such possibility here, I would like to take one of my present workers and former students Adolph Schneider with me, whereby part of his time would be allocated to the teaching of mathematics and drawing for which he is entirely suitable and capable, as he received a thorough scientific education at the [Dresden] Technische Bildungsanstalt [technical college].'[11]

It was this version of the plan that was finally implemented on 7 December 1845: the training of the students took place in Glashütte, and a special 'Sunday school' was set up for all courses that went beyond the subject of watchmaking. The apprenticeship was reduced from four to three years, and the required age for admission

Jahre festzusetzen, und 2. um den jungen Leuten die nöthige wissenschaftliche Bildung zu verschaffen, wo ich hier auf die technische Bildungsanstalt rechnete, dort aber dazu gar keine Gelegenheit vorhanden ist, will ich einen meiner jetzigen Arbeiter und früheren Schüler Adolph Schneider mitnehmen und einen Theil seiner Zeit zum Unterricht in Mathematik und Zeichnen verwenden, wozu er ganz geeignet und fähig ist, indem er in hiesiger technischer Bildungsanstalt eine tüchtige wissenschaftliche Ausbildung gewonnen hat.«[11]

Nunmehr besaß der Plan jene Form, in welcher er schließlich ab dem 7. Dezember 1845 umgesetzt wurde: Die Ausbildung der Schüler erfolgte in Glashütte, für die Ausbildung über die Uhrmacherei hinaus wurde eine eigene Schule, die »Sonntagsschule«, ins Leben gerufen. Die Lehrzeit wurde von vier auf drei Jahre verkürzt, das geforderte Eingangsalter der Schüler herabgesetzt. Lange siedelte selbst nach Glashütte über und nahm die Endmontage der Uhren dort vor. Gleichzeitig brachte er für den Unterricht in Mathematik und Zeichnen mit Adolph Schneider einen Assistenten mit nach Glashütte, welcher sich später selbst als Uhrenfabrikant im Ort etablieren sollte.

Erst diese Änderungen schufen die Basis für das Entstehen der Uhrenindustrie in Glashütte. Bei Umsetzung des ursprünglichen Planes erscheint es zumindest fraglich, ob die Schüler nach Beendigung ihrer Ausbildung tatsächlich in ihren Heimatort zurückgegangen oder ob sie nicht lieber in Dresden geblieben wären – was auch für Lange aufgrund der kürzeren Liefer- und Kommunikationswege von Vorteil gewesen wäre.

Einige der von Lange ausgebildeten Jugendlichen des ersten Jahrganges machten sich nach Beendigung ihrer Ausbildung als Zulieferer selbstständig, obwohl sie bei ihrem Schritt zum Unternehmer teilweise erst 16 oder 17 Jahre alt waren. Ungeachtet dessen und der anfänglichen Bedenken Langes wegen des Alters schafften sie es dennoch, ihren Zulieferbetrieb über Jahrzehnte hinweg am Markt zu behaupten; so der Unruhhersteller Carl Bernhard Kohl, der Zeiger-

was also lowered. Lange moved to Glashütte and completed the final assembly of the watches himself on site. Furthermore, Adolph Schneider, whom he brought to Glashütte as his assistant and to teach mathematics and drawing, later went on to establish his own watch manufactory in the town.

These revisions provided the basis for the establishment of the watchmaking industry in Glashütte. It remains debatable, had the original plan been executed, whether the students would have actually returned to their hometowns after completing their apprenticeships or whether they would have chosen to stay in Dresden – which would also have been advantageous to Lange on account of the shorter delivery routes and easier communication. Some of the first young men to be trained by Lange set themselves up as suppliers straight after their apprenticeship, despite the fact that when they made the step to becoming business owners they were often only 16 or 17 years old. Nevertheless, and in spite of Lange's initial concern about their age, they managed to uphold their market position as suppliers for many decades, for instance, the balance manufacturer Carl Bernhard Kohl, the watch-hand maker August Gläser, the producer of watch cases Carl Ferdinand Goldsche, and Friedrich Weichold who manufactured parts for escapements. These small workshops proved to be important innovators in the following years, for example, Kohl's accomplishments in developing a compensation balance that had an impact far beyond the borders of Glashütte.

The Glashütte workshop system, initiated by Ferdinand Adolph Lange, laid the foundation for the development of Glashütte precision watches. This system would never have evolved as it did if it were not for the active participation of Gustav Adolph Lehmann. In recognition of his contributions, the Ministry of the Interior first appointed Lehmann as inspector of the entire apprenticeship.[12] In the years after 1845, various differences of opinion arose between Lehmann and Lange, especially in regard to the direction the school should take and Lehmann's sphere of

macher August Gläser, der Gestellfertiger Carl Ferdinand Goldsche oder Friedrich Weichold, welcher Teile für die Gänge herstellte. Diese kleinen Unternehmen sollten sich in der Folgezeit zudem als wichtige Träger von Innovationen erweisen, etwa die Leistungen von Kohl bei der Entwicklung der Kompensationsunruh, die weit über Glashütte hinaus wirkten.

Das Glashütter Verlagswesen, von Ferdinand Adolph Lange initiiert, legte den Grundstein für die Entwicklung der Glashütter Präzisionsuhren. Dieses System wäre jedoch ohne das aktive Mitwirken von Gustav Adolph Lehmann nicht in dieser Form zum Tragen gekommen. In Anerkennung seiner Bemühungen setzte das Innenministerium Lehmann zunächst als Inspektor für die gesamte Ausbildung ein.[12] In den Jahren nach 1845 kam es jedoch zu Meinungsverschiedenheiten zwischen Lehmann und Lange, insbesondere was die künftige Ausrichtung der Schule und die Einflussmöglichkeiten Lehmanns betraf. Diese Kontroversen eskalierten im Jahr 1851, woraufhin Lehmann durch das Innenministerium seiner Aufgabe enthoben wurde.[13] Diese Entwicklungen erklären auch, warum seine Rolle in der Frühphase der Glashütter Uhrenherstellung heute nahezu vergessen ist.

Für Lange selbst erwiesen sich die ersten Jahre seiner Tätigkeit in Glashütte als wirtschaftlich kompliziert. Die Schweizer Uhrenhersteller hatten sich in der Zwischenzeit ebenfalls erheblich weiterentwickelt. Um auf dem Markt bestehen zu können, musste Lange sowohl in der Technologie als auch in der Breite der Produktionspalette erhebliche Anstrengungen tätigen. Dies beleuchtet ein Brief von Lange an das Ministerium des Innern vom 12. Januar 1852, aus dem hier auszugsweise zitiert werden soll:

»Den die Lehre ist bis heute noch nicht vollendet; die die Steine bearbeiten, mussten sie fassen lernen, sie mussten neben den Steinlöchern, Steinhebel machen lernen, der den Gang macht musste viele Verbesserung daran, musste den Gang in das Werk selbst stellen lernen; die die Unruhe oder die Zeiger machen oder die die Werke drehten und hingen mussten sie später vollenden

influence. This dispute escalated in 1851, causing the Ministry of the Interior to release Lehmann from his duties.[13] These developments also explain why his role in the early phase of watchmaking in Glashütte has almost been forgotten today.

For Lange, the early years in Glashütte turned out to be difficult financially. The Swiss watchmakers had made considerable advancements in the meantime as well. To survive on the market, Lange had to invest a huge amount of effort into expanding the technology and the breadth of their product range. This is demonstrated in a letter from Lange to the Ministry of the Interior from 12 January 1852, an excerpt of which is quoted below:

'For the apprenticeship has still not yet been completed; those that work with precious stones had to learn how to set them, they had to learn how to drill holes in the stones as well as how to make jewelled levers, he who crafts the escapements had to make a lot of improvements, had to learn how to position the escapement in the watch mechanism; those who are making the balances and hands or who turn and mount the movements, later had to learn how to fully assemble them and so it has continued till the present day – furthermore, we could not stop with simple watches but had to create a whole different calibre, and make different types other than ladies' watches, watches without winding keys, chronometers etc. All these developments were necessary, they have considerably raised the value of the manufactory, but they have cost an enormous amount of effort and sacrifices of all kinds that understandably could not be allowed to affect the work, as we are dealing with someone who is one step ahead.'[14]

The quality of his own work almost became Lange's downfall. In his agreement with the Ministry of the Interior he had consented to purchase all parts that his students made once they had completed the apprenticeship, as long as these met the required quality standards.[15] After a relatively short time, however, some of Lange's former students had acquired such skills that

lernen und so ist es bis heute fortgegangen – auch konnten wir bei der einfachen Uhr nicht stehen bleiben, wir mußten andere Caliber, andere Arten als Damenuhren, Uhren ohne Schlüßel, Chronometer u. s. w. machen. Alle diese Fortschritte waren nothwendig, sie haben den Werth der Fabrick auserordentlich erhöht, aber sie haben ungeheure Anstrengungen und Opfer aller Art gekostet, und das konnte verständiger Weise nicht auf die Arbeit gelegt werden, denn wir haben es mit Jemand zu thun, der darüber hinaus ist.«[14]

Die Qualität der eigenen Arbeit wurde Lange schließlich fast zum Verhängnis. In seiner Vereinbarung mit dem Ministerium des Innern hatte er eingewilligt, seinen Schülern alle Teile abzukaufen, die sie nach Abschluss der Lehre fertigten, soweit diese den Qualitätsvorgaben entsprachen.[15] Schon nach relativ kurzer Zeit hatten jedoch einige von Langes ehemaligen Schülern ein solches Maß an Fertigkeiten erworben, dass sie wesentlich mehr Teile produzierten als Lange selbst verarbeiten konnte, die er aber gleichwohl ankaufen und bezahlen musste. Eine Entspannung war erst zu bemerken, nachdem mit Moritz Großmann (1826 – 1885) und Julius Assmann (1827 – 1886) sowie Langes früherem Assistenten Adolph Schneider weitere Uhrenproduzenten in Glashütte ansässig wurden und den Zulieferern Teile abkauften, so dass Lange nicht mehr deren gesamte Fertigung erwerben musste.[16]

Im Gegensatz zu den anderen Herstellern gelang es allerdings lediglich Lange, sein Unternehmen auf eine Basis zu stellen, die mehrere Generationen überdauern sollte. So band er seine Söhne in das Unternehmen ein: Zunächst trat im Jahr 1868 Richard Lange (1845 – 1932) als Mitinhaber in die väterliche Firma ein, ihm folgte drei Jahre später Friedrich Emil Lange (1849 – 1922). Gemeinsam gelang es ihnen, der Firma eine Kontinuität zu verschaffen, welche – abgesehen von der Unterbrechung zwischen Zwangsverstaatlichung und Eingliederung in den Glashütter Uhrenbetrieb GUB im Jahr 1951 bis zur Neugründung im Jahr 1990 – bis heute besteht und dem Glashütter Uhrenbau zu Weltruhm verhalf.

they were producing a lot more parts than Lange could actually use, but which he had to pay for. The situation only eased when Moritz Großmann (1826 – 1885) and Julius Assmann (1827 – 1886) along with Lange's assistant Adolph Schneider also established themselves as watch manufacturers in Glashütte and began purchasing parts from the suppliers so that Lange no longer had to buy their entire output.[16]

In contrast to other manufacturers, Lange was, however, the only one who managed to build his enterprise on such a sound fundament that it survived for several generations. He brought his sons into the business: Richard Lange (1845 – 1932) joined his father's company as a partner in 1868, followed three years later by Friedrich Emil Lange (1849 – 1922). Together they maintained continuity and the company – aside from a break beginning in 1951, when it was taken over by the public and incorporated into the Glashütter Uhrenbetrieb GUB, and ending with its resurrection in 1990 – still exists today and has had a significant role in establishing Glashütte's world-class reputation in watchmaking.

Taschenuhr Nr. 2747, um 1860, Lange Uhren GmbH, Glashütte (ohne Signatur)
Pocket watch No. 2747, around 1860, Lange Uhren GmbH, Glashütte (not signed)

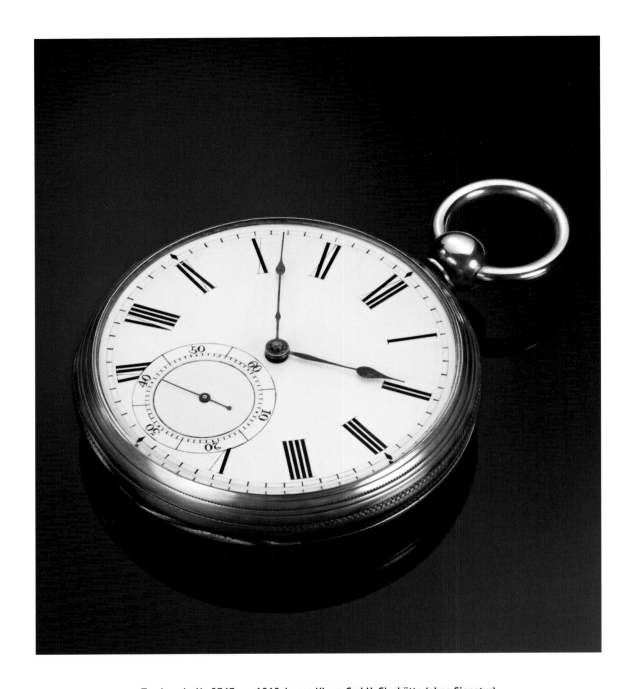

Taschenuhr Nr. 2747, um 1860, Lange Uhren GmbH, Glashütte (ohne Signatur)
Pocket watch No. 2747, around 1860, Lange Uhren GmbH, Glashütte (not signed)

Eduard Saluz

Nicht nur in Sachsen – Zur Fabrikation von Taschenuhren in Deutschland in der zweiten Hälfte des 19. Jahrhunderts

Not Only in Saxony – On the Fabrication of Pocket Watches in Germany in the Second Half of the Nineteenth Century

Wenn man heute von hochwertigen Kleinuhren »Made in Germany« spricht, dann meint man damit meist die verschiedenen Firmen in Glashütte in Sachsen. Auch die fabrikmäßige Herstellung von guten Taschenuhren in Deutschland im 19. Jahrhundert wird oft einzig mit Glashütte assoziiert. Dies ist jedoch zu kurz gegriffen, denn auch in Schlesien und im badischen Schwarzwald gab es ernst zu nehmende Ansätze zur Produktion hochwertiger Taschenuhren. So unterschiedlich die einzelnen Entwicklungen später abliefen, im Rückblick wird klar, dass an allen Standorten die gleiche Triebkraft wirkte: Einer notleidenden Region sollte durch die Uhrmacherei aufgeholfen werden. Auch zeitlich entwickelten sich die Ansätze parallel, da sie in allen drei Regionen in den 1840er Jahren ihren Anfang nahmen. Im Folgenden möchte ich diese Entwicklungen in Schlesien und im Schwarzwald kurz vorstellen.

When we speak of premium watches 'made in Germany' today, we usually mean the watch-making industry in Glashütte in Saxony. By the same token, the industrial production of quality pocket watches in Germany in the nineteenth century tends to be associated with Glashütte alone. Yet this is too narrow a view, as it overlooks the serious initiatives to establish a premium pocket watch industry in Silesia and the Baden region of the Black Forest. Although developments at these different sites took a markedly different course, with the benefit of hindsight we can now say that the initial effort was driven by the same imperative at each of them, namely the desire to revitalise an impoverished, hardscrabble region through industry. Moreover, in each of the three regions these initiatives were launched around the same time in the 1840s. I would like to present a brief outline of the development of the watchmaking industry in Silesia and the Black Forest.

Schlesien

Die hausgewerbliche Textilverarbeitung in Schlesien beschäftigte im 18. und 19. Jahrhundert eine große Zahl von Arbeiterinnen und Arbeitern. Ab dem Beginn des 19. Jahrhunderts führte die Industrialisierung jedoch zu einem stetigen Verfall der Einkommen und zur Verarmung der Bevölkerung. Nach gewaltsamen Protesten gegen die Zustände, dem so genannten Weberaufstand von 1844, hatte die preußische Regierung[1] also gute Gründe, Maßnahmen zur Verbesserung der wirtschaftlichen Situation einzuleiten.

Auf offene Ohren stieß daher 1847 ein Gesuch von Eduard Eppner (Abb. 1) in Berlin. Die Gebrüder Eppner hatten 1835 zunächst in Halle,

Silesia

In the eighteenth and nineteenth century, the cottage textile industry in Silesia provided employment for a great many men and women. The rise of mechanised textile production in the early nineteenth century, however, led to a rapid drop in piecework rates and, with it, to mass pauperisation. After the eruption of violent protests against the dire conditions, the Silesian weavers' uprising of 1844, the Prussian government[1] had very good cause to consider measures to improve the economic situation and to stave off the spectre of social unrest.

It was for this reason that Berlin took an interest in a petition submitted in 1847 by Eduard Eppner (ill. 1). The Eppner brothers had started to produce parts for pocket watch movements in 1835, first in Halle and then, from 1847, in Schraplau. But the story starts even earlier: in 1821 Wilhelm Eppner (1804 – 1875), a young watchmaker from Halle, went to Switzerland and established himself in La Chaux-de-Fonds. Over the course of the next few years he made sure that five of his brothers and half-brothers trained as watchmakers or watchcase makers and then returned to Halle to start the fabrication of watches there.[2]

His endeavours were not crowned with much success. As Eduard Eppner explained, 'the city of Halle was ill-suited' to the production of watches, as it lacked 'that auspicious coincidence of manufacture and agriculture' that made Swiss watchmakers so 'blithe and independent.'[3] The move to neighbouring Schraplau did little to improve the situation, 'since he [Eppner] did not have the necessary means' to set up the manufacturing plant and launch the fabrication.

Johann Ferdinand August Schröner, the Silesia-born mayor of Halle, recommended a move to Silesia, where Eppner would find 'a large population of labourers brought low by the decline of the linen industry and used to making do with desperately little for decades. There Eppner would be able to recruit a large workforce of willing labourers, devoted to his cause and

1
Eduard Eppner (1812 – 1887)

2
Briefkopf der Gebrüder Eppner mit Abbildung der Fabrik in Lähn, Berlin, 1869, Archiv Deutsches Uhrenmuseum, Furtwangen
Letterhead of the Eppner brothers, with image of the factory in Lähn, Berlin, 1869, Archiv Deutsches Uhrenmuseum, Furtwangen

ab 1847 in Schraplau die Fabrikation von Bestandteilen für Taschenuhrwerke aufgenommen. Zur Vorgeschichte: Wilhelm Eppner (1804 – 1875), ein junger Uhrmacher aus Halle, zog 1821 in die Schweiz und arbeitete erfolgreich in La Chaux-de-Fonds. Im Laufe der nächsten Jahre sorgte er dafür, dass fünf seiner Brüder und Halbbrüder den Beruf des Uhr- oder Gehäusemachers erlernten und nach Halle zurückkehrten, um sich dort der Uhrenfertigung zu widmen.[2]

happy to work for wages that lay far below those current in Saxony.'

Eduard Eppner thus petitioned Berlin for financial support. However, negotiations which had begun so auspiciously were brought to a halt by the 'sad catastrophe of the year 1848, as were so many good things.'[4] Nor was much progress made when talks finally resumed in 1849. The authorities in Berlin demanded that the eldest brother, Wilhelm Eppner, who ran a suc-

Der Erfolg dieser Unternehmung war mäßig. Laut Eduard Eppners eigenen Worten war »die Stadt Halle ein weniger geeigneter Ort« für die Herstellung von Kleinuhren, da dort »die wohlthätige Vereinigung von Fabrikation und Landwirtschaft« fehlte, welche die Schweizer Uhrmacher so »froh und unabhängig« machte.[3] Auch der Umzug ins benachbarte Schraplau brachte keine Verbesserung, »da ihm [Eppner] selbst bedeutendere Mittel fehlten« und er den langwierigen Aufbau der Fabrikation nicht finanzieren konnte.

Geheimrat Schröner, der Oberbürgermeister von Halle und ein geborener Schlesier, riet Eppner deshalb zur Übersiedlung nach Schlesien, denn:

»Dort finde sich eine zahlreiche Arbeiterbevölkerung durch das Herunterkommen der Leinenindustrie in trauriger Lage, diese Bevölkerung sei seit Jahrzehnten an die geringsten Bedürfnisse gewöhnt, und finde Eppner dort die Möglichkeit, schon mit viel geringeren Arbeitslöhnen als in Sachsen, der Beschäftigung frohe, seinem Streben ergebene Arbeiter zahlreich um sich zu sammeln.«

Eduard Eppner sandte daraufhin ein Gesuch um finanzielle Unterstützung seiner Unternehmung nach Berlin. Die verheißungsvoll begonnenen Verhandlungen wurden jedoch von der »traurigen Katastrophe des Jahres 1848 vernichtet wie so vieles Gute«.[4] Auch die wieder aufgenommenen Gespräche ab 1849 kamen nicht recht voran. Die Berliner Regierung verlangte, dass der älteste Bruder, Wilhelm Eppner, der in La Chaux-de-Fonds ein gut gehendes Geschäft betrieb, dieses aufgeben und nach Schlesien umziehen solle. Dazu war Wilhelm Eppner jedoch nicht bereit, woraufhin Eduard Eppners Gesuch in Berlin abgelehnt wurde. Dieser gab indes nicht nach und erwarb 1850 ein größeres Gebäude im schlesischen Lähn,[5] wohin er die Produktion verlegte (Abb. 2). Neben Wilhelm Eppner unterstützte auch ein weiterer Bruder, Albert Eppner, der seit 1845 Hof-Uhrmacher in Berlin war, das Unternehmen in Lähn.

Nachdem auch ein weiteres Gesuch um staatliche Unterstützung der Eppner'schen Fabrik, cessful enterprise in La Chaux-de-Fonds, abandon his business in Switzerland and relocate to Silesia. Wilhelm Eppner's refusal to countenance such a move led to the rejection of Eduard Eppner's request. Undeterred by the negative response, Eduard Eppner acquired a substantial building in Lähn[5] in Silesia and moved the production there (ill. 2). The enterprise in Lähn was supported by Wilhelm Eppner as well as by another brother, Albert Eppner, who had established himself as court watchmaker in Berlin in 1845.

After a second application for state support for the Eppner company – this time submitted by the municipality of Lähn – was refused, Eduard Eppner turned directly to King Friedrich Wilhelm IV:

'Reassured by Oberpräsident von Schleinitz [Johann Eduard von Schleinitz, president of the Prussian province of Silesia] and General von Nostitz [August Ludwig von Nostitz] about the admissibility of his intended approach to the king, Eppner ventured to submit his most humble application to His Majesty. [...] His Gracious Majesty did not deny the supplicant his royal favour, and when the investigation His Gracious Majesty had commanded to be undertaken yielded a favourable result about E. Eppner's endeavours and the current state of his business, His Majesty deigned to confer upon him an interest-free loan of 3000 thalers fol-lowed by a gracious loan of 7000 thalers for machines from His Excellency, the Minister of Trade and Commerce. In the interest of the country, Eppner undertook to train 100 workers and to deliver finished watches within three years.'

This excerpt provides not only the hard facts, it also offers a glimpse of the inner workings of the Prussian bureaucracy.

Eppner developed production in Lähn and 'was soon able to manufacture all the components of lever escapement watches.'[6] The components were sent to Switzerland. Difficulties in building a steady customer base prompted Eppner to apply to Berlin for further support. He was even granted the opportunity to present

3a
Taschenuhr der Firma Eppner, »Preußische Bauart« mit Ankerhemmung, Werk Nr. 22765, Lähn, um 1870,
Deutsches Uhrenmuseum, Furtwangen
Pocket watch made by the Eppner company, 'of Prussian design', with anchor escapement, movement No. 22765,
Lähn, around 1870, Deutsches Uhrenmuseum, Furtwangen

diesmal gestellt von den Gemeindebehörden von Lähn, abgelehnt worden war, wandte sich Eduard Eppner direkt an König Friedrich Wilhelm IV.:

»Von Herrn Oberpräsident v. Schleinitz, dem Herrn General von Nostitz über die Zulässigkeit des von ihm beabsichtigten Schrittes beruhigt, wagte Eppner, sein unterthänigstes Gesuch bei Sr. Majestät einzureichen. [...] Die Gnade Sr. Majestät versagte dem Bittsteller die Allerhöchste Berücksichtigung nicht, und nachdem die Aller-

his cause to the king himself. Friedrich Wilhelm IV called on a group of 'high-ranking, wealthy individuals' to found the 'Association for the Promotion of Watchmaking in Silesia' which provided Eppner with a loan of 20,000 thalers.[7] It was this support that enabled the factory in Lähn to market the first finished lever escapement movements in 1854. These movements were no longer simply copies of Swiss prototypes; Eppner proudly referred to their design as 'Prussian.'[8] The movements had a simple

höchst angeordneten Erhebungen ein günstiges Resultat über die Bemühungen des E. Eppner und den derzeitigen Zustand des Unternehmens ergeben hatten, geruhten Se. Majestät demselben ein zinsloses Darlehn von 3000 Thlr. und dem zu Folge Se. Excellenz Herr Handelsminister 7000 Thlr. für Arbeitsmaschinen in Gnaden überweisen zu lassen. Eppner übernahm dafür im Interesse des Landes die Verpflichtung, binnen 3 Jahren 100 Arbeiter auszubilden und fertige Uhren zu liefern.«

Dieses Zitat gibt neben den harten Fakten auch Einblick in die Funktionsweise der preußischen Bürokratie.

Eppner baute die Fertigung in Lähn soweit aus, dass er »bald alle einzelnen Theile zu Ankeruhren herzustellen vermochte«.[6] Diese Einzelteile wurden in die Schweiz geliefert, es gestaltete sich jedoch schwierig, dauerhafte Abnehmer zu finden, so dass Eduard Eppner weitere Gesuche um Unterstützung an die Berliner Regierung stellte.

Schließlich erhielt Eppner sogar die Gelegenheit, sein Anliegen dem König persönlich vortragen zu dürfen. Dieser regte an, dass durch »hochgestellte vermögende Persönlichkeiten« ein »Verein zur Hebung der Uhren-Fabrikation in Schlesien« gegründet wurde,[7] der ein Darlehen von 20.000 Talern für Eppner zu Verfügung stellte. Dank dieser Unterstützung war die Eppner'sche Fabrik in Lähn 1854 so weit, erste fertige Anker-Uhrenwerke liefern zu können. Diese waren nicht einfache Kopien der Schweizer Werke, sondern »Preußische Bauart«,[8] wie Eppner sie stolz bezeichnete. Die Werke besaßen eine einfache Unruhe und keine Endkurve der Unruhfeder, die Rohwerke konnten sowohl als Ankeruhren (mit langem Anker und einer separaten Ankerradbrücke) wie auch als Zylinderuhren gefertigt werden (Abb. 3a – b). Die Gehäuse der Uhren stammten von Eppners Halbbruder August Höser, der inzwischen in Breslau ein Geschäft betrieb.

Ein Artikel von 1863 gibt Zahlen zur Produktion, demnach 1856 207 Uhren, 1862 bereits 2845 Uhren gefertigt wurden. Der Text spricht

balance wheel and no overcoil on the balance spring and could be made for lever escapement watches (with a long lever and a separate escape wheel bridge) as well as for cylinder escapement watches (ills. 3a – b). The cases were made by Eppner's half-brother August Höser who had set up a business in Breslau (modern-day Wrocław).

According to an article of 1863, which provides information on production figures, 207 watches were produced in 1856; by 1862 that number had risen to 2845. The text mentions lever and cylinder escapement watches as well as pocket chronometers.[9]

This success soon came under threat. As Eduard Eppner later described it, 'the enemy came overnight.' A second watch factory was to open in Görlitz, and twenty-five workers – namely the 'most seasoned and most competent' left Lähn.[10] Although the factory in Görlitz soon failed and closed just one year after it had opened, the workers did not return to Eppner, preferring instead to go to find employment in Freiburg in Silesia (today's Świebodzice) and Glashütte in Saxony.[11]

The setback prompted Eppner to move once again. He accepted an invitation from the town of Silberberg in Lower Silesia[12] and acquired the buildings of the former fortress (ill. 4). However, the costly relocation had a negative impact on the growth and development of the company.

The patriotic fervour of the German Reich in the wake of the Franco-Prussian War of 1870/71 gave rise to a national trade press for watchmakers. The first of these journals, published from 1877, was the Deutsche Uhrmacher-Zeitung. Here and in the other specialist publications we find numerous articles about and references to the Eppner company. The article 'Ueber den Bedarf von Uhren in Deutschland und die Möglichkeit, einen Theil desselben in Deutschland selbst zu fabriziren' ('On the demand for watches in Germany and the prospect of manufacturing a share of them in Germany'), published in the Deutsche Uhrmacher-Zeitung in 1877, mentions the 'modest success' the Silberberg enterprise

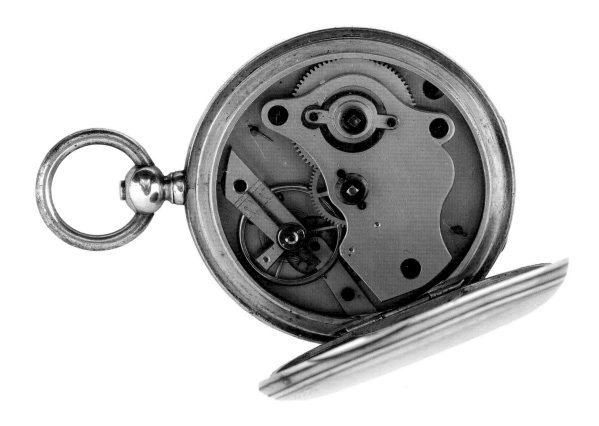

3b
**Taschenuhr der Firma Eppner, »Preußische Bauart« mit Zylinderhemmung, Werk Nr. 59468, Gehäuse bezeichnet
EAH (August Höser), Lähn, um 1875, Deutsches Uhrenmuseum, Furtwangen**
Pocket watch made by the Eppner company, 'of Prussian design', with cylinder escapement, movement No. 59468,
case marked EAH (August Höser), Lähn, around 1875, Deutsches Uhrenmuseum, Furtwangen

von Anker- und Zylinderuhren sowie von Taschenchronometern.[9]

»Doch über Nacht kam der Feind«: In Görlitz sollte eine zweite Uhrenfabrik gegründet werden. 25 Arbeiter, »und zwar die ältesten und tüchtigsten«, verließen Lähn.[10] Obwohl das Görlitzer Unternehmen schon nach einem Jahr scheiterte, kehrten die Arbeiter nicht zu Eppner zurück, sondern fanden in Freiburg in Schlesien oder im sächsischen Glashütte Beschäftigung.[11]

Dies bewog Eppner, erneut umzuziehen. Er nahm ein Angebot der Gemeinde Silberberg[12] an

had to date, 'even though the company had expanded its range to include cheaper types of watches' (ill. 5).[13] In the next issue of the journal, the company 'A. Eppner & Co.'[14] solicited support for the works in Silberberg from the German watchmakers. And the following issue featured an article entitled 'Ein Besuch in Silberberg' ('A Visit to Silberberg') which indicates that in addition to pocket watches, the Silberberg works produced all manner of turret clocks and watchmen's clocks. Under the aegis of the senior manager Eduard Eppner Albert Eppner Jun. was res-

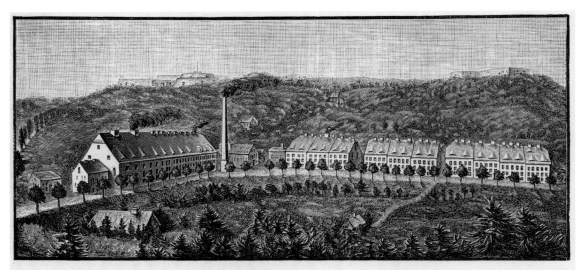

Fabrik und Arbeiterwohnungen
der Uhren-Fabrik A. Eppner & Co. in Silberberg i. Schl.

4
Abbildung der Fabrik und der Arbeiterwohnungen in Silberberg
Image of the factory and workers' residences in Silberberg

und erwarb 1869 die militärischen Gebäude der ehemaligen Festung (Abb. 4). Die mit dem erneuten Umzug verbundenen Kosten waren der Entwicklung der Fabrik jedoch nicht zuträglich.

Im Rahmen des patriotischen Aufbruchs des Deutschen Reiches nach dem Krieg 1870/71 entstand auch eine nationale Fachpresse für Uhrmacher; zunächst 1877 die Deutsche Uhrmacher-Zeitung. In dieser und in den anderen Fachorganen finden sich in der Folge viele kleinere und größere Notizen und Berichte zur Firma Eppner. Im Artikel »Ueber den Bedarf von Uhren in Deutschland und die Möglichkeit, einen Theil desselben in Deutschland selbst zu fabriziren« wird 1877 der »bescheidene Erfolg« erwähnt, welchen die Silberberger Firma bis dato hatte, »obwohl sie die Fabrikation auch auf billigere Sorten ausdehnte« (Abb. 5).[13]

In der darauffolgenden Nummer meldete sich die Firma »A. Eppner & Co.«[14] zu Wort und warb

ponsible for the production of turret clocks and Eduard Eppner Jun. for the fabrication of pocket watches. It was under Eduard Eppner Jun. that the company developed a new pocket watch calibre, which the article commends: 'Here the problem of producing a good reliable watch at a moderate price has been solved in a delightful manner.'[15] These movements were a big improvement on the 'Prussian Design' of the mid-1850s. Equipped with a compensating bimetallic balance, an overcoil on the balance spring, a short lever, and a crown, it was up to date and in line with the industry standards (ill. 6). The article in the Deutsche Uhrmacher-Zeitung also offers a detailed description of the fabrication. The level of in-house production is impressive: The plates were produced with the help of templates; wheels and pinions were fashioned entirely in-house. Even the jewel bearings were drilled and cut in Silberberg.

5
Taschenuhr, Werk mit Zylinderhemmung, Nr. 60624, um 1875, Deutsches Uhrenmuseum, Furtwangen
Pocket watch, movement with cylinder escapement, No. 60624, around 1875, Deutsches Uhrenmuseum, Furtwangen

6
Das von Eduard Eppner jun. entwickelte Taschenuhrkaliber, Werk Nr. 76690, Lähn, um 1900,
Deutsches Uhrenmuseum, Furtwangen
The pocket watch calibre designed by Eduard Eppner Jun., movement No. 76690, Lähn,
around 1900, Deutsches Uhrenmuseum, Furtwangen

um Unterstützung der Silberberger Fabrik durch die deutschen Uhrmacher.

Noch eine Nummer später erschien der Artikel »Ein Besuch in Silberberg«, aus dem hervorgeht, dass neben den Taschenuhren auch Turm- und Kontrolluhren aller Art in Silberberg gefertigt wurden. Unter dem Seniorchef Eduard Eppner war Albert Eppner jun. für die Turmuhr- und Eduard jun. für die Taschenuhrfertigung verantwortlich. Unter der Leitung von Eduard jun. wurde um diese Zeit ein neues Taschenuhrkaliber entwickelt, das der Artikel lobend erwähnt: »In erfreulicher Art ist hier die Aufgabe, eine gute curante Uhr zu einem mässigen Preise herzustellen, gelöst worden.«[15] Dieses Uhrwerk war gegenüber

Four years later, the author of the article, F. O. Gasser from Magdeburg, fell victim to an Eppner family intrigue that sheds some light on the guarded diffidence with which German watchmakers viewed Eppner watches. In an advertisement, the company 'Gebrd. Eppner, Berlin und Silberberg' accused several of their 'Niederlagen' (concessionaires), among them F. O. Gasser in Magdeburg, of selling watches by other producers.[16] In the next issue of the journal one of the accused concessionaires defended himself and pointed out that the company in Silberberg traded under the name 'A. Eppner & Co.' and that the Gebrd. Eppner in Berlin were not associated with Silberberg.[17] In a long letter to the editor,

der »Preußischen Bauart« vielfach verbessert worden durch eine kompensierende Bimetallunruhe, eine Endkurve für die Unruhfeder, einen kurzen Anker und einen Kronenaufzug; das Werk war somit durchaus auf der Höhe seiner Zeit (Abb. 6). Im Artikel der Deutschen Uhrmacher-Zeitung wird auch die Herstellung detailliert beschrieben. Die Fertigungstiefe ist beeindruckend: Die Platinen wurden mittels Schablonen gefertigt, Räder und Triebe von Grund auf selber hergestellt. Sogar die Lagersteine wurden in Silberberg gebohrt und fassoniert.

Der Verfasser dieses Artikels, F. O. Gasser aus Magdeburg, wurde vier Jahre später Opfer einer Eppner'schen Familienintrige, die einiges Licht auf die Zurückhaltung wirft, mit der die Eppner-Uhren von den deutschen Uhrmachern behandelt wurden. Die Firma »Gebrd. Eppner, Berlin und Silberberg« beschuldigte in einer Annonce mehrere ihrer »Niederlagen«, unter anderem F. O. Gasser aus Magdeburg, dass diese auch Uhren anderer Hersteller verkaufen würden.[16] In der folgenden Nummer wehrte sich einer der Beschuldigten und wies darauf hin, dass die Silberberger Firma unter »A. Eppner & Co.« firmiere und die Gebrüder Eppner aus Berlin nicht mit Silberberg verbunden seien.[17] In einem langen Leserbrief schrieb F. O. Gasser, er vermute, dass die ganze Geschichte Reklame für die Berliner Uhrenhandlung gewesen sei. Der Besitzer der Berliner Firma, Albert Eppner, wolle offenbar Nutzen aus seiner Verwandtschaft mit Eduard Eppner ziehen.

Bestätigt wird diese Sicht im Artikel »Glashütte und Silberberg« im »Allgemeinen Journal der Uhrmacherkunst« (AJUK), einer weiteren Uhrmacher-Fachzeitschrift. Darin konnte man 1890 über den stockenden Absatz der Eppner'schen Uhren lesen, »dass einige bekannte Geschäfte in Breslau und Berlin [...] bedeutenden Nutzen zogen, da sie am Orte als die berufenen Vertreter vaterländischer Taschenuhren-Industrie sich nennen durften. Während die Inhaber dieser Geschäfte reich wurden, gestalteten die Verhältnisse in der Fabrik sich immer ungünstiger [...]«.[18]

F. O. Gasser hazarded the guess that the whole story was a publicity ploy by the Berlin-based watchmakers and retailers. He suspected that the owner of the Berlin company, Albert Eppner, sought to capitalise on his kinship with Eduard Eppner. This view is corroborated in the article 'Glashütte and Silberberg' in the *Allgemeines Journal der Uhrmacherkunst* (AJUK), another specialist trade journal. In 1890, reporting on the stagnating sales of Eppner watches, it explained that 'several well-known businesses in Breslau [Wrocław] and Berlin [...] benefited significantly from being able to cast themselves as the appointed representatives of the German ['vaterländische'] pocket watch industry. While the owners of these businesses grew rich, the situation in the factory became ever more precarious [...].'[18]

The production of pocket watches in Silberberg was slowly but inexorably drawing to a close. Eduard Eppner senior died on 2 July 1887. His obituary in the Deutsche Uhrmacher-Zeitung cited an annual production of 5000 pocket watches.[19] However, drawing on the numbering of surviving Eppner pocket watches, Hans Weil concludes that this figure could only have been achieved in the 1870s – if ever.[20] He estimates that the total output came to some 70,000 watches.[21]

The company in Silberberg continued to exist well into the 1940s, but production focused primarily on turret clocks and master clock systems.[22] Whereas in Glashütte in Saxony, watch production continued under the communist, centrally planned economy of the German Democratic Republic and rose like a phoenix from the ashes after Reunification to claim its place among the horological elite, this was not possible in Silesia which became part of Poland in 1945.

Black Forest

In 1850, the 'Großherzoglich Badische Uhrenmacherschule' was founded in Furtwangen with the aim of revitalising the declining Black Forest

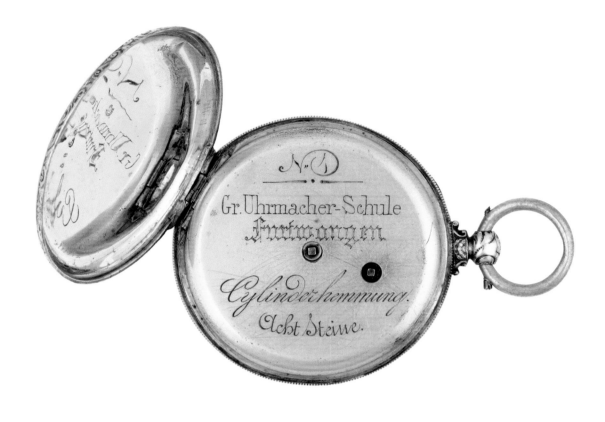

7
Taschenuhr Nr. 1 der Großherzoglich Badischen Uhrmacherschule Furtwangen, 1851, Privatbesitz
Pocket watch No. 1, made by the Großherzoglich Badische Uhrmacherschule Furtwangen, 1851, Private collection

Die Taschenuhrfertigung in Silberberg ging zu dieser Zeit dem Ende entgegen. Am 2. Juli 1887 war Eduard Eppner sen. gestorben. Im Nachruf in der Deutschen Uhrmacher-Zeitung wurde die jährliche Produktion zwar noch mit 5000 Taschenuhren angegeben,[19] Hans Weil kommt aufgrund der Nummerierung der erhaltenen Eppner-Taschenuhren jedoch zu dem Schluss, dass diese Zahl höchstens in den 1870er Jahren erreicht worden sein könne.[20] Er schätzt die Gesamtproduktion auf etwa 70.000 Stück.[21]

Zwar existierte die Firma in Silberberg noch bis in die 1940er Jahre, es wurden jedoch vor allem Turmuhren und Uhrenanlagen hergestellt.[22] Im Gegensatz zu Glashütte, das in der DDR-Zeit weiterhin Uhren produzieren konnte und nach der Wende von 1989 wie ein Phönix

clockmaking industry. At the time the Hochschwarzwald region of Baden (the higher reaches of the Black Forest) was the leading producer of simple wall clocks, with an annual production of approximately one million clocks. Production methods, however, had not kept pace with the latest technical developments. As a consequence, the clocks could no longer command the prices they once did. As cheap imports from America further reduced the profit margin, the region faced the threat of mass pauperisation. The new school was to launch and establish the pocket watch industry to complement the native clockmaking industry. The school's first annual report introduced the 'workshop for the production of pocket watches.' Two teachers trained 18 apprentices, starting with 'the industrial production

aus der Asche wieder seinen Platz in der ersten Reihe der Uhrmacherei fand, war dies in Schlesien nicht möglich, da das Gebiet seit 1945 zu Polen gehört.

Schwarzwald

Im Jahre 1850 wurde in Furtwangen die »Großherzoglich Badische Uhrenmacherschule« gegründet. Diese Einrichtung sollte der notleidenden Schwarzwälder Uhrenherstellung neue Impulse geben. Der badische Hochschwarzwald war damals zwar die weltweit bedeutendste Region für die Herstellung einfacher Wanduhren, die Jahresproduktion lag bei rund einer Million Stück, die Produktionsmethoden entsprachen jedoch nicht mehr dem Stand der Zeit. Der Region drohte eine massive Verarmung, da die erzielbaren Preise, nicht zuletzt wegen der Konkurrenz aus den USA, immer kleiner wurden.

 Neben der Großuhrmacherei, die seit langem in der Region heimisch war, sollte die neue Schule auch die Taschenuhrmacherei einführen. Im ersten Jahresbericht der neuen Schule wurde die »Werkstatt für Taschenuhrmacherei« vorgestellt: Zwei Lehrer bilden 18 Zöglinge aus, wobei es zunächst »die Zylinderuhr [ist], deren fabrikmäßige Anfertigung erstrebt werden soll.«[23] Erklärtermaßen sollte die Schule jedoch »nur so lange und so viel fabrizieren, als erforderlich seyn wird, um die jungen Arbeiter auf dem Schwarzwald zu erhalten und um Unternehmer auf dem Schwarzwalde zu ermuntern, ihr diese Fabrikation abzunehmen.«

 Am 2. August 1851 wurde dem badischen Großherzog Leopold anlässlich seines Besuches in Furtwangen die erste fertige Taschenuhr präsentiert (Abb. 7). 1852 konnte die Schule 25 silberne Taschenuhren verkaufen, 1853 wurde in Furtwangen die »Aktiengesellschaft für Taschenuhren-Fabrikation« gegründet.

 »Die Einführung der Taschenuhrenmacherei ist ein schönes Geschenk, jedoch mit großen Schwierigkeiten verbunden«,[24] schrieb Romulus Kreuzer 1856 in einer Denkschrift über die Zu-

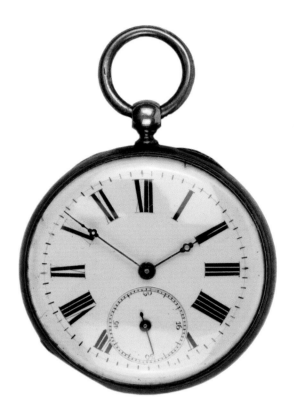

8
Taschenuhr Nr. 104 der »Act. Gesellschaft Furtwangen«, bezeichnet »Ancer-Hemmung«, das Werk besitzt jedoch Zylinderhemmung, um 1855, Deutsches Uhrenmuseum, Furtwangen
Pocket watch No. 104, made by the 'Act. Gesellschaft Furtwangen'; although marked as 'anchor escapement', the movement actually has a cylinder escapement, around 1855, Deutsches Uhrenmuseum, Furtwangen

of cylinder escapement watches.'[23] It was the stated goal of the school 'to produce only for as long and as much as necessary to maintain the young workers in the Black Forest and to encourage entrepreneurs from the region to take on and develop the business.'

 Leopold, Grand Duke of Baden, visited Furtwangen on 2 August 1851 and was presented with the first finished pocket watch (ill. 7). In 1852 the school sold 25 silver pocket watches; in 1853 the 'Aktiengesellschaft für Taschenuhren-Fabrikation' ('Public Limited Company for

9

Titelblatt des Atlasbandes zu Jess Hans Martens: Beschreibung der Hemmungen der höheren Uhrmacherkunst,
La Chaux-de-Fonds 1857, Bibliothek Deutsches Uhrenmuseum, Furtwangen
Front page of the atlas accompanying Jess Hans Martens, Beschreibung der Hemmungen der höheren
Uhrmacherkunst, La Chaux-de-Fonds, 1857, Bibliothek Deutsches Uhrenmuseum, Furtwangen

stände der Schwarzwälder Uhrmacherei. Die Aktiengesellschaft stand damals vor dem Aus, wie eine Bittschrift von 1856 zeigt.[25] Die erhaltenen Uhren dieser Firma sind sehr einfache Zylinderuhren, wobei die Uhr mit der Nummer 104 besonders interessant ist, da sie auf dem Staubdeckel stolz die absurde Bezeichnung »Ancer-Hemmung 4 Steine« trägt, jedoch ein Zylinderwerk enthält (Abb. 8).[26]

Trotzdem investierte die badische Regierung weiterhin in die Einführung der Taschenuhrmacherei. Mit Beginn des Jahres 1858 trat Jess Hans Martens (1826 – 1892) seine Stelle als

the Fabrication of Pocket Watches') was founded in Furtwangen.

'The introduction of the pocket watch industry is a beautiful gift, but it is fraught with great difficulties,'[24] wrote Romulus Kreuzer in 1856 in a memorandum on the state of horology in the Black Forest. A petition of that year shows that the Public Limited Company was teetering on the brink of collapse.[25] The surviving watches made by the company are very simple cylinder escapement watches. Of particular interest is watch number 104; its back cover proudly bears the absurd inscription 'Ancer-Hemmung 4 Steine'

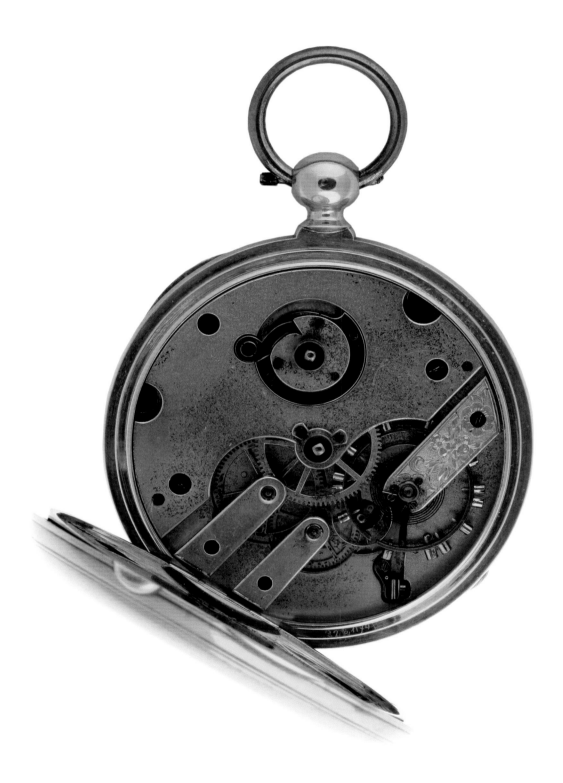

10
Jess Hans Martens, Taschenuhr mit Chronometerhemmung, Furtwangen, um 1860,
Deutsches Uhrenmuseum, Furtwangen
Jess Hans Martens, Pocket watch with chronometer escapement, Furtwangen, around 1860,
Deutsches Uhrenmuseum, Furtwangen

»Erster Lehrer der Taschenuhrmacherschule Furtwangen« an. Martens stammte aus Mildstedt bei Husum. Nach seiner Ausbildung zum Uhrmacher arbeitete er wohl von 1853 bis 1855 in Glashütte, danach zwei Jahre in La Chaux-de-Fonds, wo er ein Lehrbuch verfasste: »Beschreibung der Hemmungen der höheren Uhrmacherkunst« (Abb. 9).

Martens war ein höchst kenntnisreicher Uhrmacher, unter dem in den nächsten Jahren hochwertige Taschenuhren in Furtwangen entstanden. Belege dafür sind neben den erhaltenen Taschenuhren mit Furtwanger Herkunftsangabe (Abb. 10) insbesondere sechs kleine Sockel mit Uhrenteilen, welche auf der Weltausstellung 1862 in London gezeigt wurden. Darauf finden sich Hemmungsteile, Bimetallunruhen und sogar Lagersteine in den verschiedenen Stadien ihrer Herstellung (Abb. 11), wofür Martens eine Medaille »für ausgezeichnete Taschenuhren und Taschenchronometer«[27] erhielt.

Martens arbeitete in Furtwangen unter eigenem Namen und erhielt von der badischen Regierung eine Vergütung für die Ausbildung von Lehrlingen. Dies gestaltete sich jedoch nicht nach Wunsch. 1864 schrieb Martens: »Nach meiner sechsjährigen Erfahrung bin ich zu dem bestimmten Schlusse gelangt, daß die Einführung der Taschenuhrfabrikation hier auf dem Schwarzwalde durch Anlernung von einheimischen jungen Leuten nicht leicht ermöglicht werden kann,« da die Schwarzwälder den »jungen Leuten von weiter entlegenen Orten [...] nicht unbedeutend an Talent und Folgsamkeit nach[stehen]«.[28] Er betonte, dass »die besten Arbeiter welche ich hier erzielte, ausschließlich die sind, welche von entlegenen Orten kommen.«

Doch nicht nur mangelndes Talent und Folgsamkeit waren für das Scheitern der Furtwanger Taschenuhrfertigung verantwortlich. Erschwerend kam hinzu, dass die meisten der Lehrlinge nicht bei der Taschenuhrfertigung blieben, sondern sich dem Uhrenhandel und der Reparatur zuwandten, also »zum größeren Theile nach Beendigung der Lehrzeit der dem Schwarzwälder eigenen Wanderlust folgend ins Ausland gegangen sind«.

('lever escapement, four jewels') although it only protects a cylinder movement (ill. 8).[26]

Despite these setbacks, the government of Baden continued to invest in the launch of the pocket watch industry. At the beginning of 1858, Jess Hans Martens (1826 – 1892) took up his post as 'Head Teacher of the Furtwangen School for Pocket Watch Makers.' Martens came from Mildstedt near Husum. Having completed his training as a watchmaker, he worked in Glashütte, probably from 1853 to 1855, and then two years in La Chaux-de-Fonds, where he wrote the textbook *Beschreibung der Hemmungen der höheren Uhrmacherkunst* (Description of the Escapements of Fine Watches) (ill. 9).

Martens was a highly knowledgeable watchmaker, and it was under his aegis that premium watches began to be produced in Furtwangen. His skill is borne out by the surviving pocket watches with Furtwangen marks (ill. 10) and by the watch parts he showed at the International Exhibition in London in 1862. Presented on six small plinths were escapements, bimetallic balances, and even jewel bearings at different stages of production (ill. 11). Martens won a medal for 'excellent watches and pocket chronometers.'[27]

Martens operated in Furtwangen under his own name and received remuneration from the Baden government for training apprentices. However, things were not going as smoothly as he might have wished. In 1864, Martens wrote: 'My six years of experience have brought me to the conclusion that the fabrication of pocket watches cannot easily be established in the Black Forest through the training of young locals,' since they 'are considerably less talented and compliant than the young people from further away.'[28] He went on to stress that the best workers he had trained were those that had come from further afield.

But it was not just the lack of talent or compliance that was responsible for the failure of the Furtwangen pocket watch industry. What made matters worse was the fact that most of the apprentices soon turned their back on watch fabrication, preferring instead to work in the

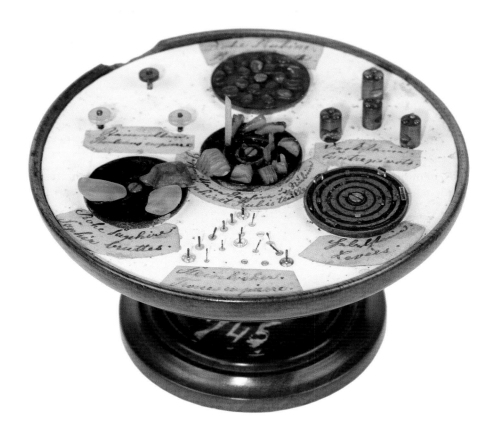

11
Jess Hans Martens, Sockel mit rohen und bearbeiteten Lochsteinen, ausgestellt auf der Weltausstellung in London 1862,
Deutsches Uhrenmuseum, Furtwangen
Jess Hans Martens, plinth with rough and cut hole jewels, shown at the International Exhibition in London in 1862,
Deutsches Uhrenmuseum, Furtwangen

Es sind nur wenige Uhren von Martens Schülern bekannt: ein Werk mit Ankerhemmung von Wilhelm Friedrich Schöchlin (1838 – 1893),[29] sowie einige Uhren mit Zylinderhemmung von Karol Kirner, die denselben Uhrwerktyp verwenden, den Martens 1862 auf der Weltausstellung in London präsentierte (Abb. 12a – b).

Ende 1863 beschloss das badische Handelsministerium die Schließung der Furtwanger Uhrmacherschule, woraufhin Jess Hans Martens die Stadt verließ und nach Freiburg im Breisgau übersiedelte. Dort eröffnete er ein Uhrengeschäft (Abb. 13) und eine »Lehr-Anstalt für Uhr-

clock trade or repair business, and that 'a great many, their apprenticeships completed, went abroad, spurred by the innate wanderlust that has always distinguished the inhabitants of the Black Forest.'

Among the very few watches by Martens' pupils that have come down to us are a movement with lever escapement by Wilhelm Friedrich Schöchlin (1838 – 1893),[29] as well as a few cylinder escapement watches by Karol Kirner that use the same type of movement as that presented by Martens at the London International Exhibition in 1862 (ills. 12a – b).

Eduard Saluz

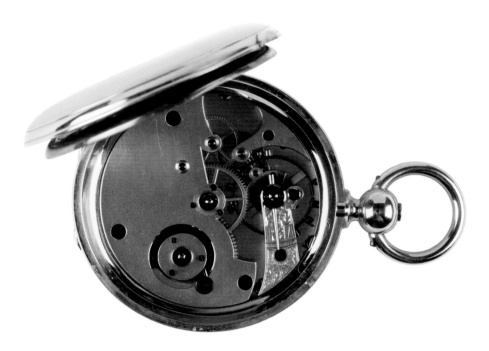

12a
Taschenuhr mit Ankerhemmung, Werk Nr. 1376 von Jess Hans Martens, Furtwangen, um 1860,
Deutsches Uhrenmuseum, Furtwangen
Pocket watch with anchor escapement, movement No. 1376, designed by Jess Hans Martens,
Furtwangen, around 1860, Deutsches Uhrenmuseum, Furtwangen

12b
Taschenuhr mit Zylinderhemmung, Werk Nr. 2256 von Karol Kirner, Furtwangen, um 1860,
Deutsches Uhrenmuseum, Furtwangen
Pocket watch with cylinder escapement, movement No. 2256, designed by Karol Kirner,
Furtwangen, around 1860, Deutsches Uhrenmuseum, Furtwangen

macher«, die er beide offenbar bis 1883 betrieb. Er stellte insgesamt wohl nur etwas mehr als 1000 Uhren her,[30] ausnahmslos mit feinen Anker- oder gar Chronometerwerken, neben Taschenuhren auch als Schiffsuhren in kardanischer Aufhängung (Abb. 14). Nach seinem Tod Ende 1892 erschien in der Deutschen Uhrmacher-Zeitung ein langer und ehrenvoller Nachruf, bis heute ist jedoch kein Portrait von Jess Hans Martens gefunden worden.

Fazit

Weder in Schlesien noch im Schwarzwald konnte sich die Fabrikation qualitativ guter Taschenuhren langfristig durchsetzen. In Schlesien wurden zwar einige zehntausend Uhren hergestellt, größtenteils jedoch mit preisgünstigen Zylinderwerken. Im Schwarzwald entstanden demgegenüber unter Jess Hans Martens qualitativ hochwertige Uhren, allerdings in sehr begrenzter Stückzahl. Glashütte in Sachsen hatte von keinem dieser Standorte eine ernst zu nehmende Konkurrenz zu fürchten. Doch im internationalen Vergleich spielte auch Glashütte nur eine marginale Rolle.

Nahezu unbemerkt entstanden in Deutschland ab etwa 1900 jedoch durchaus ernst zu nehmende Hersteller von Taschenuhren in Thüringen und im württembergischen Schwarzwald. So fertigten die Gebrüder Thiel in Ruhla schon um 1900 eine halbe Million Taschenuhren pro Jahr[31] und auch bei Thomas Haller in Schwenningen lag die Jahresproduktion damals bei gut 200.000 Uhren. Diese Fabriken begannen mit den günstigsten Werken, steigerten die Qualität aber kontinuierlich und stellten in der Zwischenkriegszeit Uhren von respektabler Güte in großer Zahl her.[32]

Doch selbst diese Erfolge verblassten neben den Stückzahlen der schweizerischen oder der US-amerikanischen Hersteller. Um 1900 lag die Jahresproduktion von Taschenuhren weltweit bei rund 20 Millionen Stück, hergestellt fast ausschließlich in der Schweiz und den USA.

13
Inserat von Jess Hans Martens, erschienen um 1870, Archiv Deutsches Uhrenmuseum, Furtwangen
Advertisement by Jess Hans Martens, date of publication around 1870, Archiv Deutsches Uhrenmuseum, Furtwangen

When the Baden ministry of trade and commerce finally decided to close the Furtwangen watchmaking school in the winter of 1863, Jess Hans Martens left the city and moved to Freiburg (im Breisgau), where he opened a shop for watches (ill. 13) and a 'Lehr-Anstalt für Uhrmacher' ('Watchmakers' School'), both of which he appears to have run until 1883. In total, he produced probably just over a thousand watches,[30] all of them equipped with sophisticated lever or chronometer movements. In addition to pocket watches, he produced marine chrono-

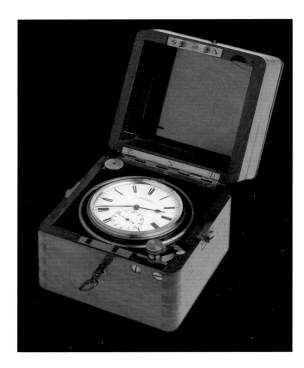

14
Jess Hans Martens, Schiffsuhr in kardanischer Aufhängung, Werk Nr. 1675, Freiburg im Breisgau, um 1870, Deutsches Uhrenmuseum, Furtwangen
Jess Hans Martens, Marine chronometer with gimbal suspensions, movement No. 1675, Freiburg (im Breisgau), around 1870, Deutsches Uhrenmuseum, Furtwangen

meters with gimbal suspensions (ill. 14). After his death in 1892, a long and respectful obituary was published in the Deutsche Uhrmacher-Zeitung. Despite his acclaim, not a single portrait of Jess Hans Martens has come down to us.

Conclusion

Despite multiple government-led and private initiatives, the production of quality pocket watches failed to take root either in Silesia or the Black Forest. Although several tens of thousands of watches were manufactured in Silesia, most of these were equipped with simple inexpensive cylinder movements. In the Black Forest, on the other hand, Jess Hans Martens fostered the fabrication of quality watches, but these were never produced in significant numbers. Neither Silesia nor the Black Forest ever posed a serious threat to the position of Glashütte in Saxony. Yet in the international context, even Glashütte played only a marginal role.

After about 1900, almost unnoticed, other serious producers of pocket watches emerged in Thuringia and in the Württemberg region of the Black Forest. Around 1900, the Gebrüder Thiel, a company founded in 1862 by the brothers Christian and Georg Thiel, produced half a million pocket watches a year in the Thuringian city of Ruhla,[31] while Thomas Haller's annual production in Schwenningen in Württemberg came to some 200,000 watches. Although both factories started out using the cheapest movements, they steadily improved the quality of their output. In the interwar years they produced large numbers of watches of respectable quality.[32] But those success stories pale into insignificance compared to the quantities produced by Swiss or American companies. Around 1900 the annual production of pocket watches worldwide ran to approximately 20 million watches, produced almost exclusively in Switzerland and the USA.

5 Vom rechten Maß
The Right Measure

Als Ferdinand Adolph Lange (1815 – 1875) im Jahr 1845 mit der seriellen Produktion von Taschenuhren begann, maßen deutsche, französische, Schweizer und englische Uhrmacher nach unterschiedlichem Maß. Auf dem Kontinent war die »Pariser Linie« (≈ 2,256 mm) weit verbreitet. Sie entsprach dem Zwölftel eines »Pouce«, der entweder nach dem duodezimalen oder nach dem dezimalen System unterteilt wurde. Dazugehörige Messgeräte nutzten in der Regel die Teilung durch 12, was die Rechenbarkeit erheblich erschwerte. Auf den Britischen Inseln maß man in Zoll (≈ 2,54 cm), der im Hinblick auf die Feinheit eines mechanischen Uhrwerks unhandlich erscheint. In der Praxis wurde die Größe vieler Uhrteile daher durch willkürliche Zahlen angegeben. Von Einheitlichkeit und Vergleichbarkeit war die internationale Uhrmacherei damit weit entfernt. Für Qualität und Quantität einer seriellen Fertigung war Normierung indes unerlässlich. Das metrische System bot hierfür die besten Voraussetzungen, da es als dezimales System rechnerisch leicht zu handhaben ist. Lange nutzte das metrische System von Beginn der Glashütter Produktion an und gehört damit zu den Pionieren seiner Verwendung in der Kleinuhrmacherei. Das Königreich Sachsen war zu diesem Zeitpunkt in der Längenmessung zu einem dezimalen System übergegangen, von einheitlichen Maßen jedoch weit entfernt. Trotz intensiver Bemühungen wurde das metrische System auch in Sachsen erst 1872 verbindlich, wie für das gesamte Deutsche Reich.

When Ferdinand Adolph Lange (1815 – 1875) began his serial production of pocket watches in 1845, German, French, Swiss and English watchmakers used different units of measurement. On the Continent, the 'ligne' was widely used (≈ 2.256 mm), this being a subdivision of the French inch ('pouce'). The 'pouce' could be subdivided using either the decimal or the duodecimal system. Watchmakers' measuring implements generally used the latter, making calculations difficult. In the British Isles, the measurement used was the inch (≈ 2.54 cm). Given the delicacy of a watch mechanism, the relatively large inch was rather impractical. Therefore, the sizes of many timekeeper parts were stated in haphazard ciphers. International watchmaking was a long way from uniformity and comparability. For quality and quantity of a serial production standardisation was essential. The metric system offered the best basis for this. Being decimal, it simplified calculations considerably. Lange used the metric system from the outset of production in Glashütte and thus became one of the pioneers of its use in watchmaking. By this time the Kingdom of Saxony had gone over to a decimal system for the measurement of length, but a unified system of measurement was still a long way off. Despite intensive efforts, the metric system only became mandatory in Saxony, along with the rest of the German Reich, in 1872.

Ferdinand Adolph Lange, Dosenmikrometer, um 1840, Lange Uhren GmbH, Glashütte

Ferdinand Adolph Lange, Micrometer with dial gauge, around 1840, Lange Uhren GmbH, Glashütte

1851 schrieb Ferdinand Adolph Lange: »mein erster und entscheidender Schritt war ein Maß zu construiren um mit größter Genauigkeit jedwedes berechnete Verhältnis im kleinsten Maasstabe auszuführen«.[1] Das von Lange entwickelte Mikrometer leistet in der Tat genau das. Über einen Mechanismus aus Zahnsegmenten und Trieben können kleinste Öffnungen der Zange auf der Skala abgelesen werden. Eine Zeigerumdrehung von 200 Grad entspricht 2 Millimetern. Die Messung ist damit auf 1/100 Millimeter Genauigkeit möglich. Der einzige Nachteil des Instruments liegt in der bogenförmigen Öffnung der Zange. Da eigentlich auf einer Geraden gemessen werden sollte, wird das Ergebnis leicht verfälscht. Durch den geringen Öffnungswinkel von maximal 6 bis 8 Millimeter ist der Fehler jedoch zu vernachlässigen.

In 1851 Ferdinand Adolph Lange wrote: 'my first and most crucial step was to construct a gauge with the smallest possible scale, allowing me to execute every calculated ratio with the greatest degree of exactitude.'[1] The micrometer which Lange developed did just that. A rack-and-pinion mechanism allows even the smallest apertures between the calliper tips to be read from the scale. One 200 degree turn of the needle corresponds to 2 millimetres, so that accurate measurements can be made to within of one hundredth of a millimetre. The only disadvantage of the instrument lies in the arc traced by the calliper tips on opening. Since measurements should in fact be along a line rather than an arc, the results are slightly distorted, but because the angle of the opening is never more than 6 to 8 millimetres, the error is negligible.

Étienne Lenoir, Normalmeter, Paris, 1810,
Mathematisch-Physikalischer Salon, Dresden

Étienne Lenoir, Standard metre, Paris, 1810,
Mathematisch-Physikalischer Salon, Dresden

Im Zuge der Revolution hatte der französische Nationalkonvent die Einführung des metrischen Systems beschlossen. Nach aufwendigen Vermessungsarbeiten zur Bestimmung des Erdumfangs durch Jean-Baptiste Delambre und Pierre Méchain wurde die Länge des Meters als 40-millionster Teil des Erdumfangs definiert. Das Urmeter aus Platin schuf 1799 der Instrumentenbauer Étienne Lenoir (1744 – 1832). Der Legationsrat und Bibliothekar Georg Beigel, Mitglied der 1811 eingesetzten sächsischen Maß- und Gewichtskommission, ließ dieses Normalmeter bereits 1810 aus Paris kommen. Es sollte ihm zum Vergleich der sächsischen Längenmaße und zur Bestimmung einer sächsischen Normal-Elle dienen.

During the French Revolution, the National Convention decided to introduce the metric system. After a lengthy surveying campaign by Jean-Baptiste Delambre and Pierre Méchain to determine the length of the circumference of the Earth, a metre was defined in 1799 as being one forty-millionth of this distance, and the original standard metre was manufactured in platinum by the instrument-maker, Étienne Lenoir (1744 – 1832). Georg Beigel, librarian and state councillor (Legionsrat), was appointed to the commission for weights and measures which was set up in Saxony in 1811. He had already received from Paris the previous year, 1810, this standard metre to help him compare the units of length then in use and to establish a standard ell for use throughout Saxony.

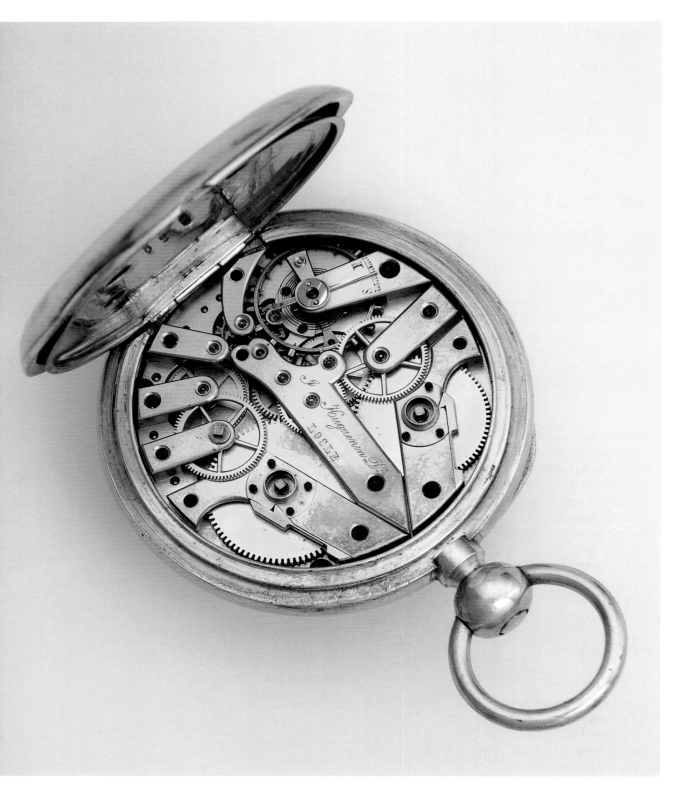

J. Huguenin, Silberne Taschenuhr, Le Locle, um 1850, Mathematisch-Physikalischer Salon, Dresden
J. Huguenin, Silver pocket watch, Le Locle, around 1850, Mathematisch-Physikalischer Salon, Dresden

Pierre-Yves Donzé

*Wie die Schweiz zur größten Uhrmachernation der Welt wurde – Ein kleiner Überblick über die Geschichte der Schweizer Uhrenindustrie von 1750 bis 1850**

*How Switzerland Became the Largest Watchmaking Nation in the World – A Short History of the Swiss Watch Industry from 1750 to 1850**

Während noch zu Beginn des 18. Jahrhunderts Großbritannien als die größte Uhrmachernation der Welt galt, übernahm die Schweiz schon in der ersten Hälfte des 19. Jahrhunderts diese Position auf dem Weltmarkt der Uhrenherstellung. Bald darauf erreichte das Land eine buchstäbliche Monopol- bzw. Vormachtstellung, die auch bei den Weltausstellungen in London (1851 und 1862) und Paris (1855 und 1867) deutlich wurde. Zu Beginn der 1870er Jahre wurde der Anteil der Schweiz an der weltweiten Uhrenproduktion auf 70 % geschätzt; die wichtigsten Konkurrenten waren Frankreich (13,6 %), Großbritannien (9,1 %) und die USA (4,5 %).[1]

In den Jahren 1750 – 1850 fand folglich eine Verschiebung in der Hierarchie der Produktionszentren zugunsten der Schweiz statt, die sich mit zwei wichtigen und komplementären Faktoren erklären lässt: die Fähigkeit, auf sich verändernde Handelsströme zu reagieren, und den Aufbau eines speziellen Produktionssystems.

Whereas Great Britain was still the largest watchmaking nation in the world in the mid-eighteenth century, Switzerland established itself as the main global producer of watches during the beginning of the nineteenth century. It would soon have a real monopoly on the global market, a supremacy that was underscored during The Great Exhibitions in London (1851 and 1862) and Paris (1855 and 1867). At the start of the 1870s, Switzerland's share of global watch production was estimated at 70 %, its main competitors being France (13.6 %), Great Britain (9.1 %), and the United States (4.5 %).[1]

The period between 1750 and 1850 thus saw an upheaval in the global hierarchy of production centres to the benefit of Switzerland. The success of Swiss watchmakers can be explained by two significant and complementary factors: the capacity to respond to a reshuffle in trade flows and the establishment of a particular production system.

Steigende Nachfrage weltweit

In Ermangelung statistischer Daten über die schweizerischen Exporte vor 1880 ist es schwierig, einen genauen Überblick über die relative Bedeutung der verschiedenen Absatzmärkte für Schweizer Uhren in der zweiten Hälfte des 18. und zu Beginn des 19. Jahrhunderts zu erlangen. Dennoch zeichnen sich die Exporte der Schweizer Uhrenindustrie in dieser Zeit durch zwei Besonderheiten aus: auf der einen Seite durch die wachsende Bedeutung des amerikanischen Marktes, auf der anderen durch die Ausweitung der Absatzmärkte auf der ganzen Welt. Es ist eine tiefgreifende Wandlung der wichtigsten Handelszentren in Kontinentaleuropa hin zur Atlantikzone zu beobachten, aus der die Schweizer Uhrenhändler vor allem dank der »internationalen Verflechtungen einer Handel treibenden Bourgeoisie« Profit schlagen konnten.[2]

Die Präsenz Schweizer Händler und Uhrmacher in den USA ist seit dem Ende des 18. Jahrhunderts belegt. Zahlreiche Händler aus Neuenburg traten in Philadelphia in den 1790er Jahren und in New York zu Beginn des 19. Jahrhunderts in Erscheinung. Zwar handelte es sich dabei hauptsächlich um Bankiers und Großhändler, durch deren Präsenz in der Neuen Welt konnten jedoch Handelsbeziehungen mit der Schweiz entstehen, die auch den Aufbau von Geschäften der Schweizer Uhrenhändlern in den Städten der Ostküste begünstigten. Das beständige Wachstum des amerikanischen Marktes mündete in den Jahren 1830–1850 in eine buchstäbliche »Amerikanisierung der helvetischen Exporte«,[3] wie es Béatrice Veyrassat treffend formulierte. Obwohl es nicht möglich ist, dieses Wachstum statistisch zu belegen, ist festzustellen, dass in diesem Zeitraum zahlreiche Zweigstellen von Schweizer Handelshäusern in den USA eröffnet wurden. Das 1833 in Saint-Imier gegründete Uhrenkontor von Auguste Agassiz (1809–1877), aus dem später das Unternehmen Longines hervorging, ist ein hervorragendes Beispiel für die Bedeutung des amerikanischen Marktes für die Schweizer Eta-

The Increase in Global Demand

In the absence of statistical data regarding Swiss exports before the 1880s, it is difficult to have a clear view of the relative significance of the various markets in which Swiss watches were sold during the second half of the eighteenth and first half of the nineteenth centuries. However, two features characterise Swiss watchmaking exports during this period: the growing significance of the American market on the one hand, and the increase in worldwide outlets on the other. A major transformation in the main continental-European trade zones occurred in favour of the Atlantic region, and Swiss watch merchants were able to benefit from these dramatic changes, thanks in particular to the 'international ramifications of a merchant upper middle class.'[2]

The presence of Swiss traders and watchmakers in the United States is documented from the end of the eighteenth century. Of particular note is an important community of merchants from Neuchâtel in Philadelphia during the 1790s, and then in New York at the start of the nineteenth century. Although this mainly comprised bankers and large-scale traders, the presence of this group in the New World facilitated the establishment and development of trade flows with Switzerland, which in turn encouraged the arrival of Swiss watch merchants in East Coast towns. This on-going expansion in the American market led to a real 'Americanisation of Helvetian exports,'[3] to quote Béatrice Veyrassat, between 1830 and 1850. Although it is not possible to measure this growth statistically, we witness the opening of branches by a number of Swiss trading companies in the United States during this time. The watchmaking office of Auguste Agassiz (1809–1877), which was founded in 1832 in Saint-Imier and would go on to become the Compagnie des Montres Longines, perfectly illustrates the significance of the American market for Swiss établisseurs (watchmaking merchants). The watches produced by Agassiz were chiefly sold in the United States

blisseure. Die von Agassiz hergestellten Uhren wurden in erster Linie in den USA verkauft; als Zwischenhändler fungierte dabei sein Schwager Auguste Mayor, der sich in den 1840er Jahren in New York als Händler niederließ.[4]

Trotz der starken Abhängigkeit vom amerikanischen Markt waren die USA im 19. Jahrhundert bei weitem nicht das einzige Standbein des Schweizer Uhrmacherhandwerks. Uhrmacher und Händler aus der Schweiz waren schon damals auf der ganzen Welt anzutreffen. Auch Europa, das im 18. Jahrhundert noch den wichtigsten Absatzmarkt des Schweizer Uhrmacherhandwerks darstellte, blieb von großer Bedeutung, da die Schweiz Handelsbeziehungen mit den größten Handelszentren des Kontinents unterhielt (Amsterdam, Frankfurt, Livorno, London, Paris usw.). In dieser Zeit war der europäische Markt von einer Expansion nach Osten geprägt, die sich insbesondere in der Einrichtung von Handelsbeziehungen mit Russland und der Türkei manifestierte. Bei Russland handelte es sich dabei nicht unbedingt um einen neuen Absatzmarkt, waren doch mehrere Genfer Uhrmacher und Juweliere, insbesondere aus den Familien Duval und Fazy, dort bereits seit dem 18. Jahrhundert vertreten. In den 1810er Jahren konnte jedoch die Ankunft neuer Händler beobachtet werden. Diese arbeiteten vorwiegend für die Uhrenhersteller aus Le Locle (Buhré, Gabus, Tissot, Zénith) und brachten Uhren in größerem Stil in Umlauf, womit sie wiederum die Entwicklung des Marktes vorantrieben. Was die Türkei betrifft, so waren dort Genfer Uhrmacher bereits seit dem 17. Jahrhundert stark vertreten, da sich am Hofe von Konstantinopel ein privilegiertes Klientel für die Schweizer Uhrmacher fand. Am Ende des 19. Jahrhunderts erfuhr dieser Markt einen bedeutsamen Aufschwung, so dass Ostasien und Lateinamerika die wichtigsten außereuropäischen Absatzmärkte darstellten.

Der Uhrenhandel in Lateinamerika wurde unter ähnlichen Bedingungen wie in den USA vollzogen, da der Uhrenexport vor dem Hintergrund des Kolonialhandels einen Teil des breiter gefächerten Warenstroms darstellte. Zu Beginn

through the mediation of Agassiz's brother-in-law, Auguste Mayor, who set himself up as a merchant in New York during the 1840s.[4]

Though reliance on the American market was strong among Swiss watchmakers in the nineteenth century, the United States was far from being Switzerland's only outlet. Not only were there Helvetian merchants and watchmakers all over the world, but Europe retained its considerable significance as the main market for Swiss watchmakers in the eighteenth century. Though they certainly maintained business relationships in the continent's main trading cities (Amsterdam, Frankfurt, Livorno, London, Paris, etc.), the distinctive feature of the European market for Swiss watchmakers during this period was its expansion eastwards, including the establishment of trade relations with Russia and Turkey. Strictly speaking, Russia was not a new outlet, as several watchmakers and jewellers from Geneva — the Duval and Fazy families in particular — had already settled there in the eighteenth century. But, from the 1810s onwards, new merchants arrived who chiefly worked for watchmakers from Le Locle (Buhré, Gabus, Tissot, Zénith) and who sold watches on a larger scale, thus stimulating development of the market. As for Turkey, this was a market in which watchmakers from Geneva had been very much present since the seventeenth century, the court of Constantinople constituting a privileged clientele for Swiss watchmakers. The Turkish market experienced significant growth at the turn of the nineteenth century. Lastly, the main non-European outlets were Latin America and East Asia.

The watch trade in Latin America was conducted in a very similar context to that of the United States, because the export of watches to this region was part of a more general flow based on colonial trading. At the start of the nineteenth century, Swiss merchants were to be found across the entire subcontinent, especially along the Atlantic (Mexico, Brazil, and Argentina). Their activities were not restricted to dealing in watches, however; they acted within the framework of colonial trade. The company Auguste

Pierre-Yves Donzé

des 19. Jahrhunderts waren Schweizer Händler auf dem gesamten Subkontinent vertreten, insbesondere aber an der Atlantikküste (Mexiko, Brasilien, Argentinien). Deren Aktivitäten beschränkten sich jedoch nicht nur auf den Handel von Uhren; vielmehr waren sie im allgemeinen Kolonialhandel tätig. Das Unternehmen Auguste Leuba & Cie. ist ein gutes Beispiel für dieses Phänomen. Um 1822 wurde es von Auguste Leuba sen. gegründet und im Jahr 1828 von seinem Sohn Auguste Leuba jun. übernommen. Seine Tätigkeitsschwerpunkte lagen nicht nur auf dem Import von Uhren, Textilien und Spirituosen nach Brasilien, sondern auch auf dem Export von Kaffee nach Europa. Auf Letzteres war das Unternehmen von der zweiten Hälfte des 19. Jahrhunderts bis zu seiner Schließung im Jahr 1908 spezialisiert.[5]

Im 19. Jahrhundert eröffneten sich dem Schweizer Uhrmacherhandwerk mit Ostasien vollkommen neue Absatzmärkte. Der chinesische Markt wurde in den 1820er Jahren von den aus Val-de-Travers stammenden Gebrüdern Bovet kontrolliert, deren Unternehmen wie ein multinationaler Konzern funktionierte: Die Organisation entsprach den Prinzipien der internationalen Arbeitsteilung, der Unternehmenssitz befand sich seit 1815 in London, die Produktion erfolgte in der Schweiz und die Uhren wurden von Guangzhou aus, wo sich einer der Brüder im Jahr 1822 niederließ, nach China vertrieben. Nach der Unterzeichnung des Vertrages von Nankin (1842), mit dem China für den Handel mit dem Westen geöffnet wurde, gelangten weitere schweizerische Handelsunternehmen, wie Vaucher Frères, Dimier Frères, Juvet und Courvoisier, nach China.[6] Mit der Zwangsöffnung von Japan für den internationalen Handel wurde die Globalisierung der Märkte im Jahr 1853 vollständig abgeschlossen. Die Uhrmacher François Perregaux (1834–1877) und James Favre-Brandt (1841–1923) waren bereits seit Beginn der 1860er Jahre in Japan etabliert, wo sie dem Uhrenhandel den Weg ebneten und den Verkauf von Uhren aus ihrem Heimatort Le Locle (Nardin, Tissot, Zénith) förderten. Mit der Öff-

Leuba & Cie. is an excellent example of this phenomenon. The business was founded in Rio around 1822 by Auguste Leuba Sen., who was joined by his son, Auguste Leuba Jun., in 1828. It handled the import of timepieces to Brazil, but also of textiles and spirits, and exported coffee back to Europe – a trade in which it specialised during the second half of the nineteenth century until its closure in 1908.[5]

The genuinely new markets opening up to Swiss watchmaking during the nineteenth century were those in East Asia. In the 1820s, the Chinese market was controlled by the Bovet brothers of Val-de-Travers. Their business operated as a real firm, organised in accordance with the principle of international division of labour, with its head office located in London from 1815, watchmaking carried out in Switzerland, and sales conducted in China from Canton, where one of the brothers had been established since 1822. After the signing of the Treaty of Nanking (1842), which opened China up to trade with the West, several other Swiss trading companies arrived on the scene, such as Vaucher Frères, Dimier Frères, Juvet, and Courvoisier.[6] Finally, the forced opening of Japan to international trade in 1853 completed the globalisation of the markets. Established in Japan from the beginning of the 1860s, Le Locle watchmakers François Perregaux (1834–1877) and James Favre-Brandt (1841–1923) lay the groundwork for watch trading in Japan, favouring the sale of watches from their home turf (Nardin, Tissot, Zénith). With Japan now trading, all nations were henceforth open for global business. Swiss watchmakers were everywhere, even if not all outlets had the same commercial significance.

The Evolution of the Production System

The growth in both demand and marketing channels led to a substantial increase in watch production in Switzerland. Their manufacture, mainly concentrated in the city of Geneva in the second half of the sixteenth century and during

nung von Japan hatten nunmehr alle Nationen Zugang zum weltweiten Handel. Schweizer Uhrmacher waren auf der ganzen Welt vertreten, auch wenn die verschiedenen Absatzmärkte nicht gleichermaßen bedeutsam waren.

Die Weiterentwicklung des Produktionssystems

Die steigende Nachfrage und die wachsenden Vertriebsnetze führten in der Schweiz zu einer signifikanten Steigerung der Uhrenproduktion. Die Uhrenherstellung, die in der zweiten Hälfte des 16. und im 17. Jahrhundert hauptsächlich in der Stadt Genf konzentriert war, weitete sich im Laufe des 18. Jahrhunderts auf den kompletten Jurabogen aus. Diese geographische Expansion ging mit einigen organisatorischen Besonderheiten einher.

Zu Beginn war die Uhrenproduktion in Genf, die von jährlich 5000 Stück im Jahr 1686 auf 85.000 Stück im Jahr 1781 angewachsen war,[7] in Zünften organisiert. Für die Uhrenhersteller hatte diese Organisation den Zweck, die Kontrolle über den Industriezweig zu wahren. Außerdem war das Erlernen des Uhrenmacherhandwerks im Jahr 1678 lediglich dem Bürgertum und der Bourgeoisie der Stadt vorbehalten. Den Angehörigen der niedrigeren Klassen (»Natifs« und »Habitants«) war es nur erlaubt, weniger angesehene Tätigkeiten auszuüben, wie die Herstellung von Uhrwerkteilen oder die Montage von Uhrengehäusen. Die Aufteilung der Tätigkeiten in der Uhrmacherei nach gesellschaftlichem Stand war eine Ursache für die sozialen Konflikte in Genf im 18. Jahrhundert; erst nach und nach wurde den Natifs (1738) und dann den Habitants (1782) wieder erlaubt, das Uhrmacherhandwerk zu erlernen.

Zuletzt führte der starke Anstieg der Produktion in der zweiten Hälfte des 18. Jahrhunderts zu einem Aufbrechen der Zunftstrukturen, denn zur Steigerung der Arbeitskraft bedurfte es einer Überarbeitung der Organisationsstrukturen in der Herstellung. Mit dem neuen Zunftreglement von 1785 wurde das Uhrmacherhandwerk auch

the seventeenth century, spread to the whole of the Jura Arc over the course of the eighteenth century. This geographical expansion was accompanied by specific organisational characteristics.

To begin with, in the city of Geneva, the production of watches — with an estimated annual production level of 5000 units in 1686 and 85,000 units in 1781[7] — was conducted within the context of corporations. The watchmakers aimed to maintain their hold over this industry and, in 1678, reserved membership in the trade for Geneva's citizens and burghers. The inferior classes ('natifs' and 'residents') were only allowed to practise poorly paid trades such as the production of movements or case making. The social division of labour in the watchmaking industry lay at the heart of the social conflicts that shook Geneva during the eighteenth century, as a result of which the natifs (1738) and then the habitants (1782) were in turn readmitted to the trade.

Eventually, the very strong growth in production during the second half of the eighteenth century destroyed this corporate framework. The organisation of production had to be revised in order to allow for an increase in the workforce. Thus the new guild regulations, adopted in 1785, opened up the watchmaking professions to women, who numbered more than a thousand in the industry by 1799.[8] Apprenticeship regulations were likewise relaxed: it was now possible to learn about more than just one aspect of a watch. The other striking feature of the shake-up of manufacturing in Geneva was the appearance of production centres outside of this lakeside city, in sparsely developed regions specifically without any corporations, which allowed the industry to expand more freely: this was especially true for the Vallée de Joux, the Neuchâtel mountains and the Vallon de Saint-Imier.

The spread of watchmaking in the Jura Arc is traditionally explained as being a result of its rise in Geneva. In order to benefit from the more liberal conditions in force in the Jura Arc and neighbouring France, where corporations did not exist, the manufacturers in Geneva are said to

Frauen zugänglich gemacht; bereits im Jahr 1799 sollte der Anteil der Frauen die Tausendermarke überschreiten.[8] Außerdem wurden die Regelungen für die Ausbildung gelockert, so dass es von nun an möglich war, sich nicht mehr nur in einem speziellen Bereich der Uhrmacherei ausbilden zu lassen. Ein weiterer wichtiger Aspekt der Auflösung der Genfer »Fabrique« war die Entstehung weiterer Produktionszentren außerhalb der Genfer Stadtgrenzen sowie in ländlicheren Regionen, in denen es zuvor keine Zünfte gegeben hatte, wodurch eine freiere Entwicklung des Industriezweiges ermöglicht wurde. Dies gilt insbesondere für die Regionen Vallée de Joux, die Neuenburger Berge und das Vallon de Saint-Imier.

Traditionell wird die Ausweitung des Uhrmacherhandwerks auf den Jurabogen als Konsequenz des Aufschwungs in Genf dargestellt. Demnach haben die Genfer Uhrmacher damit begonnen, die Arbeit aus den Stadtgrenzen hinaus zu tragen, um von den liberaleren Bedingungen im Jurabogen und im benachbarten Frankreich zu profitieren, wo ein Zunftsystem nicht existierte. Damit haben sie auch dazu beigetragen, das Wissen über das Uhrmacherhandwerk zu verbreiten. Dennoch ist das Auftreten von Uhrmacherbetrieben in den Neuenburger Bergen und dem Vallon de Saint-Imier nicht nur eine Folge der Verlagerung des Genfer Uhrmacherhandwerks. Es resultierte auch aus einer endogenen Entwicklung. Diese Region profitierte von ihren eigenen Handelsnetzen: Die Weitergabe von handwerklichem Wissen außerhalb der Region erfolgte über Uhrmacher auf Reisen, wie beispielsweise den Genfer Uhrmachermeister Simon Fornet, der in den 1760er Jahren bei Familien im Erguel lebte.[9] Zu den lehrreichsten Reisezielen zählten Paris und London, wo die weltweite Uhrmacherelite zusammenkam. Auch Persönlichkeiten wie Jean-Pierre Droz (1709 – 1780), geboren in Renan im Vallon Saint-Imier, der nach Abschluss seiner Ausbildung in La Chaux-de-Fonds zusammen mit anderen Uhrmachern von Basel nach Paris gereist war, waren dort anzutreffen. So auch Jacques-Frédéric Houriet (1743 – 1830),

have begun distributing work outside of their city and to have thus contributed to the spread of watchmaking expertise. Nevertheless, the arrival of watchmaking in the Neuchâtel mountains and the Vallon de Saint-Imier was not only due to the decentralisation of the Geneva watchmaking industry, but was also the result of internal development: this region enjoyed its own commercial channels. As for expertise, outside of the region the trade was passed on by visiting watchmakers, such as Geneva-based master watchmaker Simon Fornet, who stayed with families in Erguel during the 1760s.[9] Those who were more affluent went to Paris and London, where they rubbed shoulders with the elite in the world of watchmaking; for example, individuals like Jean-Pierre Droz (1709 – 1780), born in Renan in the Vallon de Saint-Imier, who spent time with watchmakers in Basel and Paris following his apprenticeship at La Chaux-de-Fonds, or Jacques-Frédéric Houriet (1743 – 1830), son of a Le Locle watchmaker, who went to Paris in 1759, where he was trained in the workshops of Julien Le Roy (1686 – 1759), clockmaker to the king, before returning to Le Locle in 1768 to pursue his career.[10] Over the course of the eighteenth century, the Jura Arc thus enjoyed considerable growth in watchmaking based both on privileged access to commercial channels and a proactive policy of knowledge acquisition. According to Frédéric Scheurer, the number of watchmakers in the canton of Neuchâtel grew from 464 in 1752 to 3634 in 1788.[11]

The 'Etablissage' System

Following its rise in the Jura Arc over the course of the eighteenth century until the appearance of the first factories in the final third of the nineteenth century, Swiss watchmaking was organised in line with the system known as 'établissage,' which was a method of production characterised by a clear division of labour between legally independent workshops (figure 1). The key player in this production method was the

Sohn eines Uhrmachers aus Le Locle, der nach Paris ging, um von Julien Le Roy (1686 – 1759) im Jahr 1768 nach Le Locle zurückzukehren, um seine Karriere fortzuführen.[10] Im Laufe des 18. Jahrhunderts kam es im Jurabogen zu einem deutlichen Wachstum der Uhrenindustrie, das sich auf den privilegierten Zugang zu Handelsnetzen und eine gezielte Ausbildungspolitik stützte. Gemäß Frédéric Scheurer wuchs die Zahl der Uhrmacher im Kanton Neuchâtel von 464 im Jahr 1752 auf 3634 im Jahr 1788.[11]

Das System der »Etablissage«

Mit Beginn des Aufschwungs im Jurabogen im 18. Jahrhundert bis zum Auftreten der ersten Fabriken im letzten Drittel des 19. Jahrhunderts war das Schweizer Uhrmacherhandwerk nach dem System der sogenannten »Etablissage« organisiert, das eine strikte Arbeitsteilung zwischen rechtlich unabhängigen Werkstätten bezeichnet (siehe Graphik 1). Im Zentrum dieser Produktionsweise stand der »Etablisseur«. Dieser stellte die reibungslose Funktion des Systems sicher, indem er die Rolle eines Vermittlers zwischen dem Markt und den Herstellern übernahm. Dabei war der Etablisseur kein Industrieller, sondern ein Händler. Er verteilte die Arbeiten zwischen den verschiedenen Zulieferern, die wiederum auf Zulieferer der zweiten Stufe zurückgriffen. Ein Beispiel dafür sind die Monteure der Uhrengehäuse, die das Polieren und die Emaillierung von anderen durchführen ließen. Anschließend führte der Etablisseur die extern gefertigten Teile (Gehäuse, Uhrwerke, Zeiger usw.) zusammen, welche zumeist im eigenen Uhrmacheratelier, der Werkstatt, zusammengesetzt wurden. Manche Etablisseure delegierten auch Teile ihrer Aufgaben an Uhrenhersteller weiter, die nicht über einen Zugang zum Markt verfügten und ihnen daher komplette Uhren lieferten. Die Uhrenproduktion entsprechend der Etablissage war folglich ein überaus komplexes System, das vielfältige Formen annehmen konnte.

'établisseur;' he ensured that the system functioned by assuming the role of intermediary between the market and the producers. The établisseur was not a manufacturer, but a merchant. He distributed the work to various subcontractors, who themselves also sometimes resorted to employing second-tier subcontractors. Case makers, for example, had the polishing and enamelling of their products completed by third parties. The établisseur then combined the externally produced items (cases, movements, hands, etc.), which were sometimes assembled in his own workshop, the 'comptoir d'horlogerie' (watchmaking shop). Certain établisseurs also sometimes subcontracted a portion of their work to watchmakers who, not having access to the markets, delivered complete watches to them. Watch production within the context of établissage was thus an extremely complex system that could assume very different forms.

The second duty carried out by the établisseur was the commercialisation of production. He was first and foremost a merchant and had access to trade outlets. The établisseur did not generally work alone, but rather in close collaboration with relatives and business associates. The most typical model was the presence in Switzerland — usually in a watchmaking centre such as Geneva, La Chaux-de-Fonds, or Le Locle — of a family member who supervised the watch production, and the establishment of other siblings in various parts of the world (Germany, Italy, Great Britain, United States, etc.), where they handled the sale of watches received from Switzerland. Sometimes the établisseurs went to independent watch merchants, who fulfilled an intermediary role in accessing specific markets. It should be noted that the families of établisseurs active in the watchmaking industry during the first half of the nineteenth century were often related to one another by marriage, thus forming family 'nebulas.'[12] Moreover, such families were commonly old merchant families who had amassed substantial wealth under the Ancien Régime thanks to the textile trade. It was precisely this financial weight that created the

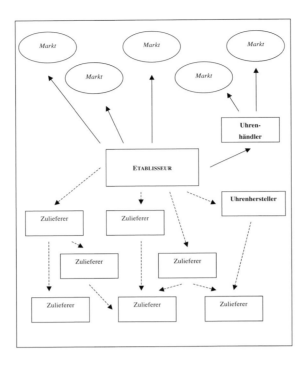

Graphik 1: Das System der »Etablissage« im Schweizer Uhrmacherhandwerk

Die zweite Funktion des Etablisseurs bestand in der Kommerzialisierung der Produktion. In erster Linie war der Etablisseur also ein Händler mit Zugang zu den Absatzmärkten, wobei er meist nicht allein arbeitete, sondern in enger Zusammenarbeit mit Geschäftspartnern und Familienangehörigen. Das am weitesten verbreitete System bestand in der Präsenz eines Familienmitglieds in der Schweiz, im Allgemeinen in einem wichtigen Zentrum der Uhrenindustrie, wie Genf, La Chaux-de-Fonds oder Le Locle. Diese Person war mit der Überwachung der Uhrenproduktion betraut, während sich andere Mitglieder der Familie in anderen Teilen der Welt (Deutschland, Italien, Großbritannien, USA usw.) befanden, wo sie die Uhren aus der Schweiz verkauften. Von Zeit zu Zeit nahmen die Etablisseure auch die Dienste von unabhängigen Uhrenhändlern in Anspruch, die als Vermittler den Zugang zu bestimmten Märkten sicherstellten. Zuletzt ist zu betonen, dass die Familien von

key players in the établissage system; they possessed the necessary capital to distribute work to small subcontractors who generally had no wealth of their own.

Conclusion

Switzerland was thus able to gradually establish itself as the undisputed leader in the global watchmaking industry in the period from 1750 to 1850. Its success was built to an equal degree on the commercial dynamism of its entrepreneurs and on its ability to organise an extremely flexible production system that facilitated the manufacture of inexpensive watches. These two key elements of Swiss watchmaking complemented one another immensely. Thanks to établissage, Swiss watchmakers were able to offer an almost limitless variety of models and therefore to respond to the extreme diversity in global

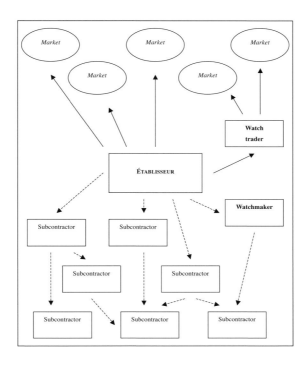

Figure 1: The 'établissage' system in Swiss watchmaking

Etablisseuren in der Uhrenindustrie in der ersten Hälfte des 19. Jahrhunderts oft untereinander durch Heirat verbunden waren, weshalb von »nebulösen«[12] Familienverbänden gesprochen werden kann. Außerdem handelte es sich im Allgemeinen um alteingesessene Händlerfamilien, die zu Zeiten des Ancien Régime durch den Textilhandel bereits ein beträchtliches Kapital angehäuft hatten. Gerade diese Finanzkraft machte sie zu den Schlüsselfiguren der Etablissage: Sie verfügten über das notwendige Kapital, um Aufgaben an kleine Zulieferer verteilen zu können, die im Allgemeinen nicht über Vermögen verfügten.

Zusammenfassung

Die Schweiz konnte sich im Zeitraum zwischen 1750 und 1850 als unumstrittener Marktführer der weltweiten Uhrenindustrie etablieren. Die-

demand. They understood the complete value chain, from the production of the watch's constituent parts to the sale of the end product, and could thus market watches whose form, size, metals, and design corresponded to the tastes of the day and to local cultures.

Swiss watchmaking therefore enjoyed undisputed worldwide leadership during the 1850s and 1860s. But this was a colossus with feet of clay. On the other side of the Atlantic, a new type of business, enjoying generous capital and modern technologies, began mass-producing standardised watches after the American Civil War. Through the 1870s, they challenged the dominating position of the Swiss watchmakers, forcing the European industry into a far-reaching transformation, the result of which would finally be a strengthening of its competitiveness on the global market.

ser Erfolg stützt sich sowohl auf die wirtschaftliche Dynamik ihrer Unternehmer als auch auf ihre Fähigkeit, ein überaus flexibles Produktionssystem aufzubauen, das eine kostengünstige Uhrenproduktion möglich machte. Diese beiden Grundelemente des Schweizer Uhrmacherhandwerks waren untrennbar miteinander verbunden. Das System der Etablissage ermöglichte den Schweizer Uhrmachern, eine nahezu unbegrenzte Palette an verschiedenen Modellen anzubieten und somit auf die Vielfalt der weltweiten Nachfrage reagieren zu können. Außerdem beherrschten sie jedes Glied der Wertschöpfungskette, von der Produktion der Einzelteile der Uhr bis zum Verkauf des Endprodukts. Auf diese Weise konnten die Schweizer Uhrmacher Produkte auf den Markt bringen, die in ihrer Form, ihrer Größe, der Wahl der verwendeten Metalle und ihrem Design den aktuellen Trends folgten und den lokalen Vorlieben entsprachen.

In den 1850er und 1860er Jahren war das Schweizer Uhrmacherhandwerk somit der unangefochtene Marktführer, auch wenn es gleichzeitig ein Riese mit tönernen Füßen war. Auf der anderen Seite des Atlantiks entstanden nach dem Sezessionskrieg neuartige Fabriken, die sich mit viel Kapital und modernen Technologien auf die Massenproduktion standardisierter Uhren spezialisierten. Im Laufe der 1870er Jahre traten diese Unternehmen in Konkurrenz zu den Schweizer Uhrenherstellern und machten ihnen ihre bis dato unangefochtene Marktdominanz streitig. Im letzten Drittel des 19. Jahrhunderts sah sich die Schweizer Uhrenindustrie schließlich gezwungen, auf die amerikanische Konkurrenz mit tiefgreifenden Umstrukturierungen zu reagieren, mit denen die Wettbewerbsfähigkeit auf dem internationalen Markt verbessert werden sollte.

6 Die Glashütter Uhr
The Glashütte Watch

Ferdinand Adolph Lange (1815 – 1875) hatte seine Marktnische schon 1843 definiert: Er wollte weder Massenware noch Präzisionsuhren fertigen, sondern hochwertige Gebrauchsuhren. Zudem sollten diese Uhren im internationalen Vergleich preiswert sein. Lange musste damit von Anfang an auf eine kostengünstige und zugleich qualitativ überzeugende Fertigung zielen. Für das Gelingen spielten viele Faktoren eine Rolle, Lange selbst benannte jedoch drei als wesentlich:

1. Berechnung statt Erfahrungswissen,
2. verbesserte Maschinen zur tadellosen Herstellung der einzelnen Teile,
3. konstruktive Einfachheit und Vollkommenheit.

Lange berechnete die Größen der Uhrenteile, so z. B. die Größe des Federhauses und das Verhältnis von Rädern und Trieben. Daneben gehörte er zu den ersten deutschen Uhrmachern, die den Radzähnen ihre bestmögliche Form gaben, nämlich die einer speziellen Rollkurve, der Epizykloide. Weiterhin ersetzte er den bis dahin gebräuchlichen Drehbogen durch das Schwungrad. Damit verkürzte sich die benötigte Zeit beim Andrehen von Zapfen, Eindrehen von Trieben oder Herstellen von Wellen erheblich. Schließlich suchte er die gesamte Konstruktion des Uhrwerks so einfach als möglich zu halten, denn ein komplizierter Mechanismus erhöht die Fehleranfälligkeit der Uhr und erschwert die serielle Fertigung. Dabei perfektionierte er zugleich die Bestandteile der Uhr und ihr Zusam-

In 1843, Ferdinand Adolph Lange (1815 – 1875) had already defined his market niche. He wanted to make neither mass-produced nor precision watches, but high-quality watches for everyday use. They also had to compare favourably with international competition in terms of price. From the start, then, Lange had to aim for cost-effective yet demonstrably high quality production. Lange identified three factors as crucial for success:

1. calculation-based planning rather than knowledge handed-down by experience,
2. improved machinery to ensure error-free manufacture of individual components,
3. a simple and flawless design.

Lange calculated the sizes of his watch components – the size of the barrel and the ratio of wheels and pinions, for example. He was also one of the first German watchmakers to implement the optimum profile for wheel teeth in his movements: the epicycloidal curve. He replaced the hitherto customary bow-lathe with the flywheel-lathe, thus considerably reducing the time taken to turn pivots and manufacture arbours. Finally, he tried to keep the overall design as simple as possible – since complexity increases the chances of error and makes serial production more difficult – while at the same time perfecting the design and interaction of the components. As Moritz Grossmann later wrote, the Glashütte watch was both 'simple and mechanically perfect.'

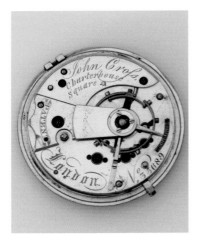
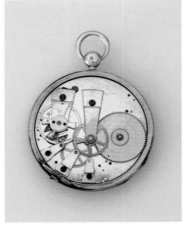
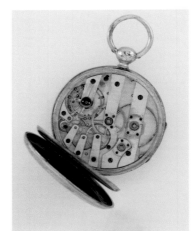

Vollplatine
Full cover plate

Lépine-Kaliber
Lépine calibre

Schweizer Brückenwerk
Swiss bar construction

menspiel. Die Glashütter Uhr war damit »einfach, aber mechanisch vollkommen«, wie Moritz Grossmann später schrieb.[1]

**Charakteristika der Glashütter Uhr:
Die ¾-Platine**

Bis in das 18. Jahrhundert waren die Werke von Taschenuhren zwischen zwei Platten montiert, die durch Pfeiler miteinander verbunden waren. Einzig die Unruhe wurde mittels eines meist kunstvoll verzierten Klobens auf der oberen Platine gelagert. Gestelle mit voller Deckplatine boten relativ viel Platz für die Anordnung des Laufwerks, was besonders Uhrwerken mit Kette und Schnecke zugute kam, die eine größere Höhe erforderten. Um 1770 konstruierte der Franzose Jean-Antoine Lépine (1720 – 1814) eine neuartige Taschenuhrform. Lépine hatte einen schlüssellosen Aufzug entwickelt und zudem auf Kette und Schnecke verzichtet. Anstelle der vollen Deckplatine benutzte er einzelne Kloben, in denen die beweglichen Teile gelagert waren. In der Folge konnte die Uhr weit flacher ausgeführt werden. Die sogenannten Lépine-Kaliber nahmen im Laufe der Zeit ver-

Characteristics of the Glashütte Watch:
the ¾ Plate

Until the early eighteenth century the movements of pocket watches were mounted between two plates, held together by pillars. Only the balance wheel was mounted outside, fixed to the back plate by means of a balance cock, usually elaborately decorated. Movements with full cover plates offered relatively spacious accommodation for the mechanism, especially useful for chain and fusee movements, which required more height. Around 1770, the French watchmaker Jean-Antoine Lépine (1720 – 1814) built a new type of pocket watch. Lépine developed a method for keyless winding, and also did away with the chain and fusee. Instead of the full cover plate, he used separate bars to support the moving parts. As a result, watches could now be made much slimmer. The so-called Lépine calibre developed variations as time went on. In Switzerland, bridges – fixed by two feet – came to be preferred to bars. However, bar and bridge movements are more expensive to make than full-plate movements and do not offer as much stability for the moving parts. The ¾ plate was developed as a compromise. It was economical

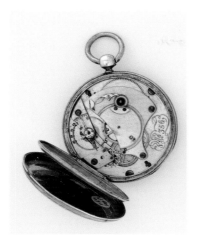
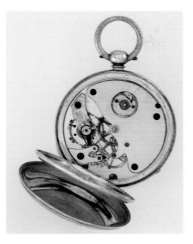
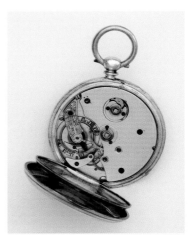

Glashütter Deckplatine, frühe Form
Glashütte cover plate, early form

¾-Platine Glashütte
¾ plate Glashütte

¾-Platine London
¾ plate London

schiedene Formen an; in der Schweiz wurden beispielsweise anstelle von Kloben häufig Brücken, an zwei Füßen befestigte Stege, verwendet. Im Vergleich zur vollen Platine sind Kloben- und Brückenwerke aufwendiger herzustellen und bieten zudem nicht die gleiche Stabilität der Lagerung. Als ein Kompromiss entwickelte sich die ¾-Platine. Sie war kostensparend in der Fertigung, erleichterte Reparatur und Reinigung und bot den beweglichen Werkteilen präzisen Halt. Ferdinand Adolph Lange benutzte sie nach einer Phase des Experimentierens für seine Uhren. Auch bessere englische Uhren wurden ab ca. 1830 häufig mit der ¾-Platine ausgestattet.

Die Ankerhemmung für Taschenuhren

Seit ihrer Erfindung um 1755 hat sich die freie Ankerhemmung für mechanische Uhren bewährt. Ihre Geschichte illustriert anschaulich den Wandel von Präzisionsstandards im Laufe der Zeit. Während die wenigen Uhren mit freier Ankerhemmung im 18. Jahrhundert als Chronometer galten, wurde die Ankerhemmung im Verlauf des 19. Jahrhunderts zu einem Merkmal hochwertiger Taschenuhren. Die Qualitätsanforderungen

to make, simplified cleaning and repairs and allowed moving parts to be mounted securely and precisely. After a period of experimentation, Ferdinand Adolph Lange adopted it for his watches. Better-quality English watches were also frequently fitted with ¾ plates from about 1830 onwards.

The Lever Escapement

Invented in 1755, the detached lever escapement stood the test of time. Its history is a good illustration of the way in which requirements for precision fluctuated over the years. Whilst the few timepieces made with detached lever escapement in the eighteenth century were regarded as chronometers, during the nineteenth century lever escapements became a feature of the high-quality pocket watch. Quality was still high, but not to the standard of a precision instrument. For popular success, the lever escapement needed a number of improvements. A lighter construction and the addition of draw to the lever palettes, for example, significantly improved reliability. Different countries developed preferences for different types of lever escapement. English watchmakers preferred escape

 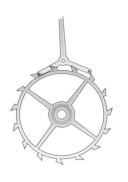 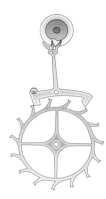

Englische Spitzzahnankerhemmung	*Rechenankerhemmung*	*Schweizer Kolbenzahnankerhemmung*	*Stiftenankerhemmung*	*Glashütter Ankerhemmung*
English lever escapement	Rack lever escapement	Swiss club-tooth lever escapement	Pin-pallet escapement	Glashütte lever escapement

waren immer noch hoch, entsprachen jedoch nicht dem eines Präzisionsinstruments. Für den allgemeinen Erfolg der Ankerhemmung war eine Reihe von Verbesserungen notwendig. Eine leichtere Bauweise und »Zug« an den Ankerpaletten sorgten beispielsweise für deutlich sichereres Funktionieren. In den einzelnen Ländern entwickelten sich Vorlieben für unterschiedliche Formen der Ankerhemmung: Englische Uhrmacher verwendeten vorrangig spitzzahnige Gangräder, während Franzosen und Schweizer auf Gangräder mit Kolbenzähnen setzten. Ferdinand Adolph Lange verwendete in den ersten Glashütter Jahren die von Louis Perron (1779 – 1836) entwickelte Stiftenankerhemmung, die preiswert und leicht herzustellen war. Um 1855 ging er zum Glashütter Ankergang mit dem typischen Gangrad mit 16 Kolbenzähnen über. Um 1875 schließlich begann A. Lange & Söhne Ankerchronometer – zertifizierte Uhren mit großer Unruhe und verbessertem Regulierverhalten – zu bauen und schloss damit den Kreis zu den Anfängen der Ankerhemmung in der Präzisionsuhrmacherei.

wheels with ratched teeth, while the French and the Swiss opted for club teeth. In the early years at Glashütte, Ferdinand Adolph Lange used the pin-pallet escapement developed by Louis Perron (1779 – 1836). It was cheap and easy to produce. Around 1855 he went over to the movement which became typical of Glashütte watches: lever escapement and club-toothed escape wheel with 16 teeth. Finally, around 1875, the firm of A. Lange & Söhne began to manufacture lever escapement chronometers – certified watches with large balances and improved regulation – thus returning to the origins of the lever escapement in precision watchmaking.

David Penney

Ingold, Nicole und Lange – Eine neue Art der Uhrenherstellung

Ingold, Nicole and Lange – A New Way of Making Watches

Das Uhrmacherhandwerk entstand im Verlauf des 16. Jahrhunderts in Mitteleuropa. Es entwickelte sich schnell zu einem hoch spezialisierten Gewerbe, an dem viele verschiedene Handwerker Teil hatten: Gehäusemacher, Zeigermacher, Graveure, Vergolder, Räderschneider, Triebmacher, Federmacher, Hemmungsmacher etc. Gegen Ende des 17. Jahrhunderts hatte es sich über das gesamte Gebiet des heutigen Europa verbreitet und in zwei relativ eigenständige Bereiche verzweigt. Rund die Hälfte der beteiligten Berufsgruppen war auf die Fertigung von Rohwerken – in Frankreich und der Schweiz als »Ebauches« bezeichnet – spezialisiert (Abb. 1). Die übrigen Fachhandwerker waren für die Finissierung bzw. Fertigbearbeitung der Rohwerke zuständig, bevor diese dann, mit dem Namen eines Lieferanten signiert, in den Verkauf gehen konnten. Einen aufschlussreichen Überblick über das Gewerbe bietet der von William Pearson[1] verfasste Artikel in »Rees's

Watchmaking began in central Europe during the sixteenth century and quickly became a business involving many different specialists: casemakers, hand makers, engravers, gilders, wheel cutters, pinion cutters, spring makers, escapement makers, etc. By the end of the seventeenth century, the now European-wide trade had split into two similar but quite different sections. Around half of the specialist tradesmen produced the rough movements (ill. 1), which the French and Swiss call 'ébauches.' The other specialists were involved in finishing these movements, getting them ready for sale, and naming them for the retailer. A good account of the business, written by William Pearson,[1] can be read in *Rees's Cyclopædia*,[2] published at the beginning of the nineteenth century. Pearson gives a list of at least 40 different specialists involved in the manufacture of a watch, many of which trades were also subdivided.

1
Kasten mit sechs Rohwerken, darunter Beispiele aus England und Frankreich (Breguet)
Box of six rough movements, including English and French (Breguet) examples

Cyclopædia«,[2] einem Anfang des 19. Jahrhunderts erschienenen Universalwörterbuch der Künste und Wissenschaften. Pearson listet über 40 verschiedene – und teilweise in sich noch weiter aufgefächerte – Einzelhandwerke auf, die an der Herstellung einer einzigen Uhr beteiligt waren.

Dieser Arbeitsteilung, die nirgends so intensiv vorangetrieben wurde wie in England, ist auch die Entstehung solch wunderbarer Kunstwerke zu verdanken. Viele verschiedene Arbeiter, alle Meister ihres Fachs, konnten gemeinsam Uhren herstellen, die prächtig anzusehen waren, die Zeit anzeigten und zudem den Zufällen eines Le-

It was this specialisation, particularly in England, that allowed the creation of such wonderful works of art. Many different workmen, all at the top of their craft, could work together to produce watches that were both beautiful to look at and also told the time; as well as being able to resist the vagaries of a life that included un-metalled roads, travel on horseback, and exposure to extremes of temperature and weather.

With the invention of the balance-spring around 1685, and its development by Thomas Tompion (1639–1713)[3] and a few other watchmakers working in London, the 'London' watch

bens trotzen konnten, das von Schotterstraßen, Reisen zu Pferd sowie extremen Temperaturen und Wetterverhältnissen geprägt war.

Schon bald nach der Erfindung der Spiralfeder im Jahre 1685 und ihrer Weiterentwicklung durch Thomas Tompion (1639 – 1713)[3] und anderen in London tätigen Uhrmachern erfreuten sich die »Londoner« Uhren europaweit einer immer größer werdenden Beliebtheit. Taschenuhren mit dieser von den Zeitgenossen als »Pendelfeder« bezeichneten Neuerung waren ihren Vorgängern an Präzision so weit überlegen, dass diese im Vergleich schlagartig als veraltet galten und kaum noch begehrenswert erschienen. Vor allem Tompion hatte sich mit seinen Taschenuhren einen Namen gemacht. Das erklärt auch, warum der heutzutage vor allem für seine Großuhren bekannte Tompion auf dem einzig erhaltenen zeitgenössischen Porträt ein Taschenuhrwerk in Händen hält (Abb. 2).

Es dauerte nicht lange, bis auch andere europäische Zentren der Uhrmacherei sich daran machten, »Pendeltaschenuhren« (Abb. 3) zu fertigen, die so genannt wurden, weil sie es ihren größeren Namensvettern, den noch relativ jungen Pendel-Standuhren, an Präzision beinahe gleichtaten. Allerdings mussten sich diese in der Gunst der Kunden erst einmal gegen die Londoner Modelle durchsetzen, was nicht wenige europäische Uhrenhersteller zu der Entscheidung veranlasste – oder aus ihrer Sicht wohl vielmehr dazu zwang –, die Konkurrenten aus London zu kopieren. Dies ging so weit, dass die Uhren mit »London« als Herstellungsort und einem häufig rein fiktiven englischen Herstellernamen signiert wurden. Weit davon entfernt, aus dem Ort zu stammen, auf den diese Fälschungen in bewusster Irreführung hinwiesen, wurden die Uhren Mitte des 18. Jahrhunderts nachweislich im bayerischen Friedberg gefertigt, zum weit überwiegenden Teil stammten sie jedoch ursprünglich aus der Schweiz (Abb. 4). Tatsächlich war der ausgedehnte Handel mit Schweizer Kopien und Fälschungen während zweier Jahrhunderte der Motor für die Entstehung neuer, florierender Uhrmacherzentren. Dieser wichtige

2
Thomas Tompion Automatopæus. Mezzotinto-Porträt von John Smith nach einem Gemälde von Sir Godfrey Kneller, um 1695
Thomas Tompion Automatopæus. Mezzotint portrait by John Smith after the original painting by Sir Godfrey Kneller, around 1695

quickly became the desired watch for customers throughout Europe. Watches with 'pendulum-springs,' as they were then known, were much more accurate and soon made earlier watches without them obsolete and undesirable. Tompion, in particular, gained a great reputation for his watches and it is no surprise that he is shown holding a watch movement in the one contemporary portrait we have of him (ill. 2), even though he is now best known for his clocks.

These new pendulum watches (ill. 3), so-called because their accuracy approached that of the relatively new pendulum clocks, also began to be made in the other watch centres in Europe.

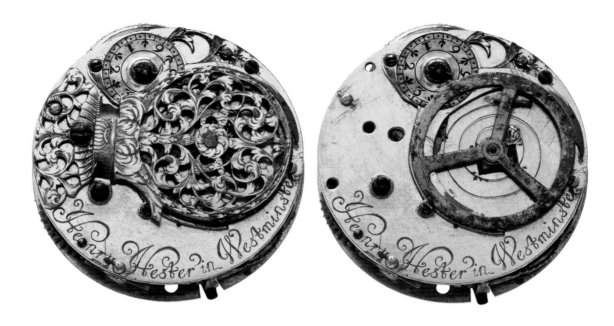

3
Zwei Ansichten eines in London hergestellten Uhrwerks mit Spindelhemmung,
die Unruh und die Spiralfeder bei entferntem Kloben zeigend, um 1695
Two views of a London made verge watch movement showing the balance and balance-spring
with the cock removed, around 1695

Vorgang ist bislang jedoch nur in Umrissen bekannt.[4]

Gegen die billigeren Schweizer Uhren, die den Markt überschwemmten, vermochte sich die niederländische Uhrmacherei um die Mitte des 18. Jahrhunderts nicht mehr durchzusetzen – ein Niedergang, der sich schon bald darauf in Deutschland wiederholte. Die ehemals bedeutende Uhrmacherkunst in Augsburg und anderen deutschen Zentren verschwand, mit wenigen Ausnahmen, von der Bildfläche. Taschenuhren kamen zu dieser Zeit aus den großen Zentren Paris und London sowie aus Genf und anderen Schweizer Städten.

Dieser Zustand blieb so lange bestehen, bis ein gewisser Pierre Frédéric Ingold (Abb. 5) in der Schweiz erschien und bessere Methoden zur Herstellung von Uhren anstrebte. Seine Ideen sind schon lange bekannt, werden allerdings meist mit dem Etikett »gescheitert« versehen.

However, such watches had to compete for customers with those made in London, and many non-English makers decided, or perhaps felt they were forced, to copy London work. Further, a great many of such copies were also engraved with 'London' as their place of manufacture, often bearing false names as well. Intended to deceive, some of these fakes are known to have been produced in Friedberg around the middle of the eighteenth century but most are known to have originated in Switzerland (ill. 4). Indeed, the extensive marketing of Swiss copies and fakes for the best part of two centuries was the main engine of change in respect to where watchmaking flourished throughout the period and is itself a most important and, as yet, little known story.[4]

By the middle of the eighteenth century Dutch watchmaking had succumbed to the influx of these cheaper Swiss watches, a process of de-

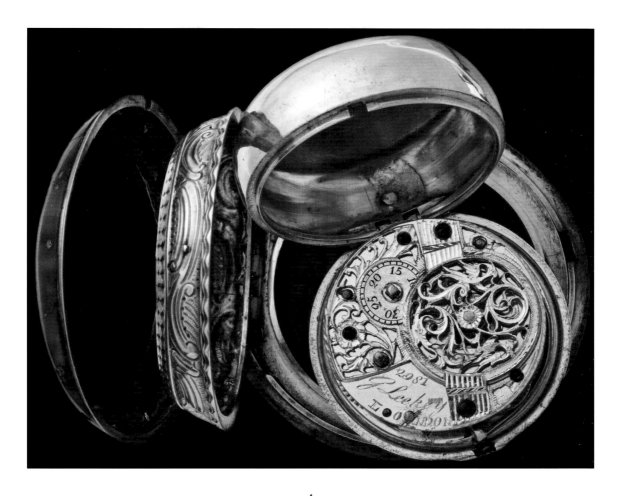

4
Typische Schweizer Taschenuhr mit Dreifachgehäuse und falschem »Londoner« Namen, um 1780
Typical Swiss-made triple-cased watch bearing a fake 'London' name, around 1780

Auf Ingold ist es jedoch zurückzuführen, dass die Art und Weise, in der auf der ganzen Welt Uhren hergestellt wurden, sich ein für alle Mal radikal änderte.

Ingold wurde am 6. Juli 1787 im schweizerischen Bienne als Sohn eines Uhrmachers und einer ebenfalls im Uhrenhandwerk tätigen Mutter geboren. Von dieser erlernte der erst dreijährige Junge nach dem frühen Tod des Vaters viele Handgriffe des Gewerbes. Mit zwölf Jahren soll er sich bereits auf das Räder- und Triebmachen sowie auf die Fertigung von Spindel- und

cline that was soon repeated in Germany. The once active business of making watches in Augsburg and other centres in Germany had vanished, with a few exceptions, and it was only in the twin centres of Paris and London, and in Geneva and other places in Switzerland, that watches continued to be manufactured.

Nothing much changed until the appearance, in Switzerland, of someone who thought there was a better way of making watches: Pierre Frédéric Ingold (ill. 5). Long known about, and almost universally written about in terms of

Zylinderhemmungen verstanden haben, einem seit jeher als besonders schwierig geltenden Zweig der Uhrmacherei.

Im Alter von 20 Jahren arbeitete Ingold in Le Locle bei Frédéric Houriet (1743 – 1830),[5] der einige der besten Taschenuhren seiner Zeit herstellte. In diese Zeit fällt auch die Begegnung mit Urban Jürgensen (1776 – 1830),[6] der damals bei Abraham Louis Breguet (1747 – 1823) arbeitete.[7] 1812 lebte Ingold in Paris, wo er mit knapper Not der Einberufung in die napoleonische Armee entging. Vermutlich war dieses verstörende Erlebnis der Anlass für Ingolds Emigration nach Amerika. Doch auf der Überfahrt von Dünkirchen wurde er von Briten, die ihn für einen französischen Staatsbürger hielten, verhaftet und etwa drei Monate festgehalten. Danach kehrte er in die Schweiz zurück.[8]

Trotz dieser Vorkommnisse arbeitete Ingold 1814 in London. Wichtiger für seine Laufbahn waren jedoch seine Pariser Jahre bei Breguet von 1817 bis 1822, während derer er, wie Jürgensen vor ihm, im Namen des Unternehmens auf Reisen ging. In dieser Zeit dürfte sich ihm Gelegenheit für die zahlreichen Kontakte in der Welt der Uhrmacherei geboten haben, die für sein Leben prägend waren.

1825 war Ingold zurück in Genf und begann mit Frédéric Japy (1749 – 1812),[9] Pierre Louis Berthoud (1754 – 1813)[10] und anderen über die Gründung einer Uhrenfabrik nachzudenken. Das Projekt wurde nicht realisiert, da man Ingold – nicht zum letzten Mal – vorwarf, er wolle den Uhrmachern ihr traditionelles Handwerk streitig machen. Mit ähnlichen Argumenten wurde 1836 auch sein Vorschlag für die Gründung einer Schule für Uhrmacherlehrlinge abgelehnt.

Unbeirrt von seinen Schweizer Misserfolgen machte sich Ingold auf den Weg nach Frankreich, um dort für seine Ideen zu werben. Zu diesem Zweck erschien 1836 ein Heft mit Plänen zur Gründung eines Unternehmens, der »Compagnie d'Horlogerie Parisienne«,[11] für die jedoch nicht das nötige Kapital aufgebracht werden konnte. Ähnliche Pläne entwickelte er 1838 für ein Unternehmen mit Sitz in Versailles,[12] die aber

5
Pierre Frédéric Ingold (1787 – 1878)

'failure,' his ideas were to radically change the manufacture of watches throughout the world.

Ingold was born in Bienne, Switzerland, on 6 July 1787. His father was a clockmaker and his mother worked in the watch trade. It was his mother, upon the early death of his father when Pierre was just three, who taught the young boy many of his skills. By twelve he is reported to have been proficient in wheel and pinion cutting, and in making verge and cylinder escapements, the latter always considered a difficult branch of the trade.

By the time he was twenty, Ingold was working in Le Locle and was staying with Frédéric

6
British Watch and Clockmaking Company (Ingold), Nr. 1341, Goldgehäuse mit Feingehaltsstempel, London, 1843
British Watch and Clockmaking Company (Ingold), No. 1341, gold case hallmarked, London, 1843

ebenfalls daran scheiterten, dass trotz der Un-
terstützung durch einige angesehene und wohl-
habende Persönlichkeiten wie Lepaute,[13] Le
Roy[14] und Robin[15] nicht die erforderlichen Mittel
zusammenkamen.

Trotz der Rückschläge in der Schweiz und in
Frankreich reiste Ingold wiederholt nach Eng-
land, um sich weiter nach Unterstützern für die
Gründung eines eigenen Unternehmens (zur in-
dustriellen Herstellung der einzelnen Bestand-
teile von Uhren) umzusehen. 1842 konnten
schließlich mithilfe von John Barwise,[16] Thomas
Earnshaw jun.[17] und einigen anderen Gleich-
gesinnten Fabrikräume in London gefunden, Ma-
schinen hergestellt und einige Taschenuhren

Houriet (1743 – 1830),[5] maker of some of the fi-
nest watches of the period. Among those whom
Ingold met during this time was Urban Jürgensen
(1776 – 1830),[6] who was then working for Abra-
ham Louis Breguet (1747 – 1823).[7] By 1812, In-
gold was working in Paris, at which time he nar-
rowly escaped conscription into Napoleon's army.
This no doubt disturbing event led him to seek
emigration to America and it was on the boat,
at Dunkirk, that Ingold was captured by the Brit-
ish. Thinking him a French national, the British
held Ingold captive for around three months,
after which he returned to Switzerland.[8]

Undeterred by this experience, Ingold was
back working in London by 1814. More impor-

produziert werden (Abb. 6). Auch seinem Gesuch nach einem Patent für seine im Detail dargelegten Methoden und Maschinen wurde stattgegeben.[18] Da die Frage der Finanzierung allerdings weiterhin ungeklärt blieb, wurde eine Gesetzesvorlage eingebracht, um die erforderlichen Gelder zu beschaffen.[19]

Das britische Handelsministerium unterstützte den Gesetzentwurf, bei Vertretern der Uhrmacherzunft aus London und Coventry löste er hingegen lautstarke Proteste[20] und Handgreiflichkeiten[21] aus. Auf vehementen Widerstand stieß das Vorhaben auch bei der Clockmakers' Company,[22] die nichts unversucht ließ, um Ingold und seine Pläne in Verruf zu bringen. Bei der zweiten Lesung am 31. März 1843 sprach sich das Parlament gegen die Gesetzesvorlage aus, die die Grundlagen für die Beschaffung des Kapitals gelegt hätte.

Bereits vor dieser Niederlage hatte sich Ingold jedoch schon nach Amerika gewandt. 1845 traf er dort ein, ohne seine Maschinen und seine kleine Belegschaft, wohl aber mit seinem »Portfolio an Ideen«, wie er es nannte. Obwohl Ingold 1852 sogar die amerikanische Staatsbürgerschaft annahm, befand er sich schon kurze Zeit später wieder in Europa. 1856 wurde ihm in Frankreich das Patent für die von ihm entwickelte »Fräse« erteilt, ein überlegenes Werkzeug zum »Wälzen« oder »Abrunden« der Radzähne.[23]

Wichtig ist ferner der Hinweis, dass Ingold nicht nur neuartige Maschinen entwickelte, sondern auch ein grundlegend verändertes Produktionssystem vor Augen hatte. Demzufolge hätten die Bediener der Maschinen eine vollständige Uhr mit all ihren Einzelteilen gefertigt, wodurch die arbeitsteilige Herstellung unter Heranziehung von Spezialisten verschiedener Disziplinen hinfällig geworden wäre. Es verwundert also nicht, dass Ingolds Einfallsreichtum den Unwillen der in großen Zahlen beteiligten Handwerkszweige auf sich zog. Seinen Plänen schlug vor allem von dort der heftigste Widerstand entgegen, wo sich die Uhrmacherkunst und die mit ihr verknüpften Zünfte auf eine besonders lange Tradition berufen konnten.

tantly, from 1817 to 1822, he was working for Breguet in Paris and, like Jürgensen before him, was employed to travel for the firm. It is during this period that Ingold would have been in the perfect position to further the many horological contacts that were a feature of his life.

Ingold was back in Geneva by 1825, at which time he held discussions with Frédéric Japy (1749 – 1812),[9] Pierre Louis Berthoud (1754 – 1813),[10] and others about the formation of a Watchmaking Company. Ingold was accused, not for the last time, of trying to take work away from traditional watchmakers and this project came to nothing, as did a School for Apprentices which he proposed in 1836.

Undeterred by his failures in Switzerland, Ingold travelled to France in order to promote his ideas. A Prospectus for a new company in Paris was published in 1836[11] but failed to attract the capital needed. In 1838, a similar company was proposed at Versailles[12] but, despite receiving the backing of such illustrious figures as Lepaute,[13] Le Roy[14] and Robin,[15] it, too, failed to attract the necessary backing.

Despite his experiences in Switzerland and France, Ingold made repeated trips to England to seek the help necessary in starting a company. By 1842, with the backing of John Barwise,[16] Thomas Earnshaw Jun.,[17] and others, premises in London were found, machines were made, and a few watches produced (ill. 6). Most importantly, an English Patent,[18] clearly setting out his methods and his machines, was sought and granted. However, there remained the question of finance and a Parliamentary Bill[19] was raised in order to attract the necessary money.

The Bill was favoured by the Board of Trade but it was received with often rowdy dissension by the London[20] and Coventry trade.[21] The project was also powerfully opposed by the Clockmakers' Company[22] which left no chance pass to discredit both Ingold and his ideas. On its second reading, on 31 March 1843, the Bill needed to raise the capital was rejected.

Even before this failure, Ingold was looking to America, and he was there by 1845, without

Ingold selbst war es Zeit seines Lebens nicht vergönnt, die Pläne für eine eigene Manufaktur in die Tat umzusetzen. Daher waren es auch nicht so sehr seine Maschinen als vielmehr seine Ideen, die seine Nachfolger in Amerika inspirierten. Auch in London gab es ein in Zusammenhang mit Ingold äußerst wichtiges Unternehmen: die um 1838 in London gegründete Firma Nicole & Capt.[24]

Bei ihrer Ankunft in London richteten sich die gebürtigen Schweizer Charles Victor Adolphe Nicole (1812 – 1876) und Jules Philippe Capt (geboren 1813) in London in 80b Dean Street ein; nur wenige Häuser entfernt von Ingold, der in Hausnummer 75 tätig war. Mehr war über die Verbindung zwischen den beiden Firmen bislang nicht bekannt. Zwei unlängst aufgefundenen wichtigen Dokumenten ist es nun jedoch zu verdanken, dass weitere Erkenntnisse ans Licht gekommen sind. In einer 1886 veröffentlichten Kurzbiographie über David Louis Antoine Nicole (1818 – 1871), Adolphes Bruder,[25] findet sich der Hinweis, dass David Nicole unter anderem »viele Werkzeuge für die Versailler Uhrenfabrik gefertigt« habe; ein Hinweis auf das uns bekannte zweite Vorhaben Ingolds in Frankreich. Angesichts der Tatsache, dass das Unternehmen Nicole & Capt nur wenig später bereits mit großem Erfolg Qualitätsuhren für Einzelhändler wie Eduard John Dent (1790 – 1853)[26] und Charles Frodsham (1810 – 1871)[27] (Abb. 7) fertigte, ist dieser Hinweis durchaus relevant.

David Nicole, der zunächst gemeinsam mit seinem Bruder arbeitete, Ende der 1860er Jahre aber eine eigene Firma hatte, soll damals außerdem der Hauptlieferant von schlüssellosen Rohwerken für Endfertiger in London, Coventry und Birmingham gewesen sein. Zu dieser Zeit dürfte die Familie Nicole also bereits tiefe Wurzeln in der Welt der englischen Uhrmacherkunst geschlagen haben.

Die zweite wichtige Auskunft über Nicole & Capt stammt von einem Nachfahren der Familie Nicole, der in Besitz einer unveröffentlicht gebliebenen Familiengeschichte ist.[28] Besonders interessant an dieser Familienchronik, die auf

his machines or his small workforce, but with his 'portfolio of ideas' as he called it. Ingold even became an American citizen, in 1852, but was almost certainly back in Europe soon after. He was granted a French Patent in 1856 for his 'Fraise,' a superior tool for 'rounding up' or 'topping' the teeth of wheels.[23] It is also important to know that along with some radical new machines, Ingold advocated a change in the system such that the machine operators made the complete watch from start to finish, thus bypassing the existing specialist workers. This is what upset the various trades, and it is perhaps no wonder that Ingold's ideas were most violently opposed where watchmaking and its associated guilds were well established.

Ingold never managed to set up and run his own manufactory, and it is perhaps his ideas rather than his machines that inspired those that came after him in America. There is, however, a most important London based firm which, until my NAWCC Paper, had been overlooked in regard to Ingold's ideas. The firm is Nicole & Capt, which was set up in London around 1838.[24]

Swiss born Charles Victor Adolphe Nicole (1812 – 1876) and Jules Philippe Capt (born 1813) arrived in London and set up shop at 80b Dean Street, only a few doors away from Ingold who was at 75. Other than this, any connection was unknown but, thankfully, two important facts have recently come to light, the first being a short biography of David Louis Antoine Nicole (1818 – 1871), Adolphe's brother, that appeared in 1886.[25] The author states that David Nicole, among other accomplishments, had 'made many tools for the Versailles Watch Company,' which was Ingold's second French venture. This is significant given what the firm of Nicole & Capt were to accomplish within a comparatively short period, producing many fine watches for retailers such as Edward John Dent (1790 – 1853)[26] and Charles Frodsham (1810 – 1871) (ill. 7).[27]

David Nicole, at first working with his brother but operating separately by the late 1860s, is also said to be the major supplier of keyless watch movements to the London, Coventry,

David Penney

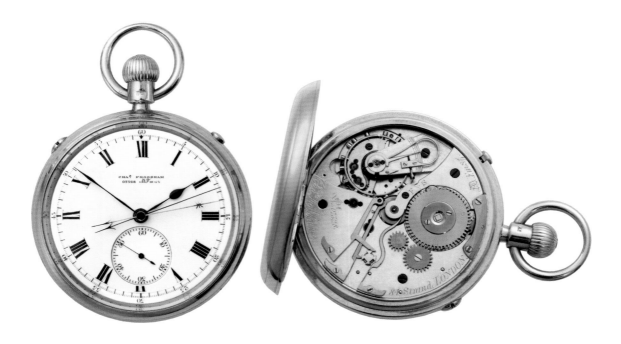

7
**Charles Frodsham, Nr. 07328, London. Typische hochwertige Uhr mit Schleppzeiger-Chronograph,
wie sie Nicole Nielsen herstellten und lieferten. Goldgehäuse mit Feingehaltsstempel, London, 1886**
Charles Frodsham, No. 07328, London. A typical high-grade watch, with split-seconds chronograph,
as made and supplied by Nicole Nielsen. Gold case hallmarked, London, 1886

Gespräche mit Angehörigen aus dem Jahr 1935 zurückgeht, ist, dass zumindest einer der damaligen Gesprächspartner alt genug war, um Nicole und seine engste Familie noch persönlich gekannt zu haben. Diesen Aufzeichnungen zufolge verließ Nicole in Begleitung einiger jüngerer Freunde den Schweizer Kanton Jura bereits mit dem Ziel, Ingold beim Aufbau seiner Uhrenmanufaktur in Versailles zu unterstützen. Weiterhin heißt es, dass Nicole später, gemeinsam mit anderen, Ingold auch auf seiner Reise nach London begleitete, um ihm dort bei seinem neuen Vorhaben zur Seite zu stehen. Vermutlich gehörten sie zu der Gruppe von »sechs oder acht« Arbeitern, deren Anwesenheit in Ingolds Werkstatt in Soho zu dem Zeitpunkt bezeugt ist, als das dringend benötigte Gesetzesvorhaben zur Finanzierung seiner Projekte im Parlament scheiterte.

and Birmingham finishers at this period, and it would seem that the Nicole family's roots were already deep within English watchmaking by this time.

The second piece of evidence concerning Nicole & Capt comes via a Nicole descendant who is in possession of an unpublished account of the history of the Nicole family.[28] Importantly, the account is based on information given by members of the family in 1935, with at least one member old enough to have known Nicole and his immediate family. The notes state that Nicole left the Swiss Jura, accompanied by some of his young friends, in order to help Ingold set up his watch company in Versailles. The notes further state that Nicole and others then travelled to London with Ingold and helped with his new venture, and it would have been this group of 'six or eight'

164

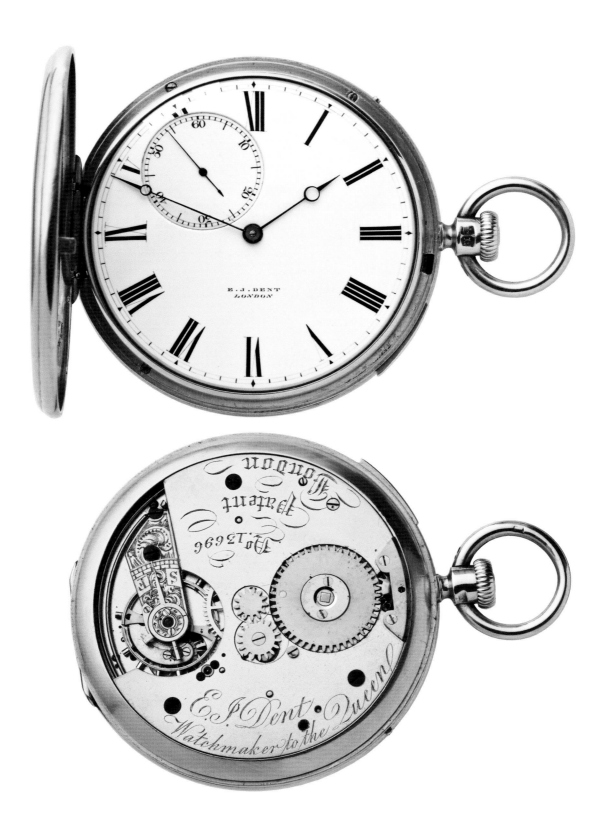

8
Edward John Dent, Nr. 13696. Eine typische frühe schlüssellose Uhr, wie sie Nicole & Capt herstellten und lieferten.
Goldgehäuse mit Feingehaltsstempel, London, 1848
Edward John Dent, No. 13696. A typical early keyless watch, as made and supplied by Nicole & Capt.
Gold case hallmarked, London, 1848

Kurz darauf ging Ingold nach Amerika, jedoch ohne die Begleitung von Nicole und den anderen. Stattdessen beschlossen Nicole und Capt in London ein eigenes Unternehmen zu gründen. Wie statistischem Material aus Volkszählungen zu entnehmen ist, lebten zu diesem Zeitpunkt sechs Schweizer Staatsbürger über der Werkstatt in der Dean Street, unter anderem Adolphe Nicole, sein Bruder Jules Henri und Jules Phillipe Capt. 1851 war die Belegschaft auf zwölf Mann gestiegen.

Außerdem unterzeichneten Nicole & Capt in diesem Jahr einen Vertrag, der dem angesehenen Londoner Uhrmacher Edward John Dent den Alleinvertrieb für die einzigartigen schlüssellosen Uhren von Nicole & Capt (Abb. 8) zugestand, denen sich der außerordentliche Erfolg Dents auf der Weltausstellung in London im selben Jahr in der Hauptsache verdankt.

Der Einfluss des Unternehmens Nicole & Capt auf die englische Uhrmacherei und sein Erfolg waren so groß, dass die Partner schnell zu den bedeutendsten Londoner Uhrmachern in der zweiten Hälfte des 19. Jahrhunderts aufstiegen – auch wenn die meisten ihrer Werke mit dem Namen anderer Einzelhändler signiert sind. Obwohl sie sich innerhalb der Zunft einen Namen gemacht hatten, waren sie einem breiteren Publikum kaum bekannt und selbst ein Kontakt zur Clockmakers' Company ist nicht überliefert. Auch dem damals neu gegründeten British Horological Institute[29] traten sie nicht bei. Erst Ende der 1880er Jahren wurde ein Bericht über das Unternehmen und seine Produktionsmethoden für das Institut vorbereitet.[30]

Diese Zurückhaltung hatte einen einfachen Grund: Die Firma Nicole & Capt – später Nicole, Nielsen & Co. – stellte ihre Uhren von Anfang an maschinell her, auf der Grundlage der Ingold'schen Erfindungen und mit Maschinen, die den seinen sehr ähnlich waren. Nicole & Capt war jedoch nicht daran gelegen, denselben Unwillen wie Ingold auf sich zu ziehen. Mit nur 18 Angestellten war das Unternehmen bereits 1881 imstande, sowohl Uhren als auch Gehäuse herzustellen, dazu noch Repetitions-

workers who were in Ingold's Soho workshop at the time that the much needed Finance Bill failed.

Ingold then went to America, but Nicole and the others decided not to accompany him this time. Instead, Nicole and Capt stayed in London and set up on their own. Census information shows six Swiss nationals, including Adolphe Nicole, his brother Jules Henri, and Jules Philippe Capt living above the shop in Dean Street at this time. By 1851, the workforce had risen to twelve.

Also by 1851, Nicole & Capt had signed an exclusive agreement with Edward John Dent that allowed this well-respected London firm to retail their distinctive keyless watches (ill. 8) – and it was these Nicole & Capt watches that were a major reason for the acclaim received by Dent at the Great Exhibition in London that year.

Nicole & Capt made an immediate impact on English watches and their success was such that they soon became the most important London watchmakers of the second half of the nineteenth century, even though most of their work bears other retailers' names. Though well known in the trade, they kept a low profile and had no known contacts with the Clockmakers' Company. Nor did they join the fledgling British Horological Institute,[29] and it was not until well into the 1880s that a visit was made and a report prepared for the Institute on Nicole's premises and their mode of manufacture.[30]

The reason for such reserve, quite simply, was that the firm of Nicole & Capt, later becoming Nicole, Nielsen & Co., was making watches by machinery, based on Ingold's ideas and using Ingold-type machines, from the very beginning, and that they did not want to attract the same sort of anger and resentment as that shown to Ingold. By 1881, the firm employed no more than eighteen people but was making both watches and cases, including repeaters, chronographs, and other complications (ill. 9).[31]

One further and hitherto unrecognised influence of Ingold's ideas was the resurrection of German watchmaking and the start of many

9

Birch & Gaydon, Nr. 2655, London. Tourbillion-Uhr von Nicole Nielsen nach der Abbildung auf Seite 18 des Firmenkatalogs.
Das Uhrwerk trägt außerdem die Nicole-Seriennummer 12196. Silbergehäuse mit Feingehaltsstempel, London, 1894
Birch & Gaydon, No. 2655, London. Tourbillion watch made by Nicole Nielsen, as shown on page 18 of their catalogue, the
movement also bearing Nicole's serial number 12196. Silver case hallmarked, London, 1894

werke, Chronographen und andere Komplika-tionen (Abb. 9).[31]

Ingolds Einfluss ist noch auf einem anderen, bislang wenig beachteten Gebiet nachweisbar. Er zeigt sich am Wiedererstarken der deutschen Uhrmacherkunst und der Gründung vieler Fir-men in Glashütte, von denen die von Gutkaes und Lange um 1845 gegründete die erste war.[32] Es ist bekannt, dass Adolph Lange eine Zeit lang mit der Breguet-Werkstatt assoziiert war, wo er Ingold getroffen und näher kennen gelernt haben könnte. Doch selbst, wenn dies nicht der

Glashütte-based firms, the first being the one formed by Gutkaes and Lange around 1845.[32] Adolph Lange is known to have also spent some time associated with the Breguet workshop where he may well have met and got to know Ingold. Even if they did not meet, Lange would certainly have been well aware of what Ingold was attempting to do, as well as what had been written and very well illustrated in Ingold's Eng-lish Patent of 1843.

While Nicole & Capt worked as quietly and secretly as possible, the important aspect of

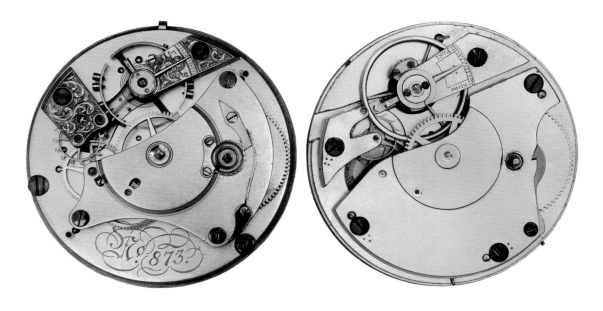

10
Links: Gutkaes & Lange, Uhrwerk Nr. 873, um 1850. Rechts im Vergleich: Uhrwerk Nr. 34 von Ingold aus dem Jahr 1843
Gutkaes & Lange movement No. 873 on the left, around 1850, compared with the movement of Ingold No. 34
dating from 1843

Fall gewesen sein sollte, wird Lange mit einiger Sicherheit von den Plänen Ingolds gewusst und die detaillierten Beschreibungen und Illustrationen in Ingolds Englischem Patent aus dem Jahr 1843 gekannt haben.

Während Nicole & Capt so wenig Aufhebens wie möglich um ihre Arbeit zu machen versuchten, standen Lange in Glashütte alle Möglichkeiten offen, einen kompletten Neustart mit Arbeitern zu unternehmen, die das Handwerk bei ihm von Grund auf neu erlernten und nicht durch Vorurteile und traditionelle Methoden vorbelastet waren. Wie viele dieser frühen Uhren tatsächlich »maschinell gefertigt« wurden, ist bisher nicht erforscht worden. Vieles spricht meines Erachtens aber dafür, dass Lange, Grossmann und andere stark von Ingolds Unternehmungen in London und von den Darlegungen in seinem Patent beeinflusst waren. Ein weiterer, womöglich nicht weniger wichtiger Einfluss für ihre Arbeit dürfte das nur ein Jahr später erworbene Englische Patent von Adolphe Nicole aus

Lange's work in Glashütte was that he could start with a clean slate and train workers that were not bound by traditional methods and prejudices. It remains to be seen just how these early watches were made, but I strongly suspect that Lange, Grossmann, and others, were heavily influenced by what they had seen of Ingold's London output, and what they read in his Patent. Further, and perhaps just as important an influence, was the seminal English Patent taken out by Adolphe Nicole just one year later in 1844.[33] It describes the first practical keyless work for both fusee and going-barrel watches, and also contains designs for chronograph work that includes the use of a heart-shaped cam, a feature still used in mechanical chronographs to this day.

America has always been considered the home of machine watchmaking, but, given the watches of Nicole & Capt and those of Gutkaes & Lange (ill. 10), the 'American System of Watchmaking' should perhaps be renamed the 'Ingold

dem Jahr 1844 gewesen sein.[33] Dort findet sich die erste Beschreibung eines praktischen, schlüssellosen Werkes für Uhren mit Schnecke und für Uhren mit Federhaus. Darüber hinaus enthält das Patent Entwürfe für Chronographenwerke, bei denen eine Herzscheibe verwendet wurde, wie sie bis heute in mechanischen Chronographen benutzt wird.

Seit jeher gilt Amerika als Heimat der maschinellen Uhrmacherei. Angesichts der Uhren von Nicole & Capt und von Gutkaes & Lange (Abb. 10) stellt sich jedoch die Frage, ob es nicht sinnvoll wäre, das »amerikanische System der Uhrenherstellung« umzubenennen in das »Ingold'sche System der Uhrenherstellung«. Zumindest aber ist es wichtig, den Erfolg dieser beiden Unternehmen, der der Gründung der späteren amerikanischen Waltham Watch Company viele Jahre vorausging, näher zu untersuchen. Die Bedeutung, die der deutschen Firma Lange und der englischen Firma Nicole für die gesamte (einschließlich der Schweizer) Uhrmacherei zukommt, könnte so ganz neu eingeschätzt werden.

System of Watchmaking.' At the very least the prior success of both companies, years before what came to be the American Waltham Watch Company, needs to be properly understood and the importance of Lange in Germany and Nicole in England for watchmaking in general, not only in these two countries but also in Switzerland, should be reassessed.

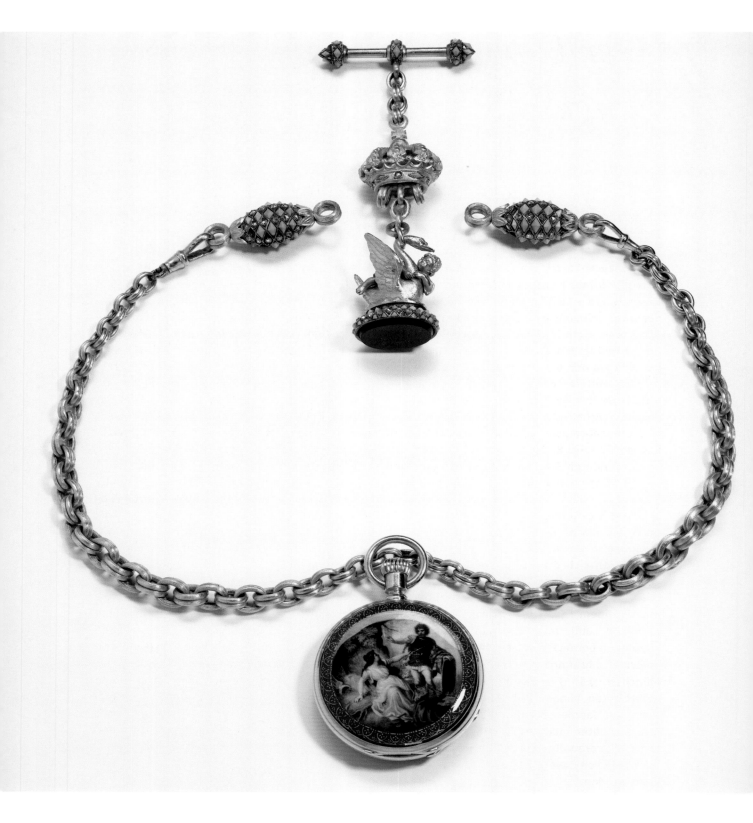

A. Lange & Söhne, Savonnette-Taschenuhr Nr. 12747, Glashütte, um 1878,
Museum der bayerischen Könige, Hohenschwangau
A. Lange & Söhne, Savonnette pocket watch No. 12747, Glashütte, around 1878,
Museum der bayerischen Könige, Hohenschwangau

7 *Der Lange-Weg zum Erfolg*
Lange's Long Road to Success

Die ersten zehn Jahre nach Gründung der Taschenuhrenfabrik wurden Ferdinand Adolph Lange (1815 – 1875) schwer. Die Kapitaldecke des Unternehmens war dünn, da die Regierung den Kredit nicht in der ursprünglich erhofften Höhe bewilligt hatte. Die Preise für Rohmaterialien stiegen und die angesetzte Produktion von jährlich 600 Taschenuhren konnte lange Zeit nicht realisiert werden. Den Arbeitern mangelte es an Erfahrung, den Uhren an Qualität. Lange verfügte jedoch über erstaunliche Beharrlichkeit und großen Fleiß. Zusammen mit seinen Mitstreitern Adolph Schneider, Julius Assmann und Moritz Grossmann verbesserte er die Konstruktion der Uhr über Jahre, bis um 1865 eine optimale Form gefunden war. Dieses Kaliber wurde durch technische Innovationen und zusätzliche Komplikationen weiterentwickelt. Parallel dazu etablierten sich die von Lange ausgebildeten Lehrlinge in eigenen Werkstätten, so dass die Glashütter Fabrikation wachsen konnte. Lange nutzte zudem früh die Möglichkeiten, die ihm nationale und internationale Industrieausstellungen boten. Preise, wie die ihm auf den Industrieausstellungen in Leipzig (1850) und München (1854) zugesprochenen Medaillen, verbreiteten Langes Ruf als Begründer einer deutschen Taschenuhrenfabrikation. Den großen Erfolg erlebten indes erst Langes Söhne Richard und Emil, deren Uhren unter anderem von König Ludwig II. von Bayern und Kaiser Wilhelm II. gekauft wurden.

The first ten years following the founding of the watch factory were hard ones for Ferdinand Adolph Lange (1815 – 1875). The financial resoruces of the company were sparse, since the government had not provided as much credit as originally hoped. Prices for raw materials rose, and for a long time the factory was not able to achieve the initial production target of 600 pocket watches per year. The workers lacked experience and the watches were of insufficient quality. Lange, however, was a man of astonishing perseverance and great diligence. Over years, with his co-pioneers Adolph Schneider, Julius Assmann and Moritz Grossmann, he gradually improved the construction of the watch, until by around 1865 he achieved an ideal design. This he continued to develop with technical innovations and additional intricacies. In the meantime, Lange's apprentices had opened their own workshops, allowing the Glashütte production to grow. Lange also made early use of the opportunities afforded by national and international industrial exhibitions. Prizes, like the medals he won at the exhibitions in Leipzig (1850) and Munich (1854), spread Lange's reputation as the founder of a German watch industry. It would remain for Lange's sons, Richard and Emil, however, to garner the greatest success; among their customers were King Ludwig II of Bavaria and Emperor Wilhelm II.

**Geschäftsbeziehungen Ferdinand Adolph Langes,
Stand April 1853**

Ferdinand Adolph Lange's business connections
in April 1853

Zum Verkauf der in Glashütte gefertigten Uhren konnte Ferdinand Adolph Lange auf ein Netzwerk zurückgreifen, das während seiner Lehrzeit und den Pariser Wanderjahren entstanden war. Für das Überleben des jungen Unternehmens war jedoch die erste Londoner Weltausstellung 1851 von entscheidender Bedeutung. Die Glashütter Uhren wurden positiv aufgenommen, die zehn mitgenommenen Muster komplett verkauft. In London knüpfte Lange eine Vielzahl von Kontakten zu englischen und amerikanischen Uhrmachern und Uhrhändlern, wobei vor allem die amerikanischen Bekanntschaften von weitreichender Wirkung waren. Über Jahrzehnte lebte Langes Uhrenfabrik hauptsächlich vom Export in die Vereinigten Staaten von Amerika.

To sell his watches, Ferdinand Adolph Lange was able to make use of a network of contacts built up during his years as an apprentice and his time as a journeyman in Paris. For the survival of the fledgling company, however, the Great Exhibition in London in 1851 was of decisive importance. The Glashütte watches were well received and the ten sample watches taken for display were all sold. While in London, Lange made numerous contacts with English and American watchmakers and dealers. The American acquaintances were to become of particularly far-reaching importance. Indeed, for decades Lange's watch factory survived mainly on exports to the United States.

Ferdinand Adolph Lange, Taschenuhr Nr. 8701, Dresden, 1873, Lange Uhren GmbH, Glashütte

Ferdinand Adolph Lange, Pocket watch No. 8701, Dresden, 1873, Lange Uhren GmbH, Glashütte

Um die rigiden Zollbestimmungen hinsichtlich der Einfuhr von Edelmetallen zu umgehen, wurden in die USA zumeist Uhrwerke aus einer Kupfer-Nickel-Zink-Legierung, dem sogenannten Neusilber, geliefert. Diese Werke mussten nicht wie die sonst üblichen Messingwerke vergoldet werden und wurden dann vor Ort in Gehäuse eingepasst.

In order to evade strict customs controls on the import of precious metals, watch movements sent to the USA were mostly made of an alloy of copper, nickel and zinc, known as nickel silver. Unlike the usual brass movements, these did not require gilding. The movements were then fitted into watch cases at their destination.

**Ferdinand Adolph Lange, Taschenuhr Nr. 3542 mit springender Sekunde ohne Nullstellung, Dresden, 1865,
Lange Uhren GmbH, Glashütte**
Ferdinand Adolph Lange, Pocket watch No. 3542, seconde morte without zero setting, Dresden, 1865,
Lange Uhren GmbH, Glashütte

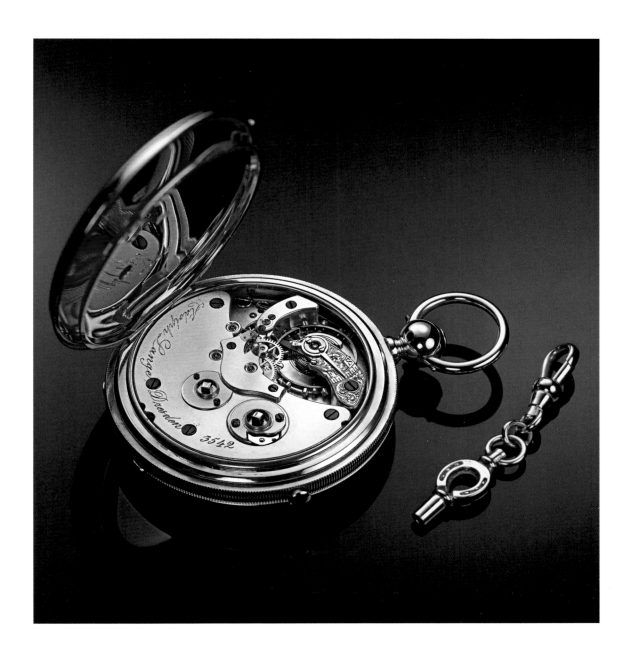

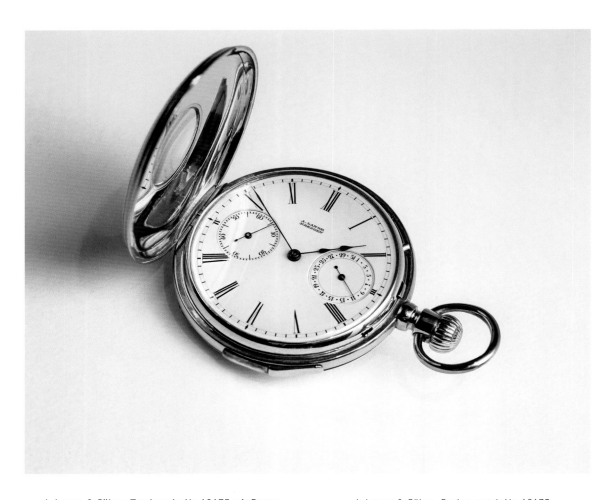

**A. Lange & Söhne, Taschenuhr Nr. 10173 mit Datum
und Viertelrepetition, Glashütte, 1877,
Lange Uhren GmbH, Glashütte**

A. Lange & Söhne, Pocket watch No. 10173,
quarter repeater with date, Glashütte, 1877,
Lange Uhren GmbH, Glashütte

Wichtige Voraussetzungen für den Erfolg der Glashütter Uhrenproduktion waren die ständige technische Vervollkommnung der Uhren sowie die Erweiterung der Produktpalette. Um 1865 begann Ferdinand Adolph Lange mit einem konstanten Antrieb für die Unruhe zu experimentieren. Um 1867 entwickelte er ein Uhrwerk mit zentraler springender Sekunde, das es erlaubte, die Zeit weitaus präziser abzulesen. Bereits 1866 hatte er sich in den USA eine einfache Viertelrepetition patentieren lassen. Der Besitzer der Taschenuhr Nr. 10173 konnte also nach Betätigung des seitlichen Schiebers die Anzahl der verflossenen Stunden und Viertelstunden schlagen hören.

Glashütte watch production owed its success to continual technical refinement and an expanding product range. Around 1865, Ferdinand Adolph Lange began to experiment with a constant impulse for the balance. Around 1867 he developed a watch movement with a central dead second, allowing for a much more precise reading of the time. By 1866 he had already had a simple quarter repeater movement patented in the USA. So, by sliding the side lever, the owner of a pocket watch such as this was able to hear the time (up to the most recent quarter hour) chimed out in hours and quarters.

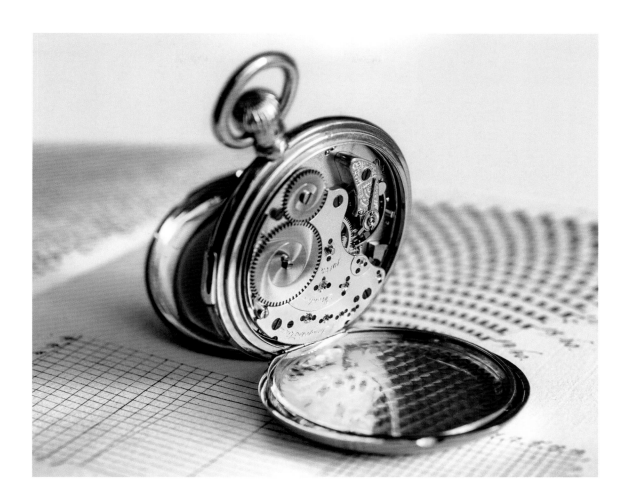

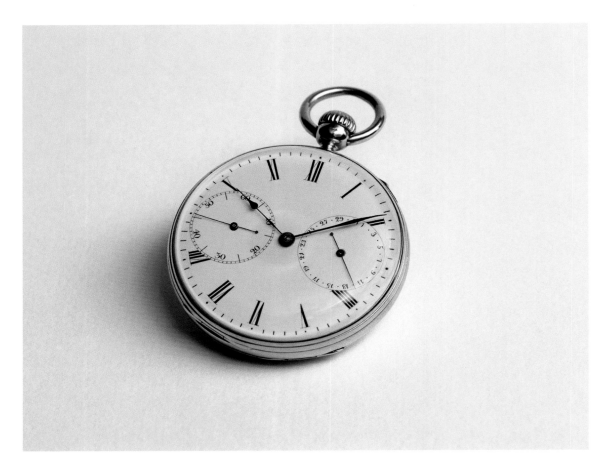

**Gutkaes & Lange, Taschenuhr Nr. 1340, um 1850,
Lange Uhren GmbH**

Gutkaes & Lange, Pocket watch No. 1340, around 1850,
Lange Uhren GmbH

Zur ersten internationalen Weltausstellung 1851 in London präsentierte Ferdinand Adolph Lange unter anderem zwei Uhren mit Kronenaufzug. Der schlüssellose Aufzug war noch neu. Erst 1842 hatte Jean Adrien Philippe die erste Taschenuhr mit funktionierendem Kronenaufzug konstruiert, für die er 1844 auf der Französischen Industrieausstellung die Goldmedaille erhielt. Der Kronenaufzug erlaubte eine bequemere Handhabung der Uhr. Das Gehäuse musste beim Aufziehen nicht mehr geöffnet werden, so dass das Werk besser vor Verschmutzungen geschützt war. Auch ließ der Kronenaufzug flachere Werkkonstruktionen zu. Frühe Kronenaufzüge waren nur in einer Richtung drehbar, so zum Beispiel bei der hier gezeigten Taschenuhr Nr. 1340.

At the first Great Exhibtion of 1851 in London, Ferdinand Adolph Lange presented, amongst other things, two watches with winding crowns. Keyless winding was still new. It was only in 1842 that Jean Adrien Philippe had built the first pocket watch with a functioning winding crown, for which he won the Gold Medal at the French Industrial Exposition of 1844. Such a crown made winding the watch much more convenient, and also protected the movement from dirt, since the case no longer had to be opened. It also meant that the movement could be made slimmer. Early crowns could only be turned in one direction, as, for instance, in the pocket watch No. 1340.

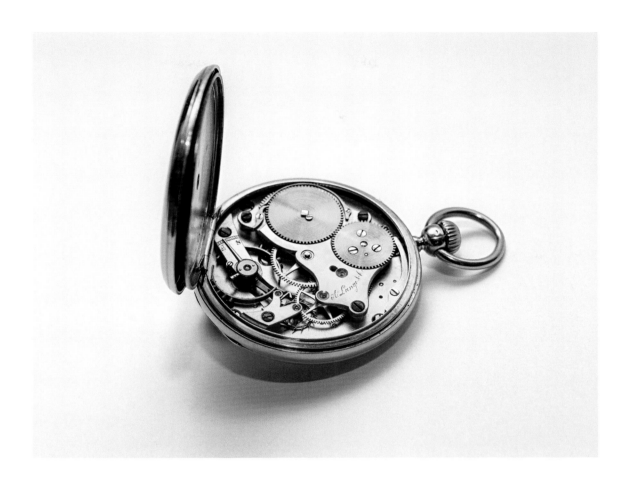

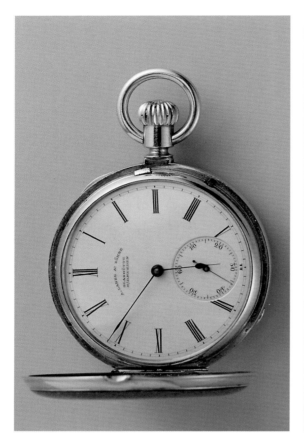

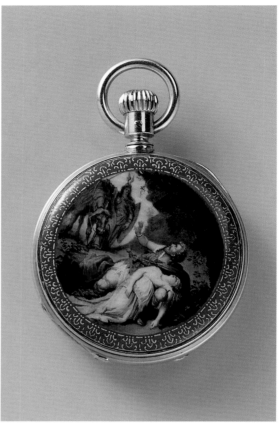

A. Lange & Söhne, Savonnette-Taschenuhr Nr. 12747, Glashütte, um 1878, Museum der bayerischen Könige, Hohenschwangau

A. Lange & Söhne, Savonnette pocket watch No. 12747, Glashütte, around 1878, Museum der bayerischen Könige, Hohenschwangau

Mit dem französischen Begriff »Savonnette« bezeichnet man Taschenuhren, deren Glas und Zifferblatt durch einen Sprungdeckel geschützt sind. Diese prunkvolle Uhr wurde von König Ludwig II. von Bayern erworben. Sie zeigt fünf emaillierte Szenen aus Richard Wagners »Ring des Nibelungen«. Ludwig II. schenkte sie dem Opernsänger Heinrich Vogl, einem gefeierten Heldentenor, der 1878 bei der Premiere des »Siegfried« im Königlichen Hof- und Nationaltheater München die Titelpartie gesungen hatte.

The French name 'savonette' is given to pocket watches whose glass and dial were protected by a hunter cover. This magnificent watch was purchased by King Ludwig II of Bavaria. Five enamels show scenes from Richard Wagner's 'Ring.' Ludwig presented it to the opera singer Heinrich Vogl, a celebrated heldentenor. Vogl had sung the title role in the premier of 'Siegfried' at the Royal National Theatre in Munich in 1878.

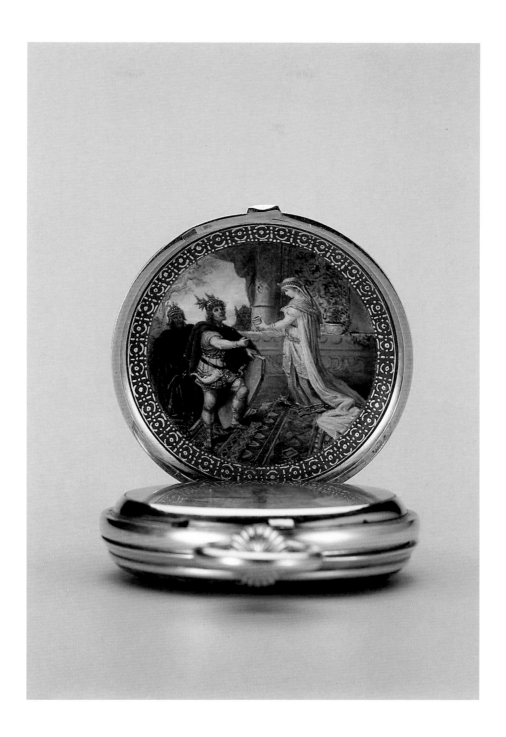

Anmerkungen / Annotations

Peter Plaßmeyer
Der Mathematisch-Physikalische Salon und der Weg Sachsens in die internationale Uhrenwelt
The Mathematisch-Physikalischer Salon and Saxony's Path into the World of International Watchmaking

1 Arndt Simon: »Eine frühe astronomische Pendeluhr mit gestürztem Aufbau aus der Werkstatt des Reichsgrafen Hans von Löser«, in: Klassik-Uhren 3/2014, S. 14 – 21.

2 Zur Werkstatt des Reichsgrafen von Löser siehe Michael Korey: »Das ›mechanische Laboratorium‹ des Reichsgrafen Hans von Löser«, in: Peter Plaßmeyer (Hg.): Die Luftpumpe am Himmel. Wissenschaft in Sachsen zur Zeit Augusts des Starken und Augusts III., Dresden 2007, S. 21 – 26.

3 Johann Gottfried Köhler, Sekundenzähler, Dresden, 1790, Staatliche Kunstsammlungen Dresden, Mathematisch-Physikalischer Salon, Inv.-Nr. D III 23. – Zu Köhlers Sekundenzähler siehe Michael Jaroschewski: Die amtliche Zeit für Dresden. Ein Sekundenzähler zur Ermittlung der astronomischen Zeit im Observatorium des Mathematisch-Physikalischen Salons zu Dresden um 1790. Konzept der Erhaltung und Restaurierung, Diplomarbeit, Hochschule für Technik und Wirtschaft, Berlin 2008 (unveröffentlicht).

4 Johann Heinrich Seyffert, Sekundenpendeluhr, Dresden, 1794, Staatliche Kunstsammlungen Dresden, Mathematisch-Physikalischer Salon, Inv.-Nr. D III 11.

5 Reinhard Meis: 100 Jahre Uhrenindustrie in Glashütte. Von 1845 – 1945, Bd. 1, München 2011, S. 31, Abb. 33, 34.

6 David Thompson: Clocks, London 2004, S. 120f.

7 Zu Mudge und Zach siehe den Beitrag von Sibylle Gluch in diesem Band.

1 Arndt Simon, 'Eine frühe astronomische Pendeluhr mit gestürztem Aufbau aus der Werkstatt des Reichsgrafen Hans von Löser', in: Klassik-Uhren 3/2014, pp. 14 – 21.

2 For more on the workshop of Count von Löser, see Michael Korey, 'Das "mechanische Laboratorium" des Reichsgrafen Hans von Löser', in: Peter Plaßmeyer (ed.), Die Luftpumpe am Himmel. Wissenschaft in Sachsen zur Zeit Augusts des Starken und Augusts III., Dresden, 2007, pp. 21 – 26.

3 Johann Gottfried Köhler, Seconds counter, Dresden, 1790, Mathematisch-Physikalischer Salon, Staatliche Kunstsammlungen Dresden, inv. no. D III 23. For more on Köhler's seconds counter, see Michael Jaroschewski, Die amtliche Zeit für Dresden. Ein Sekundenzähler zur Ermittlung der astronomischen Zeit im Observatorium des Mathematisch-Physikalischen Salons zu Dresden um 1790. Konzept der Erhaltung und Restaurierung. Thesis, Hochschule für Technik und Wirtschaft, Berlin, 2008 (unpublished).

4 Johann Heinrich Seyffert, Seconds pendulum, Dresden, 1794, Staatliche Kunstsammlungen Dresden, Mathematisch-Physikalischer Salon, inv. no. D III 11.

5 Reinhard Meis, 100 Jahre Uhrenindustrie in Glashütte. Von 1845 – 1945. Munich, 2011, Vol. 1, p. 31, ills. 33, 34.

6 David Thompson, Clocks, London, 2004, pp. 120 – 121.

7 On Mudge and Zach, see essay by Sibylle Gluch in this volume.

David Thompson
Englische Uhrmacherkunst im 18. Jahrhundert
Watchmaking in England in the Eighteenth Century





1 Um 1695 entwickelte Thomas Tompion ein Uhrenmodell mit Kommahemmung, von dem nur ein einziges Exemplar erhalten geblieben ist. Vgl. Jeremy Evans: Thomas Tompion at the Dial and Three Crowns, Ticehurst 2006, S. 101.

2 John Jefferys (1701 – 1754) besaß ein Geschäft am Red Lion Square in London. 1752/53 erhielt er den Auftrag, eine Uhr nach einem Entwurf von John Harrison anzufertigen und dessen letzte Erfindungen zur Verbesserung der Präzision von Taschenuhren umzusetzen. Diese Uhr befindet sich als Leihgabe in der Clockmakers' Company in London.

3 Zitiert aus einem Brief von Ferdinand Berthoud vom 14. März 1766.

4 Ein Überblick über englische Uhren für den Export nach Fernost findet sich bei Ian White: English Clocks for the Eastern Market, Ticehurst 2012. Näheres zur Geschichte der Schweizer Uhrenproduktion für den Export nach China vgl. Alfred Chapuis: La Montre Chinoise, Neuchatel 1919 und Neuauflagen.

5 Zum Stand des Uhrenbaus in England zu Beginn des 19. Jahrhunderts vgl. House of Commons (Hg.): Report from the Committee on the Petitions of Watchmakers of Coventry &c with the Minutes of the Evidence Taken Before the Committee and an Appendix, London 11. Juli 1817. Vgl. auch Leonard Weiss: Watchmaking in England, 1760 – 1820, London 1982.

6 Vgl. David Thompson: »The Watches of Ellicotts of London«, in: Antiquarian Horology, Vol. XXIII, S. 306 – 321 (Sommer 1997), S. 429 – 442 (Herbst 1997).

7 Thomas Hatton: An Introduction to the Mechanical Part of Clock and Watch Work, Greenwich 1978 (Faksimile der Ausgabe 1773).

8 William Weston arbeitete zunächst von 1790 bis 1818 in London, 23 Greenhill Rents, und tat sich später mit John Willis zu einer Geschäftspartnerschaft zusammen. Das Unternehmen, das von verschiedenen Mitgliedern der Familie Willis bis Ende des 19. Jahrhunderts weitergeführt wurde, produzierte weit bis ins 19. Jahrhundert Zifferblätter von höchster Qualität.

9 Thomas Mudge wurde 1715 als Sohn des Pfarrers Zachariah Mudge in Exeter geboren. 1730 trat er die Lehre bei George Graham an, wurde im Januar 1738 freier Uhrmacher und übernahm nach Grahams Tod dessen Geschäft in der Fleet Street in London. Er stieg zu einem der führenden Uhrmacher Englands auf und gründete eine Partnerschaft mit William Dutton, der ebenfalls bei Graham in die Lehre gegangen war. 1765 veröffentlichte Mudge »Thoughts on the Means of Improving Watches, Particularly those for Use at Sea«. Später zog er sich nach Plymouth zurück, starb aber 1792 in London im Haus seines Sohnes Thomas.

10 Rupert Gould: The Marine Chronometer, London 1923, Nachdruck mit einem Vorwort von Jonathan Betts, Woodbridge 2013.





1 In about 1695, Thomas Tompion invented a form of virgule escapement for watches of which only one example is known to survive – see Jeremy Evans, Thomas Tompion at the Dial and Three Crowns, Ticehurst, 2006, p. 101.

2 John Jefferys (1701 – 1754) had his business in Red Lion Square London. In 1752/53 he was commissioned to make a watch by John Harrison, incorporating his latest innovations to improve the performance of the pocket watch. The watch is currently on loan to the Clockmakers' Company, London.

3 Quote from a letter written by Ferdinand Berthoud, dated 14 March 1766.

4 For a comprehensive account of English clock and watchmaking for the export market to the Middle and Far East, see Ian White, English Clocks for the Eastern Market, Ticehurst 2012. For the story of watchmaking in Switzerland for export to China, see Alfred Chapuis, La Montre Chinoise, Neuchatel, 1919 and reprints.

5 For an in-depth study of the state of watchmaking in England at the beginning of the nineteenth century, see House of Commons (ed.), Report from the Committee on the Petitions of Watchmakers of Coventry &c with the Minutes of the Evidence Taken Before the Committee and an Appendix, London, printed 11 July 1817. See also Leonard Weiss, Watchmaking in England, 1760 – 1820, London, 1982.

6 See David Thompson, 'The Watches of Ellicotts of London', in: Antiquarian Horology, Vol. XXIII, pp. 306 – 321 (Summer 1997), pp. 429 – 442 (Autumn 1997).

7 Thomas Hatton, An Introduction to the Mechanical Part of Clock and Watch Work, Greenwich, 1978 (facsimile of 1773 edition).

8 William Weston was working at 23 Greenhill Rents, London between 1790 and 1818 and was later in partnership with John Willis. He then worked in partnership with Thomas Willis and the company continued in the nineteenth century to make perhaps the finest enamel dials in London. The company was carried on by successive members of the Willis family until at least the end of the nineteenth century.

9 Thomas Mudge, born in 1715 in Exeter, the son of the Reverend Zachariah Mudge. He was apprenticed to George Graham in 1730 and became a free clockmaker in January 1738. He inherited Graham's business in Fleet Street, London where he became one of the foremost clock, watch, and chronometer makers in England. He ran a business in partnership with William Dutton, also a Graham apprentice. In 1765 Mudge published his work, *Thoughts on the Means of Improving Watches, Particularly those for Use at Sea*. Mudge retired to Plymouth but died at his son Thomas's house in London in 1792.

10 Rupert Gould, The Marine Chronometer, London, 1923, reprint with forward by Jonathan Betts, Woodbridge, 2013.

11 For an account of Thomas Mudge and his work on precision timekeepers, see William J. H. Andrewes (ed.), The





11 Einzelheiten zu Thomas Mudges Präzisionsuhren vgl. William J. H. Andrewes (Hg.): The Quest for Longitude, Harvard University 1996, darin: David Penney: »Thomas Mudge and the Longitude: a Reason to Excel«.

12 Zur Entwicklung der Temperaturkompensation bei Marinechronometern und tragbaren Uhren vgl. Gould 2013.

13 John Arnold wurde vermutlich 1736 in Bodmin in Cornwall geboren und erlernte das Uhrmacherhandwerk bei seinem Vater. 1762 eröffnete er in Devereux Court in London eine eigene Werkstatt, mit der er später an den Strand umzog. Mit seiner 1764 König George III. als Geschenk vermachten Ringuhr verschaffte er sich Anerkennung in der höheren Gesellschaft und stieg zu einem der bedeutendsten Uhrmacher in London auf. Er starb 1799. Für eine ausführliche Darstellung von Leben und Werk vgl. Vaudrey Mercer: John Arnold & Son, Ticehurst 1972.

14 Thomas Earnshaw wurde 1749 in Ashton-under-Lyne geboren und ging vermutlich bei William Hughes in London in die Lehre. Nach anfänglichen Schwierigkeiten konnte er sich als Uhrenveredler niederlassen und wurde später zu einem berühmten Uhr- und Chronometermacher. Nach seinem Tod 1829 übernahm sein Sohn Thomas das Geschäft.

15 Zur Entwicklung der Chronometer von Arnold und Earshaw vgl. Andrewes 1996, darin: Jonathan Betts: »Arnold and Earnshaw: The Practical Solution«.

16 Nevil Maskelyne: An Answer to a Narrative of Facts, London 1792, S. 123.

17 Thomas Mudge jun.: A Description with Plates, London 1799, S. XXXIX.

18 Der gebürtige Schweizer Josiah Emery, Sohn von Jacques Emery und Susanne-Marie Gammeter, getauft in Etagnières nahe Chardonne am 11. November 1725, kam vermutlich in den 1750er Jahren nach London, wo er sich als Uhrmacher in der Warwick Street in Soho gegenüber der Hedge Lane niederließ. Zur eingehenderen Auseinandersetzung mit seiner Arbeit und zu Uhren mit Ankerhemmung vgl. Jonathan Betts: »Josiah Emery: Watchmaker of Charing Cross«, in: Antiquarian Horology, fünf Bände beginnend mit Bd. XXII (1996), S. 394.

19 Eine ausführliche Darstellung der Liverpooler Uhrenindustrie liefert Alan Treherne: »The Contribution of South-west Lancashire to Horology Part 1: Watch and Chronometer Movement Making and Finishing«, in: Antiquarian Horology, Vol. XXXII, S. 457.

20 Peter Litherland wurde 1756 in Warrington geboren. Sein Geschäft befand sich in Mount Pleasant in Liverpool. Nach seinem Tod im Jahr 1804 wurde es unter dem Namen Litherland and Company weitergeführt. Litherland-Uhren wurden in großer Zahl hergestellt, nicht nur für den unternehmenseigenen Vertrieb, sondern auch für viele andere Hersteller.

21 Edward Massey wurde 1768 in Newcastle-under-Lyme geboren. Aus seiner Ehe mit Jane Roulstone gingen sieben Kinder hervor. Ab etwa 1790 war er als Uhrmacher tätig, zunächst von ca. 1795 bis ca. 1790 mit Niederlassungen in Hanley und Burslem. Von 1813 bis ca. 1821 hatte er ein Geschäft in der Ironmonger Row in Coventry, von 1819 bis ca. 1830 in Scoles in Prescot, von 1833 bis 1847 in Clerkenwell in London in der King Street 28 und schließlich von 1847 bis zu seinem Tod 1852 ebendort in der Chadwell Street 17.

Quest for Longitude, Harvard University, 1996, especially David Penney, 'Thomas Mudge and the Longitude: a Reason to Excel'.

12 For an account of the development of temperature compensation in marine and portable timekeepers see Gould 2013.

13 John Arnold was born around 1736 in Bodmin in Cornwall, where he was apprenticed to his father. In 1762, he established his business in Devereux Court in London and later moved to the Strand. In 1764 he presented a watch mounted in a finger ring to King George III, a gift that would have quickly given him recognition in high society. He became one of the foremost chronometer and watchmakers in London. He died in 1799. For an account of his life and work, see Vaudrey Mercer, John Arnold & Son, Ticehurst, 1972.

14 Thomas Earnshaw was born in Ashton-under-Lyne in 1749. He was probably apprenticed to William Hughes in London. After a troubled early career he established himself as a watch finisher and went on to become a renowned chronometer and watchmaker. He died in 1829 and was succeeded by his son Thomas.

15 For a detailed account of the development of Arnold and Earshaw chronometers, see Andrewes 1996, especially Jonathan Betts, 'Arnold and Earnshaw: The Practical Solution'.

16 Nevil Maskelyne, An Answer to a Narrative of Facts, London, 1792, p. 123.

17 Thomas Mudge Jun., A Description with Plates, London, 1799, p. XXXIX.

18 Josiah Emery came to London from his native Switzerland probably as a child in the 1730s and established himself as a watchmaker in Warwick Street, 'Opposite Hedge Lane,' in Soho. The son of Jacques Emery and Susanne-Marie Gammeter, he was baptized at Etagnières near Chardonne on 11 November 1725. For a comprehensive assessment of the work of Josiah Emery and the lever watches, see Jonathan Betts, 'Josiah Emery: Watchmaker of Charing Cross', in: Antiquarian Horology, published in five parts beginning in Vol. XXII (1996), p. 394.

19 For a narrative of the Liverpool watchmaking industry, see Alan Treherne, 'The Contribution of South-west Lancashire to Horology Part 1: Watch and Chronometer Movement Making and Finishing', in: Antiquarian Horology, Vol. XXXII, p. 457.

20 Peter Litherland was born in Warrington in 1756, his business was at Mount Pleasant, Liverpool. After Litherland's death in 1804 the business continued as Litherland and Company. Production of Litherland watches was considerable and they were made not only for retail by the company itself but also for a numerous other retailers.

21 Edward Massey was born in Newcastle-under-Lyme in 1768 and married Jane Roulstone, with whom he had seven children. He worked as a watchmaker from around 1790, with businesses in Hanley and Burslem from c. 1795 to c. 1804. He was based in Ironmonger Row, Coventry, between 1813 and c. 1821; in Scoles in Prescot between 1819 and c. 1830; at 28 King Street, Clerkenwell, London, between 1833 and 1847; and at 17 Chadwell Street, also in Clerkenwell, between 1847 and 1852, the year he died.

Vom Transportieren der präzisen Zeit
Transporting the Precise Time

1 Franz Xaver von Zach: Monatliche Correspondenz zur Beförderung der Erd- und Himmels-Kunde, Bd. 2, 1800, S. 546.

1 Franz Xaver von Zach, Monatliche Correspondenz zur Beförderung der Erd- und Himmels-Kunde, Vol. 2, 1800, p. 546.

Sibylle Gluch
Die Anfänge und Schwierigkeiten der Dresdner Präzisionsuhrmacherei
The Beginnings and Challenges of Presision Clock- and Watchmaking in Dresden

1 HStA Dresden, 10025 Geheimes Konsilium, Loc. 5747: Innungssachen, Vol. VIII, 1790, fol. 200r.
2 Ibid., fol. 200r – 204v.
3 Seyffert stellte durchaus Taschenuhren her, wie sie in Dresden üblich waren, z. B. die Taschenuhr Nr. 56 mit Repetition von 1797 (MPS Inv.-Nr. D IV a 94).
4 Astronomisches Jahrbuch für 1802, S. 121.
5 Monatliche Correspondenz, Bd. 3, 1801, S. 498.
6 Astronomisches Jahrbuch für 1802, S. 121.
7 HStA Dresden, 10026 Geheimes Kabinett, Loc. 2573/1, fol. 283r.
8 Ibid., fol. 284v.
9 Otto Seydl (Hg.): Briefe Franz Xaver Freiherrn von Zach, Direktor der Herzoglichen Sternwarte am Gotha-Seeberg, und seines Nachfolgers Bernhard von Lindenau von 1791 – 1816 an P. Martin Alois David, Adjunkt und Direktor der Königlich Prager Sternwarte, Prag 1938, S. 147f.
10 HStA Dresden, 10026 Geheimes Kabinett, Loc. 2573/1, fol. 284v. Herbert Dittrich hat auf die Ähnlichkeiten zwischen den Ankerchronometern von Emery und Seyffert hingewiesen, ohne Seyfferts »Anzeige« zu kennen. Siehe Herbert Dittrich: Erfinder und Visionäre. Die Pioniere der Präzisionsuhren-Herstellung in Dresden und Glashütte, hg. von der Stiftung Deutsches Uhrenmuseum Glashütte – Nicolas G. Hayek, Dresden 2009, S. 84f.
11 Arbeitsjournal Seyffert (in der Folge AJ), Bd. II, S. 358, Eintrag vom 09.08.1811.
12 Gerd Ahrens schrieb, dass Seyfferts Nr. 4 über Zug verfüge. Das wäre jedoch höchst ungewöhnlich und müsste überprüft werden, was bis jetzt leider nicht möglich war. Vgl. Gerd Ahrens: »Frühe tragbare Ankeruhren in Deutschland«, in: Freunde Alter Uhren 16 (1977), S. 80 – 85 (S. 83).
13 Die Jugendbriefe Alexander von Humboldts, 1787 – 1799, hg. u. erläutert von Ilse Jahn u. Fritz G. Lange, Berlin 1973, S. 671: »Mein Seyffert'scher Chronometer, der nur zur Hälfte auf Diamanten geht, ist bis auf 4 bis 5'' täglich genau.« – Diamanten wurden (und werden) nicht als Lagersteine, sondern als Decksteine benutzt.

1 HStA Dresden, 10025 Geheimes Konsilium, Loc. 5747: Innungssachen, Vol. VIII, 1790, fol. 200r.
2 Ibid., fol. 200r – 204v.
3 Seyffert indeed produced pocket watches, as were customary in Dresden, e. g., the pocket watch No. 56 with repeater of 1797 (MPS inv. no. D IV a 94).
4 Astronomisches Jahrbuch of 1802, p. 121.
5 Monatliche Correspondenz, Vol. 3, 1801, p. 498.
6 Astronomisches Jahrbuch of 1802, p. 121.
7 HStA Dresden, 10026 Geheimes Kabinett, Loc. 2573/1, fol. 283r.
8 Ibid., fol. 284v.
9 Otto Seydl (ed.), Letters from Baron Franz Xaver von Zach, director of the Gotha observatory (Thuringia), and his successor Bernhard von Lindenau from 1791 – 1816 to P. Martin Alois David, adjunct and director of the Royal Observatory in Prague, Prague, 1938, p. 147f.
10 HStA Dresden, 10026 Geheimes Kabinett, Loc. 2573/1, fol. 284v. Herbert Dittrich noted the similarities between Emery and Seyffert's anchor chronometers, without knowing Seyffert's 'Anzeige'. See H. Dittrich: Erfinder und Visionäre. Die Pioniere der Präzisionsuhren-Herstellung in Dresden und Glashütte, ed. by Stiftung Deutsches Uhrenmuseum Glashütte – Nicolas G. Hayek, Dresden, 2009, p. 84f.
11 Seyffert's work journal (Arbeitsjournal, referred to hereafter as AJ), Vol. II, p. 358, entry from 9 Aug. 1811.
12 Gerd Ahrens wrote that Seyffert's No. 4 was equipped with a draw. This would have been highly unusual however and this claim would have to be checked, which has unfortunately not been possible until now. Cf. Gerd Ahrens, 'Frühe tragbare Ankeruhren in Deutschland', in: Freunde Alter Uhren 16 (1977), pp. 80 – 85 (p. 83).
13 Die Jugendbriefe Alexander von Humboldts, 1787 – 1799, ed. with commentaries by Ilse Jahn and Fritz G. Lange, Berlin, 1973, p. 671: in which he states 'my Seyffert chronometer, only half of which runs on diamonds, is accurate to 4 or 5'' every day.' – Diamonds were (and still are) used not as jewel bearings, but as capstones.

14 HStA DD, 10026 Geheimes Kabinett, Loc. 2573/1, fol. 284v.

15 Heute im Mathematisch-Physikalischen Salon, Dresden, Inv.-Nr. B VIII 81.

16 Das Chronometer Nr. 5, heute in der Sammlung Beyer in Zürich, zeigt die typische Unruh mit Doppel-S-förmiger Kompensation und Unruhbrücke, besitzt aber eine Chronometerhemmung mit Wippe. Nach meiner Einschätzung müsste die Hemmungspartie auf ihren Originalzustand hin geprüft werden.

17 Hinsichtlich der Chronometer Nr. 3 und Nr. 4 spricht Seyffert vom »gleichen Mechanismo«. Siehe HStA Dresden, 10026 Geheimes Kabinett, Loc. 2573/1, fol. 285r+v. Zum Chronometer Nr. 1 bemerkte Alexander von Humboldt 1804 in seiner in Mexiko-Stadt niedergeschriebenen Instrumentenliste: »Une Montre de Longitude de Seyffert ou Chronometre de poche d'après les principes de Mudge avec les compensations de temperature.« Siehe Staatsbibliothek Berlin, Handschriftenabteilung, gr. Ka, 2, Mappe 4, Nr. 34r+v.

18 Auf ihrer Reise nach Dresden 1785 hatten Zach und Brühl das Seechronometer Nr. 1 von Mudge nicht dabei, denn Zach bemerkt im »Astronomischen Jahrbuch«, dass es erst am 5. Dezember 1785 aus Amerika zurückgekehrt sei. Vgl. Astronomisches Jahrbuch für 1789, S. 237.

19 Thomas Mudge: A Description, with Plates, of the Time-Keeper invented by the late Mr. Thomas Mudge, London 1799.

20 AJ Seyffert, Bd. I, S. 193.

21 AJ Seyffert, Bd. I, S. 403.

22 Die Arbeitsjournale Seyfferts geben verschiedentlich Hinweise auf Reparaturaufträge, so z. B. Bd. I, fol. 137: Brockbanks; Bd. II, fol. 121: Arnold; Bd. II, fol. 145: Haley. Von Grant hatte Seyffert einige Chronometer in den Händen. Eines davon ist erhalten und heute in Privatbesitz. Es ist jetzt allerdings mit einer Chronometerhemmung mit Feder ausgestattet, die entgegen der Annahme Herbert Dittrichs nicht von Seyffert stammen kann. Seyffert vermerkte auf der Uhr, dass er einen »neuen Anker, Gabel und Unruhe«, mithin eine Ankerhemmung, gefertigt habe. Vgl. Dittrich 2009, S. 71.

23 AJ Seyffert, Bd. 1, fol. 138: »ich werde durch diese sinnreiche Vorrichtung künftig meine Chronometer verbessern.«

24 HStA Dresden, 10047 Amt Dresden, Nr. 3175, fol. 2r – 31v. Die Nachlassakte ist leider nicht vollständig, sondern bricht mitten in der Auflistung der Bibliothek ab. Maschinen, Werkzeuge, unvollendete Uhren etc. sind auf den verbliebenen Seiten nicht erwähnt.

25 Monatliche Correspondenz, Bd. 3, 1801, S. 492.

26 1801 ging Kirchel nach Bautzen zu dem Uhrmacher Paul Kindermann in Stellung, wo er allerdings nur sieben Monate blieb. Nachdem er in Bautzen kein Auskommen finden konnte, kehrte er nach Dresden zurück. 1808 bemühte er sich, zur Meisterprüfung der Dresdner Kleinuhrmacher zugelassen zu werden, was ihm nach einigen Schwierigkeiten von Seiten der Innung auch gelang. Weitere Mitarbeiter Seyfferts waren ein gewisser Thomas, bei den Behörden als Scholar der Mechanik geführt (vor 1804), und ein van Boom, der in den Arbeitsjournalen von 1801 genannt wird. Ab Frühjahr 1808 scheint Seyffert niemanden mehr beschäftigt zu haben.

27 HStA Dresden, 10026 Geheimes Kabinett, Loc. 2573/1, fol. 282r – 289v.

14 HStA Dresden, 10026 Geheimes Kabinett, Loc. 2573/1, fol. 284v.

15 Now in the Mathematisch-Physikalischer Salon, Dresden, inv. no. B VIII 81.

16 The chronometer No. 5, now held in the Beyer Collection in Zurich, is an example of the use of the typical double S-shaped compensation and balance, but is equipped with a chronometer escapement with detent. In my view, the escapement part should be examined to establish its original condition.

17 Regarding chronometers No. 3 and No. 4, Seyffert speaks of the 'same mechanism'. See HStA Dresden, 10026 Geheimes Kabinett, Loc. 2573/1, fol. 285r+v. Regarding chronometer No. 1, Alexander von Humboldt commented in 1804, in his list of instruments compiled in Mexico City: 'Une Montre de Longitude de Seyffert ou Chronometre de poche d'après les principes de Mudge avec les compensations de temperature.' See Staatsbibliothek Berlin, Handschriftenabteilung, gr. Ka, 2, Mappe 4, No. 34r+v.

18 On their journey to Dresden in 1785, Zach and Brühl did not have Mudge's marine chronometer No. 1 with them, for Zach notes in the *Astronomisches Jahrbuch* that it only returned from America on 5 December 1785. Cf. Astronomisches Jahrbuch for 1789, p. 237.

19 Thomas Mudge, A Description, with Plates, of the Time-Keeper invented by the late Mr. Thomas Mudge, London, 1799.

20 AJ Seyffert, Vol. I, p. 193.

21 AJ Seyffert, Vol. I, p. 403.

22 Seyffert's work journals give various indications of repair orders, for example Vol. I, fol. 137: Brockbanks; Vol. II, fol. 121: Arnold; vol. II, fol. 145: Haley. It was from Grant that Seyffert could lay his hands on several chronometers. One of them is preserved and is now found in a private collection. It is now, however, equipped with a chronometer escapement with a spring and cannot have originated from Seyffert, contrary to Herbert Dittrich's assumption. Seyffert marked on the timepiece that he had manufactured a 'new anchor, fork and balance,' in short a lever escapement. See Dittrich 2009, p. 71.

23 AJ Seyffert, vol. 1, fol. 138: 'I will improve my chronometers in future through this ingenious device.'

24 HStA Dresden, 10047 Amt Dresden, No. 3175, fol. 2r – 31v. The file describing the estate is unfortunately incomplete and breaks off half-way through the library's list. Machines, tools, unfinished timekeepers, etc. are not mentioned on the remaining pages.

25 Monatliche Correspondenz, Vol. 3, 1801, p. 492.

26 In 1801, Kirchel went to Bautzen to work under the watchmaker Paul Kindermann, where he remained, however, for only seven months. Unable to make a living in Bautzen, he returned to Dresden. In 1808, he applied to be admitted to the master's examination of the Dresden watchmakers' guild, which he eventually passed after experiencing some difficulties on the part of the guild. Other employees of Seyffert's included a certain Thomas known to the authorities as a 'scholar of mechanics' (before 1804), and a Van Boom, whose name appears in the work journals from 1801. From spring 1808, Seyffert seems to have employed no one new.

27 HStA Dresden, 10026 Geheimes Kabinett, Loc. 2573/1, fol. 282r – 289v.

28 AJ Seyffert, Bd. III, fol. 9, Eintrag vom 06.02.1813.

29 HStA Dresden, 10026 Geheimes Kabinett, Loc. 2573/1, fol. 283r.

30 Etliche Schweizer Uhrmacher entsandten Vertreter in die Messestadt Leipzig. Federn kaufte Seyffert beispielsweise bei E. Melly aus Genf. Die Gebrüder Melly tauchen bereits in den 80er Jahren des 18. Jahrhunderts in den Leipziger Adresskalendern auf. Mit einem Mitglied der Familie Courvoisier aus Le Locle scheint Seyffert befreundet gewesen zu sein. Hier kaufte er u. a. Zifferblätter und Zeiger. Im Leipziger Adresskalender von 1812 wird H. (möglicherweise Henri) Courvoisier als Uhrenhändler aus Locle genannt. Die dazugehörige Firma müsste Courvoisier & Cie. sein.

31 AJ Seyffert, Bd. III, S. 224, Eintrag vom 14.10.1817.

32 Feststellung anhand des Chronometers Nr. 8, die anderen müssten überprüft werden. Zu Mudge und Emery vgl. George Daniels: »Mudge's Lever Escapement«, in: Antiquarian Horology and the Proceedings of the Antiquarian Horological Society, H. 5 (1968), S. 396 – 421 und Jonathan Betts: »Josiah Emery, Part 3, The Lever Escapement«, in: Antiquarian Horology and the Proceedings of the Antiquarian Horological Society, H. 7 (1996), S. 26 – 44 (S. 38).

33 Oberlausitzische Bibliothek der Wissenschaften, Gersdorfs Briefschaft, Bd. V: Brief von Gersdorf an Seyffert vom 20.08.1802, fol. 349r und von Seyffert an Gersdorf vom 02.03.1803, fol. 354r – 355v.

34 HStA Dresden, 10026 Geheimes Kabinett, Loc. 2573/1, fol. 254r – 256v.

35 Inv.-Nr. D IV a 444 und D IV a 96.

36 Stadtarchiv Dresden, Vorort 11.2.68, Dep. 8: Innungsbuch der Kleinuhrmacher zu Dresden, Anno 1800, Caput 1.

37 Ibid., fol. 61r, Eintrag vom 26.04.1813. Gutkaes' Vater wird im »Allgemeinen Straßen- und Wohnungs-Anzeiger für die Residenzstadt Berlin« von 1812, S. 23 als Orchestermitglied geführt. Leider sind für die Jahre 1802 bis 1811 keine Berliner Adresskalender überliefert, so dass sich anhand dieser Quellen der Aufenthalt in Berlin nicht genauer bestimmen lässt.

38 Stadtarchiv Dresden, Vorort 11.2.68, Dep. 8: Innungsbuch der Kleinuhrmacher zu Dresden, Anno 1800, fol. 64v, Eintrag vom 06.10.1815.

39 Gutkaes beherrschte die französische Sprache. Die Annahme, er sei bei Breguet gewesen, basiert auf dem Zertifikat für die Repetitionsuhr Nr. 3872 von Breguet, ausgestellt am 12. Februar 1825. Friedrich Gutkaes in Dresden wird hier neben u. a. Kessels in Altona und Fatton in London als möglicher Ansprechpartner im Falle von Problemen mit der Uhr genannt.

40 HStA Dresden, 10078 Landes-Ökonomie, Manufaktur- und Kommerziendeputation, Nr. 1344, fol. 77r.

41 Die Dresdner Adresskalender führen Gutkaes ab 1829 als »Mechanicus bei dem mathematischen Salon«.

42 AJ Schmidt, S. 6, Eintrag vom 28.09.1818 und S. 103, Eintrag vom 22.05.1819.

43 Klaus Schillinger: »Johann Gottfried Köhler – Inspektor am Mathematisch-Physikalischen Salon Dresden – aktiver Beobachter des gestirnten Himmels im letzten Viertel des 18. Jahrhunderts«, in: Jürgen Hamel und Inge Keil (Hg.), Der Meister und die Fernrohre, Frankfurt a. M. 2007, S. 257 – 300 (= Acta Historica Astronomiae, Vol. 33).

44 HStA Dresden, 10078 Landes-Ökonomie, Manufaktur- und Kommerziendeputation, Nr. 1344, fol. 76r – 79v.

28 AJ Seyffert, Vol. III, fol. 9, entry of 6 Feb. 1813.

29 HStA Dresden, 10026 Geheimes Kabinett, Loc. 2573/1, fol. 283r.

30 Many Swiss watchmakers sent representatives to the city of Leipzig. Seyffert purchased springs, for example, from E. Melly from Geneva. The Melly brothers are mentioned as early as the 1880s in the Leipzig address calendars. Seyffert seems to have befriended a member of the Courvoisier family in Le Locle. From them his purchases included dials and hands. In the Leipzig address calendar of 1812, 'H.' (possibly Henri) Courvoisier is named as a watch dealer from Le Locle. He would have operated under the company name Courvoisier & Cie.

31 AJ Seyffert, Vol. III, p. 224, entry of 14 Oct. 1817.

32 This can be ascertained by examining chronometer No. 8; the others have yet to be checked. On Mudge and Emery, cf. George Daniels, 'Mudge's Lever Escapement', in: Antiquarian Horology and the Proceedings of the Antiquarian Horological Society, H. 5 (1968), pp. 396 – 421 and Jonathan Betts, 'Josiah Emery, Part 3, The Lever Escapement', in: Antiquarian Horology and the Proceedings of the Antiquarian Horological Society, H. 7 (1996), pp. 26 – 44 (p. 38).

33 Bibliothek der Wissenschaften in Oberlausitz, Gersdorf's correspondence, Vol. V: letter from Gersdorf to Seyffert, dated 20 Aug. 1802, fol. 349r and from Seyffert to Gersdorf dated 2 March 1803, fol. 354r – 355v.

34 HStA Dresden, 10026 Geheimes Kabinett, Loc. 2573/1, fol. 254r – 256v.

35 Inv. no. D IV a 444 and D IV a 96.

36 Stadtarchiv Dresden, Vorort 11.2.68, Dep. 8: Innungsbuch der Kleinuhrmacher zu Dresden, Anno 1800, Caput 1.

37 Ibid., fol. 61r, entry of 26 Apr. 1813. Gutkaes' father is named as orchestra member in the *Allgemeinen Straßen- und Wohnungs-Anzeiger für die Residenzstadt Berlin* of 1812, p. 23. Regrettably no Berlin address calendars have survived for the years 1802 to 1811, making it impossible to determine more accurately the length of the family's period of residence in Berlin.

38 Stadtarchiv Dresden, Vorort 11.2.68, Dep. 8: Innungsbuch der Kleinuhrmacher zu Dresden, Anno 1800, fol. 64v, entry of 6 Oct. 1815.

39 Gutkaes mastered the French language. The assumption that he worked under Breguet is based on the certificate for Breguet's repeating clock No. 3872, issued on 12 February 1825. Friedrich Gutkaes in Dresden is stated here along with Kessels in Altona and Fatton in London as a possible point of contact in case of problems.

40 HStA Dresden, 10078 Landes-Ökonomie, Manufaktur- und Kommerziendeputation, No. 1344, fol. 77r.

41 The Dresden address calendar includes Gutkaes' name from 1829 as 'mechanicus at the Mathematischer Salon.'

42 AJ Schmidt, p. 6, entry of 28 Sept. 1818 and p. 103, entry of 22 May 1819.

43 Klaus Schillinger, 'Johann Gottfried Köhler – Inspektor am Mathematisch-Physikalischen Salon Dresden – aktiver Beobachter des gestirnten Himmels im letzten Viertel des 18. Jahrhunderts', in: Jürgen Hamel and Inge Keil (eds.), Der Meister und die Fernrohre, Frankfurt a. M., 2007, pp. 257 – 300 (= Acta Historica Astronomiae, Vol. 33).

44 HStA Dresden, 10078 Landes-Ökonomie, Manufaktur- und Kommerziendeputation, No. 1344, fol. 76r – 79v.

45 Ibid.

45 Ibid.

46 Ibid., fol. 90r–91r.

47 Ibid., fol. 92r. Weisse arbeitete möglicherweise nach dem Verlagssystem – darauf deutet zumindest sein Schreiben hin.

48 Astronomisches Jahrbuch für 1822, S. 252 und Annalen der Physik, Bd. 33, H. 2 (1819), S. 232.

49 Stadtarchiv Dresden, Vorort 11.2.68, Dep. 8: Innungsbuch der Kleinuhrmacher zu Dresden, Anno 1800.

50 Der von Herbert Dittrich genannte Victor Gannery arbeitete bei F. A. Lange und nicht bei Gutkaes sen. Vgl. Dittrich 2009, S. 97.

51 Bericht über die Ausstellung sächsischer Gewerb-Erzeugnisse im Jahre 1831, Dresden u. Leipzig 1832, S. 34.

52 Diese Zahlen stammen aus der Auflistung Wilhelm Gotthelf Lohrmanns, ab 1827 Oberinspektor des Mathematisch-Physikalischen Salons, vom 03.08.1829. Siehe HStA Dresden, 10078 Landes-Ökonomie-, Manufaktur- und Kommerziendeputation, Nr. 1344, fol. 122r – 126v. Gutkaes selbst nennt ebenfalls insgesamt 56 Stück Chronometer, Seeuhren und astronomische Pendeluhren mit »Einschluß des vom Jahre 1820 an gemachten kleinen Anfangs«. Vgl. ibid., fol. 116v.

53 Ibid., fol. 116r – 120v.

54 Ibid., fol. 130r+v.

55 Annalen der Physik, Bd. 74, H. 8 (1823), S. 459.

56 Briefwechsel zwischen Gauss und Bessel, hg. auf Veranlassung der Königlich Preussischen Akademie der Wissenschaften, Leipzig 1880, Brief Nr. 111: Gauss an Bessel, 09.12.1819 (S. 309) und Brief Nr. 117: Bessel an Gauss, 30.04.1820 (S. 333). Gauss scheint nichts gekauft zu haben.

57 HStA Dresden, 10078 Landes-Ökonomie-, Manufaktur- und Kommerziendeputation, Nr. 1344, fol. 133r u. 135r.

58 SUB Göttingen, Gauss-Briefe A, Nr. 10, Brief Nr. 15: Hansteen an Gauss, 22.12.1853. Herzlichen Dank an Karin Reich, die mir diesen Auszug zuschickte.

59 Siehe Günther Oestmann: Heinrich Johann Kessels (1781 –1849). Ein bedeutender Verfertiger von Chronometern und Präzisionspendeluhren, Frankfurt a. M. 2011 (= Acta Historica Astronomiae, Vol. 44), bes. S. 30–32.

60 Siehe Karl J. Langer, »Taschenchronometer Gutkaes No. 59«, in: Alte Uhren und moderne Zeitmessung 3 (1991), S. 29 – 33 (bes. S. 29f.).

61 Angeblich veranlasste Raffaels Bild der Heiligen Cecilia in Bologna diesen Ausruf. Siehe Guiseppe Fumagalli (Hg.), Chi l'ha detto? 2327 citazioni italiane e straniere in lingua originale e con la traduzione, di origine storica e letteraria, Mailand 1989, S. 221f.

62 In Dresden wurde beispielsweise den Absolventen der 1828 gegründeten Technischen Bildungsanstalt Gewerbefreiheit gewährt.

46 Ibid., fol. 90r–91r.

47 Ibid., fol. 92r. Weisse's output was possibly based on the domestic system – which his letter at least seems to imply.

48 Astronomisches Jahrbuch for 1822, p. 252 and Annalen der Physik, vol. 33, H. 2 (1819), p. 232.

49 Stadtarchiv Dresden, Vorort 11.2.68, Dep. 8: Innungsbuch der Kleinuhrmacher zu Dresden, Anno 1800.

50 Victor Gannery, mentioned by Herbert Dittrich, worked for F. A. Lange and not for Gutkaes sen. Cf. Dittrich 2009, p. 97.

51 Bericht über die Ausstellung sächsischer Gewerb-Erzeugnisse im Jahre 1831, Dresden and Leipzig, 1832, p. 34.

52 These figures are taken from the list compiled by Wilhelm Gotthelf Lohrmann, chief inspector of the Mathematisch-Physikalischer Salon from 1827, dated 3 Aug. 1829. See HStA Dresden, 10078 Landes-Ökonomie-, Manufaktur- und Kommerziendeputation, No. 1344, fol. 122r – 126v. Gutkaes himself mentions a total of 56 chronometers, marine clocks, and astronomical pendulum clocks 'including the small start made in 1820.' Cf. ibid., fol. 116v.

53 Ibid., fol. 116r – 120v.

54 Ibid., fol. 130r+v.

55 Annalen der Physik, Vol. 74, H. 8 (1823), p. 459.

56 Correspondence between Gauss and Bessel, ed. at the request of the Königlich Preussische Akademie der Wissenschaften, Leipzig 1880, letter 111: Gauss to Bessel, 9 Dec. 1819 (p. 309) and letter 117: Bessel to Gauss, 30 Apr. 1820 (p. 333). Gauss appears not to have bought anything from him.

57 HStA Dresden, 10078 Landes-Ökonomie-, Manufaktur- und Kommerziendeputation, No. 1344, fol. 133r and 135r.

58 SUB Göttingen, Gauss letters A, No. 10, letter 15: Hansteen to Gauss, 22 Dec. 1853. Thank you to Karin Reich, who sent me this excerpt.

59 See Günther Oestmann, Heinrich Johann Kessels (1781 – 1849). Ein bedeutender Verfertiger von Chronometern und Präzisionspendeluhren, Frankfurt a. M., 2011 (= Acta Historica Astronomiae, Vol. 44), esp. pp. 30 – 32.

60 See Karl J. Langer, 'Taschenchronometer Gutkaes No. 59', in: Alte Uhren und moderne Zeitmessung 3 (1991), pp. 29 – 33 (esp. p. 29f.).

61 Legend has it that Raphael's picture of Saint Cecilia in Bologna provoked this exclamation. See Guiseppe Fumagalli (ed.), Chi l'ha detto? 2327 citazioni italiane e straniere in lingua originale e con la traduzione, di origine storica e letteraria, Milan, 1989, p. 221f.

62 In Dresden for example the graduates of the Technische Bildungsanstalt (founded 1828) were granted economic liberty.

Mathias Ullmann
Der Weg von Dresden nach Glashütte
The Journey from Dresden to Glashütte



1 F. A. Lange an C. A. H. Freiherr von Weißenbach, Dresden, 25.06.1843. Staatsarchiv Dresden, 10736 – Ministerium des Innern, Nr. 5941, fol. 1. In den Zitaten wird jeweils die originale Schreibweise der Vorlage beibehalten.
2 Ibid., fol. 14 f.
3 Ibid., fol. 7.
4 Ibid., fol. 22 f.
5 Ibid., fol. 25.
6 Staatsarchiv Dresden, 10753 – Amtshauptmannschaft Dippoldiswalde, Nr. 443, fol. 4 – 7.
7 Ibid., fol. 7 f.
8 Staatsarchiv Dresden, 10736 – Ministerium des Innern, Nr. 5941, fol. 48 – 52.
9 Ibid., fol. 67.
10 Siehe Staatsarchiv Dresden, 10753 – Amtshauptmannschaft Dippoldiswalde, Nr. 443, fol. 31 – 33.
11 Ibid., fol. 71 f.
12 Siehe den Brief von Lehmann an Lange und Bernhard Gutkaes, Dippoldiswalde, 09.02.1846, in: ibid., fol. 100 f.
13 Siehe den Brief von Lehmann an das Innenministerium vom 08.02.1852, in: Staatsarchiv Dresden, 10736 – Ministerium des Innern, Nr. 5942, fol. 31 – 33.
14 Ibid., fol. 9 v.
15 Siehe u. a. § 38 des Regulativs für die in Glashütte gegründete Unterrichtsanstalt zu Erlernung und Verbreitung der Fabrikation der Bestandtheile der Taschenuhren vom 16.03.1846: »Solange der Unternehmer die als brauchbar befundenen Arbeiten nach Art. 31 vollständig abnimmt und vergütet, ist dem Ausgelernten während der Verdingungszeit nicht gestattet, irgend einen von ihm gefertigten Gegenstand an andere Personen abzulassen, überhaupt auf keine Weise irgend einen Handel oder ein anderes Geschäfft zu treiben oder aus der Anstalt auszutreten.« Vgl. Staatsarchiv Dresden, 10753, Nr. 443, fol. 14 e.
16 Siehe den Brief von Lange an das Ministerium des Innern vom 06.04.1855: »Mit der höhern Ausbildung unserer Arbeiter hat sich ihr Ruf vermehret und haben die Geschäfte wesentlich zugenommen. Es bestehen neben unsern nun noch zwei Comptoire, das frühere von Assmann und ein neu gegründetes von Großmann, unseren frühern Gehülfen, aus Dresden. Es ist einleuchtend, wie sehr daher unentbehrlich und beschäftigt meine frühern Schüler alle seyn müssen – aber sie sind doppelt wichtig und unentbehrlich, jetzt wo so viele unter ihnen selbst wieder Schüler zu leiten und zu bilden haben.« Vgl. Staatsarchiv Dresden, 10736, Nr. 5942, fol. 87 v.

1 F. A. Lange to C. A. H. Freiherr von Weißenbach, Dresden, 25 June 1843. Staatsarchiv Dresden, 10736 – Ministry of the Interior, No. 5941, fol. 1.
2 Ibid., fol. 14 f.
3 Ibid., fol. 7.
4 Ibid., fol. 22 f.
5 Ibid., fol. 25.
6 Staatsarchiv Dresden, 10753 – Amtshauptmannschaft Dippoldiswalde, No. 443, fol. 4 – 7.
7 Ibid., fol. 7 f.
8 Staatsarchiv Dresden, 10736 – Ministry of the Interior, No. 5941, fol. 48 – 752.
9 Ibid., fol. 67.
10 See Staatsarchiv Dresden, 10753 – Amtshauptmannschaft Dippoldiswalde, No. 443, fol. 31 – 733.
11 Ibid., fol. 71 f.
12 See the letter from Lehmann to Lange and Bernhard Gutkaes, Dippoldiswalde, 9 Feb. 1846, in: ibid., fol. 100 f.
13 See the letter from Lehmann to the Ministry of the Interior from 8 Feb. 1852, in: Staatsarchiv Dresden, 10736 – Ministry of the Interior, No. 5942, fol. 31 – 733.
14 Ibid., fol. 9 v.
15 See, e.g. § 38 of the Regulativ für die in Glashütte gegründete Unterrichtsanstalt zur Erlernung und Verbreitung der Fabrikation der Bestandtheile der Taschenuhren (regulations of the school founded in Glashütte to train and promote the fabrication of pocket watch components) of 16 March 1846: 'So long as the watchmaker, in accordance with Art. 31, takes and pays for all usable pieces in full, the qualified trainee is not permitted to sell any object crafted by him to other persons during the period of his employment, nor to carry out any kind of trade or other business or to attempt to leave the school.' Cf. Staatsarchiv Dresden, 10753, No. 443, fol. 14 e.
16 See the letter from Lange to the Ministry of the Interior from 6 Apr. 1855: 'with the highquality of the training received by our workers their reputation has increased and business has picked up considerably. In addition to ours there are now two other comptoire, the first set up by Assmann, the latest by Großmann, our former assistant from Dresden. It underlines how indispensable and busy my earlier students all must be – but they are twice as important and indispensable now that so many of them have their own apprentices to manage and teach.' Cf. Staatsarchiv Dresden, 10736, No. 5942, fol. 87 v.



Eduard Saluz

Nicht nur in Sachsen – Zur Fabrikation von Taschenuhren in Deutschland
in der zweiten Hälfte des 19. Jahrhunderts
Not Only in Saxony – On the Fabrication of Pocket Watches in Germany
in the Second Half of the Nineteenth Century

1 Seit 1742 gehörte die Provinz Schlesien zum Königreich Preußen.

2 Die im Uhrengeschäft tätigen Mitglieder der Familie Eppner waren: C. W. (Wilhelm) Eppner (Uhrmacher, ca. 1804 – 1877), Eduard Eppner (Uhrmacher, 1812 – 1887), Albert Eppner (Uhrmacher), Louis Höser (Uhrmacher), Hermann Höser (Uhrmacher), E. A. (August) Höser (Gehäusemacher); die Hösers waren Halbbrüder der Eppners. Siehe Deutsche Uhrmacher-Zeitung (DUZ) 2, 1883, Nr. 5, S. 50.

3 Diese und die folgenden Zitate aus: Albert Eppner: Die Entstehung der Taschen-Uhrenfabrikation zu Lähn in Schlesien, Berlin 1854, S. 11 und 15.

4 Dieses und auch die anderen Zitate veranschaulichen, dass man die zeitgenössischen Quellen nicht ohne kritischen Blick lesen sollte. Die Werturteile zeigen deutlich die Haltung der Schreibenden.

5 Heute Wleń.

6 Illustrirte Zeitung vom 28. November 1863 (Ausriss im Archiv DU).

7 Eduard Eppner sen.: Die Entstehung der Taschen-Uhrenfabrikation zu Lähn in Schlesien, Breslau 1886, S. 21.

8 Eppner 1854, S. 19.

9 Illustrirte Zeitung vom 28. November 1863 (Ausriss im Archiv DU).

10 Eppner 1886, S. 24.

11 Siehe dazu z. B. die Biographie von Reinhold Hanke auf: http://www.glashuetteuhren.de/die-uhrenfabriken/a-lange-soehne/ (Zugriff 03.06.2014).

12 Heute Srebrna Góra.

13 DUZ 1, 1877, Nr. 15, S. 95.

14 Die unterschiedlichen Bezeichnungen der Firmen der verschiedenen Eppners in Breslau, Lähn, Silberberg und Berlin sind schwer zu durchschauen.

15 F. O. Gasser: »Ein Besuch in Silberberg«, in: DUZ 1, 1877, Nr. 18, S. 122f. (S. 123).

16 DUZ 5, 1881, Nr. 18, S. 141.

17 DUZ 5, 1881, Nr. 19, S. 149. Gemäß späteren Quellen war Albert Eppner aber durchaus Teilhaber der Silberberger Fabrik. Es sind denn auch einige Uhren mit der Bezeichnung »A. Eppner & Co. Silberberg« bekannt.

18 AJUK 15, 1890, Nr. 24, S. 375.

19 DUZ 11, 1887, Nr. 14, S. 106.

20 Interessant ist eine Bemerkung in der Zeitschrift Die Uhrmacherkunst 50, 1925, Nr. 22, S. 386, nach der das Ende der Taschenuhrproduktion in Silberberg bereits mit dem Sterben der alten, aus Lähn umgezogenen Arbeiter kam: Die schlesische »Bevölkerung eignete sich für die Entfaltung einer Präzisionsindustrie wenig«.

21 Tabelle bei Hans Weil: Die Gebrüder Eppner – Gründer der schlesischen Taschenuhrenindustrie, 2010 (PDF-Dokument, erhalten vom Verfasser 2014). Dies steht im

1 Silesia had become a province of Prussia in 1742.

2 The members of the Eppner family active in the watch business were: C. W. (Wilhelm) Eppner (watchmaker, c. 1804 – 1877), Eduard Eppner (watchmaker, 1812 – 1887), Albert Eppner (watchmaker), Louis Höser (watchmaker), Hermann Höser (watchmaker), E. A. (August) Höser (watchcase maker); the Hösers were half-brothers of the Eppners. See Deutsche Uhrmacher-Zeitung (DUZ) 2, 1883, No. 5, p. 50.

3 These and the following quotations were taken from Albert Eppner: Die Entstehung der Taschen-Uhrenfabrikation zu Lähn in Schlesien, Berlin, 1854, pp. 11 and 15.

4 The quote refers to the German revolutions of 1848. This and the other quotations are a reminder that we should not read contemporary sources uncritically. The value judgements bear eloquent witness to the stance of the writers.

5 Today's Wleń.

6 Illustrirte Zeitung of 28 November 1863 (clipping in the DU Archive).

7 Eduard Eppner Sen.: Die Entstehung der Taschen-Uhrenfabrikation zu Lähn in Schlesien, Breslau, 1886, p. 21.

8 Eppner 1854, p. 19.

9 Illustrirte Zeitung of 28 November 1863 (clipping in the DU Archive).

10 Eppner 1886, p. 24.

11 See, for example, the biography of Reinhold Hanke at: http://www.glashuetteuhren.de/die-uhrenfabriken/a-lange-soehne/ (accessed 3 June 2014).

12 Today's Srebrna Góra.

13 DUZ 1, 1877, No. 15, p. 95.

14 The different trading names of the various Eppner companies in Breslau, Lähn, Silberberg and Berlin frequently cause confusion and make it difficult to trace their history.

15 D. O. Gasser, 'Ein Besuch in Silberberg', in: DUZ 1, 1877, No. 18, p. 122f.

16 DUZ 5, 1881, No. 18, p. 141.

17 DUZ 5, 1881, No. 19, p. 149. According to older sources Albert Eppner was a partner in the Silberberg factory. There are also several watches marked 'A. Eppner & Co. Silberberg'.

18 AJUK 15, 1890, No. 24, p. 375.

19 DUZ 11, 1887, No. 14, p. 106.

20 Of particular interest is a comment in the journal Die Uhrmacherkunst 50, 1925, No. 22, p. 386, which suggests that the end of the pocket watch production in Silberberg had already begun with the dying away of the old workers who had relocated from Lähn: The Silesian 'population was ill-suited for the development of precision industry'.

21 Table in Hans Weil, 'Die Gebrüder Eppner – Gründer der schlesischen Taschenuhrenindustrie', 2010 (PDF document, received from the author in 2014). This contrasts

Gegensatz zu der enthusiastischen Schilderung von Sau-
nier/Speckhart, die von »weit über 100.000 Taschenuhren
im Gesamtwert von 10 Millionen Mark« berichten. Siehe
Claudius Saunier: Die Geschichte der Zeitmesskunst von
den ältesten Zeiten bis zur Gegenwart, ins Dt. übers. und
neu bearb. von Gustav Speckhart, Bd. 3, S. 968.
22 A. Eppner & Co.: Preisliste für öffentliche Uhren, Breslau
1901 (Scan, erhalten von Dieter Landrock).
23 Wie das Folgende zitiert nach Gerd Bender: Die Uhrenma-
cher des hohen Schwarzwaldes und ihre Werke, Bd. 2, Vil-
lingen 1978, S. 30.
24 Ibid., S. 90.
25 Vollständig abgedruckt bei ibid., S. 91f.
26 Normalerweise haben Ankeruhren eine ungerade Anzahl
Steine, Zylinderuhren eine gerade Anzahl.
27 Franz-Dieter Sauerborn: Jess Hans Martens (1826 – 1892)
– Erster Lehrer der Taschenuhrmacherschule in Furtwan-
gen – Lehrwerkstatt für Uhrmacher in Freiburg in Baden,
Buggingen 2003, S. 35.
28 Wie das Folgende zitiert nach ibid., S. 37.
29 Deutsches Uhrenmuseum, Inv.-Nr. 48-1048.
30 Bekannt sind Nummern zwischen etwa 500 und 1850.
31 Typoskript, datiert 23. Febuar 1937, mitgeteilt von Artur
Kamp, Ruhla.
32 Leider fehlt bis heute eine gute Zusammenfassung dieser
Entwicklung.

markedly with the enthusiastic account in Claudius Sau-
nier, Die Geschichte der Zeitmesskunst von den ältesten
Zeiten bis zur Gegenwart, trans. (into German) and ed. by
Gustav Speckhart, Vol. 3, 1903, p. 968, which speaks of 'in
excess of 100,000 pocket watches with a total value of 10
million marks.'
22 Eppner, A. Eppner & Co., Preisliste für öffentliche Uhren,
Breslau 1901 (scan, provided by Dieter Landrock).
23 This and the following as cited in Gerd Bender, Die Uh-
renmacher des hohen Schwarzwaldes und ihre Werke,
Vol. 2, Villingen, 1978, p. 30.
24 As cited in ibid., p. 90.
25 Reprinted completely in ibid., p. 91f.
26 Normally lever watches have an uneven number of jewels,
while cylinder watches have an even one.
27 Franz-Dieter Sauerborn, Jess Hans Martens (1826 – 1892)
– Erster Lehrer der Taschenuhrmacherschule in Furtwan-
gen – Lehrwerkstatt für Uhrmacher in Freiburg in Baden,
Buggingen, 2003, p. 35.
28 This and the following as cited in Sauerborn 2003, p. 37.
29 Deutsches Uhrenmuseum, inv. no. 48-1048.
30 Numbers between approximately 500 and 1850 are known.
31 Typescript, dated 23 February 1937, information from
Artur Kamp, Ruhla.
32 Unfortunately, a good summary of this development has
yet to be published.

Vom rechten Maß
The Right Measure

1 HStA Dresden, 10736 Ministerium des Innern, Nr. 5942,
o. S.

1 HStA Dresden, 10736 Ministry of the Interior, No. 5942,
n. p.

Pierre-Yves Donzé

Wie die Schweiz zur größten Uhrmachernation der Welt wurde – Ein kleiner Überblick über die Geschichte der Schweizer Uhrenindustrie von 1750 bis 1850
How Switzerland Became the Largest Watchmaking Nation in the World – A Short History of the Swiss Watch Industry from 1750 to 1850

* Text übernommen und angepasst von: Pierre-Yves Donzé:
History of the Swiss Watch Industry from Jacques David to
Nicolas Hayek, Bern 2014 (3. Auflage).
1 Christophe Koller: »De la lime à la machine«. L'industria-
lisation et l'État au pays de l'horlogerie. Contribution à
l'histoire économique et sociale d'une région suisse,
Courrendlin 2003, S. 103.
2 Béatrice Veyrassat: »Sortir des montagnes horlogères: les
faiseurs de globalisation (1750 – années 1830/1840)«, in:
Marie-Claude Schöpfer, Markus Stoffel und Françoise Van-

* Text taken and adapted from: Pierre-Yves Donzé, History
of the Swiss Watch Industry from Jacques David to Nicolas
Hayek, Bern, 2014 (third edition).
1 Christophe Koller, 'De la lime à la machine': L'industria-
lisation et l'État au pays de l'horlogerie. Contribution à
l'histoire économique et sociale d'une région suisse,
Courrendlin, 2003, p. 103.
2 Béatrice Veyrassat, 'Sortir des montagnes horlogères: les
faiseurs de globalisation (1750 – années 1830/1840)', in:
Marie-Claude Schöpfer, Markus Stoffel and Françoise Van-

notti (Hg.): Unternehmen, Handelshäuser und Wirtschaftsmigration im neuzeitlichen Alpenraum, Brig 2014, S. 268.

3 Béatrice Veyrassat: Réseaux d'affaires internationaux, émigrations et exportations en Amérique latine au XIXᵉ siècle. Le commerce suisse aux Amériques, Genf 1994, S. 106.

4 André Francillon: Histoire de la fabrique des Longines, précédée d'un essai sur le comptoir Agassiz, Saint-Imier 1947, S. 36.

5 Veyrassat 1994, S. 416f.

6 Alfred Chapuis: La montre chinoise, Neuchâtel 1919.

7 Marianne Belinger Konqui: »L'horlogerie à Genève«, in: Cardinal Catherine et al. (Hg.): L'homme et le temps en Suisse, 1291–1991, La Chaux-de-Fonds 1991, S. 125.

8 Ibid., S. 124.

9 Laurence Marti: Une région au rythme du temps. Histoire socio-économique du Vallon de Saint-Imier et environs, 1700–2007, Saint-Imier 2007, S. 54.

10 Dictionnaire historique de la Suisse (DHS), www.dhs.ch (aufgerufen im Dezember 2008).

11 Frédéric Scheurer: Les crises de l'industrie horlogère dans le canton de Neuchâtel, La Neuveville 1914.

12 Jean-Marc Barrelet: »De la noce au turbin. Famille et développement de l'horlogerie aux XVIIIᵉ et XIXᵉ siècles«, in: Musée neuchâtelois, 1994, S. 216.

notti (eds.), Unternehmen, Handelshäuser und Wirtschaftsmigration im neuzeitlichen Alpenraum, Brig, 2014, p. 268.

3 Béatrice Veyrassat, Réseaux d'affaires internationaux, émigrations et exportations en Amérique latine au XIXᵉ siècle. Le commerce suisse aux Amériques, Geneva, 1994, p. 106.

4 André Francillon, Histoire de la fabrique des Longines, précédée d'un essai sur le comptoir Agassiz, Saint-Imier, 1947, p. 36.

5 Veyrassat 1994, p. 416f.

6 Alfred Chapuis, La montre chinoise, Neuchâtel, 1919.

7 Marianne Belinger Konqui, 'L'horlogerie à Genève', in: Catherine Cardinal et al. (eds.), L'homme et le temps en Suisse, 1291–1991, La Chaux-de-Fonds, 1991, p. 125.

8 Ibid., p. 124.

9 Laurence Marti, Une région au rythme du temps. Histoire socio-économique du Vallon de Saint-Imier et environs, 1700–2007, Saint-Imier, 2007, p. 54.

10 Dictionnaire historique de la Suisse (DHS), www.dhs.ch (last accessed Dec. 2008).

11 Frédéric Scheurer, Les crises de l'industrie horlogère dans le canton de Neuchâtel, La Neuveville, 1914.

12 Jean-Marc Barrelet, 'De la noce au turbin. Famille et développement de l'horlogerie aux XVIIIᵉ et XIXᵉ siècles', in: Musée neuchâtelois, 1994, p. 216.

Die Glashütter Uhr
The Glashütte Watch

1 Moritz Grossmann: Abhandlung über die Konstruktion einer einfachen, aber mechanisch vollkommenen Uhr, Glashütte 1880.

1 Moritz Grossmann, Abhandlung über die Konstruktion einer einfachen, aber mechanisch vollkommenen Uhr, Glashütte, 1880.

David Penney
Ingold, Nicole und Lange – Eine neue Art der Uhrenherstellung
Ingold, Nicole and Lange – A New Way of Making Watches

1 Pfarrer William Pearson, Hon LLD, FRS, FRAS (1767–1847). Der Astronom und Autor gehörte dem Board of Visitors (Direktorium) des Royal Observatory in Greenwich, London an.

2 Abraham Rees: The Cyclopædia; or Universal Dictionary of Arts, Sciences and Literature. 39 Textbände und 5 Bände mit Tafeln, London um 1805–1818. Außerdem ders.: Rees's Clocks Watches and Chronometers, Faksimile der Auszüge und modernes Register, Newton Abbott 1970.

3 Einer der angesehensten und bekanntesten Hersteller von Taschen- und Großuhren in England, Partnerschaft mit Edward Banger von 1701 bis 1705 sowie mit George Graham

1 Rev. William Pearson, Hon LLD, FRS, FRAS (1767–1847), astronomer, author, and one of the Board of Visitors to the Royal Observatory, Greenwich, London.

2 Abraham Rees, The Cyclopædia; or Universal Dictionary of Arts, Sciences and Literature, 39 vols. text and 5 vols. plates, London, around 1805–1818. See also id., Rees's Clocks Watches and Chronometers, facsimile of extracted sections and modern index, Newton Abbott, 1970.

3 One of the England's most revered and best-known watch and clockmakers, partner with Edward Banger from 1701 to 1705 and George Graham from 1711, the latter becoming as famous and important a maker as Tompion.

ab 1711. Letzterer erlangte als Uhrmacher ähnlichen Ruhm und eine ähnliche Bedeutung wie Tompion.

4 David Penney: »The Faking of English Watches«, Vortrag auf der Versammlung der Antiquarian Horological Society in London im Juli 2014. Eine schriftliche Fassung ist derzeit in Vorbereitung und liegt voraussichtlich 2015 vor.

5 Ausbildung bei Abram Louis Perrelet in Le Locle, 1759 in Paris bei Pierre Le Roy und Ferdinand Berthoud angestellt und zur Zeit der Ankunft von A. L. Breguet in Paris ebenfalls in der Stadt. Pionier der Schweizer Chronometrie, Hersteller und Zulieferer von Tourbillon-Uhren an Breguet, Jürgensen und andere.

6 Lehrjahre zunächst bei seinem Vater in Kopenhagen, Abschluss der Lehre bei Frédéric Houriet in der Schweiz und später mit dessen Tochter Henriette verheiratet.

7 Im schweizerischen Neuchâtel geboren, gründete 1775 unter seinem Namen in Paris das bedeutende, weltbekannte Unternehmen, das heute noch besteht.

8 Diese Informationen und große Teile der frühen Lebensgeschichte Ingolds entnehme ich: Quelques Notes sur Pierre-Frederic Ingold et les travaux de E. Haudenschild, hrsg. von der Société Suisse de Chronométrie, Bienne 1932.

9 Nach seiner Lehre bei Perret in Le Locle gründete Japy 1771 in Beaucourt ein Unternehmen zur Herstellung von Rohwerken, das zum größten und wichtigsten Zulieferer in Europa aufstieg.

10 »Horloger-mécanicien de la marine«, der führende französische Chronometermacher seiner Zeit, Neffe und Nachfolger von Ferdinand Berthoud.

11 »Compagnie de l'horlogerie parisienne«, 175 – 177 Palais Royal, Paris. Zu den Aufsichtsratsmitgliedern zählten Arago, Pouillet, Seguier und Gambey. Die Kapitalausstattung der Gesellschaft betrug 2 Millionen Francs bei einem Kurs von 100 Francs je Aktie. Nach zweijährigem Betrieb scheiterte die Gesellschaft. Interessant ist, dass in der Broschüre auch eine Zweigstelle in England erwähnt wird.

12 »Die Versailler Uhrenfabrik«. Ähnlich wie bei der in Paris gegründeten Gesellschaft wurden bedeutende Persönlichkeiten in den Aufsichtsrat sowie in ein separates Herstellergremium berufen. In der Broschüre wird behauptet, die Gesellschaft sei seit Februar 1838 in Betrieb und beschäftige 200 erfahrene Handwerker. Auch dieses Unternehmen scheiterte nach zwei Jahren.

13 Pierre Michel Lepaute (1803 – 1849), Sohn des Pierre Basile Lepaute, der ein Neffe von Jean Andre Lepaute war und mit diesem 1774 zusammenarbeitete. 1816 erbte Pierre Michel das Geschäft.

14 Basile Charles Le Roy (1765 – 1839). »Uhrmacher Napoleons, seiner Frau Mutter, dem König von Westphalen, der Prinzessin Pauline und des Herzogs von Bourbon«. Gründete 1785 das nach ihm benannte Unternehmen in Paris, das ab 1828 als »Le Roy et Fils« firmierte.

15 Jean Joseph Robin (gest. 1858), »Horloger du Roi et de Madame«, Rue Saint-Honoré, Paris. Sohn von Robert Robin.

16 John Barwise (gest. 1842). 29 St. Martins Lane, London. »Chronometer- und Uhrenmacher Ihrer königlichen Hoheiten der Herzöge von York, Kent, Cumberland & Gloucester«. Gründete eines der dynamischsten und zukunftsorientierten Einzelhandelsunternehmen in London, das noch bis ins 20. Jahrhundert hinein weiterexistierte.

17 Thomas Earnshaw jun. (1784 – 1854), 119 High Holborn,

4 David Penney, 'The Faking of English Watches', lecture given at the London meeting of the Antiquarian Horological Society in July 2014. A written paper is presently underway and will hopefully be published in 2015.

5 Apprenticed to Abram Louis Perrelet in Le Locle, was in Paris by 1759, working for Pierre Le Roy and Ferdinand Berthoud. Was in Paris when A. L. Breguet arrived. Pioneer of Swiss chronometry, maker and supplier of tourbillon watches to Breguet, Jürgensen and others.

6 After starting to work for his father in Copenhagen, finished his apprenticeship with Frederic Houriet in Switzerland, and eventually married his daughter Sophie Henriette.

7 Born in Neuchâtel, Switzerland, founder of the most famous and influential Paris firm, in 1775, that continues to this day.

8 This information and much of the early history of Ingold is from: Quelques Notes sur Pierre-Frederic Ingold et les travaux de E Haudenschild, publ. by the Societe Suisse de Chronometrie, Bienne, 1932.

9 Apprenticed to Perret in Le Locle, founded a company to produce 'ébauches' at Beaucort in 1771. It was the largest and most important supplier in Europe.

10 'Horloger-Mécanicien de la Marine', the leading French chronometer maker of his period, nephew of and successor to Ferdinand Berthoud.

11 'Compagnie de l'horlogerie parisienne', 175 – 177 Palais Royal, Paris. Directors included Arago, Pouillet, Seguier, and Gambey. Capitalised at 2 million francs with individual shares priced at 100 francs, the company was in existence for less than two years before it failed. It is of interest that the prospectus included an English office for the Company.

12 'The Versailles Watch Company'. As with the Paris company, eminent figures were recruited to the Board, as well as a separate Board of Manufacturers. The prospectus claimed that the company had been in operation since February 1838 and that it employed 200 superior workmen. Again, the company failed within two years.

13 Pierre Michel Lepaute (1803 – 1849), son of Pierre Basile Lepaute, who was the nephew of and partner with Jean Andre Lepaute in 1774. Pierre Michel inherited the business in 1816.

14 Basile Charles Le Roy (1765 – 1839), 'Clockmaker to Napoleon, Mme Mere, the King of Westphalia, the Princess Pauline and the duc de Bourbon'. Founded the Paris-based business of Le Roy in 1785, becoming Le Roy et Fils in 1828.

15 Jean Joseph Robin (d. 1858), 'Horloger du Roi et de Madame', Rue Saint-Honore, Paris. Son of Robert Robin.

16 John Barwise (d. 1842), 29 St. Martins Lane, London, 'Chronometer, Watch & Clock Makers to their Royal Highnesses the Dukes of York, Kent, Cumberland & Gloucester'. Formed one of the most energetic and forward-thinking London retail firms, which continued in business well into the twentieth century.

17 Thomas Earnshaw Jun. (1784 – 1854), 119 High Holborn, London, son of Thomas Earnshaw, continued the successful chronometer business started by his father.

18 Pierre Frédéric Ingold, English Patent No. 9993, 21 December 1843.

19 'The British Watch and Clockmaking Company Bill', second

London. Übernahm die erfolgreiche Chronometermanufaktur seines Vaters Thomas Earnshaw.

18 Pierre Frédéric Ingold, Englisches Patent Nr. 9993, 21. Dezember 1843.

19 »The British Watch and Clockmaking Company Bill«, zweite Lesung am 31. März 1843. Abgelehnt im House of Commons mit 154 zu 77 Stimmen.

20 Coventry Herald, 31. März 1843. Bericht über eine Versammlung in der Gastwirtschaft »Duke of Cumberland« in Coventry zur Erörterung der von den Betroffenen als solche wahrgenommenen Gefährdung ihrer Existenzgrundlage, sowie ein Bericht über eine ähnliche Versammlung in der Londoner Gastwirtschaft »Crown and Anchor«.

21 The Watchmaker Jeweller & Silversmith, Oktober 1884. Zusammenfassung eines Berichts über »Die Ursachen des Niedergangs des englischen Uhrengewerbes«, in dem berichtet wird, dass »die in [Ingolds] Fabrik beschäftigten Handwerker von den Handwerkern aus Clerkenwell angegriffen wurden, ihre Fenster eingeschlagen wurden und ihnen schwere Verletzungen und großes Leid zugefügt wurde.«

22 The Clockmakers' Company, eine Zunft der City of London, die 1631 gemäß »Königlicher Charta« gegründet wurde und deren Unterlagen in der Bibliothek der Guildhall in London aufbewahrt werden.

23 An dieser Stelle sei auf den Beitrag von Roger Carrington und seinem Vater in »Antiquarian Horology« verwiesen, worin die Geschichte von Ingolds Londoner Vorhaben in größerer Ausführlichkeit dargelegt ist. Siehe Roger F. und R. W. Carrington: »Pierre Frederic Ingold and the British Watch and Clockmaking Company«, in: Antiquarian Horology, Frühling und Sommer 1978. Außerdem Roger F. Carrington: »The British Watch and Clockmaking Company (Some further notes)«, in: Antiquarian Horology, Herbst 1990. Näheres dazu findet sich auch in meiner von der National Association of Watch & Clock Collectors (NAWCC) veröffentlichten Untersuchung, die Ingolds Einfluss auf die Uhrmacherei in Europa und Amerika zum Gegenstand hat. Siehe David Penney: »Pierre Frederic Ingold – His Impact on Watch Making both in Europe and America«, Vortrag auf dem 23. NAWCC-Seminar, Oktober 2002 in Boxborough, Massachusetts. Erschienen in: Boston: Cradle of Industrial Watchmaking. NAWCC Special Order Supplement No. 5, Columbia, Pennsylvania 2005.

24 Siehe ebd. zu Charles Victor Adolphe Nicole und Jules Philippe Capt. Die beiden gebürtigen Schweizer begründeten ihre Partnerschaft etwa im Jahr 1838. Nach Capts Tod tat sich Nicole um 1870 mit dem Dänen Emil Nielsen (gest. 1899) zusammen. 1876 wurde das Unternehmen in Nicole, Nielsen & Co. umfirmiert, 1888 in eine Gesellschaft mit beschränkter Haftung umgewandelt, die Nicole, Nielsen & Co. Ltd., die dann 1917 in North & Sons Ltd. umbenannt, 1933 aufgelöst und im Jahr darauf endgültig geschlossen wurde. Nicole & Capt halten den Rekord bei der Ganggenauigkeit einer englischen Uhr (einer Tourbillion-Uhr), die beim Präzisionstest im Londoner Kew Observatorium 93,9 von möglichen 100 Punkten erreichte.

25 Invention, 14. August 1886, S. 1891.

26 Einer der berühmtesten Uhren- und Chronometermacher seiner Zeit in London. Von 1830 bis 1840 in Partnerschaft mit John Roger Arnold, gemeinsam mit Edmund Beckett Denison (dem späteren Lord Grimthorpe) Entwürfe für die Turmuhr im Westminster Palast (»Big Ben«).

reading 31 March 1843. Rejected in the House of Commons by a vote of 154 to 77.

20 Coventry Herald, 31 March 1843. Report of a meeting convened in the 'Duke of Cumberland' public house in Coventry to consider the perceived threat to the participants' livelihood, as well as a report of a similar meeting held at the 'Crown and Anchor' public house in London.

21 The Watchmaker Jeweller & Silversmith, October 1884. Abstract of a report on 'The Causes of the Decline of the English Watch and Clock Trades,' in which it is reported that 'the workmen engaged in [Ingold's] factory were attacked by the workmen of Clerkenwell, their windows were broken, and great injury and cruelty inflicted.'

22 The Clockmakers' Company, a City of London Livery Company incorporated by Royal Charter in 1631 and whose records are housed at the Guildhall Library, London.

23 For those wishing to know more about the man and his importance, the story of Ingold's London venture is clearly laid out in the article by Roger Carrington and his father in *Antiquarian Horology*: Roger F. and R. W. Carrington, 'Pierre Frederic Ingold and the British Watch and Clockmaking Company', in: Antiquarian Horology, Spring and Summer 1978, and Roger F Carrington, 'The British Watch and Clockmaking Company (Some further notes)', in: Antiquarian Horology, Autumn 1990. See also my Paper concerning Ingold's effect on watchmaking both in Europe and America published by the NAWCC: David Penney, 'Pierre Frederic Ingold: His Impact on Watch Making both in Europe and America', lecture given at the 23rd NAWCC Seminar, October, 2002 at Boxborough, Massachusetts. Published in: Boston: Cradle of Industrial Watchmaking, NAWCC Special Order supplement No. 5, Columbia, Pennsylvania, 2005.

24 See ibid: Charles Victor Adolphe Nicole and Jules Philippe Capt, both Swiss born, started their partnership around 1838. Around 1870, after Capt's death, Nicole was joined by Danish-born Sophus Emil Nielsen (d. 1899), and in 1876 the firm became Nicole, Nielsen & Co. In 1888, the business was converted into a limited liability company, becoming Nicole, Nielsen, & Co. Ltd. In 1917, the company name was changed to North & Sons Ltd. The firm went into liquidation in 1933, finally closing in 1934. They are holders of the precision timekeeping record for an English watch (a tourbillion), achieving 93.9 marks out of a possible 100 at the Kew Trials.

25 Invention, 14 August 1886, p. 1891.

26 One of the most famous London clock, watch, and chronometer makers. In partnership with John Roger Arnold 1830 – 1840, he worked with Edmund Beckett Denison (later Lord Grimthorpe) in designing the turret clock for the Palace of Westminster, commonly called 'Big Ben.'

27 A rival of Dents and an equally famous London clock, watch, and chronometer maker. Purchased the business of J. R. Arnold in 1843, after which the watches were signed Arnold & Frodsham. The title reverted to Charles Frodsham in 1858. The firm had strong ties to that of Nicole, Nielsen & Co., the latter producing most of Frodsham's complicated watches.

28 Anne Nicole, Val de Joux, Switzerland. 'Nicole' is one of the old Swiss families and has a history as long and as distinguished as those of Piguet, Meylan, LeCoultre, and others.

29 The British Horological Institute, started by London-based

27 Der Konkurrent von Dent, der diesem an Ruhm als Uhren- und Chronometermacher in London in nichts nachstand. 1843 kaufte er das Unternehmen J. R. Arnold, dessen Uhren seitdem mit »Arnold & Frodsham« signiert wurden, bis man 1858 zum ursprünglichen Signet »Charles Frodsham« zurückkehrte. Enge Zusammenarbeit mit der Firma Nicole, Nielsen & Co., aus deren Herstellung die meisten der komplizierten Frodsham-Uhren stammten.

28 Anne Nicole, Vallée de Joux, Schweiz. Der Familienname Nicole zählt in der Schweiz zu den ältesten Familiennamen mit einer ähnlich langen und ehrwürdigen Tradition wie die Familien Piguet, Meylan, LeCoultre etc.

29 Das British Horological Institute wurde 1858 von Uhrmachern in London gegründet, weil diese die Clockmakers' Company als wenig nützlich für die Menschen betrachtete, die das Handwerk tatsächlich ausübten. Die ab 1858 herausgegebene institutseigene Monatszeitschrift »Horological Journal« erscheint bis heute.

30 Horological Journal, Juni 1889, S. 145: »Besuch bei der Uhrenfabrik von Nicole, Nielsen & Co«; »[...] dort müssen nicht nur einfache Uhren gefertigt werden, sondern Sekunden- und Minuten-Chronographen, Schleppzeiger, Tastuhren sowie eine Reihe weiterer komplizierter Werke, die beinahe das gesamte Spektrum der Taschenzeitmesser abdecken [...]. Doch mit Ausdauer und beträchtlichem mechanischen Können war es dem Unternehmen möglich, eben jene Geräte und Instrumente zu entwerfen, die geeignet sind, seinen Anforderungen zu entsprechen und mit diesen sehr zufriedenstellende Ergebnisse zu erzielen.«

31 Einige Einzelheiten über ihre späte Produktionsphase sind dem einzigen überlieferten Firmenkatalog vom Anfang des 20. Jahrhunderts zu entnehmen: High-Class English Watches. Verkaufskatalog, um 1900, hrsg. von Nicole, Nielsen & Co. Ltd., 14 Soho Square, London and Watford. Nachdruck in limitierter Auflage durch David Penney, Grooms Cottage, Elsenham Hall, Bishops Stortford, Herts, CM22 6DP, Vereinigtes Königreich, 2002.

32 Reinhard Meis: A. Lange & Söhne, München 1997.

33 Adolphe Nicole, Englisches Patent Nr. 10348, Oktober 1844.

watchmakers in 1858, partly because the Clockmakers' Company was seen to be of little use to practising clock and watchmakers. Their monthly magazine, the *Horological Journal*, first appeared in 1858 and continues to be published to this day.

30 Horological Journal, June 1889, p. 145: 'Visit to Nicole, Nielsen & Co's Watch Factory'; '[...] not only plain watches, but seconds and minute chronographs, split seconds, touch watches, and a variety of other complicated pieces embracing nearly the whole range of pocket timekeepers, have to be produced [...]. However, patience and considerable mechanical ability have enabled the firm to design special appliances suited to their requirements with very satisfactory results.'

31 Some details of their later production can be found in the only trade catalogue known to have been produced by the firm, issued at the beginning of the twentieth century: High-Class English Watches, trade catalogue issued around 1900 by Nicole, Nielsen & Co. Ltd., 14 Soho Square, London and Watford. Limited edition reprint by David Penney, Grooms Cottage, Elsenham Hall, Bishops Stortford, Herts, CM22 6DP, United Kingdom, 2002.

32 Reinhard Meis, A. Lange & Söhne, Munich, 1997.

33 Adolphe Nicole, English Patent No. 10348, October 1844.

Abbildungsnachweis / Credits

Impressum / Imprint

Dieser Katalog erscheint anlässlich der Ausstellung »Einfach – Vollkommen. Sachsens Weg in die internationale Uhrenwelt. Ferdinand Adolph Lange zum 200. Geburtstag« im Mathematisch-Physikalischen Salon, Zwinger, Dresden, vom 18. Februar bis 14. Juni 2015.

This catalogue is published on the occasion of the exhibition *Simple and Perfect. Saxony's Path into the World of International Watchmaking. In celebration of Ferdinand Adolph Lange's 200th Birthday* in the Mathematisch-Physikalischer Salon, Zwinger, Dresden, from 18 February to 14 June 2015.

Katalog / Catalogue

Herausgegeben von / Published by
Staatliche Kunstsammlungen Dresden
Peter Plaßmeyer, Sibylle Gluch

Redaktion / Editors
Sibylle Gluch
Peter Plaßmeyer

Einführungen und Objekttexte / Introductions and object texts
Sibylle Gluch

Bildredaktion und Fotobestellung / Image editing and photo ordering
Sibylle Gluch
Peter Müller

Übersetzungen / Translations
Lance Anderson
Anne Vonderstein
Wieners & Wieners

Lektorat / Copyediting and proofreading
Isabel Hartwig, Deutscher Kunstverlag (Deutsch / German)
Catherine Framm, Berlin (Englisch / English)

Gestaltung / Layout
Kasper Zwaaneveld, Deutscher Kunstverlag

Satz / Typography
Jens Möbius, Deutscher Kunstverlag

Reproduktionen / Reproductions
Birgit Gric, Deutscher Kunstverlag

Druck und Bindung / Printing and binding
BGZ Druckzentrum GmbH, Berlin

Bibliografische Information der Deutschen Nationalbibliothek
Die Deutsche Nationalbibliothek verzeichnet diese Publikation in der Deutschen Nationalbibliografie; detaillierte bibliografische Daten sind im Internet über http://dnb.dnb.de abrufbar.

Bibliographic information published by the Deutsche Nationalbibliothek
The Deutsche Nationalbibliothek lists this publication in the Deutsche Nationalbibliografie; detailed bibliographic data are available in the Internet at http://dnb.d-nb.de.

© 2015 Staatliche Kunstsammlungen Dresden (Mathematisch-Physikalischer Salon, Autoren und Fotografen / authors and photographers)

© 2015 Deutscher Kunstverlag GmbH Berlin München
Paul-Lincke-Ufer 34
D-10999 Berlin

www.deutscherkunstverlag.de
ISBN 978-3-422-07309-8

Ausstellung / Exhibition

Staatliche Kunstsammlungen Dresden

Generaldirektor / Director General
Hartwig Fischer

Kaufmännischer Direktor / Commercial Director
Dirk Burghardt

Mathematisch-Physikalischer Salon

Direktor / Director
Peter Plaßmeyer

Idee und Konzeption / Idea and concept
Sibylle Gluch
Peter Plaßmeyer

Ausstellunggestaltung / Exhibition design
whitebox GbR, Dresden

Medienplanung und -gestaltung / Media Planning and design
whitebox GbR, Dresden
Kalinka + Pfahl GbR, Haan
Kumpels & Friends
Hochschule für Technik und Wirtschaft (HTW), Dresden:
Markus Wacker
Jenny Reinhardt
Claudia Bergmann

Projektleitung / Project management
Peter Plaßmeyer

Projektteam / Project team
Sibylle Gluch
Johannes Eulitz

Direktionssekretariat / Directorial secretariat
Simone Köhler

Restauratorische Betreuung / Restoration
Restaurierungswerkstatt / Restoration workshop
Mathematisch-Physikalischer Salon:
Andreas Holfert
Johannes Eulitz
Lothar Hasselmeyer

Ausstellungsmanagement / Exhibition management
Barbara Rühl
Catrin Dietrich

Bau, Technik, Sicherheit / Construction, technology, security
Michael John

Ausstellungsaufbau / Exhibition set-up
Team Fissler

Bildung und Vermittlung / Education and mediation
Claudia Schmidt
Ramona Nietzold

Publikationsvertrieb / Publications
Evelin Pfeifer

Personal / Human resources
Ingolf Epp

Marketing
Martina Miesler
Anke Wowereit

Veranstaltungsmanagement / Event management
Annelie Lorenz
Anne Böttger
Sarah Jürgel

Presse / Press
Stephan Adam
Anja Priewe

Rechnungswesen und Controlling / Accounting and controlling
Elke Schmieder
Andrea Feistl

Gefördert durch / Sponsored by

Staatliche Kunstsammlungen Dresden
Mathematisch-Physikalischer Salon
Zwinger
01067 Dresden
www.skd.museum